D1201993

GLOSSARY OF ART, ARCHITECTURE AND DESIGN SINCE 1945

TERMS AND LABELS DESCRIBING MOVEMENTS
STYLES AND GROUPS DERIVED FROM THE
VOCABULARY OF ARTISTS AND CRITICS

SECOND REVISED EDITION

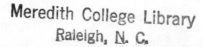

JOHN A WALKER

GLOSSARY OF ART, ARCHITECTURE AND DESIGN SINCE 1945

TERMS AND LABELS DESCRIBING MOVEMENTS
STYLES AND GROUPS DERIVED FROM THE
VOCABULARY OF ARTISTS AND CRITICS

SECOND REVISED EDITION

CLIVE BINGLEY LINNET BOOKS
LONDON HAMDEN · CONN

FIRST PUBLISHED 1973
THIS SECOND REVISED EDITION
FIRST PUBLISHED 1977 BY CLIVE BINGLEY LTD
16 PEMBRIDGE ROAD LONDON W11
SIMULTANEOUSLY PUBLISHED IN THE USA BY LINNET BOOKS
AN IMPRINT OF THE SHOE STRING PRESS INC
995 SHERMAN AVENUE HAMDEN CONNECTICUT 06514
SET IN 10 ON 12 POINT PRESS ROMAN BY ALLSET
AND PRINTED AND BOUND IN THE UK BY
REDWOOD BURN LTD OF TROWBRIDGE AND ESHER
COPYRIGHT © JOHN A WALKER 1977
ALL RIGHTS RESERVED
BINGLEY ISBN: 0-85157-229-4
LINNET ISBN: 0-208-01543-4

CONTENTS

93283

PREFACE TO THE SECOND EDITION

In this new edition I have revised and up-dated many of the existing entries, improved the bibliographical references, included certain terms omitted from the first edition and added new terms which have emerged in the literature of contemporary art in the past four years.

ACKNOWLEDGEMENTS: My thanks to David Cheshire for his constant supply of references, to Lynn Riggall for information on Flash Art, to Judy Hoffberg for information concerning certain American groups, to Michael Hazzledine for the entry on Concrete Poetry, to Vicki Bailey, Jeanie Lowe and Michael Strain for their research work, to Sylvia Katz for information on Plastics, to Lisa Tickner and Vicki Bailey for the entry on Feminist Art, to Peter Moore for the entry on Comix, to Peter Gidal for information on Structural Film, to Clive Phillpot for his work on the Book Art entry, and to Toni Del Renzio for his comments on the Independent Group entry.

JOHN A WALKER
December 1976

INTRODUCTION

I am for Kool-Art, 7-UPart, Pepsi-Art, Sunshine art, 39 cents art, 15 cents art, Vatronol art, Dro-bomb art, Vam art, Menthol art, L X M art, Ex-lax art, Venida art, Heaven Hill art, Pamrly art, Son-o-med art, Rx art, 9.99 art, Now art, New art, How art, Fire sale art, Last chance art, Only art, Diamond art, Tomorrow art, Franks art, Ducks art, Meat-o-rama art.

<div align="right">CLAES OLDENBURG 1967</div>

It is a commonplace that the number and variety of art movements, styles, groups and techniques have increased rapidly since the beginnings of modern art; since 1945 the rate of increase seems to have been exponential. Part of this proliferation may be more apparent than real in that the means of recording and disseminating information about art has probably expanded at a greater rate than art activities themselves; thus we may be more aware of current art than our forebears were of the art of their time. Nevertheless the increase is substantial enough and has been accompanied by a matching growth in the number of art terms, or labels, to encompass new developments.

As Clement Greenberg remarks: 'There are Assemblage, Pop and Op; there are Hard Edge, Colour Field and Shaped Canvas; there are Neo-Figurative, Funky and Environmental; there are Minimal, Kinetic, and Luminous; there are Computer, Cybernetic, Systems, Participatory—and so on. (One of the really new things about art in the sixties is the rash of labels.... most of them devised by artists themselves—which is likewise new; art-labelling used to be the affair of journalists.)'(1)

Even the most cursory examination of today's art books, journals, newspaper articles and exhibition catalogues will confirm that a considerable nomenclature exists and there is no adequate published guide, that I am aware of, to help the reader negotiate the intricacies of modern art criticism.

The complexity of the contemporary art scene begins with the individual artist: he may be born in one country, train in another, work in several others, produce art belonging to three or four internationally recognised styles in the course of his career, he may also associate with

a number of polemical groups. The development of new media extends the coverage given to art, and the international circulation of periodicals and exhibitions brings a knowledge of new art to the most obscure corners of the earth. These factors tend to accelerate the rate of turnover of styles and labels (a succession of styles is already inherent in the notion of avant garde art). An art critic may organise a large exhibition to illustrate a new tendency only to find he has conducted its burial service, the massive exposure of a particular mode of art can provoke, within months, a reaction among younger artists who will develop art forms extolling values antagonistic to those of the first mode. Global conditions prevail and it is extremely difficult to make a convincing case for nationalistic schools of art, though occasionally an art term reflects the existence of a local movement.

Education and affluence in the developed countries have created a considerable interest in the arts. The existence, on the one hand, of an avid public and, on the other, a medley of art styles has led to an unprecedented demand for interpretation. The art critic attempts to communicate his aesthetic response to living art by means of words; in the face of new art the existing vocabulary often proves inadequate, so, as the artist discovers new forms, the critic coins new labels: an inexorable process. It should also be kept in mind that art critics are primarily journalists and work under the pressure of deadlines and a chroni chronic lack of column space; consequently they are compelled to adopt catchwords as a form of shorthand. (2) Such writing has been accused of being a secret language developed by art critics for private communication via art magazines. Each critic, like the artists he discusses, wants to be remembered for his contribution to art history, and therefore he generates labels in the hope that his will gain public acceptance while his rival's terms fail.

The most prolific centre for art since the second world war has been in the United States; their art has also been the most original (not withstanding Patrick Heron's vaunting of British art achievements) and the triumph of American art is matched by the triumph of American art criticism, for the most creative and influential art critics are American or live and work in the United States: Clement Greenberg, Harold Rosenberg, Michael Fried, Jack Burnham, Max Kozloff, Lucy Lippard, Robert Morris, John Coplans, Lawrence Alloway (English but resident in the USA), among others. England fares rather better in the field of architectural criticism, having produced a number of polemical writers—

Reyner Banham, Peter Cook, Charles Jencks—who delight in labels, categories and classifications of current architecture and design.

Many commentators on art have expressed profound doubts about the practice of art labelling; generally they oppose it on the grounds that it puts an obstacle in the way of appreciation, distancing the spectator from the artwork, for example consider the following quotations:

'One of people's hang-ups is labelling and categorising.' (3)

'Classification has always bothered people interested in visual art . . . if one can know where a work of art "belongs" one can diminish its challenge to the imagination and emotions.' (4)

'People who intellectualise about art are devoted to the idea of art history and therefore everything must have its place, its category and its labels.' (5)

Some artists also resent being categorised. As Jaroslav Serpan remarks: 'Strange situation! Assigned by the inevitable stickers on of labels to several successive movements, how is it that I have never felt completely at home in any one of them?' (6)

The architectural writer Peter Collins objects to the speed with which labels are applied: ' . . . nothing but frustration can result from labelling nascent developments with catchwords, and categorising their (architects) first expressions as paradigms, before the creators themselves are clearly aware of what they are aiming at, and before it is certain that the forms produced are of any historic worth.' (7)

In reply one might ask how long a critic should wait before he coins a name, before he determines historical worth—six months? Six years? Sixty years? Explorers name unknown mountains and rivers as they discover them; similarly, critics name new art or architecture as it appears, or when existing works are suddenly perceived in a new light. Art labels survive, or die, according to the same laws of evolution and change as affect the art they refer to.

Though labels are heavily criticised, the precise reasons why they are considered evil are rarely made explicit; exceptionally, one writer claimed that the architectural label 'New Brutalism' was a bad term because the idea of 'brutal' architecture put off prospective clients.

The most cogent and trenchant attack on art labels was mounted by Dore Ashton in 1966, when she compared them to the brand names of commodities, and claimed that art critics were performing middle man, packaging and merchandising operations in the cultural sphere, directly paralleling those found in the business world. Furthermore she

complained that critics encouraged status obsolescence and contrived fashions in art to produce a rapid turnover: 'the consumption of cultural products is up, but independent experience is down, brand names and slogans proliferate, but deep comprehension dwindles.' (8)

Ashton's analysis is undoubtedly correct, but one wonders whether she objects to packaging in the supermarket as much as she does in the cultural sphere; presumably the sales techniques she deplores are the result of vast industrial production and expanding economies. It seems likely that the introduction of merchandising techniques in the promotion of culture is the inevitable consequence of a comparable increase in the production of art, an increase made possible by the surplus wealth resulting from industrialisation. No solution to this dilemma can be expected until a radical change has taken place in the economic and social structure of Western consumer societies.

Most adverse comments on art labels reveal, it seems to me, a lamentable ignorance of the role of language in human affairs. The coining of neologisms to describe new phenomena and concepts, in order to add to the existing total of cultural knowledge, is a basic activity of human perception, thought and communication. A plausible reason for the dislike of any new terms is given by Stroud Cornock: 'any change in our vocabulary must—by disturbing our delicate superstructure of belief and assumptions —threaten our existing cultural modalities . . . an unfamiliar vocabulary is like an insurgent or guerilla force . . . ' (9)

The development of specialist vocabularies characterises all new fields of knowledge, whether scientific, technological, social or artistic, without exception. What seems to disturb art commentators is the disparity between the label and the art it denotes, but *this disparity occurs between all words and the objects they describe.* Ultimately to criticise art labelling is to criticise language for being what it is. Linguists confirm that our picture of reality is, to a large extent, conditioned by the language of the group to which we belong, but, as I have already stated, this is a general problem and is not restricted to the vocabulary of art criticism. It is absurd to believe that the visual arts could exist in human experience isolated from the context of language. (10)

In any event, the flow of new terms will not be stemmed by mere disapproval. Even if art critics could be silenced there would still remain many artists prepared to manufacture slogans and labels to publicise their own work. Furthermore art feeds on art and it can be argued that the essence of the art of the late 1960s and early 1970s is that it is a form

10

of art criticism: Conceptual artists consciously usurp the role of art critics. Indeed one of the insights of Conceptual Art is the importance of language as supportive to art, as Charles Harrison points out:

'Any information which the artist provides will inevitably become a part of the spectator's area of consideration—and this includes titles, however flippantly added.'

' . . . the spectator's experience of the work of art will come to include work by writers and others. Mud does stick. Fried's criticism is now a part of Noland's art. No wonder the better artists tend to protect their art from indifferent exposure; *ie* to protect the idea from indiscriminate presentation of its presentation. The notion of "cubes" obscures the endeavour of Braque and Picasso and no critic's initiative will prize it loose.' (11)

Evidently Harrison disapproves of Michael Fried's critical writing, and of the label 'Cubism', but he does not suggest that criticism and labels can be dispensed with. On the contrary, he is pointing out that artists, having realised their importance, are increasingly exercising control over them.

In my view the only viable approach to art labels is not to ignore them but to confront them head on, to discriminate between the useful and the obscurantist. After all, criticism is a creative activity and some practitioners are more skilful than others, so that terms vary markedly in their usefulness or appropriateness. Udo Kultermann condemns all art labels as 'imprecise, misleading' and believes they are 'symptomatic of the helplessness of the majority of art critics in the face of the phenomena which now assail them' (*ie* the multiplicity of trends). (12) However, let us consider the term 'Minimal Art', which seems to me an example of helpful description in that the adjective 'minimal' summarises (as far as one word ever can) the nature of this particular mode of art. On the other hand, 'New Realism' is much less useful: 'new' will soon lose its currency, and 'realism' already possesses a cluster of historical associations. J P Hodin points out that art criticism is historically orientated (always relating the new to the past) (13), hence the tendency to attach the prefixes 'new', or 'neo', 'post' to existing terms: for example 'Neo-Dada', 'Post-Minimalism'. Some writers resort to absurd and clumsy combinations of existing terms in order to categorise new art; for example the Argentine critic Aldo Pellegrini has devised phrases such as 'Surrealising Neo-Figuration' and 'Post-Expressionistic-Neo-Figuration'; clearly in these situations a neologism would have been infinitely preferable.

11

Frequently, critics fail to define their terms or to indicate the context in which they first appeared, and terms quickly become debased or loose meaning as a result.

Often the intention behind the use of a particular label is derogatory; ironically such labels frequently stick (this was the case with 'Impressionism'). Many critics dismiss a colleague's terms with derision but in the process they give the despised terms wider currency. Unquestionably, terms become obsolete extremely quickly and many in this glossary are already of historical, sociological, or mere curiosity value. Some art terms are fatuous and I may be accused of giving them a spurious authority by listing them in glossary form, but often, even apparently trivial labels reveal the existence of a widespread approach to art, or the influence of a particular philosophical idea, peculiar to a certain period— for example, the use of the word 'situation' by several different groups of artists around 1960.

A striking characteristic of art since 1945, revealed by the terminology of art criticism, is its desperate eclecticism, as Janel Daley confirms: 'The use of jargon in fashionable art propaganda is beyond parody but what distinguishes it from other jargon-ridden fields . . . is the promiscuousness with which it raids wildly disparate and often mutually contradictory fields of intellectual endeavour for its vocabulary . . . ' (14)

This borrowing of concepts from non-art disciplines has added to the difficulty of compiling this glossary, because I cannot claim more than slight acquaintanceship with philosophy, ecology, science, technology, structuralism, linguistics . . . Therefore I apologise in advance to any specialists in these areas who find my treatment of their field of knowledge cursory.

Another salient feature of art since 1945 that has emerged during the compilation of this glossary is the overwhelming influence of a single artist: Marcel Duchamp. As an ex-student of Richard Hamilton I have been aware of the importance of Duchamp for many years, but I had not grasped the extent to which his art and example had informed the development of post-war Western art; whole movements appear to have been founded on his smallest gestures.

As I stated at the beginning of this introduction, there is no convenient source of reference concerning art labels appearing in periodical articles, exhibition catalogue notes, or the texts of art books (but almost never their indexes) since 1945. (The end of the second world war was chosen as a starting point because the pre-war period has been reasonably well documented, and in order to limit the scale of the enquiry. However, I

12

have not adhered rigidly to the date limit: the term 'Art Deco' has been included even though it refers to a pre-war style; other terms concerning taste have been listed because they are ignored by most art dictionaries.) Existing art dictionaries pay little heed to recent developments. McGraw Hill's five volume work, published in 1969, defines 'Op', 'Pop' and 'Kinetic', but as it encompasses the whole history of art the contemporary scene cannot be covered in detail. Art dictionaries also tend to ignore design and architectural terms, such as 'Borax', 'Styling', 'Environmentalism'; concepts of taste, such as 'Kitsch', 'Camp' or 'Good Design' are particularly elusive.

Normally, art dictionaries consist of short essays written by a number of different authors produced under the direction of an editor who attempts to impose a consistent approach and to achieve a balance between contributions; all too frequently poor modulation between terms and inadequate cross referencing result from this method. Some prestigious works, like the *Oxford companion to art*, are not as useful as they might be because they fail to provide a separate name and subject index to their A-Z entries, thus making it difficult to trace information scattered by the alphabetical arrangement.

The art magazine *Leonardo* regularly includes glossaries of terms derived from articles published in each issue, but unfortunately the entries are usually too brief or partial to be generally useful; furthermore, they consist, in the main, of definitions of scientific and technical processes rather than of art movements, styles or groups.

All the terms in this glossary are derived from the published literature on art since 1945 (see bibliographical note) and were selected on a pragmatic basis: the well-known terms—'Abstract Expressionism', 'Colour-Field Painting', etc—selected themselves, the less familiar terms were noted if they were used by several different writers, and occasionally a term was listed if it encapsulated a useful, but otherwise undifferentiated, notion. The selection process was not merely mechanical; at all times it was tempered by a practical knowledge of art gained through the activity of painting and by regular visits to exhibitions held in London since 1956.

Although the glossary lists the more important foreign terms, the bulk of the entries are Anglo-American. The topics covered include architecture, art—painting, sculpture, ceramics—some graphic and industrial design, and some town planning; excluded are theatre, music, literature and fashion. Terms relating to craft operations, tools and technical processes have been excluded because there are several

13

existing dictionaries which list them; also it has been my intention to concentrate on the more conceptual and theoretical notions which are so often neglected by art dictionary compilers. A number of artist's groups and names of art organisations are included, but great selectivity has been exercised in this area, for a separate volume is required to cover groups adequately.

A favourite ploy of art journalists is to name a new form of art after the material employed by the artist, for example, 'Wool Art', 'Sand Art'. The majority of such terms are trivial and self-explanatory, and therefore they have been excluded.

Although I have attempted to cover the period since 1945 systematically, most emphasis has been placed on recent art; firstly because of the ever-increasing complexity and interconnection of art movements as one moves towards the 1970s, and secondly because the information relating to recent art tends to be scattered in many disparate periodicals and exhibition catalogues which may only be available in a specialist art, or architectural, library, whereas information concerning earlier art movements is generally summarised in books which can be purchased from bookshops or borrowed via the public library system.

The glossary is intended primarily as a work of reference, but it could also form the basis of a list of subject headings for the classification of periodical articles in an art library. Furthermore it could serve as an art historical tool: an analysis of terms according to common characteristics would reveal the major trends in art since 1945, for example, one could list terms reflecting the influence of science and technology, terms reflecting the influence of consumerism, terms reflecting formalist preoccupations, etc.

REFERENCES
1 C Greenberg 'Avant garde attitudes: new art in the sixties' *Studio international* 179 (921) April 1970 p 142.
2 E Lucie Smith 'Problems of the working critic of the modern visual arts' *British journal of aesthetics* 11 (3) Summer 1971 237-246.
3 J Toche 'Guerrilla Art Action' *Art and artists* 6 (11) issue No 71 February 1972 p 22.
4 M Kozloff 'The inert and the frenetic'—essay in *Renderings* (Studio Vista, 1970) p 248.
5 A Mackintosh 'Larry Bell: an interview' *Art and artists* 6 (10) issue No 70 January 1972 p 39.
14

6 J Serpan—quoted in *Abstract art since 1945* by W Haftmann and others (Thames & Hudson, 1971) p 159.

7 P Collins 'Historicism' *Architectural review* 127 (762) August 1960 101-103.

8 D Ashton 'New York commentary: marketing techniques in the promotion of art' *Studio international* 172 (883) November 1966 270-273.

9 S Cornock 'Towards a general systems model of the artistic process' *Control magazine* (6) 1972 3-6.

10 M Black *The labyrinth of language* (Penguin, 1972) 160-165.

11 C Harrison 'Notes towards art work' *Studio international* 179 (919) February 1970 42-43.

12 U Kultermann *The new painting* (Pall Mall Press, 1969) p 9.

13 J P Hodin 'Modernism'—essay in *Encyclopedia of world art,* vol 10 (New York, McGraw Hill, 1965) 201-209 columns.

14 J Daley 'Art scientificism' *Art and artists* 7 (1) issue no 73 April 1972 12-13.

A

1 ABSOLUTE ARCHITECTURE: A proposal for a pure, non-objective and purposeless architecture made by Walter Pichler and Hans Hollein in 1962. Absolute Architecture can be regarded as the antithesis of functionalism, its form would be dictated by the individual architect's taste not by utilitarian requirements. See also Utopian Architecture.

V Conrads (ed) *Programmes and manifestoes on twentieth century architecture* (Lund Humphries, 1970).

2 ABSTRACT EXPRESSIONISM: A movement in American painting of the late 1940s and early 1950s acclaimed and imitated throughout the world. The phrase 'Abstract Expressionism' was first used consistently in 1929 to describe the works of Kandinsky; Robert Coates of the *New Yorker* applied it to American painting in 1945. The movement's name appears to indicate that it was a synthesis of two previous forms of art—Abstraction and Expressionism— but this is an over-simplification. Surrealism had a great influence in its development (exemplified in the transitional work of Arshile Gorky), especially the automatic writing techniques employed by the European artists. Certain Abstract Expressionists also had affinities with Oriental art. Indeed the movement included a large number of painters working in a wide variety of styles, consequently several other terms have been coined—Abstract Impressionism, Abstract Imagists, Abstract Sublime, Action Painting, Colour-Field Painting—to draw attention to particular tendencies within Abstract Expressionism.

The main characteristics of Abstract Expressionist painting were: large scale, generally abstract but with some figurative or symbolic elements, a deep involvement with subject matter (see Intrasubjectives), romanticism, loose painterly brushwork, asymmetrical compositions, dramatic colour or tonal contrasts. The artists laid great stress on the process of painting, almost regarding it as a ritual act, and they developed unconventional techniques for applying paint to canvas (see Drip painting). The major figures of the movement were: Willem De Kooning, Franz Kline, Philip Guston, Jackson Pollock, Robert Motherwell, Mark Rothko, Barnett Newman, and Clyfford Still.

See also All Over Painting, Calligraphic Painting, Tachisme.

P G Pavia 'The unwanted title: Abstract Expressionism' *It is* (5) Spring 1960 8-11.

I Sandler *Abstract Expressionism: the triumph of American painting* (Pall Mall Press, 1970).

M Tuchman *The New York School: Abstract Expressionism in the 40s and 50s* (Thames & Hudson, 1970).

D Ashton *The life & times of the New York School* (NY, Viking Press; Bath, Adams & Dart, 1972).

A Everitt *Abstract Expressionism* (Thames & Hudson, 1975).

3 ABSTRACT EXPRESSIONIST CERAMICISTS: A West Coast group of American artists producing experimental ceramics and polychrome sculpture, influenced by Abstract Expressionism, who emerged in the mid 1950s. They were given this rather clumsy label by John Coplans in 1966. The group included Billy Al Bengston, Mike Frinkens, John Mason, Jim Melchert, Kenneth Price, and Peter Voulkos.

See also Funk Art.

J Coplans 'Abstract Expressionist ceramics' *Artforum* 5 (3) November 1966 34-41.

4 ABSTRACT EXPRESSIONIST SCULPTURE: During the late 1950s and early 1960s a number of American sculptors produced work in the idiom of Abstract Expressionism. Sculptors such as Richard Stankiewicz, John Chamberlain, Mark di Suvero and Claire Falkenstein tried to emulate those qualities of improvisation, spontaneity and loose structure characteristic of paintings by Willem De Kooning and Franz Kline. The traditional methods of sculpture, that is, the modelling and carving traditions, were considered antipathetic to such qualities; therefore the sculptors felt compelled to seek out new materials (see Junk Sculpture) and new techniques of composition (see Assemblage Art). The description 'Abstract Expressionist' has also been applied to certain works by the New York sculptress Eva Hesse, for example, the 1969 piece 'Contingent'.

N and E Calas 'Abstract Expressionist Sculpture'—chapter in—*Icons and images of the sixties* (NY, Dutton, 1971) 50-58.

5 ABSTRACT ILLUSIONISM: A tendency in American abstract painting of the middle 1960s, noted by Barbara Rose in October 1967, marked by a return to illusionism. The painters concerned—Darby Bannard, Ron Davis, Jules Olitski, Frank Stella, Larry Zox and others—used such pictorial devices as two point perspective, orthographic drawing,

cool/warm colour contrasts to achieve depth effects. A few months earlier Lucy Lippard had described the same tendency, under the heading 'perverse perspectives', as a new and incongruous illusionism "incorporating the statement of the flat surface of a painting and counter statement of an inverse perspective that juts out into the spectator's space".

The English critic Bryan Robertson, in his catalogue introduction to the Royal Academy 'British Sculptors' exhibition of 1972, also used the expression 'Abstract Illusionism' to characterise the work of Kenneth Draper, Nigel Hall, Paul Huxley, Bridget Riley and William Tucker.

L Lippard 'Perverse perspectives' *Art international* 11 (3) March 20 1967 28-33 and 44.

B Rose 'Abstract Illusionism' *Artforum* 6 (2) October 1967 33-37.

6 ABSTRACT IMAGISTS: A name applied to certain artists of the Abstract Expressionist movement—Mark Rothko, Barnett Newman, Adolph Gottlieb, Ad Reinhardt, Robert Motherwell and Clyfford Still—to distinguish them from gestural expressionists such as Jackson Pollock or Franz Kline. The term derives from a 1961 Guggenheim Museum exhibition entitled 'American Abstract Expressionists and Imagists'. These artists exploit large flatly painted coloured areas and sign-like elements to suggest a symbolic content. The term 'Quietistic' has also been proposed to describe this kind of painting.

See also Invisible Painting.

7 ABSTRACT IMPRESSIONISM: Elaine De Kooning coined this term in 1951 to describe paintings with a uniform pattern of brushstrokes, which retained the optical effects of Impressionism while dispensing with its representational content. (A consequence of the success of Abstract Expressionism was a re-evaluation of large-scale All-Over paintings such as those by Monet.) In 1956 Louis Finkelstein called Philip Guston's paintings 'Abstract Impressionist' in order to distinguish them from the more violent Action paintings created at the same time. Two years later the British Arts Council supported an exhibition entitled 'Abstract Impressionism' organised by Lawrence Alloway; it included works by Bernard and Harold Cohen, Nicholas De Stael, Sam Francis, Patrick Heron, Joan Mitchell, Jean-Paul Riopelle, and Pierre Tal Coat. Aldo Pellegrini, the Argentine critic, also applies this label (in his book *New tendencies in art*) to a group of French abstractionists—Jean Bazaine, Alfred

Manessier, and Gustave Singier—whose paintings were popular in the immediate post-war period.

L Finkelstein 'New look: Abstract Impressionism' *Art News* 55 (1) March 1956 36-39, 66-68.

L Alloway 'Some notes on Abstract Impressionism'—in—*Abstract Impressionism* (Arts Council of Great Britain, 1958).

8 ABSTRACT LANDSCAPE: A mode of painting practised in the middle 1950s by a number of artists belonging to the School of Paris: Zao Wou-Ki, Pierre Tal Coat, Vieira da Silva, James Guitet, John F Koenig and others. Michel Ragon, the French art critic, coined the term 'Paysagisme abstrait' in 1956 in an attempt to characterise abstract paintings which by their naturalistic colours and atmospheric use of tones suggest natural landscape; Ragon himself admits that the term is absurd.

M Ragon *Vingt cinq ans d'art vivant* (Paris, Casterman, 1969).

9 ABSTRACT SUBLIME (or American Sublime): A phrase used by the American art critic Robert Rosenblum in 1961 to characterise paintings by Jackson Pollock, Barnett Newman, Mark Rothko, and Clyfford Still. Newman had previously employed the word 'sublime' in connection with his own work in 1948, having been influenced by Edmund Burke's theory of the division between the beautiful—smoothness, gentle curves, polish, delicacy—and the sublime—terrible objects, obscurity, solitude, vastness. Rosenblum found a parallel between those qualities typical of the Romantic movement and those characteristic of Abstract Expressionism; this relationship has also been discussed by Lawrence Alloway.

'The ides of art 6: opinions on "what is sublime in art?" ' *The Tigers eye* 1 (6) December 1948 46-56.

S H Monk *The sublime: a study of critical theories in XVIII century England* (Michigan, U of Michigan Press, 1960).

R Rosenblum 'The abstract sublime' (1961)—in—*New York painting and sculpture 1940-1970*, by H Geldzahler & others (Pall Mall Press, 1969) 350-359.

L Alloway 'American sublime' *Living arts* (2) 1963 11-22.

10 ACADEMIC ART: 'The academy teaches that the great aims of art cannot be achieved by copying nature in a servile way; it views nature as filled with imperfections so that one must select from and improve upon her . . . the subject is to convey the sense of a universal experience in heroic terms, heroic in action or suffering. In the presentation of the

subject, the invention of the composition, the artist is to strive for strict legibility and unity; only one subject or event is to be depicted and nothing is to detract from it . . . above all, nothing unseemly is to be shown, even if it is part of the story' (Goldstein).

A desire to understand how the 'great' artists of any period were influenced by the artistic standards and practices of their time has led to a revival of interest in the academies which dominated European art for over three centuries.

Authorities differ on definitions of Academic Art: Boime believes that the principal difference between academic and 'independent' work is technical, that it consists in a difference in the way paint is applied to canvas; Whitfield identifies 'academic' with the ennobled nude; while Goldstein sees the process of concentrating on a central figure or incident, with the picture built-up around it, as the main characteristic of Academic Art, and points out that Rococo, Classical, and Romantic pictures can all be painted according to academic rules.

The perjorative connotation attached to the term 'academic' dates back to the birth of Modern Art which is generally regarded—over simplistically—as a consequence of the rejections of the rules and values of the French Academy by the Impressionists (Boime has shown that Impressionist practice overlapped with that of the Academy to a surprising extent). Since it is part of the ethos of the Avant Garde to seek out 'forbidden' material, certain despised characteristics of Academic Art reappear within Modern Art, for example, meticulous execution is common to Gérome and Photo-Realism. Also the longevity and dominance of Modern Art has caused some observers to wonder if Modernism is a new academy.

See also Bourgeois Realism.

'Institutes and associations' *Encyclopedia of world art* vol 8 (NY, McGraw Hill, 1958) 136-183 columns.

T B Hess & J Ashbery *The Academy . . .* (NY, Macmillan, 1967) Art News Annual 33.

S Whitfield *The academic tradition* (Indiana University Art Museum, 1968).

A Boime *The Academy and French painting in the nineteenth century* (Phaidon, 1971).

N Pevsner *Academies of art past and present* (1940) (NY, Da Capo reprint, 1973).

C Goldstein 'Towards a definition of Academic Art' *Art bulletin* 57 (1) March 1975 102-109.

11 ACME HOUSING ASSOCIATION: A charitable organisation, established in London in 1972, which obtains living/working accommodation for artists by renting short-life property and by purchasing old property. In May 1976 ACME opened a gallery in Covent Garden to display work by members of the association and the work of non-members.

The ACME Housing Association (ACME, 1976).

12 ACTION ARCHITECTURE: A phrase coined by G M Kallmann in 1959. It refers to the work of a new generation of architects who seek 'fierce, direct and brutal action in design', who use materials 'as found' and who respond to particular situations. According to Peter Collins it refers to architecture created with the aid of sketches rather than precise working drawings, and by the personal supervision of the architect on the building site. The concept of Action Architecture is clearly derived from Harold Rosenberg's formulation 'Action Painting'.

G M Kallmann 'The "Action" architecture of a new generation' *Architectural forum* 111 (4) October 1959 132-137 and 244.

P Collins *Changing ideals in modern architecture* (Faber, 1965).

13 ACTION OFFICE: A flexible system of office furniture for individuals or groups capable of being arranged in a variety of different configurations. The Action Office was designed in 1964 by the American architect George Nelson, for the furniture manufacturers Herman Miller Inc, after a research study into the work pattern of American business executives conducted by Robert Propst.

See also Bürolandschaft.

R Cuddon 'Design review: office furniture' *Architectural review* 140 (837) November 1966 369-370.

G Nelson 'Action office' *Architectural design* 36 (2) February 1966 p 101.

14 ACTION PAINTING (also called Gestural Painting): Harold Rosenberg, a critic on the staff of *Art news*, invented this term in 1952 to describe the loosely painted, gestural works of Jackson Pollock, Franz Kline, Willem de Kooning and Jack Tworkov. Such painting depended upon the unconscious as a source of inspiration; it extended into oil painting the automatic writing technique developed by the Surrealists. Rosenberg's use of the word 'action' stressed the existentialist act of painting—the process of making was given greater emphasis than the finished work (the question of when a painting could be regarded as 'finished' being a major

talking point at that time). Rosenberg regarded the canvas as an arena in which the painter could act, the result being not so much a picture as an event. Mary MacCarthy riposted in a review "you cannot hang an event on a wall, only a picture".

See also Abstract Expressionism, Tachisme, Drip Painting, Process Art.

H Rosenberg 'The American Action Painters'—in—*The tradition of the new* (Thames and Hudson, 1962) 23-39.

H Rosenberg 'Action Painting: crisis and distortion'—in—*The anxious object:art today and its audience* (Thames and Hudson, 1965) 38-47.

H Rosenberg 'The premises of Action Painting' *Encounter* 20 (5) May 1963 47-50.

M Rowell *La peinture, le geste, l'action: L'existentialisme en peinture* (Paris: Editions Klincksieck, 1972).

15 ACTION SPACE: A highly mobile community arts organisation led by Ken Turner established in 1968 and based in Camden, London. Action Space uses inflatables, improvised drama, video, and multi-media presentations to educate, to entertain, and to redefine the role of art in society.

See also Community Art, Participatory Art, Video Art.

O Pritchett 'Action Space Man' *The guardian* August 17 1972 p6.

H Hebert 'Merry video' *The guardian* November 6 1975 p9.

16 ACTIONS (or Aktionen): In Germany the word 'aktion' has recently become very popular. It means 'activity', 'process', 'undertaking'. In the context of recent art it refers to a form of event, similar to Happenings, developed primarily by German and Austrian artists (see Direct Art, Haus-Rucker Co, Fluxus). In Bern an art gallery—the 'Aktiongalerie'—is devoted to this form of art. A number of Austrian artists, especially those who make up the Vienna Institute of Direct Art, belong to a movement called 'Wiener Aktionismus', the essential concept of which is 'material action'. These artists claim to have abandoned the use of a medium to represent reality, in favour of the direct use of reality itself as a means of formal creation; thus Actions are not so much theatrical performances (pretended reality) as literal events. They can be regarded as a determined attempt to end the art/life dichotomy.

Actions imply a social and political consciousness among artists: Joseph Beuys has founded a political party, and in such Actions as the one at the Tate Gallery in 1972 he discusses politics, art, and education with the aid of chalk and blackboard. One also finds the word 'action' employed by
22

community art associations in Britain (Inter-Action, Action Space) and by radical groups in the United States (Guerrilla Art Action).

See also Community Art, Happenings, Process Art.

S Simon 'Wolf Vostell's action imagery' *Art international* 12 (9) November 20 1968 40-47.

W Vostell *Aktionen: Happenings und demonstrationen seit 1965* (Hamburg: Rowohlt, 1970).

Joseph Beuys Aktioner aktionen (Stockholm: Moderna Museet 1971).

P Restany '1972–the American crisis and the great game of the establishment' *Domus* (507) February 1972 47-51.

P Weiermair 'New tendencies in Austrian art' *Studio International* 183 (944) May 1972 pp 207-209.

F Popper *Art–Action and participation* (Studio Vista, 1975).

17 ACTUAL ART: A form of Street Art or Happenings performed in Prague in the middle 1960s by a number of Czechoslovakian artists calling themselves 'Art of the Actual Group' or 'Group Actual'. It was led by Milan Knizak and its members included Sona Svecova, Vit Mach and Jan Trtilek. In 1973 Knizak was imprisoned for his allegedly anti-revolutionary attitude.

See also Actions, Happenings, Street Art.

A Kaprow *Assemblage, Environments and Happenings* (NY, Abrams, 1965) 299-310.

M Knizak 'Actual in Czechoslovakia' *Art & artists* 7 (7) October 1972 40-43.

(Special issue on Czechoslovakian art) *Schmuck* January 1974.

18 ACTUALISM: A term used by the French writer Alain Jouffrey to describe what happens to art in revolutionary situations such as those in France during May 1968. In such situations art as an independent entity distinct from social reality is abolished. Once works of art cease to be categorised as art then their real significance, or irrelevance, is revealed by their actual meaning and action. Jouffrey believes that art should no longer function as the armchair of the state, that artists should seek the 'death' of art in order to communicate directly with all sections of society.

See also Living Art.

A Jouffrey 'What's to be done about art?'–in–*Art and confrontation: France and the arts in an age of change* (Studio Vista, 1970) 175-201.

23

19 ADDITIVE ARCHITECTURE: Jorn Utzon's term for architecture and furniture consisting of standardised parts that can be added to as the need for expansion arises.

See also Kinetic Architecture.

20 ADHOCISM: A term coined by Charles Jencks and first used in architectural criticism in 1968 to describe a method of design in which each part of a building, or complex of buildings, is produced separately by a specialist or expert with little regard to the conception as a whole. Jencks claims that it is no longer necessary for an architect to invent new forms, he can select the best of what is already available from catalogues and collage the parts together. Adhocism can also be applied to any design problem which demands to be solved quickly: the designer improvises a solution from whatever resources are already at hand, for example, using a toothbrush to clean a typewriter. This process is also referred to as 'bricolage' after Claude Lévi-Strauss (a bricoleur is an odd-job man or handyman). In a recent critique of Adhocism Reyner Banham attacks the whole notion of 'improvisatory design' and claims that Lévi-Strauss's term 'bricolage' has been misused.

C Jencks 'Criticism: Adhocism on the South Bank' *Architectural review* 144 (857) July 1968 27-30.

C Jencks & N Silver 'The case for improvisation' *Architectural design* 42 (10) October 1972 604-607.

C Jencks & N Silver *Adhocism* (Secker & Warburg, 1972).

R Banham 'Arts in society: Bricologues à la lanterne' *New society* 37 (717) July 1 1976 25-26.

21 ADP (Art Design Photo): An annual bibliography of books, catalogues, and periodical articles on modern art, graphic design, photography, and art libraries compiled by the British art librarian and bibliographer Alexander Davis. The first issue of ADP was published in 1973 and documented over 5000 items issued in the previous year.

See also RILA.

22 ADVOCACY PLANNING: An American concept dating from the 1960s: the term was first used in 1965 by Paul Davidoff. It denotes planning and architectural design done on behalf of minority or deprived groups within cities, especially when fighting against urban renewal schemes and plans for motorways. Socially conscious individuals or groups such as ARCH (Architects' Renewal Committee in Harlem) represent—as

a legal advocate does—the views of ordinary people when negotiating with planning authorities.

See also Community Architecture.

'Advocacy planning: what it is, how it works' *Progressive architecture* 49 September 1968 102-115.

'Advocacy: a community planning voice' *Design quarterly* (82/83) 1971.

D McConaghy 'The limitations of advocacy' *RIBA journal* 80 (2) February 1972 63-66.

23 AFFICHES LACÉRÉES (torn posters): Torn or lacerated posters fascinated a number of European artists in the post-war period and they were elevated to the rank of fine art by the polemics of Pierre Restany in 1960 (see Le Nouveau Réalisme). Raymond Hains, a French photographer, began collecting torn posters from hoardings in Paris in 1949; later he was assisted by J de la Villeglé. In 1959, another Frenchman, François Dufrêne became interested, especially in the reverse side of posters. Two Italians, Mimmo Rotella and Alberti Moretti, also developed a preoccupation with torn posters independently of the French during the 1950s. The art of torn posters consists of three stages: (1) selection and presentation of posters as they are discovered in the streets; (2) the creation of torn posters by the unsticking process called 'Décollage'; (3) rubbing the backs of posters to produce images. Torn posters share a stylistic affinity with the paintings of Abstract Expressionism and L'Art Informel produced during the same period.

See also Décollage.

J de la Villeglé 'L'Affiche lacérée; ses successives immixtions dans les arts' *Leonardo* 2(1) January 1969 33-44.

J-B Lebrun 'Les "affichistes" de la rage à la froideur' *XXe Siècle* 37 (45) December 1975 63-72.

24 AIR (Art Information Registry): A London organisation founded in 1967 by Peter Sedgley, Stuart Brisley and others to provide a channel between artists and their public, to act as an alternative to the commercial gallery system. The registry, or artists' index, consists of colour slides, photographs, press cuttings, catalogues and biographical details relating to over 500 British artists; it is available to public and private collectors and to exhibition organisers. AIR publishes a directory of useful addresses (*Airmail*) and a monthly newsletter. The address of AIR is now 125-129 Shaftesbury Avenue, London WC2 H8AD; these premises include a

series of spacious galleries where exhibitions of work by AIR artists are mounted.

See also SPACE.

S Braden 'A.I.R. R.A. R.I.P.? S.P.A.C.E.D.' *Time out* (84) September 24th-30th 1971 20-21.

Report on Art Information Registry 1967-1971 (AIR, 1971).

25 AIR ART (including Blow-Up Art, Gonflable Art, Inflatable Sculpture, Sky Art): A broad category encompassing a variety of different structures and activities which have in common the fact that they exploit the possibilities of compressed air, or the natural force of the wind, usually in association with plastic envelopes of various kinds. Air Art, a subspecies of Kinetic Art, gained an independent status as a result of three exhibitions held in the late 1960s: (1) 'Structures gonflables' (1968) held at the Musée d'art Moderne, Paris which featured works by the Utopie Group; (2) 'Air Art' (1968) held at the Philadelphia Arts Council which featured works by Hans Haacke, Les Levine, David Medalla, Robert Morris, and others; (3) 'Inflatable sculpture' (1969) held at the Jewish Museum, New York which featured works by Charles Frazier, David Jacobs, Susan L Williams, Andy Warhol, Otto Piene, and others. Most of the artists who participated in these shows were not specialists in Air Art, but Otto Piene, a German artist working in the United States, has been obsessed with sky works for a number of years. Apologists for Air Art have found precedents for it in the art of Leonardo, Duchamp, Klein, and Manzoni. The significant qualities of Air Art were: (a) its public character (sky works can be seen by thousands); (b) its participatory aspect (the appeal of inflatables to the athletic); and (c) its contribution to the anti or post-object trend in the art of the late 1960s.

Those artists totally committed to the neglected aesthetic of air like Piene, or Graham Stevens of the Eventstructure Research Group, tended in their excitement at its future prospects, to make exaggerated claims for it; for example, describing air structures as the cultural expression of the energy continuum of the universe, or asserting that they have a revolutionary potential for social change.

See also Blow-Up Furniture, Eventstructure, Kinetic Art, Pneumatic Architecture, Soft Art, Utopie Group.

W Sharp 'Air Art' *Studio international* 175 (900) May 1968 262-265.

J Glusberg 'Air Art one' *Art & artists* 3 (10) January 1969 40-49.

N Frackman 'Inflatable sculpture' *Arts magazine* 44 (1) September/October 1969 p55.

G Stevens 'Pneumatics and atmospheres' *Architectural design* 43 (3) March 1972 165-171.

G Stevens 'Blow-Up' *Art & artists* 7 (2) May 1972 42-45.

O Piene *More sky art* (Cambridge, Mass, MIT Press, 1973).

H Woody 'Kinetic environmental art: sky sculpture' *Leonardo* 7 (3) Summer 1974 207-210.

26 ALL-OVER PAINTINGS: Works avoiding any kind of central composition or grouping of forms into areas of special interest to create a figure/ground effect. They are usually painted in a uniform manner or with accents distributed evenly across the surface of the canvas, filling it up to the framing edges. The phrase is frequently applied to the paintings of Jackson Pollock and also to the late works of Monet. C H Waddington finds a connection between all-overness in art and certain ideas in science, namely, the everywhere dense continuum of events concept that has replaced the 'billiard ball' atomic theory of matter.

See also Non-Relational Painting.

'Panel: All-over Painting' *It is* (2) Autumn 1958 72-77.

C H Waddington *Behind appearance* . . . (Edinburgh University Press, 1969).

27 ALTERNATIVE DESIGN (or Counter Design, Social Design): An attempt by socially aware designers living in the affluent West to use their inventiveness, specialist knowledge, and skills for the benefit of those most in need. Design as an alternative to industrial design in the service of big business. Alternative designers are concerned about the social implications of mass production and industrialisation and seek through better design to ameliorate their adverse effects; they also design for underprivileged minorities within their own societies (eg the disabled); and they contribute unpaid design time to tackling problems of the poor in the underdeveloped countries of the Third World. The British organisation SIAD (Society of Industrial Artists and Designers) has set up an Alternative Design group and a conference entitled 'Design for need' was held at the Royal College of Art, London in 1976.

Victor Papanek, perhaps the best known advocate and practitioner of 'integrated, comprehensive, anticipatory design' (aside from R Buckminster Fuller), refuses to patent or copyright his designs so that anyone who wishes to use them can do so.

See also Community Architecture, Radical Design.

V Papanek *Design for the real world* (Thames & Hudson, 1972; Paladin, 1974).

A Mondini 'The land of good design'–in–*Italy: the new domestic landscape* (NY, MOMA, 1972) 370-379.

'Alternative design issue' *Designer* September 1976.

28 ALTERNATIVE DEVELOPMENTS (AD): Richard Cork, the English art critic, was given the task of selecting artists to be included in the massive exhibition of English art held in Milan in 1976 whose work fell outside the confines of painting and sculpture. Since the media, form and content of the output of these artists was so diverse no positive term could be found which would describe it adequately, hence the negative but open-ended phrase 'Alternative Developments'. Whether the art described as alternative to painting and sculpture replaces these traditional activities or whether they all run parallel to one another is a trivial question which is of concern to certain British painters who feel threatened by AD art; see for example the abrasive, debunking article by James Faure-Walker in *Artscribe.*

R Cork 'Alternative developments' *Arte Ingelese oggi 1960-76*, Part 2 (Milan: Electra Editrice, 1976).

J Faure-Walker 'AD' *Artscribe* (2) Spring 1976 6-7, p11.

29 AMERICAN-TYPE PAINTING: Title of an essay by Clement Greenberg first published in *Partisan review* in 1955. Essentially the term is an alternative for 'Abstract Expressionism'; Greenberg credits the invention of the term to the English painter Patrick Heron.

C Greenberg ' "American-type" painting'–in–*Art and culture* (Thames & Hudson, 1973) 208 -229.

30 ANALYTICAL ART: A term first used in 1970 by Terry Atkinson to characterise the work of certain British and American Conceptual artists, that is, those associated with the *Art & language* magazine and another journal entitled *Analytical art* which appeared for two issues in 1971-72. Their work was called 'analytical' because its methods were analogous to those of British analytical philosophy; as Charles Harrison expressed it: (Joseph) 'Kosuth and the Art-Language artists have extended the legitimate vocabulary of art in the direction of philosophy by promoting certain modes of analysis, previously considered proper to other disciplines, from a secondary to a primary status in the consideration and construction of art'.

See also Conceptual Art, Art & Language.

T Atkinson 'From an Art-Language point of view' *Art-Language* 1 (2) February 1970 25-53.

C Harrison 'A very abstract context' *Studio international* 180 (927) November 1970 194-198.

31 ANAMORPHIC ART: Paintings and drawings containing images which appear grotesquely distorted or stretched but which become 'normal' when viewed in a mirror with a curved surface, or from a particular vantage point (usually at a slant to the support). Leonardo's notebooks contain examples and a famous instance of anamorphosis is the skull depicted in Holbein's painting 'The ambassadors' (1533); however, Anamorphic Art did not become fully fashionable until the seventeenth and eighteenth centuries. Many twentieth century photographers have used anamorphic lenses to produce stretched or compressed images. In the first half of the 1970s a Paris exhibition, a book, and several periodical articles indicated a revival of interest in this form of art.

F Leema & others *Anamorphosen* . . . (Cologne, Dumont Schauberg, 1975); *The curious magic of Anamorphic Art* (NY, Abrams, 1976).

M Gardner 'Mathematical games' *Scientific American* 232 (1) January 1975 110-116, + front cover.

G Barriere 'Des objets peints non-identifiable' *Connaissance des arts* (288) February 1976 48-55.

32 ANARCHITECTURE: A word coined by Robin Evans from the Greek 'an' meaning 'non', and 'architecture'. An-architecture means non architecture, or Anarchi-tecture meaning 'the "tectonics" of non control.'

Also a description applied to the piquant activities of Gordon Matta-Clark: eg sawing a house in half in the name of art.

R Evans 'Toward anarchitecture' *AAQ* 2 (1) January 1970 58-69.

A Brunelle 'The great divide "Anarchitecture" by Matta-Clark' *Art in America* 62 (5) September/October 1974 92-93.

D Wall 'Gordon Matta-Clark's building dissections' *Arts magazine* 50 (9) May 1976 74-79.

33 ANONIMA: A group of American painters—Ernst Benkert, Francis Hewitt and Edwin Mieckowski—who operate as a research team. The group was established in Cleveland in 1964 and moved to New York in 1967. The members of Anonima set themselves rigorous programmes of research into perceptual problems relating to the art of painting. Their

paintings are abstract and executed in a hard edge style (see Hard-Edge Painting), their work is featured in their own journal *Anonima* and in books on Optical art (see Op Art). The name 'Anonima' was selected from a book on Italian steamships (in Italian the word means 'incorporated').

H P Raleigh 'Anonima Group' *Leonardo* 2 (4) October 1969 423-430.

34 ANONIMA DESIGN: The name of a group of radical Italian architects and designers: Jaretti, Luzi, Prandi, Riccato, Virano.

'Anonima design' *Casabella* 37 (379) July 1973 36-41.

'Anonima design' *Contemporanea* (Firenze, Centro Di, 1974) 304-306.

35 ANONYMOUS DESIGN: Title of an exhibition held in 1974 at the Louisana Museum, Humlebaek (near Copenhagen) consisting of examples of mass produced household goods and utensils on which no designers' name appeared. The products were selected on the grounds that they possessed 'genuine character, good form, fine performance, and honest use of materials'.

See also 'Good Design'.

'Anonym Design' *Louisana Revy* 14 (3/4) April-August 1974 1-28, 70-75.

S Hansen 'Anonymous design' *Mobilia* (228-229) July-August 1974 2-9.

36 ANONYMOUS SCULPTURE: A description applied by Bernhard and Hilla Becher to certain types of industrial structures—gas holders, kilns, silos, water towers, pithead winding towers, blast furnaces, and cooling towers—which they regard as exhibiting sculptural qualities. The Bechers have assiduously documented hundreds of examples of these structures in Europe and the United States and displays of their photographs have been mounted in dozens of art galleries. To illustrate differences and similarities between items the Bechers produce display panels containing a series of photos of one particular type of structure. The somewhat surprising popularity of these photographs in avant garde gallery and magazine circles can be attributed to the vogue for serial imagery, documentation and photo-works in recent art.

B & H Becher *Anonyme Skulpturen: eine typologie technischer bauten* (Dusseldorf, Art Press, 1970).

Bernd & Hilla Becher (Arts Council of Great Britain, 1974).

B & H Becher *Photographs 1957-75* (Cologne, Rheinland-Verlag, 1975).

30

37 ANT FARM: A group of American architects, designers and others from a variety of backgrounds formed in San Francisco in 1968 by Doug Michels and Chip Lord. Its strange name came from a remark that the only interesting things in architecture were happening underground, 'like an ant farm'. The group is concerned with architecture, educational reform, communication, graphic design, film, life-theatre, and high art. It sets no limit to the media it may use. The members of the group describe themselves as a family and attempt to create a common life style; they hope to transform existing social and economic systems by presenting alternatives. Their work is featured in Underground magazines, in *Architectural design* and *Progressive architecture*, where they are described as 'architecture freaks' and 'environmental nomads'; projects include a portable snake plus media van with video equipment, an electronic oasis for nomadic tribes of the future; they also provide information on do-it-yourself domes and inflatable structures.

T Albright 'Ant Farm' *Rolling stone* (48) December 13 1969 p 36.
'Conceptual Architecture' *Design quarterly* (78/79) 1970 5-10.
G Celant 'Ant Farm' *Casabella* (376) April 1973 27-31.

38 ANTHROPOLOGIZED ART: A term invented by the American artist Joseph Kosuth and used by him since around 1972. The science of anthropology, Kosuth argues, requires that the anthropologist stands outside the cultures he studies; this fact makes it difficult for the anthropologist to scrutinise his own society. The artist, on the other hand, is immersed in a particular society and his activities embody its culture; therefore the artist-as-anthropologist is in a unique position to develop an understanding of his own culture providing he is willing to undertake an auto-critique of his own behaviour. Kosuth prescribes that Anthropologized Art 'must concern itself with exposing institutional contradictions and thereby obliterating art ideologies which pre-suppose the autonomy of art'.

J Kosuth '(Notes) On an anthropologized art'—in—*Kunst bleibt kunst* (catalogue for Projekt '74) (Cologne, 1974).
J Kosuth 'The artist as anthropologist' *The fox* 1 (1) 1975 18-30.
J Kosuth '1975' *The fox* 1 (2) 1975 86-96.

39 ANTI-ART: Most critics regard this notion as having originated with Dada, the European movement which totally repudiated bourgeois art and culture. The invention of the term 'anti-art' is credited to Marcel Duchamp, an artist who has also been dubbed 'the master of anti-art'.

31

A vandal who mutilates a famous painting or sculpture commits an act against art but his gesture is not itself regarded as art; however, when Duchamp added a moustache to a reproduction of the 'Mona Lisa' his reputation as an artist was sufficient to transform his negative gesture into art, hence the emergence of the genre Anti-Art Art. It is virtually impossible for an artist to attack art without his attack being construed as art at a later date. For example, the purpose of Duchamp's readymades —everyday objects chosen on the grounds of aesthetic indifference—was to question certain of our basic assumptions about art yet these objects, or replicas of them, were later displayed (much to Duchamp's amusement and disgust) in museums as examples of Modern Art. Logically speaking Anti-Art Art must be against itself therefore its destructive project must ultimately end in suicide: artworks designed to destroy themselves (see Auto-Destructive Art & Destructive Art).

Since art is not a static concept new art often encroaches on areas of experience previously considered non-art. There is a tendency among laymen and critics to greet all new movements as Anti-Art because the new inevitably challenges their existing idea of art. There is some justification for this attitude in that most Avant Garde movements make a point of breaking with tradition and their spokesmen denigrate previous and rival forms of art. After Dada, as Harold Rosenberg has pointed out, the denunciation of art became part of the etiquette of the Avant Garde.

In Herbert Marcuse's view Anti-Art is work that is visual and involves drawing but is not intended as art; graffiti, for example. Gregory Battcock suggests that works transgressing accepted standards of morality, such as Underground sex comics, should count as Anti-Art, though he dislikes the term itself and proposes 'Outlaw Art' as a replacement.

The American aesthetician George Dickie regards art as an institution and in his eyes true Anti-Art consists of activity which occurs within the institution and manipulates its norms but then fails to provide any art. Vito Acconci is cited as an example of an artist who operates in this manner.

H Rosenberg *Artworks and packages* (NY, Dell, 1964) p 24, 26.

G Battcock 'Marcuse and Anti-Art' Part I *Arts magazine* 43 (8) Summer 1969 17-19; Part II *Arts magazine* 44 (2) November 1969 20-22.

U Meyer 'The eruption of Anti-Art'—in—*Idea art: a critical anthology;* edited by G Battcock (NY, Dutton, 1973) 116-134.

G Dickie 'What is Anti-Art?' *Journal of aesthetics and art criticism* 33 (4) Summer 1975 419-421.

40 ANTI-FORM: A term used primarily by the American artist Robert Morris to describe sculptures of the late 1960s which focus on materials,

the force of gravity, and the process of production, and by so doing react against the geometric, predominantly rectangular forms of previous abstract sculpture, in particular Minimal Art. Max Kozloff regards such works as an attack on the status of the object in art. Allan Kaprow insists that no sculpture can be against or without form, and suggests that 'Anti-form' means 'anti-geometry'; he also points out that a similar approach to art was developed in Happenings. Morris has further defined Anti-form as an 'attempt to contradict one's taste'.

See also Happenings, Minimal Art, Process Art.

A Kaprow 'The shape of the art environment: how anti-form is Anti-form" ' *Artforum* 6 (10) Summer 1968 32-33.

R Morris 'Anti-Form' *Artforum* 6 (8) April 1968 33-35.

G Muller 'Robert Morris presents Anti-Form: the Castelli Warehouse show' *Arts magazine* 43 (4) February 1969 29-30.

M Kozloff '9 in a warehouse' *Artforum* 7 (6) February 1969 38-42.

41 ANTI-ILLUSION: Title of major exhibition of American art (sculpture, films, music, painting) held at the Whitney Museum, New York in 1969. Artists represented included Carl Andre, Michael Asher, Eva Hesse, Barry Le Va, Robert Morris, Bruce Nauman, Richard Serra, Michael Snow and Keith Sonnier. Their work stressed materials and procedures and attempted to exclude 'descriptive, poetic, or psychological referents'; it rejected 'all traditions of illusion in art'.

See also Process Art, Minimal Art.

Anti-illusion: Procedures/materials (NY: Whitney Museum of American art, 1969).

42 APG (Artist Placement Group): A visionary project launched in 1966 by the British artists John and Barbara Latham, Jeffrey Shaw, and Barry Flanagan. These founder members were joined soon afterwards by David Hall and Stuart Brisley. The function of APG is to act as a mediating mechanism between artists and organisations: its aim is to place artists within organisations—industries, business, universities, local authorities, government departments, development corporations, hospital boards, new towns—not primarily in order to produce art objects but to act as catalysts for cultural change. An exhibition of work by APG artists was mounted at the Hayward Gallery, London in December 1971. This show prompted a series of highly critical articles in the art press accusing APG of muddled thinking, false claims, misuse of language and amateurism. Nevertheless APG continues to operate; a summary of the theoretical

basis of APG (plus a detailed bibliography) and a review of recent place-
ments is to be found in the March/April 1976 issue of *Studio International.*

J A Walker 'APG: the individual and the organisation, a decade of con-
ceptual engineering' *Studio international* 191 (980) March/April 1976
162-172.

43 ARC (Paris): Initials standing for Animation-Research-Confrontation,
a programme of exhibitions, performances, meetings, and critical dis-
cussions concerning contemporary art organised by P Gaudibert at the
Musée d'Art Moderne, Paris between 1967 and 1972.

P Gaudibert 'An experiment in active culture in Paris: ARC 1967-72'
Studio international 185 (953) March 1973 112-113.

44 ARCHIGRAM: An organisation of architects, designers and environ-
mental researchers led by Peter Cook, based in London and the United
States. Members include Warren Chalk, Ron Herron, Dennis Crompton,
David Greene and Mike Webb. *Archigram magazine*, or manifesto, has
been published since 1961, but the group itself was formed two years
later by young architects reacting against the boredom and sterility of
post-war British architecture and suspicious of monumental, 'definitive'
architecture. As Peter Cook explains, the title for the magazine 'came
from the notion of a more urgent and simple item than a journal, like a
telegram or 'Aerogramme' hence "archi(tecture)-gram" '.

Archigram delights in experimental projects; the group greatly ad-
mires the kind of advanced technology displayed in the American space
programme. Their schemes are often consumer oriented and make use
of combinations of services and appliances rather than traditional build-
ing structures. Projects include Plug-in architecture, Clip-on architecture,
capsule dwellings, mobile villages, instant cities. These ideas are com-
municated largely via lively collages and graphics. In 1970 Archigram
won first prize in an international competition for the design of an enter-
tainments centre at Monte Carlo. In January 1973 the group mounted
an exhibition on the history of Archigram at the ICA, London.

See also Plug-in Architecture.

'Archigram group, London: a chronological survey' *Architectural
design* 35 (11) November 1965 534-535.

P Cook & others (eds) *Archigram* (Studio Vista, 1972).

45 ARCHITECTURE ACTIVE: A term used by the French architect
André Wogenscky to indicate the reciprocal relationship between man
34

and architecture, that is, man produces architecture and in turn architecture influences man.

A Wogenscky *Architecture active* (Paris, Casterman, 1972).

46 UNE ARCHITECTURE AUTRE: Reyner Banham coined this phrase in 1955 (it was derived from *Un Art Autre*) to describe a trend in the architectural thinking of the period subversive to the norms of traditional architecture. In his view this trend was characterised by vehemence, by new concepts of order, by an uninhibited attitude to materials, that were related to similar qualities found in the paintings of Jean Dubuffet, Jackson Pollock, and in Musique Concrete. Banham also suggested that 'Other Architecture' should consider alternative means of defining environments or solving functional needs besides the building of monumental structures. According to Banham the only designer whose approach approximated to his concept of Other Architecture was R Buckminster Fuller.

R Banham *The New Brutalism: ethic or aesthetic* (Architectural Press, 1966) 68-69.

47 ARCHITECTURE MACHINE: Title of a book by Nicholas Negroponte in which he discusses the use of computers in architectural design and planning. Negroponte is concerned with more than computer-aided design: he would like to see the computer fully integrated into the design process.

See also Computer Art.

N Negroponte *The architecture machine: toward a more human environment* (MIT Press, 1970).

48 ARCHITECTURE WITHOUT ARCHITECTS: Title of an exhibition of photographs, collected over forty years by Bernard Rudofsky, held in New York in 1965. The photographs illustrated shelters and structures—caves, earthworks, tree houses, tents, villages . . . —used or built by people with no professional training in architecture: early man, ancient and primitive peoples, nomadic tribes, peasants . . . This type of architecture has also been called 'Non-pedigreed', 'Vernacular', 'Anonymous', 'Spontaneous', 'Indigenous', 'Rural', 'Rude' and 'Exotic'.

B Rudofsky *Architecture without architects* (NY, MOMA, 1965).

L Wodehouse 'Indigenous architecture' *AAQ* 7 (3) July/September 1975 23-28.

49 ARCHIVES OF AMERICAN ART: A research collection of over two million items devoted to American art—artists' letters, papers, journals; records of dealers, collectors, critics, curators; scrapbooks, files of organisations—established in Detroit in 1954. The archive developed throughout the 1960s and in 1970 it became a bureau of the Smithsonian Institution, Washington. There are five regional offices with material available on micro-film; a journal—*American art journal*—is published quarterly.

G McCoy (ed) *Archives of American Art: a directory of resources* (NY, Bowker, 1972).

D M Sokol 'In praise of archives' *Art in America* 61 (6) November/December 1973 42-43.

50 ARCHIZOOM (Studio Archizoom Associati): A group of six Florentine architects and designers—Andrea Branzi, Gilberto Corretti, Paolo Deganello, Massimo Morozzi, Dario and Lucia Bartolini—founded in 1966. The members of Archizoom are representative of the anti-functional, supersensualist trend in Italian design. Their work is featured in such magazines as *Domus, Casabella, Architectural design* and the Milanese magazine *In.*

See also Supersensualists.

'Conceptual architecture' *Design quarterly* (78/79) 1970 17-21.

51 ARCOLOGY: A new conception of architecture involving a fusion of architecture and ecology proposed by Paolo Soleri an Italian architect resident in the United States. Arcology is Soleri's solution to the urban problems of the twentieth century; he proposes vast vertical megastructures capable of housing up to three million inhabitants. One of Soleri's visionary projects called 'Arcosanti' is slowly being constructed by student labour in the Arizona desert.

See also Megastructures.

P Soleri *Arcology: the city in the image of man* (Cambridge, Mass, MIT Press, 1969).

D Wall *Visionary cities: the arcology of Paolo Soleri* (Pall Mall Press, 1971).

H Skolimowski 'Paolo Soleri: the philosophy of urban life' *AAQ* 3 (1) Winter 1971 34-42.

R Banham 'Arts in society: the mesa Messiah' *New Society* May 6 1976 306-307.

52 ARIS (Art Research in Scandinavia): Title of a semi-annual periodical published from Lund since 1969. ARIS is supported by the Swedish Humanities Research Council and promoted by the Collegium for Contemporary Art. It contains papers in Swedish and English on contemporary art and also methodological and theoretical studies.

53 ARLIS (Arts Libraries Society in the United Kingdom and the Republic of Ireland): A society founded in London in 1969 'to promote art librarianship particularly by acting as a forum for the interchange of information and materials'. Membership is open to individuals and to institutions in the United Kingdom. From October 1969 to March 1976 ARLIS published a newsletter; from Spring 1976 this publication has been largely superseded by a more scholarly journal: *Art libraries journal.* As a result of the founding of ARLIS in England a similar society—ARLIS (NA)—was established in the United States. Discussions have been taking place concerning the feasibility of establishing an international art libraries society.

C Phillpot 'ARLIS—The Art Libraries Society' *ARLIS/NA Newsletter* 1 (2) February 1973 2-3.

54 ART & LANGUAGE (A&L):Founded in 1966 A&L is an informal grouping of artists who work together, either collectively or collaboratively. Members resident in Britain have included Terry Atkinson, Michael Baldwin, David Bainbridge, Charles Harrison, Graham Howard, Harold Hurrell, Philip Pilkington, David Rushton and Paul Wood. Members based in the United States have included Ian Burn, Sarah Charlesworth, Preston Heller, Michael Corris, Joseph Kosuth, Andrew Menard, Mel Ramsden and Terry Smith. (Neither list of names can be regarded as definitive because the personnel of A&L fluctuates continuously.) Initially A&L produced a series of works which provided a critique of Duchamp's ideas and the theory of Minimal Art. Then followed an investigation into the concept 'art' and the question was raised whether the papers written by A&L artists could count as art (in the same way that papers by scientists are science). In 1969 A&L began to publish a journal to make their discourse more widely available. Originally it carried the subtitle 'journal of conceptual art' but the association with the Conceptual Art movement has since proved an embarrassment to the group.

Working together involves talking to one another, writing papers which are passed around for annotation and discussion, presenting group shows in an art context. One becomes a member of A&L by participating in

37

these activities. The most striking features of A&L are its adoption of language as the primary medium (rather than painting or sculpture) and its rejection of the unique, handmade, finished object. In the late 1960s A&L borrowed the methods of British analytical philosophy and subsequently ransacked a host of academic disciplines—sociology, logic, linguistics, anthropology, etc—in search of concepts and instrumentalities. Generally they 'collage' their findings together to produce an almost incomprehensible (though often humorous) argot which either intrigues or alienates the reader. One characteristic of language is that it is sensory-mode indifferent, that is, it can be understood via the eyes (print), via the ears (speech), via the hands (braille), hence language tends to appeal to the mind rather than the senses. As a result the work of A&L is highly cerebral and is made public via printed texts, posters, tape recordings, microfilm, and seminars.

In the mid 1970s a marked shift towards the left is evident in the writings of A&L; they are increasingly concerned with the economic infrastructure of the art industry, with the relationship between art and ideology, and the role of art in the class struggle. These concerns are particularly evident in a new journal established by the American branch of A&L (*The Fox*).

In 1976 certain members of A&L in New York felt the need to establish a more radical collective hence the emergence of '(Provisional) Art & Language' (PAL). The name of this splinter group indicates on the one hand a desire to break with the history of A&L and on the other hand a desire to maintain a connection with that history.

Most critics of A&L focus on the obscurity of its discourse, but one could also cite its hectoring tone and bully-boy tactics towards rivals and outsiders. While parasitic on the international artworld A&L offers no viable alternative form of art; its searches endlessly in a somewhat random fashion and despite the immense intellectual effort expended its findings have been meagre.

See also Analytical Art, Conceptual Art, Political Art.

Art-Language 1 (1) 1969- .

The Fox 1 (1) 1975- .

P Maenz (ed) *Art & Language* (Koln, Dumont, 1972).

T Smith 'Art and Art & Language' *Artforum* 12 (6) February 1974 49-52.

'Extract from Art-Language proceedings' *Audio arts* 1 (1) 1974 sound recording.

Art & Language 1966-1975 (Oxford, MOMA, 1975).

55 ART-AS-ART: A tautological dogma constantly reiterated in the writings of the American abstract painter Ad Reinhardt (Mr Pure) from the 1950s to his death in 1967. Taking as his starting point the fact that the existence of the concept 'art' in human culture indicates a category which is distinct from everything else Reinhardt sought to establish art as a pure, independent, autonomous realm, self-conscious and pre-occupied with its own means and processes, having no meaning outside of itself. Such an art would transcend history by being timeless and the only suitable location for it would be insulated from the world inside a museum exclusively devoted to Fine Art.

A Reinhardt *Art-as-art: the selected writings of Ad Reinhardt;* edited by B Rose (NY, Viking Press, 1975).

56 UN ART AUTRE: Title of a book by the French writer Michel Tapié published in 1952. In the same year a Paris exhibition featuring work by Karel Appel, Camille Bryen, Wols, Willem De Kooning, Mark Tobey, Jean-Paul Riopelle, Alberto Burri, Jean Dubuffet, Jean Fautrier and Georges Mathieu was organised with the same title. In his book Tapié also employed the phrase 'L'Art informel' and the literature is rather confused as to the usage of these two terms. Tapié claimed that post-war trends indicated a complete break with traditional modes and that the primary characteristic of this 'other art' was the relinquishing of all forms of control. According to H H Arnason the term is so broad as to be almost meaningless.

See also L'Art Informel.

M Tapié *Un art autre* . . (Paris, Gabriel-Giraud, 1952).

M Tapié *Morphologie autre* (Turin, Edizioni d'arte Fratelli Pozzi, 1960).

57 L'ART BRUT (raw art): The French artist Jean Dubuffet tried consistently in his work and his statements to avoid the traps of traditional art (or Cultural Art), and to rehabilitate discredited materials and values. For many years he collected examples of crude, unsophisticated artworks— street graffiti, paintings and drawings by psychotics, prisoners, primitives, children, by any non-professional artist—which he called 'L'Art Brut'. In 1948 he founded a society to encourage the study of raw art and a year later he organised an exhibition of his collection at the Galerie René Drouin, Paris. (His collection is now permanently on display in Lausanne, Switzerland.) Dubuffet admired raw art for its innocent vision, directness of technique, use of unconventional materials and emulated these qualities in his own painting; for example, he experimented with different

materials such as sand, ashes, vegetable matter, to produce rough textures in which he scrawled and scratched childlike imagery, and thus his own work has also come to be known as L'Art Brut.

See also Cultural Art, Graffiti, Matter Art, Outsider Art, Remedial Art.

J Dubuffet *L'Art Brut préféré aux arts culturels* (Paris, Compagnie de L'Art Brut, 1949).

L'Art Brut, fascicules 1-8 (Paris, Compagnie de L'Art Brut, 1964-66).

L'Art Brut (Paris, Musée des Arts Décoratifs, 1967).

Catalogue de la collection de L'Art Brut (Paris, 1971).

R Law & C Dars 'The minds eye' *Sunday Times magazine* October 22 1972 46-51.

M Thévoz *Art Brut* (Academy Editions, 1976).

D de Rham 'L'Art Brut à Lausanne' *L'Oeil* (249) April 1976 22-27.

58 ART DECO: This term derives from the title of a 1925 Paris exhibition: 'L'Exposition Internationale des Arts Décoratifs et Industriels Modernes'. It was used as early as 1935 but has only become fashionable in the late 1960s as a result of a spate of articles and books. Bevis Hillier defines Art Deco as 'an assertively modern style, developing in the 1920s and reaching high point in the thirties; it drew inspiration from . . . Art Nouveau, Cubism, the Russian Ballet, American Indian art and the Bauhaus . . . it ran to symmetry . . . and to the rectilinear.' It was the style of Odeon cinemas, ocean liners and hotel interiors, it tried to adapt design to the requirements of mass production and was expressed therefore in the applied rather than fine arts. Art Deco has also been called 'Aztec Airways', Jazz Modern', 'Modernistic', 'Functional' or named after its chief artists, 'Style Poiret', 'Style Chanel', 'Style Puriforcat' or it was referred to by the date of the exhibition, 'Style 1925', 'La Mode 1925', 'Paris 25'.

Another authority on the period, Martin Battersby, claims that the term 'Art Deco' has been misused; he says that it was a curvilinear style, but more formalised than Art Nouveau, making use of vivid colours such as cerise, orange, violet, emerald . . . and that it ended in 1925, the simpler more geometric design appearing after that date Battersby calls 'Modernist'. A third writer, Peter Wollen, believes that the subject is still undefined; he attacks the cult of Art Deco and describes it as Kitsch, haute trend, second rate vanguardism. He regards the leading Art Deco artists as parasites on the genuine creators of the Modern Movement. The revival of 1920s and 1930s design has influenced the work of a number of fine artists, notably Roy Lichtenstein, Frank Stella and Colin Self.

Writers and publishers apparently find the subject of Art Deco inexhaustible, judging from the number of books covering all aspects of the style—sculpture, architecture, design, advertising, fashion—which appeared in the first half of the 1970s.

See also Austerity-Binge, Kitsch, Modern Movement, Depression Modern.

B Hillier *Art Deco of the 20s and 30s* (Studio Vista, 1968).

G Veronsi *Into the twenties: style and design 1909-1929* (Thames & Hudson, 1968).

M Battersby *The decorative twenties* (Studio Vista, 1969).

Y Brunhammer *The nineteen twenties style* (Hamlyn, 1969).

B Nevil 'Fashions in living—Art Deco: the first modern style' *Vogue* (British) 126 (10) August 1969 92-97.

M Battersby *The decorative thirties* (Studio Vista, 1971).

B Hillier *The world of Art Deco* (Studio Vista, 1971).

P Wollen 'Decor Artif' *Studio international* 182 (938) November 1971 213-214.

K M McClinton *Art Deco: a guide for collectors* (NY, Clarkson N Potter, 1972).

J Mebane *Collecting nostalgia: the first guide to the antiques of the 30s and 40s* (New Rochelle, NY, Arlington House, 1972).

M Loeb *Art Deco designs and motifs* (NY, Dover, 1972).

T Menten *The Art Deco style in household objects, architecture, sculpture, graphics, jewelry* (NY, Dover, 1972).

M Battersby *Art Deco fashion* (Academy Editions, 1974).

M Battersby *Colour book of Art Deco* (Octopus, 1974).

A Lesieutre *The spirit and splendour of Art Deco* (Paddington Press, 1974).

P Maenz *Art Deco—forms between two wars 1920-1940* (Koln, Dumont Schauberg, 1974).

D Vlack & R Appelbaum *Art Deco architecture in New York* (NY, Harper & Row, 1974).

C Robinson & R H Bletter *Skyscraper style: Art Deco New York* (NY, OUP, 1975).

V Arwas *Art Deco sculpture* (Academy, 1975).

T Menten *Advertising art in the Art Deco style* (NY, Dover, 1976).

59 L'ART INFORMEL: An extremely broad term devised by the French writer Michel Tapié in his book *Un art autre* to describe a trend in the art of the 1950s towards a mainly abstract but non-geometric style characterised

by such terms as 'shapeless', 'intuitive', 'psychic improvisation'. L'Art Informel included such tendencies as Tachisme, Matter Art, Lyrical Abstraction, and American Action painting (though it refers primarily to European art). This form of painting dominated Parisian taste for a decade until 1962 when, to the relief of Concrete and Kinetic artists, it suddenly became unfashionable.

English writers have generally translated 'informel' as 'informal' (thus 'L'Art Informel' becomes 'Informalism'); however, the words are not equivalent: 'informel' is not the antithesis of 'formal'. (Exceptionally in 1970 the American critic Carter Ratcliff described several New York painters as 'The New Informalists' because their work sidestepped the formalist concerns of American painting of the previous decade.)

See also Action Painting, Art Autre, Lyrical Abstraction, New Informalists, Tachisme.

J Paulham *L'Art informel* (Paris, Gallimard, 1962).

60 ART METROPOLE: A non-profit making agency which documents and promotes the activities of Canadian artists working in new and collaborative media. A distribution service for artists' books, recordings, videotapes and other multiple products is being established. Art Metropole is located at 241 Yonge St, Toronto M5B 1N8.

61 ART OF THE REAL: Title of an exhibition of American art held at the Tate Gallery, London in 1969 to illustrate a tendency in American painting and sculpture: to make no appeal to emotion but to offer works in the form of simple, irreducible, irrefutable objects. Among the artists represented were Sol LeWitt, Robert Morris, Ellsworth Kelly, Kenneth Noland, Frank Stella, Donald Judd and Larry Poons. The exhibition contained several disparate styles more precisely defined elsewhere (see Hard-Edge Painting, Minimal Art, Op Art).

The art of the real: an aspect of American painting and sculpture 1948-1968 (Tate Gallery, 1969).

62 ART POVERA (Poor or Impoverished Art): A term devised by the Italian critic Germano Celant in 1967 to describe certain works by the artists Carl Andre, Joseph Beuys, Walter de Maria, Jan Dibbets, Hans Haacke, Joseph Kosuth, Robert Morris, Dennis Oppenheim, Richard Serra and others. In a book he edited in 1969 Celant listed alternative terms— Actual Art, Conceptual Art, Earthworks, Impossible Art, Micro-emotive Art, Raw Materialist Art, Anti-Form—indicating that Art Povera was a

broad category encompassing several international trends in the art of the 1960s (in my view Art Povera occupied the middle ground between the two extremes of Minimal and Conceptual Art). Celant's label stressed the unworthiness (ie non fine art) of the materials employed by the artists listed above: coal, sand, earth, wood, stones, twigs, cement, felt, rubber, rope, newspapers, etc. Art Povera was often temporary by nature and its creation frequently took place at remote sites consequently its occurrence was only made permanent and known to the public by means of document-ation which was subsequently marketed via the gallery system. Art Povera reflected a new romanticism or a new primitivism: the penchant for rural or wild country, the artist as magician or alchemist working with natural elements (water, snow, ice, grass) and using natural forces (gravity, wind growth). A hostile reviewer described Art Povera as 'poor art, of poor materials, in exultation of a poor life'.

See also Anti-Form, Conceptual Art, Earth Art, Ecological Art, Matter Art, Minimal Art.

G Celant (ed) *Art povera* (Studio Vista, 1969).

63 ARTWORKERS COALITION (AWC): An association of art workers founded in New York in 1969. One of its leading figures, Carl Andre, has explained that the term 'art worker' was preferred to 'artist' because it included everyone who made 'a productive contribution to art'. The AWC opposed the capitalist gallery/dealer establishment and the 'star' system of promoting artists. It supported social and political protest in the field of art; specifically it demanded reform of museum administration equal rights for black and Puerto Rican artists, and the end of the war in Vietnam. Members of AWC were prepared to remove 'their' works from the public galleries that owned them as a form of protest, to organise strikes, sit-ins, demonstrations and picketing. (In England a related group called the 'International Coalition for the Abolition of Art' disrupted the opening of the 1970 'Young Contemporaries Exhibition'.) A larger group-ing called 'New York Strike' consisted of former AWC members plus mu-seum and gallery workers; two smaller but more militant groups were 'Guerrilla Art Action' and 'Art Workers United'.

AWC disintegrated around 1970 following the disenchantment of mem-bers opposed to the militant policies of confrontation which had been adopted.

See also Artists' Union, Black Art, Cultural Art, Guerrilla Art Action, National Art Worker's Community.

L Picard 'Protest and rebellion: the function of the Art Workers Coalition' *Arts magazine* 44 (7) May 1970 18-24.

T Schwartz 'The politicalisation of the Avant Garde II' *Art in America* 60 (2) March/April 1972 70-79.

C Tisdall 'Any old iron' *The guardian* June 1 1972 p10.

L Lippard 'The Art Workers' Coalition'—in—*Idea art: a critical anthology;* edited by G Battcock (NY, Dutton, 1973) 102-115.

64 ARTEURS: A term devised by Jean-Claude Lambert to describe 'those for whom the very meaning of artistic activity has undergone so complete a mutation that they cannot be considered artists in the conventional sense'.

J-C Lambert 'Les arteurs ou le depassement de l'art' *Opus International* (22) January 1971 10-19.

65 ARTHROPODS: Invertebrate animals with articulate, segmented bodies and limbs; a term applied by Jim Burns to a number of experimental design groups because 'their members are articulated or interconnected for singular purposes of environmental creation, while still being segmented into their individual personae as artists, architects, designers, planners or performers'. The groups in question include Haus-Rucker-Co, God & Co, Missing Link Productions, 9999, Superstudio, Coop Himmelblau, Eventstructure Researcy Group, Onyx, and others.

See also Evenstructure, Haus-Rucker-Co, Superstudio.

J Burns *Arthropods: new design futures* (NY, Praeger, 1972).

66 ARTISTS FOR DEMOCRACY (AFD): A group of left-wing artists and others working in the realm of culture (including the artist David Medalla and the critic Guy Brett) formed on May 6 1974 for the purpose of supporting liberation movements throughout the world and integrating artistic practice and political struggle. AFD has a gallery/meeting place in Whitfield St, London, where displays, events and festivals are staged to celebrate the victory of the North Vietnamese and to support resistance in Chile. The work of the AFD artists has been dubbed 'Third world art' and 'Democratic art'.

See also Artists Liberation Front.

C Tisdall 'Democratic art' *The guardian* March 26 1975 p 12.

'Artists for Democracy' *Studio international* 189 (975) May/June 1975 p226.

67 ARTISTS LIBERATION FRONT: A movement for peoples culture founded by David Medalla (an artist born in Manilla working in London) and John Dugger on May 1 1971.

See also Artists for Democracy.

A survey of the avant-garde in Britain vol 1 (Gallery House, 1972) 13-22.

D Medalla 'Art for whom?' *Art & artists* 7 (10) January 1973 26-31.

68 ARTISTS MEETING FOR CULTURAL CHANGE (AMCC): A loose coalition of politically conscious artists and art workers meeting regularly since the Winter of 1975 on Sunday evenings at the Artists' Space to discuss such issues as imperialism, feminism, and work in an attempt to develop a more effective form of artistic practice.

The Fox 1 (3) 1976 40-58.

69 ARTISTS NOW: A group consisting of Ian Bruce, David Castillejo, Christopher Cornford, Charles Gosford and Frances Routh whose concern for the plight of the creative artist in Britain prompted them to produce a detailed report on patronage.

Patronage of the creative artist (Artists Now, 1974).

70 ARTISTS' SPACE: A non-profit making gallery/meeting place at 155 Wooster St, New York. Artists' Space was established in 1973 with the financial aid of the New York State Council on the Arts and the National Endowments for the Arts for the purpose of showing work by lesser-known artists and artists not affiliated with commercial galleries. A slide file of artists' works is maintained and the selection for exhibitions is made by a frequently changing panel of artists.

D Seagrief 'Creativity at work: Artists' Space' *Studio international* 187 (967) June 1974 274-275.

T Grace 'Artists' Space' *Art journal* 34 (4) Summer 1975 323-326.

71 ARTISTS' UNIONS: In 1971 a small number of British artists calling themselves 'the policy Group' initiated a scheme for the establishment of an Artists' Union to be affiliated to the Trades Union Congress (TUC). The aims of the AU are to influence the decision making processes that affect artists and thereby gain benefits for members, to foster the living arts, to encourage a closer relationship between art and the needs of the people.

The emergence of a British AU is a somewhat belated development compared to the United States where an Artists' Union was formed in the 1930s, and compared to other countries in Europe; for example, in Holland the BBK (Beroepsvereniging Beeldende Kunstenaars) was founded in the immediate post-war era.

'The Artists' Union' *Studio international* 183 (944) May 1972 p 192.

P Fuller 'United artists . . .?' *Art & artists* 7 (4) July 1972, 12-14.

'The Artists' Union—a statement' *Art & artists* 7 (5) August 1972 12-13.

S Braden 'Exhibitions: dispute in the art industry' *Time out* (132) August 25-31 1972 p37.

'Union now!' *Art & artists* 7 (6) September 1972 10-13.

G M Monroe 'The Artists' Union of New York' *Art journal* 32 (1) Fall 1972 17-20.

'The artist as an individual: the Artists' Union in Holland' *Studio international* 186 (957) July/August 1973 2-3.

72 ARTOLOGY: A term suggested by the French critic Paule Gauthier. The addition of the suffix 'ology' (from the Greek 'logos' meaning 'word', 'reason') to the word 'art' produces 'Artology', the science and theory of art. By analogy with musicologists, artologists are those who study art and are knowledgeable about it but who are not themselves practising artists. Artology is distinguished from aesthetics in not being concerned with questions of beauty in nature. Traditional disciplines such as art history, criticism, and connoisseurship would fall under its scope and in addition Artology would take account of the insights on art afforded by such disciplines as anthropology, linguistics, marxism, philosophy, psychology, semiotics and sociology.

P Gauthier (Artology) *Cimaise* (110-111) January-April 1973 97-98.

A Goodwin 'What is Artology?' *Art international* 19 (3) March 20 1975 47-48.

73 ARTS COUNCIL OF GREAT BRITAIN: This institution has been described as 'the dominant power in British art'. It is an agency funded by the Treasury (via the Department of Education and Science) founded in 1945 for the purpose of subsidising the fine arts, including music, drama, opera, ballet, painting, sculpture, community arts, and literature. Its offices are located in central London but there are a number of Regional Arts Associations supported by the Council. As far as the visual

arts are concerned the Council makes grants direct to artists, galleries, and art centres, it also organises touring exhibitions and a programme of shows at the Hayward Gallery. Periodically the Council comes under attack (see Artists Now, FACOP) for its bureaucratic officialdom, its inadequate grants, and its general lack of vision. Details of the Council's activities are to be found in its annual reports.

Patronage of the creative artist (Artists Now, 1974).

E W White *The Arts Council of Great Britain* (Davis-Poynter, 1975).

74 ARTS LAB: Jim Haynes, an American resident in Britain since 1956, established the first Arts Laboratory in Drury Lane, Covent Garden, London in 1967. It contained a theatre, cinema, art gallery and bookshop, all housed in an abandoned scrap-metal warehouse. To raise money and to overcome censorship problems Haynes ran the Arts Lab on the lines of a private club.

By the end of 1969 over 150 other Arts Labs had been founded throughout the United Kingdom. Their purpose was to provide an alternative to the commercial art-as-commodity systems; to provide artists with workshop facilities; to develop avant garde, Underground or experimental art projects and to provide the public with—in the words of Richard Neville—"centres for fun, new culture and madness".

Because of their lack of permanent funds and their experimental character, Arts Labs tended to be ephemeral organisations: the original Arts Lab closed in October 1969 and its successor the New Arts Lab, located in Roberts Street, London, was equally shortlived. Many artists found it impossible to work in the presence of a constant stream of inquisitive visitors, and consequently a separate organisation (see IRAT) was set up to concentrate on creative activities.

P Fryer 'The Arts Laboratory' *New society* October 26 1967 p557.

H Judson 'The Arts Laboratory: swinging smorgasbord' *Life* May 13 1968.

J Allen 'The Arts Lab explosion' *New society* November 21 1968 749-750.

N De Jongh 'Lights out for the Arts Lab' *The guardian* October 21 1969 p11.

J Haynes 'Arts Lab: a fortress and haven for adult games' *Ark* (45) Winter 1969 22-28.

R Neville *Playpower* (Cape, 1970).

75 ARTSPEAK: A term devised by John A Walker in 1976 (following the example of George Orwell's 'Newspeak' in *1984*) to describe the obscure, convoluted, and tortured language found in so many art magazines.

J A Walker 'Internal memorandum' *Studio international* 192 (983) September/October 1976 113-118.

76 ARTWORLD: A topic discussed by several American aestheticians. Arthur C Danto defines the artworld as 'an atmosphere of artistic theory, a knowledge of the history of art', while for George Dickie the artworld is the social institution responsible for defining art. Anita Silver has pointed out that if a society included a policeworld in which only the police decided who were the criminals it would be judged unhealthy, consequently what counts as art in any society ought to be decided on the basis of a consensus of opinion held by a broad cross section of the population. Though, of course, the artworld is very influential in forming that opinion, especially in highly specialised societies such as ours.

See also Conceptual Art, Judd's Dictum.

A C Danto 'The Artworld' *Journal of philosophy* 1964 571-584.

G Dickie *Art and the aesthetic: an institutional analysis* (Ithaca, Cornell U Press, 1974).

A Silvers 'Artworld discarded' *Journal of aesthetics and art criticism* 34 (4) Summer 1976 441-454.

77 ASPEN: The name of a place and a magazine. The magazine was first published in New York in 1965 by Phyllis Johnson (editor and publisher). It was billed as 'the magazine in the box' because its contents appeared in various physical formats to match its interdisciplinary and multi-media approach to the arts.

Aspen, the place, is a ski resort in Colorado which was once a silver-mining town. Walter J Paepcke, head and founder of the Container Corporation, held a design seminar there in 1951 and subsequently it became an annual event which attracted leading architects, designers and design theorists from all over the world. In 1955 the conference was formally incorporated as an independent and non-profit making corporation: International Design Conference in Aspen (IDCA). Discussions at Aspen have covered architecture, graphics, industrial design, interior design, and environmental planning. In 1972, for example, the theme was 'The invisible city', that is, the networks and structures of urban life—transportation

and communication services, cultural and social networks—and its resources of people, processes and places, as opposed to the physical elements—buildings, roads—usually thought of as the city.

'Invisible London' *Time out*(116) May 5-11 1972.

R Banham (ed) *The Aspen papers* (Pall Mall Press, 1974).

78 ASSEMBLAGE ART: The term 'assemblage' was first used in a fine art context by Jean Dubuffet to describe his own work in 1953; he preferred it to 'collage' because he thought the latter word should be restricted to Cubist paintings which included pasted fragments of newspapers or other materials. In its everyday sense 'assemblage' means 'the act of fitting together parts and pieces' and 'the state of being assembled' consequently the word describes an artistic technique (which cuts across the traditional boundaries of painting and sculpture) and also the end products of that technique. However, it denotes 'not only a specific technical procedure . . . but also a complex of attitudes and ideas' (Seitz). Assemblage is, therefore, a generic concept designating all forms of composite art—three-dimensional constructions—made up of natural or manufactured objects and materials. No theoretical limit is set as to what items an Assemblage artist may use; generally the objects and materials employed are non-fine art, often they are the waste products of the industrial society. In contrast, traditional painting and sculpture tends to favour a limited range of long-established materials and maintains a pure attitude to their use (no mixing).

Assemblage Art was extremely fashionable in the late 1950s and early 1960s: a large exhibition called 'Art of Assemblage' was held at the Museum of Modern Art, New York in 1961 which surveyed the development of Assemblage via Cubism, Futurism, Dada and Surrealism. Allan Kaprow has argued that Assemblage developed out of advanced painting and marked a stage in the evolution towards Environmental art. The best known exponents of Assemblage during that period were, in America, Bruce Conner, Joseph Cornell, Jim Dine, Allan Kaprow, Ed Kienholz, Louise Nevelson, Robert Rauschenberg, Simon Rodia, and, in Europe, Arman, César, Jean Dubuffet, John Latham, and Daniel Spoerri.

See also Combine Painting, Environmental Art, Junk Sculpture, Neo-Dada, No Art, Object Art, Emballages.

W C Seitz *The art of Assemblage* (NY, MOMA, 1961).

A Kaprow *Assemblage, Environments, Happenings* (NY, Abrams, 1965).

79 ASSOCIATION OF ART HISTORIANS: An organisation founded in Britain in 1974 by art historians teaching in universities, art colleges, and polytechnics in order to advance the study of the history of art.

J White 'The Association of Art Historians' *Times literary supplement* (3811) March 21 1975 p313.

80 ASSOCIATION OF ILLUSTRATORS: A British association with over four hundred members founded in 1973 in order to promote the art and profession of illustration. Since its foundation the association has begun publication of a bi-monthly newsletter and has mounted its first annual exhibition at the Thumb Gallery, London.

81 ATELIER POPULAIRE (People's Studio): Students of the École des Beaux Arts, Paris involved in the revolutionary events of May 1968 set up a workshop in their college to issue political posters produced by means of the silk-screen process. Before the riot police closed down the workshop in June, the students had designed approximately 350 different posters and distributed 120,000 copies. In order to avoid the errors of Cultural Art, designs were subject to group approval and were issued anonymously. The posters attacked the French government and police brutality; their style was completely determined by their political function and visually they achieved the kind of direct statement typical of road signs.

See also Cultural Art, Political Art.

Texts and posters by Atelier Populaire: posters from the revolution, Paris, May (Dobson, 1969).

J Berger 'Arts in society: marking the road' *New society* March 5 1970 404-405.

82 AUROVILLE: A 'futuristic' city designed in the shape of a catherine-wheel, planned to accommodate fifty thousand inhabitants, being built at a cost of £250 million near Pondicherry in South East India. Auroville's purpose is to implement the ideals of Sri Aurobindo an Indian mystic and philosopher who died in 1951: it is to become a self-sufficient international religious community. The architext executing the plans is a Frenchman, Roger Anger, and the foundation stone was laid in 1968.

D d'Monte 'On the spiritual frontier' *The guardian* February 26 1975 p14.

83 AUSTERITY/BINGE: A term coined by Bevis Hillier in an attempt to characterize the decorative arts of the 1940s and 1950s (he tries to make it do what 'Art Deco' did for the 1920s and 1930s). Hillier argues that what was common to the popular arts of the period of austerity (the bleak years of shortages and rationing) and the period of binge (the more affluent years of the 1950s) was a rejection of the antiseptic functionalism of the pre-war era. Consequently the key motifs—abstract amoeba shapes, mermaids, winged horses, balloons, clusters of coloured balls, etc—and the fads—heraldry, canal boat painting, circus and fairground art, etc—of the period were very diverse and whimsical.

See also Art Deco, Contemporary Style.

B Hillier *Austerity/Binge: the decorative arts of the forties and fifties* (Studio Vista, 1974).

84 AUTO-ART: An abbreviation of 'Autobiographical Art'. Peter Frank's term for the confessional, narcissistic, self-portraiture of artists such as John Baldessari, Laurie Anderson, Julia Heyward, Roger Welch, Chris Burden, Urs Lüthi, Hannah Wilke.

See also Body Art, Story Art.

P Frank 'Auto-Art: self indulgent? And how!' *Art news* 75 (7) September 1976 43-48.

85 AUTO-DESTRUCTIVE ART: A term invented by Gustav Metzger to describe his own work produced in the early 1960s. By adapting certain techniques of Action Painting—but using nylon and acid instead of canvas and pigment—Metzger developed a form of Destructive Art similar in concept to the self-destroying machines of Jean Tinguely dating from the same period. At a demonstration on London's South Bank on July 3 1961 Metzger used acid as a medium and sprayed it on to sheets of nylon cloth. The acid immediately attacked the nylon, creating rapidly changing shapes until the sheet was completely consumed. Thus the work was simultaneously auto-creative and auto-destructive. Metzger maintained that his use of destruction was a protest against the massive arms expenditure of modern states; he also believed Auto-Destructive Art could provide a socially acceptable outlet for human aggression.

See also Action Painting, Destructive Art, Expendable Art.

G Metzger 'Machine, Auto-creative and Auto-destructive Art' *Ark* (32) Summer 1962 7-8.

G Metzger *Auto-destructive art* (Destruction/Creation, 1965).

51

86 AUTOMATIC ART: Paintings, drawings or writings produced while their creators are in a state of distracted attention, such as a day dream or light trance. Doodles are an everyday example of this phenomenon: they are generally produced while the conscious mind is focused elsewhere. Because this kind of art apparently escapes the control of the conscious mind Automatism—the method or technique of Automatic Art—is thought, by many commentators, to be a means of access to the subconscious but the sameness of doodles suggests that they are the result of physiological motor activity and that therefore they do not reveal any profound insights into the subconscious. The automatic character of Automatic Art gives it a spurious charisma—seemingly effortless, requiring no planning, or rationally formulated intentions—but there is a paradox here: the skill an artist acquires through years of practice eventually becomes second nature and therefore his/her behaviour often appears to him/her 'automatic'.

Automatism was an integral part of the artistic practice of certain of the Surrealists, Tachists and Abstract Expressionists.

See also Process Art.

D H Menzel 'Doodling as a form of art' *Leonardo* 1(2) April 1968 175-177.

A Gauld 'Automatic art' *Man, myth & magic* (7) 1970 189-193.

87 LES AUTOMATISTES: A Canadian group of painters active between 1946 and 1951, whose work has been variously described as Surrealist. Action Painting, or Lyrical Abstraction. The group was formed by Paul-Émile Borduas (1905-60) and its members included Jean-Paul Riopelle, Fernand Leduc, Albert Dumouchel and Jean Paul Mousseau. They called themselves 'Les Automatistes' because their technique of painting was based on the automatic writing method employed by the Surrealists in the pre-war era. In 1948 the group caused a scandal by publishing a manifesto entitled 'Refus global' attacking Canadian life. Works by the group were shown in Paris exhibitions during the second half of the 1940s and Borduas and Riopelle both moved to Paris in the 1950s.

Paul-Émile Borduas 1905-60 (Montreal, Museum of Fine Arts, 1960).

G Robert 'École de Montreal' *Cimaise* (75) February/April 1966 24-36.

Borduas et les Automatistes: Montreal 1942-1955 (Montreal, Musée d'Art Contemporain; Paris, Galeries Nationales du Grand Palais, 1971).

F Gagnon 'Pellan, Borduas and the Automatists: men and ideas in Quebec' *ArtsCanada* (174/175) December/January 1972/73 48-55.

88 AVANT-GARDE ART (or Vanguard art): The French term 'avant garde' means the advance guard of an army. This military metaphor was first applied to art and literature by utopian socialist writers in France during the nineteenth century. Initially artistic radicality was closely linked with political radicality; however, in the twentieth century Avant-Garde artists have increasingly concerned themselves with aesthetic issues to the exclusion of political issues.

Avant-Garde art is that art of the current moment in history that is more advanced in concept, more extreme in technique, than all other art of present times. Renato Poggioli claims that this form of art originated in Romanticism and that it is inseparable from the development of Modern Art (other writers argue that the concepts 'Avant-Garde' and 'Modernism' are not identical). He stresses the link between the Avant-Garde and the phenomena of movements so characteristic of Modern Art: Impressionism, Symbolism, Fauvism, Cubism, etc. He lists the features of Avant-Garde art as Activism (the taste for action, dynamism, marching forward, exploration), Antagonism (opposition to the historic and social order, anti-tradition), Nihilism (destructiveness, infantilism, extreme behaviour), Agonism (romantic agony, pathos, tension, sacrifice, spiritual defeatism), Futurism (pre-vision, prophesying the art of the future). This last feature may be summed up as 'tomorrow's art today'. Poggioli sees Avant-Garde art as a manifestation of the alienation of the contemporary artist and he believes such art is here to stay: 'avant-guardism has now become the typical chronic condition of contemporary art'.

Paradoxically Avant-Garde art has developed conventions of its own and many writers speak of the 'tradition of the new' against which younger artists rebel, hence the emergence of the term 'new Avant-Garde'. By being perpetually ahead of public taste Avant-Garde art condemns the majority of the populace to a permanent condition of behindism. In Britain certain artists are now totally disenchanted with the notion of Avant-Garde art and its rejection of public languages, its contempt for stereotypes, and its neglect of mass culture. In the opinion of the critic Robert Hughes the Avant-Garde has finally exhausted itself and the term has outlived its usefulness.

See also Modernism, Post-Modernism.

R Poggioli *The theory of the Avant-Garde* (Cambridge, Mass, Belknap/ Harvard, 1968).

T B Hess & J Ashbery (eds) *The Avant-Garde* (NY, Newsweek, 1969) Art News Annual 34.

D D Egbert 'The idea of Avant-Garde in art and politics' *Leonardo* 3 (1) January 1970 75-86.

R Hughes 'The decline and fall of the Avant-Garde' *Time* December 18 1972 40-41.

J Weightman *The concept of the Avant-Garde: explorations in Modernism* (Alcove Press, 1973).

P Burger *Theorie der Avant-Garde* (Frankfurt, Suhrkamp, 1975).

B

89 BASIC DESIGN: In England during the 1950s a number of fine artists—Victor Pasmore, Richard Hamilton, Harry Thrubron, Tom Hudson and Maurice De Sausmarez—lectured at art schools such as the Central School or Arts and Crafts, London and at the art departments of universities such as Leeds and Durham (the latter located in Newcastle upon Tyne). These artists established a series of Basic Design courses modelled on the Bauhaus preliminary course run by Johannes Itten. The aim of these courses was to provide students, no matter what their individual speciality, with a grounding in the fundamental characteristics of visual design. Practical exercises were set on themes such as the relationships of colour, shape and three dimensional structures, exercises which tended to the abstract, but observation of natural forms, patterns and processes was also encouraged.

Pasmore claimed that Basic Design provided, for the first time, a scientific basis for art training. Such training attempted to develop the intellectual, analytical powers of the student, but intuition and the use of devices for harnessing the subconscious were not neglected. The concept of a unified basic training persists today in British art schools in the form of the foundation year studies applicable to all students, and Pasmore's scientific analogy is continued by 'Visual Research' departments.

Some critics have claimed that Basic Design courses in the United States were instrumental in the evolution of extremely simple structures in American sculpture in the first half of the 1960s (see Minimal Art).

The developing process (Newcastle upon Tyne, Durham University, 1959).

M De Sausmarez & others 'A visual grammar of form' (Part I) *Motif* (8) Winter 1961 3-29; (Part II) *Motif* (9) Summer 1962 47-67.

M De Sausmarez *Basic design: the dynamics of visual form* (Studio Vista, 1964).

W S Huff 'An argument for Basic Design' *Architectural design* 36 (5) May 1966 252-256.

R Banham 'The Bauhaus gospel' *The listener* September 26 1968 390-392.

P L Jones 'The failure of Basic Design' *Leonardo* 2 (2) April 1969 155-160.

E Sonntag 'Foundation studies in art' *Leonardo* 2 (4) October 1969 387-397.

N Temizsoylu *The background and development of 'Basic Design' concept* 2 vols (RCA thesis, 1972).

90 BAY AREA FIGURATION: A description applied to the work of a number of West Coast American painters—David Park, Elmer Bischoff and Richard Diebenkorn—who had studied or taught at the California School of Fine Arts (where Clyfford Still and Mark Rothko had also taught in the late 1940s). These artists produced figurative work but their style of painting was strongly influenced by the mannerisms of Abstract Expressionism. Clement Greenberg applied the term 'homeless representation' to this kind of painting.

See also Abstract Expressionism, Homeless Representation.

91 BEAUBOURG CENTRE (or Centre Pompidou): A huge art and cultural complex situated on the site of Les Halles, Paris initiated in 1969 by Georges Pompidou and opened in 1977. Its full title is 'Centre National d'Art et de Culture Georges-Pompidou'. The centre will house a cinema, a public library and information service, a documentation centre on contemporary art, Le Centre de Création Industrielle, Le Musée National d'Art Moderne, and L'Institut de Recherche et de Coordination Acoustique/ Musique (IRCAM). An international competition for the design of the Beaubourg Centre building was won by the Italian/British team of Renzo Piano and Richard Rogers.

A Michelson 'Beaubourg: the museum in the era of late capitalism' *Artforum* 13 (8) April 1975 62-67.

'Centre Pompidou' *Studio international* 975 (189) May/June 1975 p204.

W Schwarz 'Journey into space' *The guardian* September 7 1976 p10.

92 BEERVELDE GROUP: Three Flemish artists—Roger Raveel, Raoul De Keyser and Etienne Elias—and one Dutch artist—Reinier Lucasen—are often referred to as the 'Beervelde Group' because in 1966 they collaborated in the production of an environmental painting in the cellars of Beervelde Castle, near Ghent. Since their collaboration these artists have developed in different directions—abstraction, magic realism, illusionistic objects—but their work shares some characteristics, for example, bright colour, a style half-way between Kitsch and Pop Art.

C Blok 'Holland: the Beervelde murals' *Art international* 11 (9) November 20 1967 46-47.

Fortunately there is still some grass (Camden Arts Centre, 1973).

93 BEHAVIOURAL ART: The British artist Steve Willats, editor of *Control magazine*, practises a new form of art based on the concepts and techniques of cybernetics and the behavioural social sciences. Acting on the assumption that the purpose of art is to alter behaviour Willats organised several projects involving members of the general public, who belonged to different social groups, in which he used market research, social survey, and feedback methods as artistic strategies. These projects were designed to increase the participants' awareness of their physical and social environment so that they could make better use of it. In 1972 Willats founded a short-lived organisation called 'Centre for Behavioural Art', at Gallery House, London.

As a student Willats was influenced by the ideas of Roy Ascott, an artist who recognised the value of cybernetics to art and whose work in the 1960s was concerned with change and audience participation. In his writings Ascott has used the term 'Behaviourist Art'.

A theoretician interested in the relationship between biology, behaviour and art is Morse Peckham. In answer to the question 'What is the biological adaptive function of art?' Peckham replies that the experience of art is a rehearsal for novel problem situations we are likely to face in reality: 'Art is the exposure to the tensions and problems of a false world so that man may endure exposing himself to the tensions and problems of the real world'.

The label 'Behavioural Art' has also been used as the title of an exhibition held at the Galeria Remont, Warsaw in 1976. Using their own bodies a number of Polish artists staged performances based on the grammar of human behaviour, their aim was to develop conscious external manifestations which accorded with the unconscious emotional significance of bodily gesture.

See also Cybernetic Art, Participatory Art, Performance Art.

M Peckham *Man's rage for chaos: biology, behaviour and the arts* (Philadelphia, Chilton, 1965).

S Willats 'The artist as a structurist of behaviour' *Control* (5) 1969 16-17.

R Ascott 'Behaviourables and futuribles' *Control* (5) 1969 p14.

G Battcock 'Toward an art of behavioural control . .' *Domus* (513) August 1972 44-46.

R Brooks 'Behavioural Art' *Studio international* 951 (185) January 1973 27-28.

S Willats *The artist as an instigator of changes in social cognition and behaviour* (Gallery House Press, 1973).

S Willats *Art and social function* (Latimer New Dimensions, 1976).

'Behavioural Art' *Musics* (9) September 1976 20-21.

94 BIBA: The name of a series of London boutiques dating from the 1960s, and a large department store open between 1973 and 1975 famous for its glamorous decor, its spaciousness, extravagance, oddity, and style of its contents (the style was a mixture of Victoriana, Art Nouveau, Art Deco, Camp, Kitsch, and Hollywood), and the unhelpfulness of its assistants. Biba was the creation of the fashion designer Barbara Hulanicki: everything in the store was an expression of her personal taste. It occupied the old Derry & Toms building—an Art Deco classic by Bernard George built in 1933—in Kensington High Street. In 1975 Philip Norman described Biba's as the 'last symbol of London's extravagant sixties'.

See also Camp, Art Deco, Kitsch.

B Hillier 'Look at Biba' *Sunday times* September 9 1973 43-45.

A Best 'Biba' *Design* (300) December 1973 38-43.

P Norman 'The battle for Biba' *Sunday times magazine* September 28 1975 40-45.

95 BIOTECTURE: A term combining 'biology' and 'architecture' coined by Rudolf Doernach. It means architecture as an "artificial super system" as "live, dynamic, mobile, fantastic, environment systems".

R Doernach 'Biotecture' *Architectural design* 36 (2) February 1966 95-96.

96 BLACK ART (also called Afro-American Art, Neo-African Art, Negro Art): According to Barbara Rose, the term 'Black Art' has three connotations: (1) art containing 'specific subject matter relating to the Black

experience'; (2) art which rejects 'the forms of European art in favour of primitive African forms'; (3) in its broadest sense, paintings and sculpture produced by American negro artists. Black Art, in this last sense, is a variety of Ethnic Art, and reflects the new consciousness of racial pride and separatism associated with Civil Rights and the Black power movements of the 1960s.

In an effort to appease the demands of minority groups, American museums and galleries have mounted a plethora of Black Art shows since 1968, including a large scale exhibition at the Whitney Gallery, New York in 1971. A showplace for Black Art, called 'Studio Museum' was established in Harlem in 1968.

Washington DC is a city with a large negro population and a number of black artists resident there have become known internationally, notably Sam Gilliam, Alma Thomas and Carroll Sockwell.

Self-help groups and militant promotional organisations have been established to assist black artists. For example, Studio Watts in Los Angeles and a subgroup of the New York Art Strike called 'Woman Students and Artists for the Black Art Liberation' (WSABAL). The major issue confronting American black artists is whether to address themselves purely to aesthetic problems and to compete with white artists for recognition from the white art establishment, or to subsume their art to the political struggle of black liberation and to develop alternatives to the gallery system.

In 1975, FESTAC '75—the second world festival of black and African arts and culture—was held in Lagos, Nigeria. The purpose of these festivals is 'to bring together black artists from all over the world and especially to enable black artists from beyond the Atlantic periodically a "return to origin" '.

See also Ethnic Art.

F Bowling 'Critique discussion on Black Art' Part I *Arts magazine* 43 (6) April 1969 16-20; Part II *Arts magazine* 43 (7) May 1969 20-23: Part III *Arts magazine* 44 (3) December/January 1969-70 20-22.

A Werner 'Black is not a colour' *Art & artists* 4 (2) May 1969 14-17.

H Ghent 'Notes to the young black artist: revolution or evolution' *Art international* 15 (6) June 20 1971 33-35.

J W Chase *Afro-American Art* (NY, Nostrand Reinhold, 1972).

L S Sims 'Black Americans in the visual arts: a survey of bibiographical material and research resources' *Artforum* 11 (8) April 1973 66-70.

A Shields 'Is there a black aesthetics?' *Leonardo* 6 (4) Autumn 1973 319-323.

E H Fine *The Afro-American artist* (NY, Holt, Rinehardt & Winston, 1972).

C Hilliard 'Black arts festival' *Africa* (39) November 1974 p63.

97 BLACK MOUNTAIN COLLEGE: An American art institution located in North Carolina open between 1933 and 1956 noted for its experimental approach to education and the number of leading American artists who taught or studied there. BMC was kept deliberately small to reduce administrative work, its aim was to integrate academic work and community life, and to establish an equality between staff and students. Josef Albers was director at one stage; R Buckminster Fuller and Charles Olson contested for leadership in 1949. Artists associated with BMC included John Cage, Robert Rauschenberg, Robert Motherwell, Philip Guston, and Willem De Kooning. A notable feature of BMC was the variety of arts taught and the degree of interaction between arts which was encouraged. A number of periodicals were issued from BMC: *Jargon press, Origin, Black Mountain review.*

J Evats 'Black Mountain College: the total approach' *Form* (6) December 1967 20-25.

M Duberman *Black Mountain* (Wildwood House, 1974).

98 BLOW-UP FURNITURE: During the 1960s designers such as Quasar Khanh, Verner Panton, and Gernot Nalbach took advantage of technological progress in the field of plastics to produce blow-up chairs, 'furniture carpets', and water beds made from coloured or transparent plastic materials.

See also Air Art, Plastics, Pneumatic Architecture.

99 BMPT: The initial letters of the surnames of four French artists—Daniel Buren, Olivier Mosset, Michel Parmentier, Niele Toroni—who performed some joint actions in 1967. The products of BMPT represented the zero degree of painting: their works were minimal abstract canvases containing utterly banal designs (stripes, dots, circles) produced quickly by mechanical and repetitive methods. These 'paintings' were so simple, so impersonal, that any one of the group could have done them; in fact the artists claimed that their work was interchangeable and that individual talent, taste, or skill were excluded from their programme. This whole enterprise purported to be a critique of painting and meetings/demonstrations were held to inform the public. Since BMPT produced works

which were deliberately uninteresting what remains of interest is the theoretical explanations governing their behaviour.

M Claura 'Paris Commentary' *Studio international* 177 (907) January 1969 47-49.

J Clair *Art en France: une nouvelle generation* (Paris, Chêne, 1972).

100 BODY ART (or Body Sculpture, Body Works, Corporal Art): An international trend in Western art, dating roughly from 1967, which combined aspects of sculpture, performance, process and conceptualism. Amongst the arts sculpture in particular has a special relationship with the human body: sculptors are acutely conscious of 'body ego' and the appreciation of sculpture depends to a large extent on a physiological empathy between spectator and artwork; hence it was a logical step for sculptors to turn to their own bodies as material for creating art, to treat their bodies as both subject and object.

Artists who have produced works categorised as 'Body Art' include Vito Acconci, John Baldessari, Giorgi Ciam, Terry Fox, Rebecca Horn, Urs Lüthi, Barry Le Va, Bruce McLean, Bruce Nauman, Dennis Oppenheim, Gina Pane, Klaus Rinke, Larry Smith, Keith Sonnier, and William Wegman. Body Art encompassed a wide spectrum of activities too complex to be summarised here; however, certain themes recur: narcissism, masochism, and sexuality (especially bisexuality and transvestism). In the name of art human flesh has been subjected to a host of indignities; life itself has been put at risk (the work of Chris Burden).

Since Body Art, like all forms of performance, is transitory by nature, works have been recorded for publicity and exhibition purposes via photography, film and videotape (see Video Art). Many Body works were conceived in terms of an interaction between the artist and the recording medium. The difficulties of mounting a show of Body Art delayed its appearance in public museums: the first large scale mixed exhibition of Body works was held at the Museum of Contemporary Art, Chicago in 1975. Three years earlier the ICA in London organised a programme of lectures and events dealing with the body as a medium of expression; a group calling itself BAAL (Body Arts at Large) assisted with the programme.

Precedents for Body Art have been found in the work of Marcel Duchamp, Yves Klein and Piero Manzoni. According to Peter Weiermair it was also anticipated by Gunther Brus and Arnulf Rainer of the Wiener Aktionismus (see Actions, and Direct Art). The emergence of Body Art in the late 1960s was contemporaneous with a widespread upsurge of

interest in the human body: encounter groups, body painting, tattooing, nudity in the theatre, 'Hair', drag shows, the sexual revolution, scientific and academic research into the language of gestures and postures. Body Art marked a reaction to the aseptic quality of Minimal Art and the dry, cerebral character of most Conceptual Art. As Germano Celant pointed out 'the body has a language that is crude, violent and vulgar'; the official computerised language of late '60s art was 'challenged by the slang of the body', a slang that is popular and primitive, expressing itself in terms of sweat, hair, the penis and the nude.

See also Gilbert & George, Living Sculpture, Nice Style, Performance Art, Process Art.

W Sharp 'Body works' *Avalanche* (1) Fall 1970 14-17.

'Body works' *Interfunctionen* (6) September 1971 2-33.

C Nemser 'Subject-object: Body Art' *Arts magazine* 46 September/ October 1971 38-42.

G Celant 'Vito Acconci' *Domus* (509) April 1972 54-56, 60.

'Le Corps' *Chroniques de l'art vivant* (40) June 1973.

(Special issue on Body Art) *Data* 4 (12) Summer 1974.

L Vergine *Il corpo come linguaggio (la 'Body-Art' e storie simili)* (Milan, Giampaolo Preato Editore, 1974).

J Benthall & T Polhemus (eds) *The body as a medium of expression* (Allen Lane, 1975).

101 BOMBERG SCHOOL (also called Neo or Post-Bomberg School): David Bomberg, a British avant garde artist was well-known during the 1920s, but the remainder of his life, up to his death in 1957, was spent in obscurity. He taught at the Borough Polytechnic, London and influenced a number of his students who formed two groups, The Borough Group (1947) and The Borough Bottega (1953). Leon Kossoff and Frank Auerbach are the best known of Bomberg's followers. They produce figurative paintings, based on nudes or landscapes, using thick impasto applied with impassioned, if rather turgid brush storkes, which reflect the influence of Bomberg's late style.

102 BOOK ART (related terms: Artists' Books, Book as Artwork, Artists' Bookworks): Book production is an industry in which the division of labour is particularly marked: authors, illustrators, editors, typesetters, printers, binders, papermakers all make their specialist contributions. Hence the phrase 'the art of the book' can refer to skilled craftmanship in any or all of these specialities; this causes problems of classification;

for example, if skill is confined to the author's text then the book is a work of literature, if skill is deployed in all departments then it may count as a work of visual art and be displayed as an object in a museum showcase rather than read.

Traditional examples of the art of the book include the illuminated manuscripts of the middle ages, the early printed bibles of Gutenberg, and the total design concept of William Morris' Kelmscott Press publications. However, this is not what is meant by the term 'Book Art' in Avant Garde art circles in the West. This term refers to publications by individuals or small groups of artists whose background and training is the visual arts rather than literature. These publications are usually small in size, slim, white, often effete pamphlets, journals, or booklets issued in small editions and marketed via art galleries rather than via bookshops. Although cheap compared to prints or paintings, Bookworks often seem disproportionately expensive when compared to ordinary books. Frequently the text and illustrations are minimal and the majority are not splendid examples of printing or binding; what gives Bookworks their value is the quality, ingenuity, originality, perceptiveness of the artistic idea or concept informing them.

For some time the terms 'Book Art' and 'Artists' books' have been used synonymously, but the latter has more recently been used to describe publications which document a work executed in a medium which has an independent status (ie using the book format as a way of presenting a work, eg a set of photographs, which could be displayed separately) whereas 'Book Art' has been used to denote artists' books in which the book form is intrinsic to the work from its inception.

Books as art shade into books as documentation of evanescent artworks and books as vehicles for written and pictorial work. The book was inevitably 'discovered' as a form when artists began to explore the potential of mass communication media; its increased use parallels the development of Conceptual Art and Fluxus. Books were attractive in the 1960s, and subsequently, on account of their relative cheapness, expendability, mass-replication and other conventional advantages, as well as for the wider dissemination and greater accessibility of artists' work which they make possible. Some artists went on to explore the form of the book—sequentiality, diptychal images, narrative, physical materials, word/image relationships—in artworks.

The term 'Book Art' seems to have been first employed, rather loosely, by Clive Phillpot in *Studio international* (July/August 1973, p38), though Harold Rosenberg had used it earlier in the title of an essay to refer to

62

the idea of 'art-book art', ie art experienced only via reproductions (see 'Art Books, Book Art, Art'—in—*The anxious object, art today and its audience* (Thames & Hudson, 1965) 197-202). The first discussion of artists' books appears to have been published in *Data* in 1971, and the next, with a different emphasis, in *Studio international* in 1972 just before the first exhibition of artists' books held at Nigel Greenwood's gallery, London. Germano Celant in the first article traces artists' close involvement in the making and publishing of books, and takes John Cage's *Silence* (1961) as his starting point; he also acknowledges the early interest of Ed Ruscha and Piero Manzoni. Arguably the most prolific and inventive artist using the form is the German Dieter Rot who has been issuing books since 1954. Other artists who have developed or regularly use the book form are Telfer Stokes, Sol LeWitt, Hamish Fulton, Richard Long, Lawrence Weiner, and the late Marcel Broodthaers.

Not all artist-producers of pamphlets, journals, and books approve of their work being included in exhibitions of Book Art. Art & Language, for example, have protested that their medium is language (which the Swiss linguist Saussure defined as 'sound-image plus concept') not print on paper, that to treat their journals as if they were 'things' or 'objects' intended for visual contemplation like paintings, or to chain them to exhibition stands as if they were rare expensive first editions, is to misunderstand and to misrepresent their whole enterprise.

See also Concrete Poetry, Conceptual Art, Magazine Art.

G Celant 'Book as artwork 1960/1970' *Data* 1 (1) September 1971 35-49.

Book as artwork 1960/72 (Nigel Greenwood Inc Ltd, 1972).

Artists' books (Philadelphia, Moore College of Art, 1973).

'Biblioclastes . . . bibliophiles' *(Chroniques de) L'Art vivant* (47) March 1974 (special number).

U Carrion 'The new art of making books' *Kontexts* (6/7) 1975 unnumbered.

Artists' Bookworks . . . (British Council, 1975).

Artists Books . . . (Arts Council of Great Britain, 1976).

103 BORAX (or the Borax look): An American slang term dating from the 1920s, referring to cheap, showy merchandise, applied especially to shoddily built furniture, so called because of the premiums offered by the Borax soap company. It has also been used in England since 1945 by writers such as Michael Farr and critics in *Design* magazine to describe a characteristic mannerism of the design of the 1940s and 1950s: a bogus

streamlining, blubbery inflations or curves, often accompanied by parallel stripes or bands acting as decorative features on the surface of mass produced items such as Juke boxes.

See also Styling.

E Kaufmann 'Design review: Borax, or the chromium plated calf' *Architectural review* 104 (620) August 1948 88-93.

E Kaufmann—letter—*Architectural review* 104 (624) December 1968 p 314.

104 BOURGEOIS REALISM: In the first half of the 1970s a number of books were published and several exhibitions were mounted devoted to that arch-rival of early modern art—salon painting. The work of such academic painters as W A Bougereau, Lord Leighton, Paul Delaroche and Charles Gleyre was designated 'Bourgeois Realism' because, according to one scholar, it was a 'precise reflection of middle-class society at the very height of its prosperity'. (The term is clearly intended to contrast with 'Socialist Realism'.) In the 1850s salon paintings were called 'art pompier'—fireman's art—because the antique heroes depicted in salon pictures generally wore helmets like those of French firemen.

A Celebonovic *The heyday of salon painting: masterpieces of Bourgeois Realism* (Thames & Hudson, 1974).

Delaroche and Gautier (The National Gallery, 1975).

B Denvir 'The pompiers ride again' *Art & artists* 10 (12) March 1976 22-27.

105 BOWELLISM: The work of Michael Webb and other students at the Regent Street Polytechnic School of Architecture, London during the years 1956 to 1959. They were influenced by Le Corbusier, Antonio Gaudi and the appearance of the human bowels. According to Peter Cook, Bowellism represented a lost movement, nothing was actually built.

P Cook *Experimental architecture* (Studio Vists, 1970).

106 BRITAIN CAN MAKE IT: Title of an important exhibition of British design, organised by the Council of Industrial Design, held at the Victoria and Albert Museum in 1946. After the austerity of the war years long queues of visitors formed outside the V&A to see consumer goods that were not at that time generally available; consequently the exhibition was renamed by visitors 'Britain can't have it'.

107 THE BROTHERHOOD OF RURALISTS: A group of British land-scape and figure painters—Ann and Graham Arnold, David Inshaw, Peter Blake, Jann Haworth, Annie and Graham Ovenden—formed in 1975 and exhibiting together at the Royal Academy Summer show in 1976. These artists made a decision to move from the city to the country and to produce work relating to a neglected tradition of English art: the celebration of the 'spirit of the country'. A reactionary group whose paintings are whimsical, academic, and finicky in technique and who draw on such sources as the Pre-Raphaelites, Laurie Lee, Thomas Hardy, Shakespeare, Lewis Carroll, Stanley Spencer, Richard Dadd, etc.

B Moynahan 'Brotherhood of Ruralists' *Sunday times magazine* October 3 1976 78-84.

108 BÜROLANDSCHAFT: A sophisticated form of office planning developed in Germany by the specialist in office organisation, Eberhard & Wolfgang Schnelle, during the late 1950s and early 1960s, since copied by businesses throughout the world. Bürolandschaft—literally office land-scape—exploits the possibilities of open plan office (cellular offices were replaced by open plan offices in some firms in the United States before the second world war, but furniture in such offices tended to be arranged in a regimented fashion); the departments of a business and their furniture are disposed according to the flow of paperwork, communications and the movement of staff. The result looks casual, it seems to echo the soft lines of a landscape, an impression heightened by the use of potted plants; thick carpets, canteen units and a community atmosphere creates a domestic type environment.

The advantages of Bürolandschaft are claimed to be increased business efficiency, better communications, better staff conditions, greater flexibility—the furniture can easily be re-arranged, departments can easily be re-organised.

See also Action Office.

F Duffy 'Skill: Bürolandschaft' *Architectural review* 135 (804) February 1964 148-154.

'Chaos as system' *Progressive architecture* (10) October 1968 160-169.

A Boje *Open plan offices* (Business Books, 1972).

P Howard 'Office landscaping revisited' *Design and environment* Fall 1972 40-47.

109 BUSINESS ART: The philosophy of Andy Warhol: 'Business Art is the step that comes after Art. I started as a commercial artist, and I want

to finish as a business artist. After I did the thing called "art" . . . I went into business art. I wanted to be an Art businessman or a Business Artist. Being good in business is the most fascinating kind of art . . . making money is art and working is art and good business is the best art.'

A Warhol *The philosophy of Andy Warhol (from A to B and back again)* (NY, Harcourt Brace Jovanovich, 1975) p 92.

110 THE BUTTERY HATCH AESTHETIC: A characteristic of buildings designed by the American architect Louis Kahn is that services are sharply differentiated from the areas they serve. Kahn usually houses services in vertical box-like structures built alongside the blocks used by humans (see for example his 1961 Medical Research Building, Pennsylvania). In some critics' eyes this approach to services is analogous to the storage of food in larders, hence 'Buttery Hatch Aesthetic'.

R Banham 'On trial 2: Louis Kahn, the Buttery Hatch Aesthetic' *Architectural review* 131 (781) March 1962 203-206.

C

111 CAL ARTS (The California Institute of the Arts): An educational institute for the visual and the performing arts with some nine hundred students. The present campus of Cal Arts at Valencia (near Hollywood) was begun in 1969 but the institute itself dates back to 1961 when the Chouinard Art Institute merged with the Los Angeles Conservatory of Music. The late Walt Disney made substantial financial contributions to the institute.

P Selz & H J Seldis 'West Coast report: Cal Arts' *Art in America* 57 (2) March-April 1969 107-109.

'California Institute of the Arts: prologue to a community' *Arts in society* 7 (3) Fall-winter 1970.

P Gardner 'The heirs of Mickey . . .' *Art news* 72 (8) October 1973 41-43.

112 CALLIGRAMS: The name given to visual puns: words drawn or printed in such a way as to form a picture or an image, for example, Lewis Carroll's description of a mouse's tail meandering down the page

in the shape of a mouse's tail. Calligrams are an attempt to conflate the verbal and the visual. The term itself derives from Guillaume Apollinaire's book of poems *Calligrammes*. Ideograms, Calligraphic or Shaped poems are not unique to the twentieth century: examples are known dating from before the birth of Christ.

See also Concrete Poetry.

G Apollinaire *Calligrammes: poèmes de la paix et de la guerre* (Paris, Merecure de France, 1918).

S Themerson *Apollinaire's lyrical ideograms* (Gaberbocchus, 1968).

P Mayer 'Framed and shaped writing' *Studio international* 176 (903) September 1968 110-114.

113 CALLIGRAPHIC PAINTING: This description has been applied to the work of a number of American and European painters who fall into two categories: (1) those whose brush technique and painting process was directly influenced by the Oriental tradition of calligraphy; and, (2) those artists associated with Abstract Expressionism, Action Painting and Tachisme who arrived independently at an approach to painting comparable in certain respects to the calligraphy of the East. In category (1) we can place the American West Coast artist Mark Tobey, who learnt about Chinese calligraphy through a friend Teng Kuei in the 1920s, who visited Japan and later developed a form of miniature calligraphy which he called 'white writing'; also in this group we can include Ulfert Wilke, Morris Graves, Julius Bissier, and Henri Michaux. In category (2) we can list Franz Kline, Robert Motherwell, Bradley Walker Tomlin, and Hans Hartung.

L Alloway 'Sign and surface: notes on black and white painting in New York' *Quadrum* (9) 1960 49-62.

F Legrand 'Peinture et écriture' *Quadrum* (13) 1962 4-48, 179-185.

G Nordland 'Calligraphy and the art of Ulfert Wilke' *Art international* 15 (4) April 20 1971 21-24.

M Sullivan *The meeting of Eastern and Western art* (Thames & Hudson, 1973).

114 CAMP: According to Susan Sontag, Camp is a taste or sensibility characteristic of certain groups in twentieth century society, a private code among urban cliques—historically homosexual—a form of dandyism in an age of mass culture. It is also a quality discoverable in objects just before they become fashionable. Camp taste delights in artifice, theatricality, exaggeration, extravagance, playfulness, a love of the unnatural.

Kitsch objects can also be Camp if they are in extremely bad taste; this attitude is summed up in the phrase 'it's so bad it's good'. Camp Art emphasises elegance, texture and style rather than content or function: Baroque art is described as being 'Camp about religion'. Camp taste is said to have begun with the eighteenth century passion for Gothic novels, Chinoiserie, caricature and fake ruins. Examples of visual art regarded as Camp include drawings by Aubrey Beardsley and Erté, paintings by Carlo Crivelli, David Hockney, Marie Laurencin and the Pre-Raphaelites, architecture by Antonio Gaudi and comics featuring Flash Gordon and Batman. Sontag regards Art Nouveau as the most typical and fully developed Camp style (presumably this opinion is now out of date, Art Nouveau's popularity is no longer restricted to a small number of cognoscenti).

The origins of the word 'Camp' are uncertain, Roger Baker thinks it derives from the Italian 'Campeggiare' (to stand out from a background), Alan Brien prefers the French verb 'se camper' (to posture boldly); both have theatrical associations.

See also Kitsch.

A Brien 'Campers courageous' *Harpers Bazaar* 64 (1) April 1961 p 138.

'Playboy after hours: Camp' *Playboy* September 1965 27-28.

C Isherwood *The world in the evening* (Penguin, 1966).

'Camp' *The listener* October 20th 1966 572-573.

A Brien 'Private view: camper's guide' *New statesman* June 23 1967 873-874.

S Sontag 'Notes on Camp'—in—*Against interpretation* (Eyre & Spottiswoode, 1967) 275-289.

R Baker 'Anatomy of Camp' *Queen* February 19 1969 48-51.

A Carmines 'Keep the camp fires buring'—in— *The image maker;* edited by R Henderson (Richmond, Virginia, John Knox Press, 1971) 63-65.

115 CAMP ARCHITECTURE: Charles Jencks has identified various levels of Camp—high, middle, and low—which he has used to characterise a number of modern American buildings. According to Jencks the chief features of Camp Architecture are 'failed seriousness' and 'chaoticism' (Philip Johnson's word for a confusion of styles).

C Jencks 'Recent American architecture: Camp—Non Camp'—chapter 6 in—*Modern movements in architecture* (Penguin Books, 1973) 184-237.

116 CANADIAN ARTISTS REPRESENTATION (CAR): A pressure group formed in 1967 concerned with improving the rights and incomes

of artists in Canada. CAR describes itself as a 'mutual communication service in which artists can represent their own opinions and ideas particularly concerning the welfare of the professional artist'.

See also Artists' Unions.

B Lord 'Artist Power! or, reviews don't pay the rent' *ArtsCanada* 25 (3) August 1968 p41.

117 CAPITALIST REALISM: Paintings and graphics by three German artists—Konrad Fischer-Lueg, Sigmar Polke, and Gerd Richter—which comment critically on contemporary personalities and events. Capitalist Realism developed in the early 1960s and can be regarded as a German variant of Pop Art. The term 'Capitalist Realism' is West Germany's answer to the 'Socialist Realism' of East Germany.

R Block *Grafik des kapitalistischen realismus* (Berlin, Edition René Block, 1971).

118 CASSA: An acronym for 'Centre for Advanced Study of Science in Art'. The idea for CASSA was originated by Marcello Salvadori in 1961 and workshop facilities were established in North London in the middle 1960s. Salvadori was born in Italy in 1928 and came to Britain in 1955. His work is often included in exhibitions of Kinetic Art. CASSA is dedicated to an inter-disciplinary research into the relationship between science/technology and art.

See also Kinetic Art, Technological Art.

M Salvadori 'CASSA' *Studio international* 173 (890) June 1967 306-308.

119 CENTRAL LETTERING RECORD (CLR): An archive containing over 5,000 photographs and 1,000 slides of letter design from ancient times to the present day, housed in the library of the Central School of Arts and Crafts, London. The CLR was initiated by Nicolete Gray and Nicholas Biddulph; its purpose is to broaden the vocabulary of forms available to the contemporary letter designer and to serve the needs of art historians.

L Pearse 'The Central Lettering Record' *Art libraries journal* 1 (1) Spring 1976 13-21.

120 CENTRE DE RECHERCHE D'AMBIANCES (CRA): Bernard Lassus, a French kinetic sculptor and ex-pupil of Léger, set up the CRA and has

been its director since 1962. Lassus believes that mankind is moving towards a 'global landscape, a continuum: an artificial environment which by virtue of its very size will necessarily become more natural for us than what we call nature'. His aim is to transcend the traditional nature/culture dualism by developing a mediating element between natural and constructed form; in practice this involves a fusion of the roles of sculptor and architect, the use of light, colour, and visual games as a means of enlivening the urban environment. Underlying the work of the Centre is the search for general laws which will apply to problems of form and construction on any scale, hence the investigation of 'Habitants-payagistes' (dweller-landscapes), how in fact French householders modify their immediate environments. Theory derived from research has been used in the plans for a seaside community at La Coudouliere and a projected new town in the Marne valley.

See also Environmental Deisgn, Ecological Art.

B Lassus 'Environments and total landscape' *Form* (UK) (5) September 1967 13-15.

S Bann 'Bernard Lassus: Ambiance' *Art & artists* 6 (3) June 1971 20-23.

S Bann 'De l'oeuvre d'art au paysage global' *L'oeil* (215) November 1972 52-57.

S Bann 'From kineticism to didacticism in contemporary French art' *Studio international* 185 (953) March 1973 105-109.

121 CENTRE FOR ADVANCED VISUAL STUDIES (CAVS): This centre is part of the Massachusetts Institute of Technology, Cambridge, Mass, USA, and is concerned with research and experiment into all aspects of art and creativity in relation to science, technology, the environment, and communications media. CAVS was founded in 1967 by the Hungarian-born artist Gyorgy Kepes (b1906) and for many years he was the director and driving force (the present director is Otto Piene). The centre has organised lecture series, symposia, exhibitions, and issued publications; there are fourteen fellows per year.

See also Technological Art.

D Davis 'Gyorgy Kepes: the new landscape'—in—*Art and the future* . . (Thames & Hudson, 1973) 115-119.

J Benthall 'Kepes' Centre at MIT' *Art international* 19 (1) January 20 1975 28-31, 49.

122 CENTRE 42: A project for an arts centre, to bring art and culture into the lives of workers, canvassed by the English playwright Arnold Wesker in the 1960s. The centre was to be located in a disused railway engine house, called 'The Roundhouse', in Chalk Farm, North London. The name of the project derived from a 1960 Trades Union Congress resolution—number 42— which recommended trade union involvement in the arts. because of lack of funds and ideological difficulties Centre 42 never materialised, but the Roundhouse has become noted as an arts and entertainment centre, though it is now run on a commercial basis.

A Wesker 'Brief for an architect' *London magazine* 5 (5) August 1965 78-83.

M Foster 'The roundhouse' *AAQ* 3 (1) Winter 1971 43-55.

N Lyndon 'The Roundhouse, Chalk Farm Rd NW1' *Time out* (129) August 4-10 1972 12-15.

123 CENTRO DE ARTE Y COMMUNICACION (CAYC): The Centre of Art and Communication was established in 1968 in Buenos Aires; its director is Jorge Glusberg. The organisation is composed of artists, sociologists, psychologists, mathematicians and art critics; exhibitions are mounted that are relevant to its interests, which are the relationship of art to science/technology and of art ot its social setting.

124 CHEMICAL ARCHITECTURE: A proposal for a new kind of organic architecture made by the American philosopher and industrial designer, William Katavolos in 1960. Chemical powders and liquids can be activated by the addition of agents to expand into pre-determined shapes.

125 CHEMIGRAMS: A form of art based on chemistry and chemical processes using photographic paper or films developed by the Belgian artist Pierre Cordier from 1956 onwards.

G Jager 'Chemigrams' *Graphis* 28 (164) 1972/73 518-523.

C Rohonyi 'Pierre Cordier and his chimigrammes' *Novum gebrauchs-graphik* 43 (8) August 1972 38-43, 59.

126 CHICAGO SCHOOL: Chicago art started to gain national recognition in the United States when a group of artists from Chicago included in the 1959 MOMA show 'New images of man' was labelled 'the monster school'. By the mid 1960s a coherent group was centred round the Chicago Hyde

Park Art Centre, assisted and promoted by its exhibition director, Don Baum. This group exhibited—often as 'The Hairy Who'—in shows throughout America; in 1973 the US entry for the Brazilian biennial (at São Paulo) was entitled 'Made in Chicago' and consisted of twelve Chicago artists: Roger Brown, Edward C Flood, Philip Hanson, Gladys Nilsson, James Nutt, Edward Paschke, Kerig Pipe, Christiana Ramberg, Barbara Rossi, Karl Wirsum, H C Westerman and Ray Yoshida.

Chicago art, which tends to be interpreted as anti-New York art 'lies somewhere in the overlap between the primitive, the naive, and popular kitsch' (Allen & Guthrie), and is characterised by a 'chronic quoting of motifs, unwitting or conscious parodies of styles, and various uncertainties of tone' (Kozloff). It has been described as 'Imagist Art' and is often concerned with individualist fantasies of sex and aggression towards authority figures, drawing much of its imagery from juvenilia, comic strips, and 'trash treasures'. Its best known exponents are Nilsson, Nutt, Westerman and Wirsum, none of whom now live in Chicago.

F Schulze 'Art news in Chicago' *Art news* 70 (7) November 1971 45-55.

F Schulze 'Chicago' *Art international* 11 (5) May 20 1967 42-44.

F Schulze *Fantastic images: Chicago art since 1945* (NY, Wittenborn, 1972).

M Kozloff 'Chicago art since 1945' *Artforum* 11 (2) October 1972 51-56.

A Smith 'New York letter' *Art international* 16 (8) October 1972 52-53.

J Allen & D Guthrie 'Chicago-Regionalism?' *Studio international* 186 (960) November 1973 182-186.

127 CINETISATIONS: Pictures of contorted and shattered buildings created by the French sculptor Pol Bury in 1966. These images are produced by the simple device of cutting or stamping out a series of concentric circles at key points in photographs, engravings, or reproductions of architectural subjects. The resulting rings are then remounted slightly askew. This utterly destroys the stability of the buildings. Bury enlarges his pictures and transfers them onto canvas or lithographic plates.

S Watson Taylor 'Pol Bury Cinetisations' *Art & artists* 1 (10) January 1967 8-13.

128 CITY WALLS: An artists' co-operative established in New York in 1969, with the encouragement of the urban planner David Bromberg,

for the purpose of improving the environment of the city by decorating walls with murals and colourful abstract designs. Members of City Walls include Jason Cram, Robert Wiegard, Tania, and Allan d'Arcangelo.

'Painting for City Walls: the Museum of Modern Art, New York' *L'architecture d'aujourdhui* (145) September 1969 91-94.

129 CIVILIA: A plan proposed by a development corporation, the North Nuneaton Consortium in 1971 for a new, high density city with a population of one million to be sited in the West Midlands region of England. The concept of Civilia is an attempt to reverse the present decay of city life, caused by dispersal, to provide an alternative to the suburban sprawl. A special issue of *Architectural review* was devoted to Civilia, and illustrated with elaborate collages made up of clips from photographs of existing cities.

'Civilia: the end of suburban man' *Architectural review* 149 (892) June 1971.

I De Wolfe (ed) *Civilia: the end of suburban man* (Architectural Press, 1971).

130 CLASP (Consortium of Local Authorities Special Programme): In the late 1950s a number of British local education authorities co-operated in the production of school buildings by using a pre-fabrication system of construction. A CLASP school exhibited at the Milan Triennale in 1960 excited the admiration of Italian architects.

Ministry of Education *The story of CLASP* (HMSO, 1960).

R Banham 'On trial 4: CLASP' *Architectural review* 131 (783) May 1962 349-352.

131 CLASTIC ART: The American artist Carl Andre invented this term to describe those of his sculptures consisting of ready made units such as pebbles, bricks, steel slabs, bales of hay, plastic or wooden blocks and iron rods. 'Clastic' derives from a Greek word meaning to break—in English something that can be taken to pieces and re-assembled if required. Andre offers Clastic Art as an alternative to plastic art: "whereas plastic art is a repeated record or process, clastic art provides the particles for an ongoing process".

Andre believes it is not necessary to cut material in order to make sculpture, because the material itself is 'a cut in space'. He arranges the found elements for a certain period and if they are not purchased they return

to their original non-art condition. He is also concerned with the idea of re-cycling materials unwanted by society.

See also Modular Art.

'Carl Andre' *Avalanche* (1) Fall 1970 19-27.

L R Lippard *Changing: essays in art criticism* (NY, Dutton, 1971) p 274.

C Tisdall 'Any old iron' *The guardian* June 1 1972 p 10.

132 THE CLUB (or Artists' Club): An artists' meeting place and discussion forum at thirty nine East Eighth Street, New York, founded in 1948 by Barnett Newman, Mark Rothko, Robert Motherwell and William Baziotes, and frequented by the Abstract Expressionists during the 1950s.

See also Subjects of the Artist.

I H Sandler 'The Club' *Artforum* 4(1) September 1965 27-31.

B H Friedman 'The Club: an interchapter 1948-1962'—chapter in—*Jackson Pollock: energy made visible* (Weidenfeld & Nicolson, 1972) 107-114.

133 CLUSTER: An architectural and planning term much in vogue during the 1950s. The urbanist Kevin Lynch first discussed the Cluster concept in an article in the *Scientific American* in 1954. It refers to a form of city layout that has many small centres instead of a nodal point surrounded by concentric rings and a radial road pattern.

In 1957 Alison and Peter Smithson defined a Cluster, rather obscurely, as "a close knit, complicated, often moving aggregation, but an aggregation with a distinct structure". Denys Lasdun's residential towers designed from 1953 onwards were also called 'cluster blocks'.

Sibyl Moholy-Nagy uses Cluster to mean groups of houses scattered haphazardly in the twilight zone between cities and the open countryside.

K Lynch 'The form of cities' *Scientific American* 190 (4) 1954 54-63.

A & P Smithson 'Cluster patterns' *Architecture and building* 31 1956 271-272.

A & P Smithson 'Cluster city: a new shape for the community' *Architectural review* 122 (730) November 1957 333-336.

'Cluster blocks . . . ' *Architectural design* 28 (2) February 1958 62-65.

S Moholy-Nagy *Matrix of man: an illustrated history of the urban environment* (Pall Mall Press, 1968) 241-282.

74

134 CNAC (Centre National d'Art Contemporain): In 1967 a centre to document current art and artists on an international scale was established in Paris by the Ministry of Cultural Affairs. CNAC is to be located in the Beaubourg Centre complex when building work has been completed.

B Hunnisett 'Centre National d'Art Contemporain, Paris' *ARLIS newsletter* (9) October 1971 2-3.

135 COBRA: A group of European artists founded in Paris in 1948 by the Belgian poet and essayist Christian Dotremont. Members of COBRA included Pierre Alechinsky, Karel Appel, Corneille, Egill Jacobsen, Asger Jorn, Lucebert, and Karl H Pederson. They considered themselves the representatives of an International of experimental art sympathetic to Expressionism and Surrealism but opposed to geometric abstract art. The name of the group derived from the initial letters of the three capital cities where key members lived: COpenhagen, BRussels, and Amsterdam. COBRA had strong literary connections and a review was published in Denmark from 1948 to 1951. Certain members were also associated with the revolutionary political movement of the Situationists.

Exhibitions of work by COBRA artists were held in Amsterdam in 1949 and in Liege and Paris in 1951. Their paintings somewhat resembled the canvases of the American Abstract Expressionists: a blend of abstraction and figuration, vehement brushwork, powerful colour, but the results seem more decorative than the work of the Americans. Unlike the Abstract Expressionists COBRA artists employed thick impasto combined with crude child-like drawing and utilised imagery drawn from primitive and folk art sources. COBRA only existed for three years but in spite of its brief life critics now claim it was one of the most influential artistic movements of post-war European art.

See also Experimental Group, Situationists.

Cobra 1949-51 (Amsterdam, Stedelijk Museum, 1962).

M Ragon 'The Cobra group and lyrical expressionism' *Cimaise* (59) May/June 1962 26-45.

Ch Dotremont 'Cobra' *L'oeil* (96) December 1962.

Cobra 1948-51 (Rotterdam, Museum Boymans-van Beuningen, 1966).

E Langui 'Expressionism since 1945 and the Cobra movement'—in—*Figurative art since 1945,* by J P Hodin & others (Thames & Hudson, 1971) 59-90.

Gruppe Cobra und andere maler (Kiel, Kunsthalle, 1974).

75

136 COLLAGE CITY: In a special issue of *Architectural review* C Rowe and F Koetter argued that existing cities consist of a jumble of partially realised set pieces—a collage—and that this fact should be regarded as a positive feature, because it is a source of pleasure for city dwellers. Therefore planners should give up the idea of total control and cease dreaming of utopian solutions to urban problems because even if they could be realised they would not be satisfactory.

C Rowe & F Koetter 'Collage city' *Architectural review* 158 (942) August 1975.

137 COLLECTIVE ART: The powerful influence which the concept of individualism exerts amongst artists and art students tends to obscure the fact that much art is the product of collaborative, cooperative, and collective activity by groups of artists. Examples from the distant past include the collective endeavour which produced the medieval cathedrals, the bottegas of Renaissance Italy, the team work practised in Rubens' studio, while in the twentieth century instances of group manifestation are legion: Art & Language, Eventstructure Research Group, EAT, Cobra, APG, Zero, Gutai, Syn, GRAV, Spur, etc.

U Graf (ed) 'Aspekte zum theme kolektivkunst' *Werk* 57 (10) October 1970 664-674.

138 COLOUR-FIELD PAINTING: A description most commonly applied to the work of a generation of American painters—Morris Louis, Kenneth Noland, Jules Olitski and Gene Davis—exhibiting in the late 1950s and early 1960s. Exponents of Hard-Edge Painting, for example, Ellsworth Kelly, are sometimes included in the Colour-Field category. The term is also applied retrospectively to paintings produced in the late 1940s by three Abstract Expressionists: Barnett Newman, Clyfford Still and Mark Rothko; Newman is usually considered the originator and chief exponent of the Colour-Field concept.

The meaning of the term itself is complicated by the fact that art critics talk about 'Colour Painting', or 'Chromatic Abstraction', and also 'Field Painting'; 'Colour-Field' is clearly a combination of the two. Field painting began with Jackson Pollock. Field painters treat the picture surface as a continuous or extended plane, the whole picture is regarded as a single unit so that figure and ground tend to be given equal value. Colour-Field painters replace tonal contrasts and brushwork by solid areas of colour (or in the case of the Acrylic Stain painting of Morris Louis with thin washes of colour) which extend, in most cases, across the canvas

from edge to edge. These areas of colour seem as though they are, in Thomas B Hess's phrase, 'stamped out' of a larger sheet; thus it is implied that the fields of colour extend beyond the confines of the canvas to infinity. Colour is liberated, in this type of painting, from any limitation imposed by internal forms or structure.

In no longer treating the picture space as a box-like cavity Colour-Field Painting departs radically from the depth/illustionistic tradition of Western oil painting. (According to Peter Plagens, a colour field does have a shallow depth, in contrast to a spot of colour which appears to reside on the surface of the canvas). However what Colour-Field Painting lacks in depth it makes up for in breadth: most Colour-Field painters work on a monumental horizontal scale and their canvases are intended to be viewed at close quarters (Newman's idea) so that the whole field of vision of the spectator is engulfed, and then the intensity of the colour creates dramatic optical effects and great emotional impact. Because this type of painting 'envelopes' the spectator it is often described as 'environmental'.

See also Hard-Edge Painting, Stain Painting.

Color and Field 1890-1970 (Buffalo, Albright-Knox Art Gallery, 1970).

I Sandler 'Colour-Field Painters'—chapter in—*Abstract Expressionism: the triumph of American painting* (Pall Mall Press, 1970) 148-157.

E B Henning 'Colour and Field' *Art international* 15 (5) May 20 1971 46-50.

T B Hess *Barnett Newman* (Tate Gallery, 1972).

139 COMBINE PAINTINGS (or Stand-up Paintings): Robert Rauschenberg's term for those of his pictures incorporating non-art objects: coke bottles, pillows, a stuffed ram, radios . . . plus traditional pigments. John Cage has remarked that these combinations of disparate objects are, from the subject point of view, non-relational—that is, they have as much or as little in common as the different stories in a newspaper layout. Rauschenberg's Combines carry the Cubist collage principle to extreme conclusions; they stretch the accepted convention of the easel picture to breaking point.

See also Assemblage Art.

140 COMIX: An international movement arising from the development by certain artists of the comic strip; a development which became associated with and first found its audience in the American Underground of the late 1960s. The movement began on the West Coast with the appearance of comic books such as *Zap comix* (1967) and *Yellow dog* (1968). The artists—Robert Crumb, Victor Moscoso, Rick Griffin, S Clay Wilson,

Skip Williamson, Gilbert Sheldon, Bobby London—rejected the rules of the Comics Code and were thus able to explore the comic strips specific articulation of verbal and visual narrativity. Comix were immediately distributed throughout Europe via Amsterdam and interest was soon manifested: David Zack introduced the British artworld to Comix with an article in *Art & artists,* and in 1970 the American Arts Documentation Centre, Exeter University, mounted a travelling exhibition on the theme of 'The American Underground Press'.

The first British Comix appeared in July 1970: *Cyclops,* which introduced the work of Malcolm McNeill, Edward Barker and Raymond Lowry. Wider circulations were achieved by *Nasty tales* (1971) and *Cozmic comics* (1971) which featured strips by Chris Welch, Mick Farren, William Rankin and Cap Stelling alongside reprints from USA Comix. The demise of *Nasty tales* around 1974 coincided with the emergence of another strand of the Comix movement, that is, Alternative Comix, exemplified by *Class war comix* comprised wholly of drawings by Clifford Harper. In July 1976 the Birmingham Arts Lab accommodated the Konvention of Alternative Komix which resulted in the publication of *Streetcomix No 2* (1976) featuring the work of Hunt Emerson, Bob Gale, Sue Varty and Brodnax. Hunt Emerson has also produced several issues of *Large cow comix* in small quantities that typify the production of Alternative Comix in Britain.

See also Underground Art.

D Zack 'Smut for love, art and society' *Art & artists* 4 (9) December 1969 12-17.

R Lewis 'The American Underground press' *Assistant librarian* 63 (8) August 1970 122-124.

L Daniels *Comix: a history of comic books in America* (NY, Outerbridge, 1971).

M Estren *A history of Underground comics* (San Francisco, Straight Arrow, 1974).

141 COMMUNITY ARCHITECTURE (including Activist Tradition, Peoples' Architecture, Progressive Architecture): During the period 1968 to 1976 various small groups consisting of politically and socially conscious architects were formed to oppose architecture profiting the few at the expense of the many, to oppose the dominant ideology of modernism/functionalism, and to oppose the professional organisations and official institutions which serve the status quo. Because of their lack of resources and a firm base these groups tend to be highly volatile. In

Britain one can cite ARSE (Architects for a Really Socialist Environment) founded in 1969; Street Farmer (a cooperative consisting of Graham Caine, Peter Crump, and Bruce Haggart which opposed mass production and large scale technology and advocated instead ecology, amateur architecture, and community gardening); NAM (New Architecture Movement); and ARC (Architects' Revolutionary Council) founded in 1973. The last named group publish a broadsheet called *Red House* (after the first building of Philip Webb and William Morris) in which they attack the established professional organisation for British architects (the RIBA) and commit themselves to the idea of Community Architecture, that is, architecture which serves a community in a given locality or a community linked in terms of interest. In practice this means rehabilitation of old housing and in-fill rather than wholesale redevelopment, challenging speculators and official plans, working to involve local people in the decision-making process (see also Advocacy Planning). Although the name ARC includes 'revolutionary' it promotes reformism rather than revolution on the grounds that radical rhetoric and class confrontation have proved counterproductive and it promotes self-determination on the grounds that in the past activists have done all the work and thereby added 'another layer of mystification between the grass roots and the system'.

See also Alternative Design, Radical Design.

C Jencks 'The activist tradition'—chapter 6 in— *Architecture 2000: predictions and methods* (Studio Vista, 1971) 75-89.

Street Farmer 'A threatening letter to all architects' *AAQ* 4 (4) October/December 1972 17-20.

Red house (1) 1976- .

142 COMMUNITY ART: Variously described as 'an instrument to change the cycle of deprivation-inarticulateness-deprivation', 'live art'—as opposed to the 'dead art' of the museums—and 'middle-class bullshit masquerading as Art for the People', the term 'community art' covers a range of activities by groups of artists linked principally by the desire to externalize beyond the art gallery/theatre context and to establish a close relationship with particular communities for social/political ends.

In Britain the Arts Council funds Community Art groups because they fulfil one of its briefs: widening people's experience of the arts. In its view Community artists cut 'across the distinction between particular art forms'; are 'concerned with process rather than product' and 'with the effect of their work on the community rather than the achievement of standards acceptable to specialists in the various art forms'.

Community artists adopt a catholic approach to media: they use street theatre, video, media vans and buses, mural painting, inflatables, play structures, etc. They often focus their attention on children as a means of contacting adults. The techniques of street theatre and on-the-spot video recording are a means to an end rather than an end in themselves; although groups like Action Space and InterAction have bases serving as local community centres primary contact with audiences is made by carrying their work into the environment, the street, the public house, and so forth.

On the whole, the attitude of Community Art groups towards established institutions, such as industry and the welfare stae, is one of pragmatic co-operation (one group even calls itself 'Welfare State'); Myriad Events for example has received support from commercial firms in addition to that provided by the state. Local authorities are another source of funds. The Community Arts movement of the 1970s developed out of the counter-culture of the 1960s. As time passes it becomes more and more formalised and institutionalized: in 1974 an Association of Community Artists was formed to co-ordinate activities in Britain.

One ambition of Community artists is to break down the division between the specialist, professional artist and the layperson, consequently they often initiate activity, provide equipment and advice, but leave conception and execution of the work itself to members of the public. This approach is common in the community mural movement. Murals are a cheap way of brightening-up a run down area and engaging the interest of an ethnic group, hence they are especially popular in the ghetto areas of American cities. Jonathan Sale, compiler of a 'how to paint murals kit', talks of 'a street art explosion in America today of unprecendented proportions'.

Although Community Art has many enthusiastic supporters there are others, mainly fine artists from a Conceptual/Theoretical Art background, who are highly sceptical of its value as an instrument for social change. For example, John Stezaker argues that 'Public patronage gladly backs community projects because political efficacy is restricted to those communities in a piecemeal way'. Community Art can also be criticized for failing to engage the dominant ideology of Western Society which is sustained on an international scale by the mass media, and its failure to examine the pictorial/linguistic codes through which that ideology is communicated.

See also Action Space, Inter-Action, Political Art, Street Art.

P Harrison 'Art and community' *New society* 27 (590) January 24 1974 202-203.

C Kerr 'Community Art: where does the social service end and the art begin' *Southern arts* (1) March 1974 15-18.

Community arts: the report of the Community Arts Working Party (Arts Council of Great Britain, 1974).

'The surge in Community Arts' (special issue) *Arts in society* 11 (4) Spring-Summer 1975.

E & J D Cockcroft 'City Arts Workshop—People's art in New York City' *Left curve* (4) Summer 1975 3-15.

M Ramsden 'Review: "City Arts Workshop . . . Left Curve" ' *The fox* 1 (2) 1975 39-47.

J Sale *Mural kit: how to paint murals for the classroom, community centre and street corner* (Directory of social change, 1976).

143 COMPUTER ART: This form of art is more accurately described as 'computer aided art' or 'computer generated art'. It has been produced internationally since about 1956 by a wide range of people belonging to a variety of professions, in fact, anyone with access to computer time. Although computers had been used for a number of years to produce Concrete poems and electronic music their importance for the visual arts in general was not recognised until the 'Cybernetic Serendipity' exhibition held at the ICA, London in 1968. As a result of this show a Computer Arts Society was founded in Britain.

The 'art' produced via computers is mostly drawings and graphics: computers have been programmed to print out specified geometric shapes in random combinations or to transform images by a series of discreet steps—for example, the image of a man into the shape of a bottle and then into a map of Africa. Sculpture has also been produced via computer, punched tape and milling machines. The creative process is greatly assisted by the sketching facility of a light pen and cathode ray tube attached to a computer. The Korean artist Nam June Paik believes that such devices will in due course totally replace painting. Artistic improvisation and intuition are simulated in computer programming by the use of random numbers.

Even enthusiasts for Computer Art admit that aesthetically the results achieved so far are disappointing, and the limiting factor is clearly the creativity of human programmers. Nevertheless some progress has been claimed: (1) scientists and technicians with no previous interest in art have been involved; (2) the high speed of computer processing telescopes

81

the time required to run through the possible permutations of a visual idea, which is especially useful in architectural design. Jasia Reichardt believes that Computer Art is the last stance of abstraction because of the impersonality of computing procedures. Up until now computers have acted as sophisticated tools; if and when they achieve the status of independent artificial intelligences comparable in complexity to the human brain, then we may expect a radically new and authentic Computer Art.

Meanwhile computers are increasingly being used by architects and designers in the solution of design problems.

See also Cybernetic Art, Architecture Machine.

J Reichardt (ed) *Cybernetic serendipity: the computer and the arts* (Studio international, 1968).

'Computer Arts Society' *Leonardo* 2 (3) July 1969 319-320.

Page: bulletin of the Computer Arts Society, 1969- .

J Burnham 'The aesthetics of intelligent systems'—in—*On the future of art;* edited by E Fry (NY, Viking Press, 1970) 95-122.

C C Foster *Computer architecture* (NY, Van Nostrand Reinhold, 1970).

J Reichardt *The computer in art* (Studio Vista, 1971).

H W Franke *Computer graphics—computer art* (Phaidon, 1971).

'Dialogue with the machine' *BIT international* (7) 1972 1-169.

J D Lomax (ed) *Computers in the creative arts: a study guide* (National Computing Centre, 1973).

A Hyman *The computer in design* (Studio Vista, 1973).

H Cohen 'On Purpose: an enquiry into the possible roles of the computer in art' *Studio international* 187 (962) January 1974 9-16.

M L Prueitt *Computer graphics* (NY, Dover, 1975).

'Computer aided design' *Design* (336) December 1976 38-47.

144 CONCEPT ART: A term devised and copyrighted in 1961 by Henry A Flynt Jr, an American anti-artist who has been associated with the international movement known as Fluxus. Flynt defines Concept Art as 'an art of which the material is concepts, as the material of, eg music is sound. Since concepts are closely bound up with language, concept art is a kind of art of which the material is language.' As examples of Concept Art Flynt cites mathematical theorems he made up on the basis that they were aesthetically pleasing but with no regard as to whether they were true or not!

See also Anti-Art, Conceptual Art, Fluxus.

LaMonte Young (ed) *An anthology of chance operations* (Cologne, Heiner Friedrich, 1963; 2nd ed 1971).

K Friedman 'Notes on concept art' *Schmuck* March 1972 6-15; also published in *The aesthetics,* by K Friedman (Cullompton, Devon, Beau Geste Press, 1973) 39-48.

H Flynt 'Concept art'—in—*Blueprint for a higher civilization* (Milan, Multhipla Edizioni, 1975) 125-130.

145 CONCEPTUAL ARCHITECTURE (Also called Invisible Architecture, Imaginary Architecture, Nowhere Architecture): Plans and drawings for buildings and cities which have never been constructed can legitimately be regarded as architecture arrested at the conceptual stage of development, hence 'Conceptual Architecture'. In 1970 a special issue of *Design quarterly* Edited by J S Margolies was devoted to this theme. Contributors were asked to take account of the communications/psychological/entertainment environments. The issue contained a number of projects, some humorous some serious: plans for futuristic cities, a menu for 'eatable architecture' and graphics by those groups who specialize in visions of utopian and impossible architectural schemes. The words 'conceptual' and 'architecture' were employed in a cavalier fashion: they were 'defined' in an 'essay' by Peter D Eisenman which contained no text, only footnotes.

Friedrich St Florian has also made proposals for an architecture of synthetic space, as an alternative to permanent buildings, to be activated only for specific purposes. Such architecture would consist of space-defining conceptual structures (he quotes the world airway network and stacking zones above airports as examples of imaginary structures which retain the conventional engineering parameters of height, width, and depth, but which exist physically only when used by aircraft, and then only as readings on instruments). Florian has also suggested 'simulated architecture', to consist of holographic images of monuments projected into the sky by laser beams. A demonstration of his ideas was held at the Moderna Museet, Stockholm in 1969.

Earlier, in 1960, a concept for 'Aerial' or 'Immaterial Architecture' was forwarded by the architect Werner Ruhnau and the painter Yves Klein: a city roofed by moving air. They proposed the air conditioning of large geographical areas and the replacement of buildings by walls of water and fire. Furniture would be superseded by air beds and air seats. Bernard Etkin and Pete Goering of the University of Toronto Institute for Aerospace Studies have already conducted research into the use of jets

83

of air instead of conventional building. Such 'Invisible Architecture' would represent an expenditure of energy instead of materials and allow for 'instant buildings'.

At a conference on Conceptual Architecture held at Art Net, London in 1975 Will Alsop defined it as 'A limitless activity devoid of direction or dogma' ie pure research or speculation. However, he also claimed that the word 'conceptual' could be applied (a) to work which could be re-alised but lacked the funds, and (b) work which could not be built, which was done as an end in itself. Conceptual Architecture does not exclude building as an activity, according to Alsop, but it is the process which counts as architecture not the result (cp Process Art).

See also Radical Design, Utopian Architecture.

'Imaginary Architecture' *Domus* (491) October 1970 48-54.

'Conceptual Architecture' *Design quarterly* (78/79) 1970.

P Eisenman 'Notes on Conceptual Architecture' *Casabella* (359-360) 1971 49-56.

G Shane 'Conceptual Architecture: betrayal or breakthrough?' *Architectural design* 45 (3) March 1975 187-188.

W Alsop 'Conceptual Architecture: an appraisal within four walls' *Net* (1) 1975.

Gruppo Cavart 'Impossible architecture: possible answers' *Casabella* (411) March 1976 8-13.

146 CONCEPTUAL ART (also called Con Art, Idea Art, Impossible Art, Documentary Art, Begriff Kunst, Post-Object Art, Anti-Object Art, Dematerialised Art, Blind Man's Art, Head Art, Project Art): An international idiom of Avant Garde Art fashionable in the late 1960s and early 1970s. Conceptual Art emerged in part from the emphasis placed on decision making in Minimal and Process Art and it also reflected the influence of Marcel Duchamp (his readymades and critical statements), Ad Reinhardt (his writings), Yves Kelin, Piero Manzoni, and Jasper Johns, all of whom raised questions about the ontological status of the art object.

The term 'Conceptual Art' has been credited to Sol LeWitt (because of his 1967 article 'Paragraphs on Conceptual Art') but Henry Flynt has advocated a similar notion since 1961 (see Concept Art). In any event one can find examples of its use well before the 1960s (Adrian Stokes used the expression in writings dating from 1947). Artists whose work was categorised as Conceptual included Joseph Kosuth, Mel Bochner, Lawrence Weiner, Douglas Huebler, On Kawara, Victor Burgin, Christine

Kozlov, Bernar Venet, Terry Atkinson, David Bainbridge, Michael Baldwin and Harold Hurrell. The last four named British artists functioned as a group (see Art & Language) and issued a journal; in turn they influenced a number of younger British artists based in Coventry who also produced a publication (see Analytical Art). In New York Ian Burn, Mel Ramsden and Roger Cutforth founded 'The society for Theoretical Art and Analyses' while in San Francisco Tom Marioni established in 1970 'The Museum of Conceptual Art' (MOCA). In Tokyo Tarsua Yamamoto founded 'The Conceptual Art Research Association' (CARA). A striking feature of the practice of Conceptual artists was their penchant for working collaboratively and/or collectively.

It is difficult to provide an exact definition of Conceptual Art because, as Donald Brook points out, 'no single use of the phrase . . . secured de facto general acceptance'. Brook distinguished at least four different senses in which the phrase was used. In view of this problem it is only possible here to indicate, empirically, the salient characteristics of the art form: (1) Conceptual Art gave a low priority to the medium of expression and the art work as a physical object; it was concerned with software rather than with hardware. Minimal artists had showed the extent to which the making of art is dependent upon a series of rules (to the motorist the rules of the road are just as important as the road itself), which can be used to generate objects if required; as LeWitt observed 'an idea is a machine that makes art'. Conceptual artists regarded the rules, or sets of decisions, as the essential feature of art not the physical objects. Art objects were despised because they were too closely geared to the use of particular materials and craft skills, emphasising the artist's manual ability rather than his mental resources. They were also dismissed because they appealed largely to sensory experience—what Duchamp called 'visual thrill'—at the expense of conceptual experience. Initially, in pursuit of a 'dematerialised' art conceptual artists produced works which were physical but not directly available to the human senses, for example, works composed of inert gases or electromagnetic waves (see Natural Sculpture), whose existence was only detectable via readings on instruments.

Nevertheless ideas have to be communicated through some physical means, hence the use of documentation—photographs, videotape, texts, speech (the artist Ian Wilson used oral communication as his medium)—in Conceptual Art and the primary place of language.

(2) Because of its use of language and the emphasis on theory Conceptual Art tended to annex the function of the art critic and the art theorist.

85

In so doing it drew attention to those support languages which surround art objects and mediate their meaning. Kosuth notes that a scientist's theoretical writings are considered just as much 'science' as his laboratory work, whereas until the advent of Conceptual Art an artist's theories had been regarded merely as extras. Art critics countered the usurpation of their role by themselves producing examples of Conceptual Art. Paintings and sculptures are appropriate for galleries and museums while texts and photographs are more suited to publications: pamphlets and journals (see Book Art, Magazine Art). Thus Conceptual Art increased the power of the art magazine at the expense of the art gallery. By producing texts Conceptual artists challenged the notion of unique, handmade, expensive art commodities but the commercial gallery/dealer system quickly found ways to market them and thereby recuperated the implied criticism.

(3) Conceptual Art encompassed a wide variety of artistic behaviour (see also Performance Art) but in its extreme form—known as 'acute' or 'ultra-conceptualism'—it was a philosophical enquiry into the concept 'art'. Hence it was concerned with abstraction—not in the sense of abstracting from nature by reduction—but in the sense of dealing with general notions such as are embodied in words. Kosuth, author of the expression 'art as idea, as idea', maintained that art was a linguistic system, that artworks were propositions 'presented within the context of art as a comment on art' and that each genuinely new artwork extended the existing concept of art; thus art was seen as a self-expanding, tautological system: 'art is the definition of art'. (See also Artworld, Meta-Art.)

Conceptual Art aroused much adverse criticism: it was called 'verbiage art', 'gibberish', 'cerebral wanking'; even its advocates admitted it was private, cryptic and baffling. However, it did perform a valuable service in drawing attention to the conceptual element in all works of art. By the mid 1970s the growing use of the term 'Post-Conceptual' indicated that the movement was past its peak. This fact was confirmed by the leftward political drift evident in the work of so many ex-conceptualists.

See also Political Art.

S LeWitt 'Paragraphs on Conceptual Art' *Artforum* 5 (10) Summer 1967 79-83.

Conceptual Art and conceptual aspects (NY, Cultural Center, 1970).
Idea structures (Camden Arts Centre, Central library, 1970).

Art in the mind (Oberlin, Ohio, Allen Memorial Museum, 1970).
'L'Art Conceptual' *VH 101* (3) Autumn 1970 2-53.

K Groh *If I had a mind . . . Concept Art, Project Art* (Cologne, Dumont, 1971).

D Brook 'Toward a definition of Conceptual Art' *Leonardo* 5 (1) Winter 1972 49-50.

K Hoffman *Kunst im kopf* (Cologne, Dumont, 1972).

U Meyer *Conceptual Art* (NY, Dutton, 1972)

E Migliorini *Conceptual Art* (Florence, Edizioni d'Arte Il Fiorino, 1972).

The new art (Hayward Gallery, 1972).

C Millet *Textes sur l'art conceptual* (Paris, Daniel Templon, 1972).

K Honnef *Concept Art* (Cologne, Phaidon, 1973).

L R Lippard *Six years: the dematerialization of the art object from 1966 to 1972 . . .* (Studio Vista, 1973).

147 CONCERNED PHOTOGRAPHY (and Community Photography): In 1966 an international fund for Concerned Photography was established by Cornell Capa and in the following year the first exhibition with the title 'The Concerned Photographer' was mounted at the Riverside Museum, New York. Subsequently various editions of this exhibition toured the United States (1968-1970) and Europe (1970-). The purpose of the fund and exhibit was 'to promote and sponsor the use of photography as a medium for revealing the human condition, commenting on the events of our time and improving understanding among people'. Photographers who have been placed in this category include Robert Capa, Werner Bischof, David Seymour 'Chim', André Kertész, Leonard Freed, Donald McCullin, Gordon Parks, Bruce Davidson, Ernst Haas, Marc Riboud, and William Eugene Smith. These photographers have recorded scenes of war, death, grief, happiness, slums, minorities, and the gamut of relations between humans in groups; they acted as witnesses to the problems of our age.

In the 1970s Concerned Photography became more practical in that photographers with a social conscience began operating in local communities. For example, in the East End of London the Half Moon Photography Workshop was established: it mounts exhibitions, encourages laymen and children to take up photography, and publishes a cheap magazine with articles on 'War photojournalism', 'Third-World photography', and the ethics and politics of photography. The aim of such workshops is to break down the distinction between professionals and amateurs and to use photography as a tool for social change.

See also Photo-Works.

'The Concerned Photographer' *Camera* May 1969 (special issue).
C Capa (ed) *The Concerned Photographer* (Thames & Hudson, 1972).
C Capa (ed) *The Concerned Photographer 2* (Thames & Hudson, 1972).
C Capa 'The concerned photographers' *Zoom* (16) 1973 78-95.
Camerawork (1) February 1976- (magazine of the Half Moon Photography Workshop).

148 CONCRETE ART (In French: Art Concret; in German: Konkrete Kunst): A form of art propounded by a group of artists established in Paris in 1930, led by Theo Van Doesburg, who also edited a review/manifesto entitled 'Art Concret'. The word 'concrete' was introduced to replace 'abstract': the latter was regarded as unsatisfactory because it suggested a separation from reality; 'concrete' on the other hand is, according to the dictionary, 'concerned with realities or actual instances rather than abstractions', exemplified by the expression 'give me a concrete example'; the noun 'concretion', meaning 'the act or process of becoming solid or calcified', is also relevant. Thus the Concrete artist does not abstract from nature. He constructs from the given elements of natural phenomena (colour, form, space, light, etc) objects which are, according to their originators, 'the concretion of the creative spirit'.

Many artists have exploited the notions of Concrete Art, the best known of whom is Max Bill. It was one of the major tendencies of European art to survive the second world war because its practitioners lived in neutral countries such as Switzerland and Argentina. In the immediate post-war period, major exhibitions of Concrete Art were organised and a number of groups were formed. In Italy, for example, Gillo Dorfles founded in 1948 the 'Movimento Arte Concreta' (MAC)' The word 'concrete' gained wider currency when it was adopted by a new generation of artists concerned with Concrete Poetry.

In 1960 Bill organised in Zurich a large scale survey of Concrete Art covering the first fifty years of its development. Since that date the mainstreams of European and American art have moved away from pure construction and Concrete Art as a movement has lost impetus, though many artists continue to be influenced by its concepts.

Konkrete kunst (Basle, Kunsthalle, 1944).
Art concret (Paris, Galerie Drouin, 1945).
Spirale (Bern 1953-1964), quarterly devoted to Concrete Art.
Konkrete kunst: 50 jahre entwicklung (Zurich, Kunstgesellschaft, 1960).

149 CONCRETE EXPRESSIONISM: Irving Sandler's name for the work of a group of American painters, including Al Held, exhibiting in New York in 1965.

150 CONCRETE POETRY (including Audiovisual Texts, Constellations, Evident Poetry, Kinetic Poetry, Machine Poetry, Objective Poetry, Optical Poetry, Poem-Paintings, Poetry of Surface, Popcrete, Process Texts, Publit, Semiotic Poetry, Visual Texts, Word Art): Concrete Poetry has been placed 'between poetry and painting' (the title of an exhibition at the ICA, London in 1965). Typically, the Concrete poet arranges language elements freely across a surface, not just in linear syntax. Like any image, his work must be reproduced as exactly as possible. Stephane Mallarmé's 'Un coup de dés' has been an important influence, as have the poetry and manifestos of the Dadaists, Constructivists, and Futurists: Marinetti, for example, called for a poetry of nouns only, standing in their 'naked purity' and 'essential colour'. Carlo Belloli's 'wall text-poems' of 1943 were a direct response to this call. Later in the same decade the Lettrists used letter forms in their paintings and by 1953 the Swede Oyvind Fahlstrom was using the phrase 'Concrete Poetry' to relate his poetry to Musique Concrete.

The movement took its definitive form in the work of Eugen Gomringer, based in Switzerland, and the Brazilian Noigandres group. In 1955 when Gomringer and Decio Pignatari, one of the Noigandres, agreed on the name 'Concrete Poetry' they were taking as their model the Concrete Art of Max Bill, an abstract art of mathematical perfection and autonomy. To make a similarly self-sufficient art out of words the Concrete poets used the device of self-reference, so that meaning and appearance coincided or strongly interacted. This could be achieved by exemplifying in the poem's structure some quality or process as well as by simply arranging words to form an image. Or by making word clusters which defined limited areas of meaning and allowed the reader to make his own connections within each cluster. The poets saw their work as a way of improving the efficiency of language and the influence of disciplines such as linguistics and information theory can be seen in the repetitions and permutations that occur so often in their poems.

Concrete Poetry was an international movement. Work in the pure Concrete manner has been made in Germany by Claus Bremer, in Austria by Gerhard Ruhm and Friedrich Achleitner, in Mexico by Mathias Goeritz, in Scotland by Edwin Morgan, in the USA by Emmett Williams and

89

in Czechslovakia by Zenek Barborka, whose 'Process Texts' have expanded the art-form to book length.

Gomringer restricted himself to one typeface and two 'colours'—black ink on white paper—while the Noigandres used a wider range of colours and typefaces but retained the same classical balance between visual and semantic content. During the 1960s Word Art proliferated in many forms (under many labels), in a wider range of techniques and often using looser structures. Ian Hamilton Finlay has used stones, metal and other materials (he often places his poems in a landscape setting) all closely related to the sense of his poems. Pignatari moved on to the invented sign-systems of 'Semiotic Poetry' and Augusto de Campos, another of the Noigandres, to the photo-sequences he called 'Popcrete'. Belloli kept his distance from the Concrete poets, calling his later work, however similar to theirs, 'Audiovisual texts'. The visual qualities of word and letter forms have been explored in the 'Poetry of surface' of Franz Mon, Ferdinand Kriwet's 'Publit' and 'Poem-Paintings', Jiri Kolář's 'Evident Poetry' and Jiri Valoch's 'Optical Poetry'.

The pattern-making possibilities of the typewriter have been taken up by Dom Sylvester Houédard, a 'Kinetic poet' who produces 'Typestracts'. Another typewriter poet, Pierre Garnier, calls his work 'Machine Poetry' and published a manifesto in 1963 in which he used the term 'Spatialism' (also used by Lucio Fontana in the 1940s) to cover all the then current trends in Word Art. In recent years all labels have fallen out of favour except perhaps 'Visual Texts' and 'Concrete Poetry', used in its most general sense.

See also Calligrams, Concrete Art, Spatialism, Typewriter Art.

E Williams (ed) *An anthology of Concrete Poetry* (NY, Something Else Press, 1967).

S Bann (ed) *Concrete poetry: an international anthology* (London Magazine, 1967).

M E Solt (Ed) *Concrete Poetry: a world view* (Bloomington, Indiana U Press, 1968).

J Sharkey (ed) *Mindplay: an anthology of British Concrete Poetry* (Lorrimer, 1971).

Akros 6 (8) March 1972 (special issue).

151 CONSENSUS PAINTING: A term coined by the British marxist writer and artist Andrew Brighton to describe non-Vanguard, non-Modernist contemporary paintings such as those which serve as the

originals for sets of popular prints and those exhibited in the Summer exhibitions of the Royal Academy. Consensus Painting reflects the values and sentiments of the British bourgeoisie; it reflects a consensus of taste about what constitutes 'good' art—sincerity, personal vision, tradition, sound craftmanship, normality—and also a consensus of ideas about the world (an ideology). In an examination of the RA Summer exhibitions since 1945 Brighton shows that Consensus Painting is not static but that it has constantly to make adjustments in order to accommodate itself to the changes taking place in British society.

A Brighton 'Consensus painting and the Royal Academy since 1945' *Studio international* 188 (971) November 1974 174-176.

152 CONSTRUCTIONISM: The American artist Charles Biederman coined this term in 1938 to describe his own work—a form of relief deriving from painting but sharing some of the three dimensional qualities of sculpture—and a method of creation. The French artist Jean Gorin produced similar works at the same time but the artists were unaware of each other's art until the late 1940s. Since then a number of American and European artists have adopted the Constructionist label (some indiscriminately—in 1952 Biederman felt constrained to introduce a new term: see Structurism).

During the 1950s a generation of British artists—John Ernest, Adrian Heath, Anthony Hill, Kenneth and Mary Martin, Victor Pasmore, Peter Stroud and Gillian Wise—were influenced by Biederman's ideas; Pasmore in particular was deeply impressed by Biederman's monumental history of art as the evolution of visual knowledge, which he read in 1951.

C Biederman *Art as the evolution of visual knowledge*, (Red Wing, Minnesota, Biederman, 1948).

153 CONSTRUCTIVISM: Art historians generally locate the origins of Constructivism in the work and writings produced by certain Russian artists in the 1920s. Yet despite its historical, geographical and national specificity writers such as George Rickey and Stephen Bann have extended the label to cover post-war movements in Europe and North America. This has provoked Ronald Hunt to remark 'Constructivism must be just about the most abused term in current art usage'. Hunt objects to the fact that the radical political element present in the original Soviet context has been filtered out and that Constructivism now refers to any art which is constructed and which displays order, logic, structure, abstraction and geometry.

G Rickey *Constructivism: origins and evolution* (Studio Vista, 1967).

S Bann (ed) *The tradition of Constructivism* (Thames & Hudson, 1974).

R Hunt 'Constructivism mistaken' *Studio international* 188(971) November 1974 p209.

154 CONTEMPORARY STYLE: During the period 1945 to 1956 the word 'contemporary' was used by many British writers to describe the art, architecture and design of their era, for example, the Institute of Contemporary Art was founded in 1947, Herbert Read's book *Contemporary British art* was published in 1951. Characteristics of the Contemporary Style were most clearly seen in the applied arts but they were also manifested to some extent in sculpture (see Geometry of Fear) and Action Painting: lightness, gaiety, a spiky, spindly look. In furniture this appearance resulted from the use of thin metal rods and pale timber instead of dark, of wooden legs which were often splayed out and tapered, metal fittings which had brightly coloured plastic blobs at their extremities. Magazine racks were constructed of wire covered with plastic, the gaps between metal supports were bridged by decorative lacing made of plastic, a mannerism that derived from the sculpture of Naum Gabo, Alexander Calder and Barbara Hepworth. Wallpaper and textile design favoured geometrical patterns: snow crystals, coffin shapes or elongated hexagons.

The Contemporary Style was popularised by the Festival of Britain exposition of 1951, giving rise to another term 'Festival Style' or 'South Bank Style'; *Design* magazine also calls it the 'New English Style'. Authorities on design disagree as to whether a Festival Style really existed, but they do admit that the phrase has been used; Richard Hamilton regards it as a sub-classification of Contemporary Style. Peter Cook says that 1952 design "contained a mixture of post-war spinoff (the technology of laminates, alloys and micro-mechanics) and latter-day thirties styling".

In the context of an exhibition, experimental design was appropriate but the mannerisms of 1951 quickly became cliches disfiguring the interior decor of coffee bars, public houses and exterior features such as street furniture. Many Contemporary Style products were eccentric in design and poorly constructed.

True to the pattern of post-war revivals—first Art Nouveau, then Art Deco—Contemporary Style products have now acquired the status of collector's items (see Austerity/Binge).

'FoB + 10' *Design* (149) May 1961 40-51.

M Frayn 'Festival'—in—*Age of austerity 1945-51* edited by M Sissons and P French (Penguin, 1964) 330-353.

P Cook *Experimental Architecture* (Studio Vista, 1971) p 17.

M Banham & B Hillier (eds) *A tonic to the nation: the Festival of Britain 1951* (Thames & Hudson, 1976).

155 CONTEXTUAL ART: 'Art as a Contextual Art' was the title adopted in 1976 by a group of Swedish artists at a conference at Malmö, and in an exhibition at Lund University. These artists oppose conceptual art and the production of art objects for cultural consumption. They describe Contextual Art as a form of social practice.

Art as a Contextual Art (Lund, Edition Sellen-GalerieS:t Petn, 1976).

156 CONTEXTUALISM: An approach to urban planning which considers the city in its totality, the view that the experience of a city is greater than the sum of its parts. According to Graham Shane architectural design 'must fit with, respond to, mediate its surroundings, perhaps completing a pattern implicit in the street layout or introducing a new one. Crucial to this appreciation of urban patterns is the gestalt double image of the figure-ground', that is, the capacity of the viewer to read buildings as figures on the ground of the streets or vice versa. Shane argues that 'during the mid-1960s there was a conscious revival of the contextualist approach on both sides of the Atlantic'.

T L Schumaker 'Contextualism: urban ideals and deformations' *Casabella* (359-360) 1971 78-86.

G Shane 'Contextualism' *Architectural design* 46 (11) November 1976 676-679.

157 CONTEXTUALISTIC AESTHETICS: A view of art and aesthetic awareness based on a distinction between intuition and logic, the former being regarded as more fundamental, the empirical knowledge of individuals rather than an understanding of universals and concepts. Logical analysis is seen as distorting reality, especially aesthetic experience, because it atomises and freezes the flux of experience. 'The aesthetic experience is immersed in a context of continuous happenings. It is distinguished from other happenings by an enhanced immediacy of the quality of what is happening. This quality is "had", "intuited" .' Contextualistic Aesthetics (though not originally called that) forms a part of a philosophy which was developed, mostly in the 1920s and 1930s, from the

writings of Charles S Peirce, William James, Henri Bergson, Benedetto Croce, John Dewey, and Stephen Pepper.

S C Pepper 'The development of Contextualistic aesthetics' *Antioch review* 28 (2) Summer 1968 169-185.

158 CONTINUUM: A group formed by three artists—Bob Janz, Mike MacKinnon, and Dante Leonelli—exhibiting light and motion works at the Axiom gallery, London in 1968. The name 'Continuum' referred to transformations through time achieved by artworks capable of real change. Although their works resembled Kinetics the members of the group claimed that they had more in common with American artists such as Kenneth Noland and George Rickey. Continuum involved the close co-operation of its members but not anonymous group activity. It exploited modern materials, such as neon light and plastics, and maintained close contact with industry.

See also Kinetic Art, Technological Art.

C L Morgan 'Continuum light and motion systems' *Art & artists* 5 (3) June 1970 60-63.

Continuum (Hayward Gallery, 1970).

159 CONTRACT FURNITURE: Large quantities of furniture produced as a result of an agreement, or contract, between an architect, or a corporation, and a furniture manufacturer, or supplier. During the post-war building boom large-scale office blocks and institutions were constructed and required complete ranges of furniture to equip them; as a result Contract Furniture became an important and profitable part of the furnishing trade. As one writer noted, because architects order large quantities of such furniture they are in a position to demand improvements in design and quality.

S Southin 'Furniture—subject to contract' *Design* (182) February 1964 22-29.

160 COOL ART: The adjective 'cool' or 'cold' (in German 'Kalte', in Italian 'fredda') has been used in a metaphorical sense by many art critics in recent years to characterise various forms of art exhibiting the qualities of detachment, severity, rationality, hermeticism, impersonality, austerity; appealing to the intellect rather than the senses or the emotions. In general Cool Art is abstract, geometric, with sharply defined contours or forms, and comprised of repetitive structures or units.

For example, the Swiss artist Karl Gerstner who produces abstract programmed artworks has published a book entitled *Kalte Kunst (1957/63)*; in 1964 Philip Leider called a group of Los Angeles artists—Robert Irwin, Kenneth Price, Joe Goode, Ed Ruscha, Larry Bell and others—'The cool school' because their work manifested 'a hatred of the superfluous, a drive towards compression, a precision of execution . . . impeccability of surface' (see Finish Fetish), and marked 'a new distance between artist and viewer': a 'hands off' quality; coldness has also been detected in Hard-Edge Painting, in Minimal Art, in Fundamental Painting and even in Pop Art.

P Leider 'The Cool School' *Artforum* 2 (12) Summer 1964 p 47.

I Sandler 'The new Cool Art' *Art in America* 53 (1) February 1965 99-101.

E Wolfram ' "Isms cool or isms isn't" ' *Art & artists* 2 (2) May 1967 12-15.

H Coulonges 'The new cool school' *Realities* (253) December 1971 50-57.

G Celant 'American "cool" painting' *Domus* (523) June 1973 49-51.

G Celant 'La "pittura fredda" Europea' *Domus* (527) October 1973 52-54.

161 COOPÉRATIVE DES MALASSIS: A group of politically committed French painters—Henri Cueco, Lucien Fleury, Jean Claude Latil, Michel Parré and Gerard Tisserand—who withdrew a collectively produced work from the 1972 Grand Palais show as a protest against police action against a demonstration. Their painting, entitled 'Le Grand Mécheu ou 12 ans d'histoire contemporaine en France', consisted of forty five canvases depicting their countrymen as sheep, police as pigs, and various French politicians.

See also Political Art.

M Peppiatt 'Paris letter: Summer' *Art international* 16 (8) October 1972 55-56.

'Les Malassis' *Opus international* (37) October 1972 64-65.

162 CO-REALISM: A term invented by Frederick J Kiesler (1896-1965, an American of Austrian origin) to name a concept emphasizing the continuity of space and time and the correlation between sculptural object and its environmental context. Kiesler worked in a number of disciplines —theatre design, painting, sculpture, and architecture—and was associated with several art movements including De Stijl and Surrealism; he has also

been called 'the father of Happenings'. During his career Kiesler proposed
various forms of visionary architecture—Endless Architecture, Spiral Archi-
tecture, Magical Architecture—all of which were clearly anti-functional
in inspiration (he dismissed functional architecture as 'the mysticism of
hygiene').

See also Happenings, Environmental Art, Utopian Architecture.

Frederick Kiesler: environmental sculpture (NY, Guggenheim Museum,
1964).

F Kiesler 'Second manifesto of co-realism' *Art international* 9 (2)
March 1965 16-19.

F J Kiesler *Inside the endless house* (NY, Simon & Schuster, 1966).

Programmes and manifestos on 20th century architecture; edited by
V Conrads (Lund Humphries, 1970) 150-151.

163 CRITICAL REALISM: This term has been employed by Russian
literary critics for many years to refer to writings which accurately de-
scribed the evils of bourgeois society and which, therefore, were looked
upon with favour by socialists. For a Marxist critic such as the Hungarian
Gyorgy Lukács Critical Realism was the appropriate mode for an artist
in a pre-revolutionary situation; (after the revolution Socialist Realism
would supersede Critical Realism).

In the visual arts 'Kritischer Realismus' was the term adopted by a
group of German artists—Hans-Jurgen Diehl, Wolfgang Petrick, Peter
Sorge, Klaus Vogelgensang, and Bettina Von Arnim—who made photo-
montages, from newspaper and magazine material, attacking contemporary
culture. The Swedish artist Peter Dahl has also used the term in relation
to his own paintings, in particular to a series of twenty works entitled
'Dreams from the corner of the sofa' which caused something of a scandal
because they depicted a sexual fantasy involving the image of a member
of the Swedish Royal family.

See also Bourgeois Realism.

G Lukacs *The meaning of contemporary realism* (Merlin Press, 1963).

M B Wadell 'Critical Realism: a case study' *ARIS* 1974 1-114.

164 CULTURAL ART: A pejorative term, defined by Jean Dubuffet
in 1949 as 'the opium of the people', and employed since the abortive
French revolution of May 1968 by critics such as Jean Clay.

Cultural Art is roughly equivalent to Fine Art, in the sense of art as
pure investigation for its own sake. Such art is 'Tame Art'. The cultural
artist plays at freedom instead of living it, he is harmless, his art is a safety

valve for the discontents of society; in return society accords him a privileged status—in reality an invisible prison. Any attempt to escape from the cultural ghetto by means of group activities or by the production of Multiples is doomed to failure; the artist must inevitably fall back upon the bourgeois gallery system and its exploitation of art for money. The alternative to Cultural Art is called 'Wild Art'—the artist is urged to intervene in social life, to take direct political action, to develop the concept of Street Art, in order to break away from the normal art venues and modes of expression.

See also Atelier Populaire, Multiples, Street Art.

J Clay 'Art tamed and wild' *Studio international* 177 (912) June 1969 261-265.

165 CUSTOM PAINTING: Mass produced goods, in particular motorcycles and automobiles, have been personalised by means of painted decoration since the late 1940s. This art form emerged in Southern California and its originator is claimed to be Van Dutch Holland. Nowadays production model vehicles are little used, customising has become a cult of the fantastic—the Kustom car cult—involving the total fabrication of an automobile or motorcycle from special parts.

The expression 'Custom Painting' was also used in the 1960s by the British Pop artist Peter Phillips to describe a series of his own works. Phillips selected images from particular sub-cultures, such as that of the leather jacketed rockers, as a step towards a custom made art. For the further development of this concept see Hybrid Enterprises and Fine Artz.

G Card 'Custom Painting'—letter in—*Studio international* 174 (891) July/August 1967 p 7.

T Wolfe *The kandy kolored tangerine flake streamlined baby* (Cape, 1966) title essay 76-107.

F Schulke 'Portrait of the artist as an easy rider' *Sunday times magazine* September 2 1973 44-45.

E J Opat 'Van art' *Print* 29 (6) November/December 1975 54-59.

166 CYBERNETIC ART (also called Cyborg Art, Cyberart, Post-Kinetic Art): Norbert Weiner, the principal founder of the scientific theory of cybernetics described it as " control and communication in the animal and the machine", and also as the study of messages as a means of controlling machinery and society. Fundamental to cybernetics is the concept of feedback, that is the return of part of the energy output of a

system, in the form of information, for correcting or controlling the future behaviour of the system.

During the 1960s a number of artists, predominantly European Kineticists, began to apply these scientific ideas in their work; cybernetics seemed to provide a means of overcoming the limitations of Kinetic Art in respect of spectator participation. Several Cybernetic sculptures were built capable of responding to environmental stimuli, including the proximity of the spectator or any sounds that he might make. Nicholas Schoffer created such a work as early as 1954. Other artists who have produced similar sculpture or environments include Enrique Castro-Cid, Nam June Paik, Charles Mattox, Robert Breer and the American art and technology group Pulsa. Jack Burnham believes that the aim of what he calls Cyborg Art (the cybernetic organism as an art form) is to achieve the degree of communicative interaction of two humans conversing together. Such art attempts to simulate the structure of life rather than imitating its appearance, and its ultimate goal is total integration with intelligent life forms; at this level artifacts are replaced by systems, Cybernetic Art is superseded by Systems Art.

The English artist Roy Ascott has been influenced by Cybernetics in his work and in his theories. He maintains that the trend towards a fusion of the arts can be accounted for by a 'cybernetic vision' in which art is regarded as a behaviour within society. Several other English artists who are cybernetics orientated contribute to a journal published in London, edited by Steve Willats, called *Control magazine* (see Behavioural Art).

A note of warning: artists, critics and exhibition organisers often use the term 'cybernetics' and 'computers' interchangeably, but while the two are related and frequently occur together in practice, they are not identical fields of knowledge; Cybernetic Art and Computer Art are not one and the same.

See also Computer Art, Kinetic Art, Pulsa, Systems Art.

R Ascott 'Behaviourist art and the cybernetic vision' (Part I) *Cybernetica* 9 (4) 1966 247-264; (Part II) *Cybernetica* 10 (1) 1967 25-56.

R Ascott 'The cybernetic stance: my process and purpose' *Leonardo* 1 (2) April 1968 105-112.

J Burnham 'Robot and Cyborg Art'—chapter in—*Beyond modern sculpture . . .* (Allen Lane, Penguin Press, 1968) 312-376.

J Reichardt—(ed)—*Cybernetic serendipity: the computer and the arts* (Studio International, 1968).

M J Apter 'Cybernetics and art' *Leonardo* 2 (3) July 1969 257-265.

J Reichardt—(ed)—*Cybernetics, art and ideas* (Studio Vista, 1971).

167 CYMATICS (or Kymatic): This word, deriving from the Greek 'Kyma' meaning 'the wave', is used by the artist/scientist Dr Hans Jenny to describe his research into the structure and dynamics of waves, vibrations, and periodic phenomena. Strictly speaking Cymatics is not an art term but many of Jenny's experiments relate to Kinetic Art and his photographs and books interest many artists; consequently Cymatics is often featured in art journals and in art galleries.

See also Kinetic Art.

H Jenny *Cymatics: the structure and dynamics of waves and vibrations* (Basle, Basilius, 1967).

D

168 DAU AL SET (Dice with seven): The name of a magazine and a group of Spanish artists which existed in Barcelona from 1948 to 1953. Members of the group were influenced by Surrealism and their work was part of the European tendencies known as L'Art Informel and Matter Art. The best known painters of the group were Antonio Tapies, Juan-José Tharrats, and Modesta Cuixart.

See also L'Art Informel, Matter Art.

169 DE-ARCHITECTURIZATION: A term employed by the American artist and architect James Wines to denote a subversion, or inversion, of the functional postulates of design derived from the Bauhaus, which he regards as oppressive. Wines is the founder and current president of SITE, Inc a group which have carried out a series of Surrealistic projects in America, for example, they designed showrooms for a mail order firm which appeared to be unfinished: crumbling fabric with walls pealing away from the rest of the structure.

See also SITE.

J Wines 'De-architecturization: the iconography of disaster' *Architectural design* 45 (7) July 1975 426-428.

J Wines 'De-architecturization' *Arts in society* 12 (3) Fall-Winter 1975 350-363.

170 DÉCOLLAGE: The opposite of collage. It means ungluing, unsticking, taking off. The art of décollage occurs naturally in cities when poster hoardings are torn and defaced revealing several layers of imagery. Décollage was discovered by the Surrealist Leo Malet in 1934 and became extremely popular as a method of producing art in Europe during the 1950s. Artists associated with this latter development included Raymond Hains, Jacques de la Villeglé, François Dufrêne, Mimmo Rotella, Austin Cooper and Gwyther Irwin.

For Wolf Vostell, a German representative of the international movement known as Fluxus, the word 'décollage' acquired a more profound meaning than merely a technique for producing decorative artifacts. To him it signified the dissolution, destruction and change inherent in human existence: 'Life is dé-coll-age in that the body in one process builds up and deteriorates as it grows older—a continuous destruction'. Vostell developed a series of destructive events (see also Actions, and Happenings) which reflected this insight and which were also critical contemporary society. During the 1960s Vostell edited a magazine, *Décoll/age*, which featured the work of Fluxus artists.

See also Affiche Lacérées, Fluxus, Destructive Art.

Décoll/age (Cologne) 1-7, 1962-1969.

W Vostell 'Dé-coll-age' *Art & artists* 1 (5) August 1966 9-10.

L Malet 'A new art medium (1) how poetry devours walls' *Leonardo* 2 (4) October 1969 419-420.

J Merkert 'Pre-Fluxus Vostell' *Arts & artists* 8 (2) May 1973 32-37.

S W Peters 'Vostell and the vengeful environment' *Art in America* 63 (3) May-June 1975 50-51.

171 DEDUCTIVE STRUCTURE: A theory of pictorial construction expounded by the American art critic Michael Fried in numerous articles since 1965. Fried makes a useful distinction between the actual shape of the support which he calls 'literal shape', and the internal patterning of a painting which he calls 'depicted shape'. According to Fried the vertical bands (depicted shape) in Barnett Newman's canvases are deduced from the two side framing edges (literal shape) and this explicit acknowledgement of the shape of support marks a significant step in the development of Modernist painting. This theory has also been applied to the paintings of Kenneth Noland, but in particular to the work of Frank Stella to explain the phenomenon of shaped canvas.

See also Modernist Painting, Shaped Canvas.

W S Rubin *Frank Stella* (NY, MOMA, 1970) 54-60.

172 DEPRESSION MODERN: A term coined by Martin Greif to denote the design of the 1930s, the decade of economic depression. Greif argues that Art Deco belongs to the 1920s and that Depression Modern marked a reaction against it. According to Greif Depression Modern is characterized by simplicity, honesty, smoothness of forms, clarity of line, horizontality, streamlining, and functional expressiveness. These features are exemplified in the design of cars, radios, domestic furniture and kitchen appliances.

See also Art Deco.

M Greif *Depression modern: the thirties style in America* (NY, Univers Books, 1975).

173 DESIGN COUNCIL: A British organisation established by the Board of Trade in 1944 and known until 1972 as 'The Council of Industrial Design'. Its purpose was "to promote . . . the improvement of design in the products of British industry". This aim was to be achieved by awards, publicity, and exhibitions. In 1949, the council began publication of *Design* magazine, and in 1956 a permanent display centre—the 'Design Centre' located in the Haymarket, London—was opened to the public. The director of COID during the years 1947 to 1959 was the British furniture designer Gordon Russell.

See also 'Good' Design.

M Farr *Design in British industry: a mid century survey* (Cambridge, University Press, 1955) 208-222.

F MacCarthy *All things bright and beautiful: design in Britain 1830 to today* (Allen & Unwin, 1972).

174 DESIGN RESEARCH UNIT (DRU): A British industrial design office established in January 1943 by the Ministry of Information. The idea for DRU was originated by Marcus Brumwell, Milner Gray, Misha Black and Herbert Read; the last mentioned became its first director. The purpose of DRU was to provide a practical service to industry in the form of advice, research and consultancy to improve the quality of design in British products so that they could compete in post-war world markets. It was thought that only a team of designers pooling their specialist knowledge could offer a service sophisticated enough to tackle large-scale design commissions. The DRU has worked successfully in the areas of exhibition design, interior design and corporate design for national bodies and large British industrial organisations.

J & A Blake *The practical idealists: twenty five years of designing for industry* (Lund Humphries, 1969).

175 DESTRUCTIVE ART: The twin phenomena of violence and destruction so characteristic of the history of the twentieth century have featured as subject matter in modern art, but during the first half of the 1960s a number of artists from different countries, conscious of the unprecedented potential for destruction created by mankind since 1945, developed a new form of art in which violence and destruction were used as methods of creation, and Destructive Art emerged as an aesthetic in its own right. Such art usually took place in public, so that an audience could witness the transformations of objects by successive acts of destruction, the process of change being regarded as art not the resultant debris. Jean Tinguely exhibited self-destroying machines, Jean Toche smashed typewriters, John Latham built and exploded Skoob towers ('Skoob' equals 'books' spelt backwards), Werner Schreib drew images with fire: a technique he called 'Pyrogravure', Gustav Metzger used acid to destroy nylon sheets (see Auto-Destructive Art). Tosun Bayrak, a Turkish/American artist based in New York became noted for his street events involving blood and animal corpses. In fact most Actions and Happenings contain a high proportion of aggression and destructive activity, especially those produced by Austrians (see Direct Art).

In 1966 a 'Destruction in Arts Symposium' (DIAS) was held in London, organised by Gustav Metzger and John Sharkey. More than twenty artists from ten countries attended, and examples of their Destructive Art presented during the course of the symposium created a furore in the press and led to prosecutions for indecent exhibitions. DIAS claimed that destructive techniques in art were a worldwide activity, and that there was a close relationship between the new art form and social reality. They maintained that human aggression could be sublimated through art, and that violence would be socially acceptable in the form of art, but the critics did not agree—in their view violence breeds violence, and they condemned Destructive Art as 'perverse, ugly and anti-social'. A second DIAS was held in the United States in 1968.

See also Actions, Happenings, Street Art.

(Special issue on violence and destruction in art) *Art & artists* 1 (5) August 1966.

'Excerpts from selected papers presented at the 1966 Destruction in Art Symposium' *Studio international* 172 (884) December 1966 282-283.

Destruction art: destroy to create (NY, Finch College of Art, 1968).

102

C Willard 'Violence and art' *Art in America* 57 (1) January/February 1969 36-43.

Happenings and Fluxus (Cologne, Kunstverein, 1970).

L Rothschild 'Violence and caprice in recent art' *Leonardo* 5 (4) Autumn 1972 325-328.

J Fraser *Violence in the arts* (Cambridge U Press, 1974).

176 DIAGRAMS: The word 'diagram' derives from a Greek term meaning 'to mark out in lines'. Diagrams are linear devices which provide an outline or general scheme of an object, situation, system, or process so as to exhibit selected relationships but without depicting surface appearances. Fine distinctions can be drawn between charts, graphs, plans, tables, maps, and diagrams but the latter word is often used as a blanket term; alternatively some writers have suggested 'paragrams' as a cover term. Although diagrams are chiefly employed by scientists, logicians, and statisticians they have also been used by art historians, art critics, art educators, philosophers and psychologists of art, and by artists, architects, and designers. The significant increase in the use of diagrams, or diagrammatic graphic layouts, by fine artists in recent years can be ascribed to the influence of such disciplines as computer science, cybernetics, linguistics, structuralism, and also the emphasis on the logical presentation of information in Conceptual Art. Artists who have utilized diagrams in various ways include Joseph Beuys, Daniel Buren, Victor Burgin, Lawrence Burt, John Hilliard, Joseph Kosuth, Roy Lichtenstein, Ad Reinhardt, John Stezaker, Bernar Venet, Andy Warhol, and Steve Willats. One could also cite the use of diagrammatic schemas in Tantra art, Yoga art, and in Concrete poetry.

Most diagrams have both pictorial and linguistic characteristics (they often contain a number of different coding systems) hence they are of particular interest to those contemporary artists who are concerned with integrating the verbal and the visual. By demonstrating the value of multiple coding diagrams are exemplary: they contradict the Formalist notion that each medium should strive to achieve absolute purity.

Diagrams perform utilitarian functions so efficiently that their role in communication tends to be overlooked; for example, the London Underground Diagram devised by Henry C Beck in 1931 is only just beginning to be recognised as a classic of twentieth century graphic design.

A Lockwood *Diagrams: a visual survey of graphs, maps, charts and diagrams for the graphic designer* (Studio Vista, 1969).

J Bertin & others *La sémiologie graphique: les diagrammes, les reseaux, les cartes* (The Hague/Paris, Mouton, 2nd ed 1973).

W H Herdeg *Graphis diagrams: the graphic visualization of abstract data* (Zurich, Graphis Press, 1974).

J A Walker *Art diagrams* (unpublished, 1975).

J A Walker 'Diagrams their relevance to art' *Control* (9) December 1975 18-20.

J A Walker 'The London Underground Diagram: a semiotic analysis' (unpublished, 1975).

177 DIGSWELL ARTS TRUST: Digswell is the name of a house situated on the outskirts of Welwyn Garden City which accommodates a number of artists and craftsmen. The Digswell Arts Trust was founded in 1957 by Henry Morris, a visionary educator, with the intention of providing workshops for artists and forging a link between the artist and the local community.

R Carr 'Bridging the gap' *The guardian* November 22 1973 p15.

178 DIMENSIONAL PAINTING: Three-dimensional forms with painted surfaces, a term devised by the English abstract painter Justin Knowles.
See also Shaped Canvas.

P Overy 'Justin Knowles: dimensional paintings' *Studio international* 173 (885) January 1967 32-33.

179 DIRECT ART: A group of Austrian artists—Otto Muehl, Hermann Nitsch and Gunther Brus, who called themselves at one point the 'Vienna Institute for Direct Art'—have organised a series of Actions somewhat similar to Happenings since the early 1960s.

Their events include brutal sexual and sado-masochistic behaviour; food stuffed into bags which are then burst, the dead carcass of a lamb crucified in an eight hour ceremony, blood and flesh smeared over participants. These artists belong to an Austrian movement known as the 'Wiener Aktionismus', the central idea of which is 'material action'. They believe that the representation of reality via a medium—painting, sculpture, theatrical performance—is no longer meaningful, that the only relevant art is one which employs reality itself as a means of formal creation. Thus their art consists not of performances but of direct literal events.

Because this form of art accentuates the horrific and macabre aspects of daily life in the twentieth century, in order to act as a social irritant, it has been called 'Irritart' by the Italian critic Lea Vergine.

Hermann Nitsch's events take place under the rubric of 'Orgy Mystery Theatre' (or O-M Theatre) the concept for which he developed in 1957 though the first materialisation did not take place until 1962. Other artists who produced similar work during the 1960s include Rudolf Schwarzkogler, Otmar Bauer, and Arnulf Rainer (advocate of 'catatonic' art). Kurt Kren, the Austrian film maker, also collaborated with Brus and co and documented several Actions.

See also Actions, Body Art, Happenings, Performance Art.

O Muehl *Mama & papa—materialaktion 63-69* (Frankfurt, Kohlkunst-Verlag, 1969).

H Nitsch *Orgien, mysterien theater* (Darmstadt, Maerz Verlag, 1969).

G Brus (ed) *Die schastromel nr 3* (Cologne, Interfunctionen, 1970).

Wien: bildkompendium Wiener Aktionismus und film (Frankfurt, Kohlkunst-Verlag, 1970).

P Weiermair 'New tendencies in Austrian art' *Studio international* 183 (944) May 1972 207-209.

K Tsiakma 'Hermann Nitsch: a modern ritual' *Studio international* 192 (982) July/August 1976 13-15.

180 DIRECTED ARCHITECTURE (or Programmed Architecture): A concept developed by the Italians Leonardo and Laura Mosso: architecture or structural planning generated by the creativity of masses of individuals—like language—with the help of computer systems.

L & L Mosso 'Self generation of form and the new ecology' *AAQ* 3 (1) Winter 1971 8-24.

L & L Mosso 'Manifesto of Directed Architecture' *AAQ* 3 (1) Winter 1971 25-28.

181 DISNEYANA: Walt Disney (1901-1966) was, in the words of David Kunzle, 'the century's most important figure in bourgeois popular culture'. And although Disney is dead, his anthropomorphized animal characters—Mickey Mouse, Donald Duck, Pluto, Goofy, Scrooge McDuck, etc—live on in a variety of media: comics, films, newspaper strips, TV programmes, collectibles of all kinds, and are assiduously promoted on a global scale by Walt Disney Productions, Ltd, a multinational corporation. Disney's final creations the fantasy worlds, or amusement parks, located in Florida and California attract over ten million visitors per year and the Disney business empire is the largest and richest entertainment industry in the world with an estimated annual turnover of four hundred million dollars. Images of Disney characters are used to sell a host of products made by

non-Disney companies; the companies have to buy a license before they can use a Disney image (this mode of selling is called 'character merchandising').

Writings on Disney, of which there are a large number, can be sorted into three main types: (1) uncritical celebrations of the man and his artistic achievements; (2) those taking a camp delight in Disney products; and, (3) those which analyse and demystify the Disney myth. As third-world critics have shown the 'innocent' American folklore Disney produced in such vast quantities is a powerful ideological, cultural weapon serving capitalism and imperialism, all the more pernicious because its target audience is children.

R D Field *The art of Walt Disney* (Collins, 1944).

D D Miller *The story of Walt Disney* (NY, Holt, 1957).

R Schickel *Walt Disney* (Weidenfeld & Nicolson, 1968).

L Maltin *The Disney films* (NY, Crown, 1973).

C Munsey *Disneyana: Walt Disney collectibles* (NY, Hawthorn Books, 1974).

A Dorfman & A Mattelart *How to read Donald Duck: imperialist ideology in the Disney comic* (NY, International General, 1975).

C Finch *The art of Walt Disney: from Mickey Mouse to the magic kingdoms* (NY, Abrams, 1975).

182 DOCUMENTA: Title of a mammoth exhibition of contemporary art held every four to five years in the summer months at Kassel, Germany since 1955. Arnold Bode was the 'father' of the idea and the exhibition was instituted by the Gesellschaft fur Abendlandsische Kunst (Society for Western art). The Documenta exhibitions are currently organised on a thematic basis, for example, in 1972 the theme was 'questioning reality' and in 1977 'art and media'. Each exhibition is accompanied by a massive catalogue and is reviewed in detail by most major art magazines.

In a highly critical article René Denizot claimed that Documenta 5 was an exemplary exhibition because 'it displayed the supremacy of the gallery as an institution', that is, the exhibition organisers/the gallery determined the character and the meaning of art, and enclosed it: 'the gallery . . . became in D5 an iron collar from which art could never be set free'.

J Harten 'Documenta 5 at Kassel' *Studio international* 184 (946) July/August 1972 2-4.

R Denizot 'Exposition of an exhibition: a backward look at Documenta 5' *Studio international* 185 (953) March 1973 98-99.

106

183 DRIFTWOOD AESTEHTIC: A fad of the 1950s for collecting drift-wood from the beach and other found objects.

D Bourdon 'The driftwood aesthetic' *Art journal* 25 (1) Fall 1965 26-32.

184 DRIP PAINTING: A painting technique made famous by Jackson Pollock in the late 1940s and early 1950s. (In 1956 *Time* magazine dubbed Pollock 'Jack the dripper'.)

Pollock laid unstretched canvas on the floor of his studio and dripped and poured liquid housepaint (Duco) onto it; the paint was flung across the surface with the aid of a stick or allowed to dribble from holes punched in the bottom of paint cans. Several critics have pointed out that the formal significance of this technique is that it compresses the problems of drawing and painting into a single action. American artists have demon-strated a remarkable ability to find solutions that 'telescope' traditional problems of painting.

See also Action Painting, Process Art, Stain Painting, Tachisme.

185 DUSSELDORF SCHOOL: In the years since 1960 Dusseldorf has emerged as an important international art centre, where German and other European artists continue the tradition of experimentation established by Group Zero; the best known of these artists are perhaps Dieter Rot and Joseph Beuys. A large scale exhibition of work by the Dusseldorf School, organized by the Richard Demarco Gallery, called 'Strategy: get arts' was held at the Edinburgh School of Art in 1970.

See also Group Zero.

186 DVIZHENIE: The name of a group of Russian artists led by Lev Nusberg, founded in 1962, devoted to Kinetic Art. In Russian the word 'Dvizhenie' (which is variously spelt in the West: Dvijzenie, Dvijenie, Dwidjenje, Dvigenje) means 'movement'. This is one of the few manifes-tations of Russian art which receives extensive coverage in the Western art press.

See also Kinetic Art

D Konecny 'Moscow Kineticists' *Studio international* 172 (880) August 1966 90-92.

L Nusberg 'What is Kinetism?' *Form* (UK) (4) April 15 1967 19-22.

'A kinetic performance in Leningrad' *Studio international* 174 (895) December 1967 p287.

Dvijenie catalogue (Nurenberg Biennale, 1969).

P Restany 'L'humanisme technologique en URSS: Lev Nusberg et le Groupe Dvizenie' *Domus* (524) July 1973 52-54.

187 DYMAXION: This word, a combination of 'dynamism', 'maximum' and 'ion', was coined in 1929 by two public relations men, employees of Marshal Fields, a Chicago department store, to describe a futuristic house designed by R Buckminster Fuller displayed in the store as a setting for new furniture. They invented the term after a close study of Fuller's writings and vocabulary. Since 1929 Fuller has often used the word: 'Dymaxion Car', 'Dymaxion Bathroom', 'Dymaxion chronofile'. He means by it maximum efficiency and performance in terms of the available technology.

R W Marks *The Dymaxion world of Buckminster Fuller* (Carbondale & Edwardsville, Southern Illinois University Press, 1960).

E

188 EARTH ART & LAND ART (also called Dirt Art, Earthworks, Terrestrial Art, Topological Art, Field Art, Site Art): An international movement which emerged in the middle 1960s developing out of Minimal Art and closely related to Art Povera and Conceptual Art. Artists who have produced works categorized as Earth or Land Art include Carl Andre, Walter De Maria, Sol LeWitt, Robert Morris, Neil Jenny, Dennis Oppenheim, Jan Dibbets, Robert Smithson, Richard Long, Hamish Fulton, and Michael Heizer. Earth artists rejected the traditional materials and methods of sculpture in favour of 'actual' materials such as rocks, soil, turf and snow. They began by dumping quantities of earth onto the floors of art galleries allowing it to form its own shape; then they dug into the earth's surface creating holes and trenches (Andre called the resulting cavities 'negative sculptures'). Later, earth-moving equipment and dynamite were used to construct grandiose monuments reminiscent of pre-historic earthworks. It seems more than a coincidence that such works were built during a period when a passion for pre-historic mounds and ley lines developed among members of the Underground subculture.

The introduction of the term 'Land Art' indicated a shift away from the sculptural emphasis on materials toward a more pictorial attitude:

lines and patterns were 'drawn' on the ground by walking through grass, or by scraping away snow. Some works were so extensive that they were only fully visible from the air (Land Art was criticised for being exclusive to owners of aircraft). A striking historical precedent for Land Art are the ancient ground drawings found in the Nazca desert region of Peru; these vast, anonymous, mysterious works completely outclass contemporary examples. Maria Reiche, a German geographer, has devoted her life to studying the Nazca lines. Her books have been sold in art galleries and exhibitions of her photographs have been mounted in museums. The richer American Land artists have made journeys of homage to see the ground drawings in Peru.

The term 'Field Art' refers to works situated in farming areas where the artist has directed the harvesting of crops or controlled the layout of crop seeding. In other works man-made constructions were juxtaposed against landscape backgrounds to produce various kinds of optical illusions when recorded photographically. Walking and cycling tours were recorded in sets of photographs or via routes drawn on maps. As in Conceptual Art, documentation became crucial because it provided a product which the galleries could market and because many of the works recorded were in remote sites far from the urban public.

Earth Art was called 'the new picturesque' because of its affinity with the eighteenth century vogue for landscape gardening. Jean Clay disapproved of the Land artist's traditionalism, his back-to-nature ideology, and claimed that real aesthetics had been replaced by aestheticized reality. The advantages of Earth and Land Art were thought to be released from the precious-object/art-gallery system, a greater freedom for the artist (if he enjoyed the outdoor life), a return to the pre-historic function of art as a private act of faith.

See also Art Povera, Conceptual Art, Performance Art, Landscape Sculpture, SITE

M Reiche *Mystery of the desert* (Stuttgart, Vaihinger, 1968).

R Smithson 'A sedimentation of the mind: Earth projects' *Artforum* 7 (1) September 1968 44-50.

P Hutchinson 'Earth in upheaval: Earthworks and landscapes' *Arts magazine* 43 (2) November 1968 19-21.

S Tillim 'Earthworks and the new picturesque' *Artforum* 7 (4) December 1968 42-45.

Earth Art (Ithaca, Andrew Dickson White Museum, 1969).

(Land Art: several photo essays) *Avalanche* (1) Fall 1970.

'Land Art/Earthworks' *Interfunctionen* (7) September 1971 46-59.

D Hickey 'Earthscapes, landworks and Oz' *Art in America* 59 (5) September/October 1971 40-49.

C Tomkins 'Onward and upward with the arts: maybe a quantum leap' *New Yorker* February 5 1972 42-64.

Peruvian ground drawings (Munich, Kunstraum, 1974).

B Chatwin & L McIntyre 'Riddle of the Pampa' *Sunday times magazine* October 26 1975 52-67.

R Morris 'Aligned with Nazca' *Artforum* 14 (2) October 1975 26-39.

E C Baker 'Artworks on the land' *Art in America* 64 (1) January/February 1976 92-96.

189 EARTHWORK ARCHITECTURE: The German architect Engelbert Kremser proposes to construct buildings by applying concrete to mounds of soil acting as formworks; once the concrete has set the earth can be removed; cave-like structures will result. Kremser claims that his proposal would "reinstate the almost forgotten relationship between architecture and sculpture".

'Earthwork Architecture' *Architectural review* 145 (866) April 1969 241-243.

190 EAT (Experiments in Art and Technology): In the autumn of 1966 a festival of art and technology entitled 'Nine evenings: theatre and engineering' was held in New York. As a result of this exhibition the organisation EAT was founded in January 1967. Its director was Billy Kluver of Bell Telephone Laboratories, and members included Robert Rauschenberg, Gyorgy Kepes, John Cage, and R Buckminster Fuller. The aim of EAT was to foster co-operation between artists and technologists by matching their interests and specialities. An exhibition of works by members of EAT called 'Some more beginnings' was held at the Brooklyn Museum in 1969; it included computer generated films, Kinetic Art, Liquid Sculpture, and psychedelic environments.

See also Technological Art.

EAT news 1 (1) 1967- .

J Reichart 'EAT and after' *Studio international* 175 (900) May 1968 236-237.

B Kluver 'EAT' *Metro* (14) June 1968 55-58.

'Experiments in Art and Technology (EAT), New York' *Leonardo* 1 (4) October 1968 487-488.

A Herve 'Eating into art' *Réalités* (225) August 1969 52-55.

G Youngbloood 'The open empire' *Studio international* 179 (921) April 1970 177-178.

EAT *Pavilions* (NY, Dutton, 1973).

191 ECCENTRIC ABSTRACTION: Title of an exhibition of American sculpture organized by Lucy R Lippard, held at the Fischbach Gallery, New York in the Autumn of 1966; the show included work by artists such as Eva Hesse, Bruce Nauman, Keith Sonnier, Don Potts and Gary Kuehn. The adjective 'eccentric' was applied to this sculpture because its forms, unlike the geometric tradition, were perverse, bizarre.

The Eccentric Abstractionists evolved a style which combined characteristics of Minimalism and, paradoxically, Surrealism. They favoured ugly or vulgar synthetic materials with qualities of flexibility and limpness (see Soft Sculpture). Lippard also included in her category 'Eccentric Abstraction' the work of West Coast Funk artists.

See also Minimal Art, Funk Art, Post-Minimalism.

D Antin, 'Another category: Eccentric Abstraction' *Artforum* 5 (3) November 1966 56-57.

L Lippard 'Eccentric Abstraction'—chapter in—*Changing: essays in art criticism* (NY, Dutton, 1971) 98-111.

192 ECO-MUSEUMS: The Eco-Museum (the word 'eco' is an abbreviation of 'ecological') is a French concept developed in the late 1960s. The idea is that a whole area of the countryside is designated a museum and everything within those boundaries becomes an exhibit. There is an example at Le Creusot, Burgundy which was once a district of heavy industry and coal mining but is now predominantly rural.

193 ECOLOGICAL ARCHITECTURE: In response to the problem of prohibitively expensive fuels and dwindling world energy resources various research projects have been undertaken since 1970, in Europe and America, to construct self-sufficient, self-servicing houses. The aim has been to produce a house which is largely (but not totally) independent of public mains supplies by exploiting ambient energy sources—wind power, solar radiation—and by recycling techniques—using rainwater, human waste to produce gas for cooking or as a fertilizer.

The best known projects are Graham Caine's 'Ecological House' which he built in South London, the 'Autonomous House' built by Jaap t'Hooft at De Kleine Aarde in Holland, and the 'Autarchic House' (the word 'autarchy' means 'absolute sovereignty', 'self-government') research

programme being undertaken at Cambridge by Alexander Pike. The latter project concentrates on theoretical problems in order to establish principles for realistic production techniques.

See also Arcology.

G Leach 'Living off the sun in South London' *The observer* August 27 1972 1-2.

G Caine 'A revolutionary structure' *Oz* (45) November 1972 12-13.

A Pike 'Autonomous house' *Architectural design* 44 (11) 1974 681-689.

T Osman 'Dome sweet dome' *Sunday times magazine* November 30 1975 68-75.

A Tucker 'Brave new autarchic home' *The guardian* December 30 1975 p6.

194 ECOLOGICAL ART (also called Environment Art, Eco Art, Force Art, Systems Art, Thermostat Art, Bio-Kinetic Art): The environment and ecology were two subjects that received a massive amount of attention during the 1960s, and, given the eclecticism of modern art, it was inevitable that towards the end of the decade a number of artists should have produced works involving ecology, for instance, Luis F Benedit, Robert Irwin, Hans Haacke, David Medalla, Charles Ross, Newton Harrison, John Van Saun, Takis, Dennis Oppenheim and Peter Hutchinson. The critic Herb Aach claims to have been the first person to use the term 'Ecological Art' in 1968.

Eco Art made use of natural physical forces and chemical or biological cyclical processes. It involved such disparate elements as fire, the wind, water, humidity, crystals, worms, locusts, bees, snails, fungus, and such activities as planting crops and farming fish. Eco Art 'worked' in a literal sense because the artists created open systems than engaged in a dialogue with nature. The formal restraints of Eco Art were (1) a minimum of human interference, and (2) economy of materials. The intention of Eco artists was to enhance the spectators awareness of natural processes by presenting microcosmic models of macrocosmic phenomena.

Some artists were intrigued by the possibility of creating works in unusual environments. For example, in 1969 Hutchinson and Oppenheim devised artworks in the sea off the coast of Tobago in the West Indies. These works were subsequently labelled 'Underwater Sculpture', 'Scuba Sculpture' and 'Oceanographic Art'.

Precedents for Eco Art were found in certain works by Marcel Duchamp and Yves Klein, namely, those using the action of the weather as a means of creation.

112

Alchemy and the occult were two further topics which became fashionable in the 1960s: art historians discovered the extent of Duchamp's and Klein's interest in alchemy; the artists Haacke, Van Saun, Takis and Ross were dubbed 'the new alchemists' because they isolated and made 'visible the elements, systems and forces around which the phenomenal world coheres'.

Art critics were enthusiastic, but reviewers in science journals were more sceptical and dismissed Eco Art on the grounds that it was scientifically elementary and that it gloried in technomania instead of attacking it.

See also Environmental Art, Robot Art.

Ecologic art (NY, John Gibson Gallery, 1969).

A Robbin 'Peter Hutchinson's Ecological Art' *Art international* 14 (2) February 1970 52-55.

'Art and ecology' *Arts Canada* 27(4) issue no 146/147 August 1970 (special issue)

Earth, air, fire, water: elements of art 2 vols (Boston, Museum of Fine Arts, 1971).

D Young 'The New Alchemists' *Art & artists* 5 (11) February 1971 46-49.

C Nemser 'The alchemist and the phenomenologist' *Art in America* 59 (2) March/April 1971 100-103.

F Arnold 'Art: Alan Sonfist' *New scientist* August 5 1971 336-337.

J Benthall 'Sonfist's Art'—letter in—*New scientist* August 12 1971 p 389.

J Benthall 'Art and ecology'—chapter in—*Science and technology in art today* (Thames & Hudson, 1972) 126-141.

G Kepes (ed) *Arts of the environment* (Aidan Ellis, 1972).

Écologie écologisme (Lausanne, Institut d'Etude et de Recherche en Information Visuelle, 1975).

E F Fry *Projects in nature* (Far Hill, New Jersey, Merriewold West Inc, 1975).

195 EKISTICS: A neologism coined from several Greek words meaning 'home', 'settlement' and 'settling down'. It was devised by the Greek architect and planner Constantinos A Doxiadis towards the end of the second world war, to designate a new field of knowledge: the science of human settlements. Ekistics collates information relevant to human settlements from many separate disciplines—economics, social sciences, political science, history, anthropology, technology, city and regional planning;

it also attempts to provide systematic scientific and mathematical techniques for using this knowledge. Doxiadis is president of the Athens Centre for Ekistics, founded in 1963, which issues a journal *Ekistics*. In 1965 a World Society for Ekistics was established in London .

C A Doxiadis *Ekistics: an introduction to the science of human settlements* (Hutchinson, 1968).

196 ELECTROGRAPHIC ARCHITECTURE: A phrase coined by the American writer Tom Wolfe to describe large scale, electric light, advertising signs found in the United States, especially in towns like Las Vegas and Los Angeles. Electrographics are not merely lettering, but "whole structures designed primarily as pictures or representational sculpture". They are intended to be 'read' from moving automobiles. Wolfe claims that the commercial artists who design Electrographics are "at least ten years ahead of serious artists in almost every field", and that their work is 'wild', 'baroque' and expresses "the new age of motion and mass wealth".

T Wolfe 'Electrographic Architecture' *Architectural design* 39 (7) July 1969 379-382.

197 ELECTRONIC ART: A variety of Kinetic Art exploiting the abstract patterns appearing on the screens of cathode ray tubes or oscilloscopes. The American artist Ben F Laposky has worked with such devices since 1950 and he calls the results 'oscillons' or 'electronic abstractions'. A better-known Electronic artist is the Korean Nam June Paik who specialises in the use of multiple television sets combined with human performers.

Any artwork making use of electricity, such as neon sculpture, tends to be designated 'Electric Art' and/or 'Electronic Art'.

B F Laposky 'Oscillons: electronic abstractions *Leonardo* 2 (4) October 1969 345-354.

Electronic Art: elektronische und elektrische objekte und environments, neon objekte (Dusseldorf, Verlag Kalender, 1969).

Electric art (Los Angeles, California University, 1969).

198 EMBALLAGES: This word derives from the French 'emballage' meaning 'to wrap' or 'pack' and is used by the Polish painter, sculptor, creator of Happenings, theatre director, Tadeusz Kantor (1915-) to describe those of his works in which 'the act of tying, tangling, or wrapping, concealing or disclosing, plays a central part. He uses clothes,

114

costumes, bandages, paper, cloth and found objects . . . Although the idea was formalised in a manifesto published in 1963, it was present in his work from 1956 . . . ' Kantor produces Assemblages which are similar in style, if not in quality, to those of Robert Rauschenberg, however, his supporters claim that the Emballage concept is not merely a formal category but 'the essence of the creative process'.

See also Assemblage Art, Packaging.

Tadeusz Kantor: Emballages (Warsaw, Galeria Foksal PSP Books, 1976).

Tadeusz Kantor: Emballages 1960-70 (Whitechapel Gallery, 1976).

199 EMBLEMATIC ART (or Emblemism, Sign Painting, Signal Art): A number of American painters, notably Frank Stella, Kenneth Noland, Jasper Johns and Robert Indiana have employed common emblems as motifs for paintings, that is flags, chevrons, stripes, targets, signs, numbers and maps. The appeal of these devices is that they provide a flat image for a flat surface; their imagery is 'given', and thus it releases the artist from the problem of subject matter, so that he is then free to tackle the 'real' subject matter of painting—the process of applying pigment to canvas. Emblems operate as a unifying factor over a series of paintings in which variations of colour, tone, scale, or brushwork have been played; lastly, they raise questions in the spectator's mind about the identity of the object he confronts.

200 ENDLESS ARCHITECTURE: A new approach to architecture identified by Richard Llewelyn-Davies in 1951, a method of design making use of identical units repeated in a building to suggest infinite extension. Llewelyn-Davies derived his ideas from paintings by Piet Mondrian and buildings by Mies van der Rohe (the notion also seems identical to Brancusi's 'Endless Column' sculptures; see also Colour-Field Painting and Serial Art). The English architect John Weeks, who had collaborated with Llewelyn-Davies, later extended the concept of Endless Architecture to allow for growth and change (see Indeterminate Architecture).

R Llewelyn-Davies 'Endless Architecture' *Architectural Association journal* 67 (755) September/October 1951 106-113.

201 ENTROPY: A controversial and puzzling scientific concept dating from the nineteenth century used by physicists, engineers, and information theorists. Entropy is generally defined as a quantitative measure of the degree of disorder in a system. Given that in natural processes an

increase in entropy occurs it has seemed to some observers that the universe is progressively tending towards a state of disorder known as maximum entropy. For example, Hollis Frampton remarks "assuming a beginning and an end to the universe, all evidence indicates that the whole contraption is winding down like the spring in a cheap movie camera". In 1971 the psychologist and aesthetician Rudolf Arnheim examined the discrepancy between nature's alleged drive towards chaos and the artist's drive towards order. His book provoked a series of articles in *Leonardo* in 1973 by both artists and scientists in which Arnheim was accused of misunderstanding and misapplying the concept of entropy.

The term was also used by the American sculptor Robert Smithson in his writings. In 1966 Smithson claimed that the work of American Minimal sculptors and painters 'provided a visual analog for the second law of thermodynamics' by destroying classical notions of time and space and by celebrating 'the banal, the empty, the cool'.

R Smithson 'Entropy and the new monuments' *Artforum* 4 (10) June 1966 26-31.

R Arnheim *Entropy and art: an essay on disorder and order* (Berkeley & Los Angeles, U of California Press, 1971).

R Smithson 'Entropy made visible' *On site* (4) 1975? 26-31.

202 ENVIRONMENTAL ART (also called Arte Ambiental, ArtSpaces, Total Art): The term 'environmental' has been applied to such a variety of structures created by artists belonging to such diverse movements as Assemblage, Kinetic, Pop, Minimal, Folk, etc, that its value as a characterization is somewhat limited. What these structures have in common is that they totally enclose the spectator and are large enough to allow him to move about within the work (of course architecture, interior design, museum and exhibition display, and certain booths at funfairs have always provided environments to delight and divert the senses, but these have usually served other functions besides the purely aesthetic). This form of art was prefigured by Kurt Schwitter's 'Merzbauten' and the elaborate decor of the Surrealist exhibitions in the 1930s, but recent Environmental Art developed out of post-war painting, via collage, Assemblage, and tableau, rather than out of pre-war Dada and Surrealism. For example, Colour-Field painting can be cited as an influence: the huge scale of American painting of this type dominated the spectator's vision, the use of fields of colour suggested an extension of pictorial space beyond the framing edge, and thus the space of these works was called 'environmental'.

The emergence of Environmental Art reflected a desire on the part of many artists to escape the limitations of the single art object, which has to compete for our attention with all the other objects in the world; to escape the role of such objects as commodities in the gallery system. Artists also wanted to extend their control beyond the confines of paintings and sculptures in order to provide a more comprehensive sensory experience: in Environmental Art the physical space of the artwork coalesces with that of the spectator. In Environmental Art 'Spatial articulation becomes the object of the artist who immerses himself in that space, treating it concretely like material to be moulded. He puts it together and organizes it, not only on a superficial and visual level, but in such a way that it affects the spectator's own senses and movement. The result . . . involves a real experience of the given field, with the plastic relationships providing the environment with an extra dimension. This environment may be 'moulded' in either an ordered or a disordered fashion, giving the effect of planned or casual assembly.' (Celant)

Amongst the earliest post-war environments were those constructed by the Americans Allan Kaprow, Jim Dine, and George Segal in the late 1950s. These works contained lots of rubbish, lights, and recorded noise reflecting the improvised quality of Abstract Expressionism. Often the routes through such environments were made deliberately tortuous for the visitor to negotiate. The American environments of that period merged imperceptibly with Happenings (they have been described as the passive and active sides of the same coin). Later, during the 1960s, environments tended to be more restrained and austere in accordance with the cooler approach of Minimal Art. However, once the genre was established artists of all persuasions produced examples: the English artist Victor Pasmore, working in the tradition of Constructivism, produced with others in 1957 and 1959 two environments entitled 'Exhibit I & II'; the assembler Ed Kienholz created 'Roxy's' a complete replica of a brothel (1961) and 'The Beanery' (1965): the kineticist Jesus Raphael Soto created environments called 'Penetrables' (1969); ten young British artists influenced primarily by Pop Art designed fanciful domestic interiors based on the theme 'a sitting room' at the ICA, London in 1970; while in the same year three Los Angeles artists—Larry Bell, Robert Irwin, and Doug Wheeler—created three environments designed to control the spectator's perceptual experience, at the Tate Gallery, London. Air artists, Psychedelic artists, groups such as USCO and Space Structure Workshop were also producing environments to serve their respective purposes. Environmental Art does not necessarily consist of bulky physical structures of wood or stone:

spatial experience can be modulated by means of light beams or sound waves (see Pulsa, Laser Art).

Environmental Art continued to excite interest in the mid 1970s: the Venice Biennale of 1976 was devoted to the topic of the environment and it featured a survey of 'Ambient Art' historical and contemporary, organised by the Italian critic Germano Celant; a group of artists led by the veteran Pop artist Red Grooms produced a highly popular 3D caricature of New York life in the same year (according to Grooms their sideshow was not an environment but a 'theme park').

In the 1960s the word 'environment' became extremely fashionable as a result of man's efforts to produce totally controlled surroundings, from town planning and the design of office interiors, to the ultimate artificial environment, the space capsule. As a consequence of R Buckminster Fuller's advocacy the whole earth came to be seen as a spaceship, and the ecological crisis caused by pollution created a new consciousness concerning the fragility of our habitat. In the art context this brought about a shift in the meaning of the word 'environment': it no longer referred exclusively to indoor structures but also to forms of art making direct use of natural systems responsive to their surroundings (see Ecological Art), or to the work of artists programming the man-made environment (see Media Art).

S Bann 'Environmental Art' *Studio international* 173 (886) February 1967 78-82.

C Oldenburg *Store days* (NY, Something Else Press, 1967).

N R Piene 'Environments and performances' *Art in America* 55 (3) May/June 1967 39-47.

J Lipman 'Period rooms—the sixties and seventies' *Art in America* 58 (6) November/December 1970 126-129.

H Rosenberg 'Light! Lights!'—in—*Artworks and packages* (NY, Dell, 1971) 132-143.

A Henri *Environments and Happenings* (Thames & Hudson, 1974).

G Celant 'Artspaces' *Studio international* 190 (977) September/October 1975 114-123.

203 ENVIRONMENTAL DESIGN: A relatively new discipline taught in some art and architectural schools, defined by Maurice Jay as 'the scientific design and control of the man-made environment'. Such design is concerned with the total environment consequently it encompasses such diverse topics as architecture, urban planning, interior design, engineering, lighting, acoustics, heating, and ergonomics.

In 1968 the first meeting of EDRA (Environmental Design Research Association) was held in North Carolina. This association undertakes research into those aspects of the social and behavioural sciences which are of direct relevance to Environmental Design. Three journals are connected with EDRA: *Environment and behaviour, Man environment systems, Design methods group newsletter;* the association also publishes the proceedings of its annual conferences.

See also Centre de Recherche d'Ambiances.

M Jay 'Environmental design: an introduction' *Design* (218) February 1967 44-49.

R P Dober *Environmental design* (NY, Van Nostrand Reinhold, 1969).

T Crosby *How to play the environment game* (Penguin/Arts Council of Great Britain, 1973).

204 ENVIRONMENTALISM: According to Lance Wright, an approach to building design in which the architect relinquishing the will to structure space, attempts to blend his architecture into its setting to such an extent that it becomes almost invisible. The exterior walls of an ideal environmentalist building—such as the IBM offices at Corsham, designed by Norman Foster Associates—consist of glass surfaces that mirror the surrounding landscape, the interior is open plan to give the impression of infinite space, its inhabitants are not conscious of enclosure or structure. This approach to building design has emerged as a result of the development of internal services, for example air conditioning, which have become more important than external structures.

Other writers use the term 'Environmentalism' in a broader sense to describe the use made by many modern architects of bollards and trees in an effort to humanize the brutal appearance of their buildings.

L Wright 'Offices: Corsham Hants' *Architectural review* 151 (899) January 1972 15-24.

205 EROTIC ART: Although Erotic Art is not specific to the post-1945 era, it was not until the 1960s that, as a result of social changes in the Western world, Erotic Art became a respectable topic in academic circles (courses on Erotic Art were introduced into British art colleges by the art historian Peter Webb from 1968 onwards), and a subject suitable for popular consumption via books and exhibitions (large scale international exhibitions of Erotic Art in Denmark and Sweden in 1968/69 organised by Drs Phyllis and Eberhard Kronhausen attracted over a quarter of a million visitors).

Mario Amaya has defined Erotic Art as 'art that arouses sexual sensations in body or mind'. He does not explain how these sensations are to be discharged. Most compilations of Erotic Art are simply collections of reproductions of drawings, paintings and sculptures depicting sexual behaviour, that is, eroticism is equated with sex but this overlooks the fact that a work of art may evoke an erotic sensation without depicting sexual activity and that, conversely, images of sexual intercourse may not stimulate any erotic response. Also, such collections fail to acknowledge that the concept 'art' implies skill and quality: a drawing by Rembrandt of the sexual act is art while a drawing of the same act by an inept amateur is not. In short, collections of Erotic Art are rag bags crammed with works from different countries, periods, styles, cultures, and media which have been lumped together on the dubious premise that they all have eroticism in common. However, while sexual activity is a universal attribute of the human race 'the erotic' is a cultural concept which varies from society to society and from period to period.

Included in collections of Erotic Art are scenes of homosexuality, bestiality, etc; indeed, the whole gamut of human sexual behaviour. This raises the question of the relationship between Erotic Art and pornography. Is pornography simply Erotic Art minus its aesthetic component? If pornography is more powerful in evoking a sexual response does this not suggest that the sublimating force of art actually militates against sexual arousal? Certainly the nudes of Titian and Matisse transcend eroticism at the genital level. Perhaps the difference lies in the way sexual response is discharged: the pornographic image is thought of as transparent, it is merely a means to an end. Whereas in Erotic Art sexuality is aroused and discharged within the work; sensuousness is linked to form and the use of the medium so that contemplating the artwork becomes itself a sexual act, or at least a sensuous experience, akin to the voyeur's pleasure in seeing.

Crusaders for sexual freedom advocate the complete abolition of censorship in the belief that the therapeutic value of Erotic Art will obviate the need for pornography. However, unless sexual liberation is matched by emancipation in the economic, social and political spheres sexual freedom will remain a fur lining on the chains that hold us captive.

Contemporary artists noted for their interest in sexual themes include Vito Acconci, Balthus, Hans Bellmer, Francis Bacon, Barry Burman, Robert Crumb, Allen Jones, David Hockney, Richard Lindner, and Andy Warhol (films).

See also Pin-Ups.

P & E Kronhausen *Erotic art, a survey of erotic fact and fancy in fine arts* vol 1 (NY, Grove Press, 1968), vol 2 (NY, Grove Press, 1970).

P Gerhard *Pornography or art?* (Words & Pictures, 1971).

V Kahmen *Eroticism in contemporary art* (Studio Vista, 1972).

E Lucie-Smith *Eroticism in Western art* (Thames & Hudson, 1972).

P Webb & others *The erotic arts* (Secker & Warburg, 1975); this book contains a detailed bibliography.

206 ERSATZ ARCHITECTURE: 'Ersatz' is a German word meaning 'substitute', 'replacement' or, pejoratively, 'a phoney'. The architectural critic Charles Jencks has employed the term to describe architecture with forms borrowed indiscriminately from various sources. He identifies many subdivisions within the category, for example, Synthetic, Trompe l'oeil Counterfeit, Eclectic, Delerious Trademark, Iconic Advertisement, etc. Ersatz Architecture is found on both sides of the Atlantic but is at its most virulent in the USA, particularly in Los Angeles. Jencks regards it as the authentic culture of the masses and claims that new principles of mediocrity need to be devised to evaluate it (see Camp). Ersatz Architecture is partly the result of modern technology which is capable of producing architecture in any known style. However, it need not be an exact copy: it can also be a pastiche which captures the essence of the original, for example, Grauman's Chinese Theatre, Hollywood (1927), or the structures inside Walt Disney World, Orlando, Florida. Alternatively it can be a gigantic version of an everyday object, for example, the Brown Derby restaurant, Los Angeles (1926) built in the shape of a hat.

Alistair Best prefers the term 'Kitsch Architecture' to describe those buildings which provide 'exotic substitutes', 'skin-deep' or 'instant' environments. He cites as examples the Disney Worlds and the Watney Mann Schooner Inns. These are, he claims, examples of 'escapist design'.

See also Kitsch, Pop Architecture.

A Best 'Flight of fancy' *Design* (293) May 1973 60-65.

C Jencks 'Ersatz in LA' *Architectural design* 43 (9) September 1973 596-601.

C Jencks 'Trompe l'oeil counterfeit' *Studio international* 190 (977) September/October 1975 108-114.

207 ETHNIC ART: This expression began to be used in the late 1960s in the United States to refer to art produced by distinct population groups, for example, the Puerto Ricans, and in particular to art produced by racial groups such as the negroes (see Black Art) and chicanos (in 1975 an

121

organisation called MARCH—Movimento ARtistico CHicano—based in Chicago was founded to promote Chicano Art). Copywriters in fashion magazines such as *Nova* have also described African beads and Ethiopian necklaces as 'Ethnic Jewellery'. The emergence of the term 'Ethnic Art' indicated the new self-consciousness and importance given to minorities in society following the cultural revolution of the 1960s.

A survey of the cultural activities of ethnic minorities in Britain ('minority arts')—West Indians, Asians, Poles, Ukranians, Cypriots, Chinese— conducted by Naseem Khan, revealed that little financial support or encouragement was forthcoming from official bodies and the broadcasting media. Khan believes that Ethnic Arts bring a new stimulus to British culture and that institutional support would make for an easier transition to a new society. The fact that the 1976 Notting Hill West Indian street carnival ended in a riot involving a confrontation between young blacks and white police measures the distance between what is and what ought to be.

N Khan *The arts Britain ignores* (Community Relations Commission, 1976).

208 ETHOLOGY & ART: Ethology is a science concerned with the function and evolution of animal behaviour patterns. Ethological theory, when applied to art, suggests that people have built-in species reactions to certain combinations of form, colour, etc in the same way that animals instinctively respond to danger signals peculiar to their species. If these triggers could be identified artists could manipulate them in a conscious manner to produce pre-determined effects. R G Coss cites Klee and Miro as examples of artists who use 'emotional releasers'. The argument that all people react in much the same way to the image of an eye, or a many legged insect, is opposed by phenomenologists and existentialists who stress the individuality of each person's circumstances and learned responses.

D Sandle 'The science of art' *Science journal* March 1967 2-7.

R G Coss 'The ethological command in art' *Leonardo* 1 (3) July 1968 273-287.

209 EVENTSTRUCTURE: A theoretical notion propounded by the British artist John Latham in the years since 1954. Latham's theory stresses structure in events (structure through time) rather than structure in art objects (structure in space), hence process is given priority over product. Latham's ideas were adopted by three artists—Theo Botschiver,

122

Jeffrey Shaw, and Sean Wellesley-Miller—in 1967 who formed, in Amsterdam, the 'Eventstructure Research Group' (ERG). The purpose of ERG was to create an alternative to 'museum art' by staging events at public festivals and in the street; to encourage physical participation and adult play by providing PVC inflatables. Their work has been described as 'operational art' and vaunted as "an art of real consequences".

See also Air Art, Participatory Art, Street Art.

J Latham 'Eventstructure' *Studio international* 174 (892) September 1967 p82.

'Concepts for an operational art . . .' *Arts & artists* 3 (10) January 1969 46-49.

T Smith 'Eventstructure Research Group in Australia' *Studio international* 184 (948) October 1972 149-150.

J Shaw 'Event-structure Research Group' *The mewspaper* (Royal College of Art) (22) April/May 1974 3-4.

210 EXHIBIT I & II: Two abstract environmental constructions devised by Victor Pasmore and Richard Hamilton. Exhibit I was shown at the ICA, London and at Newcastle upon Tyne in 1957, and Exhibit II at Newcastle in 1959. The construction consisted of variously coloured acrylic sheets, with differing degrees of transparency, placed at right angles to each other in metal frameworks or suspended from the ceiling. The result was a maze like spatial structure within which spectators could move, though this was not encouraged in the case of Exhibit II, where variations of transparency alone created an impression of penetration.

211 EXISTENTIALISM & ART: There is a twofold relation between existentialism and art: (1) the interest existentialist philosophers have shown in aesthetic theory; and (2) the influence of the philosophy of existentialism—often misrepresented and popularised—on artistic practice. To existentialist philosophers—given their view of human life as a continual process of choice, and their stress on subjectivity and individualism—the artist at work often serves, in their writings, as the paradigm of authentic human existence. Although Sartre's theory of committed or 'engaged' art refers to literature the idea that artists must accept responsibility for the effect of what they produce, despite the unpredictable nature of an absurd world, can obviously be extended to all creative media. It is not possible to identify a specific existentialist aesthetic because different existentialist writers draw variously on Marxist, Freudian, Jungian, and sundry other explanations of the phenomenon of art.

Existentialism was a fashionable philosophy in the immediate post-war years and it was during that period that its influence on art—Action Painting, Tachisme, Geometry of Fear, Francis Bacon, Giacometti—was at its height. While this influence was more an emotional identification with existentialism rather than a technical understanding of its theory it is clear that the emphasis in Action Painting on unpremeditation, the creative act, the process, and high moral commitment of the artist, was akin to the existentialist's view of man as isolated, alienated, facing tragic/absurd choices which are resolved through action. Sartre's view that 'there are no aesthetic values a priori but there are values which will appear in due course in the coherence of the picture' seems particularly close to the aesthetic of Action Painting.

Often the term 'existentialist' is used loosely to refer to the experience of anxiety, alienation, anomie, meaninglessness common to life in modern cities. By extension, there is a tendency for any art which portrays disturbed or tortured people to be described as 'existentialist'. For example, in his book *The new humanism* Barry Schwartz includes in his category 'existential humanism' works which depict 'the betrayal of human potential and the anguish of diminished man' (eg Francis Bacon's paintings).

See also Action Painting, Geometry of Fear, Humanist Art.

V M Ames 'Existentialism and the arts' *Journal of aesthetics and art criticism* 9 (3) March 1951 252-256.

D Ashton *The unknown shore: a view of contemporary art* (Studio Vista, 1962).

A B Fallico *Art and existentialism* (Englewood Cliffs, New Jersey, Prentice Hall, 1962).

E Kaelin *An existentialist aesthetic: the theories of Sartre and Merleau-Ponty* (Madison, Milwaukee, U of Wisconsin Press, 1962).

G H Bauer *Sartre and the artist* (Chicago, U of Chicago Press, 1969).

M Rowell *La peinture, le geste, l'action: l'existentialisme en peinture* (Paris, Editions Klincksieck, 1972).

212 EXPANDED CINEMA: In his over-optimistic and extravagant text on Expanded Cinema Gene Youngblood documents the advances in the technology of audio-visual media in the United States in the 1960s: he describes synaesthetic cinema, cybernetic cinema and computer films, video, multiple-projection environments, intermedia theatre, and holographic cinema, yet he claims that these are not what is meant by the term 'expanded cinema': 'When we say expanded cinema we actually

mean expanded consciousness . . . the intermedia network of cinema and television . . . now functions as nothing less than the nervous system of mankind.'

A festival of Expanded Cinema, in which over thirty film-makers took part, was held in London at the ICA in January 1976 and included multi-screen projections, films plus live performances, and film-sculpture. According to Deke Dusinberre the British version of Expanded Cinema does not depend upon expanded technology to produce expanded perception, rather it explores old technology: 'expanding the possibilities and exigencies of cinema technology as it has existed for eighty years', in particular, 'dwelling on the techniques of cinematic presentation' in order to recruit the 'spectator into active participation in the aesthetic discourse'.

S Renan 'Expanded Cinema'—chapter six in—*The underground film: an introduction to its development in America* (Studio Vista, 1968) 227-257.

G Youngblood *Expanded Cinema* (NY, Dutton, 1970).

D Dusinberre 'On expanding cinema' *Studio international* 190 (978) November/December 1975 220-224.

D Curtis 'The festival of Expanded Cinema' *Studio international* 191 (980) March/April 1976 209-212.

213 EXPENDABLE ART (also called Disposable Art, Throw-away Art, Perishable Art, Ephemeral Art, Transient Art): All art objects are subject to decay. Most traditional artists attempted to defer the inevitable dissolution of their work by the use of durable materials and careful craftsmanship. In contrast, many modern artists are indifferent to permanence and perpetuity, and while there is no school of 'Expendable Art', the notion of expendability permeates a great deal of art activity since 1945.

This development is clearly related to the deliberate manufacture of disposable products, and goods with planned obsolescence, typical of today's consumer society. Expendability was in fact one of the characteristics of the products of popular culture admired by Richard Hamilton and listed by him in an inventory of qualities of pop culture to be emulated by fine artists (see Independent Group); though Hamilton himself never adopted it.

Expendability manifests itself in recent art in varying degrees: (1) there are poorly constructed artifacts made of cheap materials which the artist knows will decay rapidly but is indifferent to the fact (most Assemblage Art falls into this category); (2) there are artworks using materials on a once-only basis (see Happenings, Art Povera) and Carl Andre's

125

sculptures (see Clastic Art) in which materials are re-cycled; (3) there are artforms which incorporate expendability as an essential part of their aesthetic (see Auto-Destructive Art, Destructive Art, Food Art, Process Art).

Authorities such as Douglas Cooper have criticised recent art on the grounds of poor workmanship but such criticism fails to take into account the changed attitude towards art which culminated in a total indifference to the physical art object (see Conceptual Art).

J Reichardt 'Expendable Art' *Architectural design* 30 (10) October 1960 421-422.

H Rosenberg 'The art object and the aesthetics of impermanence'—in —*The anxious object: art today and its audience* (Thames & Hudson, 1965) 88-96.

D Bourdon 'Disposable art—plastic man' *Life* August 22 1969 62-67.

J R Guilfoyle 'Now you see it ...' *Industrial design* 20 (5) June 1973 42-45.

214 EXPERIMENTAL AESTHETICS: A branch of psychology which began in the 1870s with Gustav Fechner's studies of aesthetic preference (*Vorschule der aesthetic*, Leipzig, 1876). Its purpose is to find experimentally validated 'truths' about the power and appeal of art and its elements (colour, form, etc), cross-culturally as well as in particular communities. (Its methods are open to the same criticisms of all attempts to make an experimental investigation into cultural values: at some level the investigators identify 'normal', 'neutral', 'unbiased', with their own viewpoints.) A group in Toronto under Professor Berlyne has worked for some years in this field. The first International Colloquium on Experimental Aesthetics was held in Paris in June 1965.

J Hogg (ed) *Psychology and the visual arts: selected readings* (Penguin Books, 1969).

R W Pickford *Psychology and visual aesthetics* (Hutchinson Educational, 1972).

D E Berlyne (ed) *Studies in the new experimental aesthetics: steps towards an objective psychology of aesthetic appreciation* (NY, John Wiley, 1974).

F Molnar 'Experimental aesthetics or the science of art' *Leonardo* 7 (1) Winter 1974 23-26.

215 EXPERIMENTAL ART: In the literature of twentieth century art the term 'experimental', meaning 'novel', 'daring', 'outlandish', 'provocative',

126

is virtually synonymous with 'avant garde'. Paradoxically it is a word with both positive and negative connotations; it is used to praise and to condemn. Those writers for whom it is a term of praise often mean by it an empirical practice in which the artist plays with his materials and adopts chance procedures in the expectation that something of value will result. This approach might be summarised as 'try it and see'. Those writers for whom 'experimental' is a pejorative description mean by it 'a trial run', 'not the finished work', 'something transitional'. Ernst Gombrich, a theorist unsympathetic to contemporary art, has subsumed all twentieth century art under the rubric 'Experimental Art', the implication being that it is tentative, transitional, provisional, in character. In totalitarian societies, such as Russia, experimentalism in art is considered to be a sign of frivolity and decadence and is frowned upon.

Constable believed that experiments in art were analogous to those in science. He stated categorically: 'Painting is a science, and should be pursued as an inquiry into the laws of nature. Why, then, may not landscape be considered as a branch of natural philosophy, of which the pictures are but experiments.' Similarly, Stephen Bann defines an experimental artist as one 'committed to a particular path of controlled activity, of which the works he produces remain as evidence'. Picasso often described his artistic practice as 'research' and maintained that his objective was to discover, to find things, ie things that were unexpected, unintended. This is a perfectly valid procedure; however, discoveries generally happen to those with prepared minds. Also, the world only gives credit to explorers who make striking discoveries; those who search in a random fashion and find nothing are forgotten.

In science, discoveries made by chance are not so highly thought of as discoveries confirmed in experiments which were predicted in theories. In science experiments are tests conducted in controlled conditions to validate hypotheses or theories (no element of play is involved and every effort is made to reduce the chance factor). It is hard to think of any examples of contemporary artists sufficiently rigorous in their procedures to qualify as experimentalists in a scientific sense, therefore the analogy between experiments in art and in science is an extremely loose one. M Chanan claims that art is like science in that it is a problem-solving activity but unlike science its results are unpredictable and unmeasurable. Another difference is that in science experiments are merely a means to an end whereas the 'experiments' of the artist are generally prized in themselves.

See also Avant Garde Art, EAT.

R Wedewer 'Experimental painting' *Cimaise* (53) May/June 1961 28-43.

F J Malina 'Some reflections on the differences between science and art'—in—*DATA: directions in art, theory and aesthetics;* edited by A Hill (Faber & Faber, 1968) 134-145.

S Bann *Experimental painting* . . . (Studio Vista, 1970).

M Chanan 'Art as experiment' *British journal of aesthetics* 12 (2) Spring 1972 133-147.

E Gombrich 'Experimental art'—chapter 27—*Story of art* (Phaidon, 12th ed 1972) 442-475.

216 EXPERIMENTAL GROUP: Founded in Holland in 1948 by Karel Appel, Corneille and Constant; they produced figurative paintings influenced by primitive art executed in a loose improvised style. They also issued a review *Reflex* (two issues 1948, 1949). The Experimental Group did not exist for very long, but its ideas were continued in a broader, international organisation (see COBRA).

217 EXPO ART: The architecture of national pavilions, the graphic and product design displayed at international fairs and expositions and also works of art exhibited at such fairs.

F

218 FACOP (Friends of the Arts Council Operative): A shortlived pressure group which attempted to influence the policies of the Arts Council of Great Britain in 1969 because it felt that the Arts Council was not meeting the real needs of British artists.

In June 1969 five hundred artists and friends met at St Katherine's Dock, London to discuss common problems and to consider the need for an Artists' Council.

FACOP 'The need for an artists' council' *Circuit* (9) 1969 1-28.

D Bieda 'The need for an artists' council' *Art & artists* 4 (5) August 1969 p64.

219 FACTOGRAPHY: Revival of a term used in the 1920s to describe 'dialectical documentary' work by such artists as Mayakofsky, Tretyakov,

Shklovsky, Rodchenko (all from the *Novy Lef* group), Klutsis, Hearts-field, Vertov, Shub, etc. Factography as a technique was discussed by Chuzak (of *Novy Lef*) and by Walter Benjamin in his essay 'The author as producer' (though he did not use the term). 'The factograph documents, but does not leave that document as simple experience . . . The document must be set in context by a dialectical, revealing addition, and this may be, depending on the situation, a comment, a pictorial addition, a juxta-posed shot, etc' (R Hunt). Artists whom Hunt regards as contemporary factographers are Conrad Atkinson and Hans Haacke. These two artists operate in a manner similar to journalists: they undertake research and present in an art gallery context 'facts', in the form of photographs and printed information, concerning politically loaded situations or issues (Atkinson documents strikes, work, wages, prices, the troubles in North-ern Ireland; Haacke documents property ownership in New York, and the sale of artworks over several generations).

See also Photomontage.

R Hunt 'For factography!' *Studio international* 191 (980) March/April 1976 96-99.

220 FAIRGROUND ART: A form of popular art which has been exten-sively documented in recent years. The mechanisation of fairground 'rides' is about one hundred years old, and their decoration as we know it dates from the same period. Originally the power source was in the centre of each ride and this was heavily decorated, as were the proscenium arches, with cut-glass mirrors, gilding, figurines, battle scenes, peacocks, jungle scenes, etc, in a manner similar to that found in music halls and public houses at the turn of the century.

In the 1920s electrification reduced the importance of the centre but the arches were still colourfully adorned. Dodgems and the waltzer were added in the 1920s and the imagery changed to speed, winged figures; even Art Deco and abstract motifs became popular. Subsequently the original fairground baroque lost ground as Disney characters, film stars, war heroes and politicians crowded among the jungle scenes and heraldic figures. Today there are few skilled decorators left and the itinerant fairs are experiencing economic difficulties.

F Fried *A pictorial history of the carousel* (NY, A S Barnes, 1964).

D Braithwaite *Fairground architecture* (Hugh Evelyn, 1968).

G Weedon & J Gorman 'English fairground decoration' *The Penrose graphic arts international annual* 66 (Lund Humphries, 1973) 33-48.

D Scott-Stewart & M Williams *Fairground snaps* (Idea Books, 1974).

221 FANTASTIC REALISM (or Phantastischen Realismus): A number of Austrian painters—Ernst Fuchs, Erich Brauer, Rudolf Hausner, Wolfgang Hutter, and Anton Lehmdem—are known collectively as the 'Vienna School of Fantastic Realists'. They are mostly ex-students of A P Gutersloh, a teacher at the Vienna Academy, whose classes they attended in the late 1940s; they also studied paintings by the Mannerists and old masters such as Breughel and Van Eyck in the collection of the Museum of the History of Art, Vienna. The Fantastic Realists share a taste for literature and combine visionary content with academic techniques; in some respects their work continues the pre-war tradition of Surrealism. The Fantastic Realists have achieved popular and official recognition but Peter Weiermair has criticised their work on the grounds of 'bland virtuosity' and 'erotic voyeurism'.

W Schmeid *Malerei des phantastischen realismus—die Wiener Schule* (Vienna, Forum Verlag, 1964).

W Schmeid 'The imaginary and the fantastic'—in—*Figurative art since 1945* by J P Hodin & others (Thames & Hudson, 1971) 123-147.

Phantastischer Realismus: malerei und graphik aus dem Besitz der Stadt Wien (Innsbruck, Tiroler Landesmuseum Ferdinandeum, 1972).

W Schmeid *Zweihundert jahre phantastische malerei* (Berlin, Rembrandt Verlag, 1973).

222 FANTASY FURNITURE: Title of an exhibition held at the Museum of Contemporary Crafts, New York in 1966. Most modern furniture is designed within a narrow utilitarian concept of function, but the history of furniture design reveals examples of highly ornamented, elaborately carved and coloured pieces, often part sculpture, which fulfil man's emotional and psychological needs in addition to his practical requirements.

T Simpson *Fantasy furniture: design and decoration* (NY, Reinhold, 1968).

223 FAP (Front des Artistes Plasticiens): A self-help organisation established in 1971 by a number of French artists for the purpose of finding ways to make direct contact with the general public thereby avoiding the use of private and state galleries which they believe exercise a form of censorship and exploit both artists and the public.

M Troche 'Le FAP' *Opus international* (36) June 1972.

'FAP manifesto' *Studio international* 185 (953) March 1973 100-101.

224 FEMINIST ART: The immediate aim of most early suffragists—the political emancipation of women—has been extended by the recent

development of the women's movement to encompass all aspects of cultural and social life. This has prompted feminist art critics and historians to examine the patriarchal basis of culture; to point to the discriminating effects of cultural institutions in denying most women the opportunity of becoming serious artists; and to note that the post-medieval bourgeois tradition placed an increasing emphasis on the new distinction between 'fine art' and the crafts, producing a hierarchy in art which helped to isolate and devalue women's work in the domestic sphere. For several hundred years it was difficult for most European women (a) to conceive of becoming 'artists', (b) having in a few cases conceived of it, to acquire the necessary training; and (c) having trained, to exhibit and sell their work on equal terms with men.

Because of these factors it has often been suggested that one must look to less conventional areas than that of European easel painting for evidence of women's finest, freest and most unselfconscious contribution to visual culture: to North American patchwork quilts, Navajo blankets, and photography, for example. This general question of women's contribution to historical culture has been important to Feminist artists because of the need to situate their art in a tradition. And also because it provides ammunition in the attack on the sexual bias in cultural institutions and helps women to work collaboratively to establish a sympathetic environment and a critical forum. Furthermore, historical precedents legitimise the revival of specifically 'feminine' craft techniques and encourages Feminist artists to base work on such experiences as female sexuality and domesticity.

The increasing number of respected women artists in the early decades of the twentieth century—Delaunay, Munter, Tauber-Arp, O'Keeffe, Hepworth—in part the result of increasing political and social emancipation—was followed by a younger generation who made their reputations in the 1950s: Chryssa, Marisol, Frankenthaler, Hartigan and Riley. But none of these was consciously feminist in their work and many were opposed to any such interpretation, feeling that they had earned the right to be considered sexually neutral in a context where feminine attributes were not thought compatible with the production of good art.

In the last ten years, however, women have appeared in quite other terms: 'no longer fringe contributors to a succession of movements that they have not shaped, they have become a constituency, growing in numbers and consciousness' (Alloway) The women artists' movement emerged from the conjunction of two radical groupings: women's liberation, and the artists' protest movement in New York, which wished to expose the

131

injustices of the existing art structures as well as adding its own voice
to demonstrations against the Vietnam war. Women participating in
radical art groups usually found that men still expected them to play a
supporting role. In 1969, women from the Art Workers' Coalition in
New York formed WAR (Women Artists in Revolution); this was followed
by a second break-away group in 1970—the Ad Hoc Committee (of women
artists), which organised to fight institutional discrimination, beginning
with the annual exhibitions of the Whitney Museum of American Art.
After improving the representation of women in mixed shows Feminist
artists were encouraged to organise independent shows. The same con-
sciousness prompted the establishment of women's cooperatives and
galleries such as AIR (Artists in Residence, housing the Women's Art
Registry, founded 1972) and SoHo 20, opened in October 1973. A group
called Redstocking Artists produced the first issue of *Women and art*
(December 1971-) but political disagreements led to a splinter group
publishing the *Feminist Art journal* (April 1972-).

During the same period a Feminist Art movement developed on the
West Coast as a result of the efforts of Judy Chicago, Miriam Schapiro
and Paula Harper. Two key projects were 'Womanhouse' (a restored Los
Angeles mansion opened January 1972) and 'Womanspace' (a gallery
opened January 1973).

In Britain one of the first manifestations of Feminist Art to attract
the attention of the general public (and the police) was the 'Exhibition
of womanpower' held in April 1973 at the Swiss Cottage Library, London,
featuring the paintings of Monica Sjöö, Ann Berg, Beverly Skinner, Roslyn
Smythe, and Liz Moore. Since then various groups have been formed
for the purpose of mutual support and in order to develop collective
workshop, exhibition and publication facilities.

Feminist Art, then, is not simply any art produced by women but one
which addresses feminist and sexist issues, work in which the artist in
some way confronts and explores her sexual identity and experience. It
is not only as various as these issues but expresses a range of different
responses and interpretations. Nor is it uniform in media or style: it
ranges from photo-realist still lives (Audrey Flack), to work which is
conceptual (notably Lucy Lippard's c7,500 show of 26 women artists);
environmental (Womanhouse, Radnor Terrace, Kate Walker); abstract
(Chicago, Schapiro); graphic (Angela Stewart Parkes, Judith Bernstein);
or which involves mixed-media and performances (Eleanor Antin, Hannah
Wilke); as well as the traditional easel painting and sculptural techniques.
132

In terms of subject matter, eroticism and sexuality are favourite topics, because the women's movement has encouraged women to explore and enjoy their sexuality and to analyse the ways in which it is used socially and exploited commercially. Since such analysis involves the reassessment of male, as well as female, stereotypes, some Feminist artists depict male nudes (eg Eunice Golden, Sylvia Sleigh). Another discernible theme is the routine of daily life experienced by ordinary women and the contradictory demands of housework and glamour. At the other extreme is the 'Cosmic mother' imagery of Monica Sjoo and the American Mary Beth Edelson who draw upon archetypes and myths of an ancient matriarchy. There is, however, one common emphasis: explicitness and accessibility. Feminist artists seek to avoid the elitism and obscurity of so much masculine art. Hence the predominance of figuration.

Within the theoretical debate concerning Feminist Art certain issues and questions remain problematical: how to evolve standards of judgement as alternatives to those of men which have been largely rejected; how to present a new content and remain comprehensible while at the same time avoiding the middle-class, male artistic 'languages'; is there, ought there to be, a specially female style of art? Can Feminist Art escape the fate of merely effecting a stylistic change in art history by achieving its social objectives?

A R Krasilovsky 'Feminism in the arts: an interim bibliography' *Artforum* 10 (10) June 1072 72-75.

T B Hess & E C Baker (eds) *Art and sexual politics* (Collier-MacMillan, 1973).

T B Hess & L Nochlin *Woman as sex object . . .* (Allen Lane, 1973).

V L Hill (ed) *Female artists past and present* (Berkeley, Women's History Research Center, 2nd ed 1974).

M Sjoo (ed) *Some thoughts on Feminist Art* (Bristol Women's Centre, 1974).

Arts in society Spring-Summer 1974.

J Chicago *Through the flower . . .* (NY, Doubleday, 1975).

C Nemser *Art talk: conversations with twelve women artists* (NY, Scribners, 1975).

L Alloway 'Women's art in the '70s' *Art in America* 64 (3) May/June 1976 64-72.

L R Lippard *From the center: feminist essays on women's art* (NY, Dutton, 1976).

225 FINE ARTZ: In 1964 a group of ex-Slade School students—Terry Atkinson, John Bowstead, Roger Jeffs and Bernard Jennings— advocated a new role for art in a leisure-orientated consumer society. They rejected the traditional individualism of art creation in favour of teamwork; they admired the customising approach to design of teenage sub-cultures, and believed that a study of the needs of the younger generation would provide a blueprint for the future. They designed objects in modern materials using techniques such as motivation research and concepts such as styling.

See also Custom Painting, Hybrid Enterprises, Styling.

Fine Artz Associates 'Visualising . . . ' *Ark* (35) Spring 1964 38-41.

Fine Artz 'A Fine-Artz view of teenage cults' *Ark* (36) Summer 1964 39-48.

226 FINISH FETISH (also called the LA Look, California Finish Fetish, the Venice Surface): Some American artists, in particular those working in Los Angeles—Larry Bell, John McCracken, John Eversley and Ed Ruscha —are fanatically concerned to give their paintings, sculpture and environmental constructions a smooth, high gloss surface equal to those found on highly polished automobiles. Peter Plagens describes Finish Fetish as "extra spit and polish in Pop and Minimal Art plus space age materials" and calls the artists 'effete craftsmen'. Complicated procedures and expensive technology are often required to produce a perfect sheen. The cult of impeccable finish is part of a wider Los Angeles aesthetic shared by craftsmen such as those who make surfboards. It also reflects the influence of Hollywood and its emphasis on the surface of things, the facade.

P Plagens 'The LA look'—chapter 8 in—*Sunshine muse: contemporary art on the West Coast* (NY, Praeger, 1974).

227 FLASH ART: The noun 'flash' and its adjective 'flashy' mean, among other things, 'glint, sparkle or gleam', 'superficial brilliance', 'ostentatious showy display'. In the opinion of some British art students these attributes are to be found in a whole range of artifacts and cultural behaviour—in popular entertainment, in fashion, in the custom car cult, in home decoration and in the fine arts—and while these attributes are manifested in the products of other periods, they are thought to be most typical of the late 1950s and early 1960s. The students consider that these characteristics are sufficiently distinct to warrant the creation of a new aesthetic category: Flash Art.

Flash in the entertainment world is epitomised by performers such as Liberace and pop music stars such as Elvis Presley and Gary Glitter, who

134

dazzle their audience with gold lame suits, jewels, and shimmering fabrics. The practice of customising is also considered Flash, as in the way ordinary people titivate their prize possessions—homes, cars, motor cycles, clothes—with excessive decoration to make them appear glamorous. In the fine arts, artists considered Flash include Allen Jones (for his exploitation of gaudy fashions and soft-core porn), Peter Phillips (for his Custom Painting), Andy Warhol (for his use of silver and his cool, star image), Frank Stella (for his use of very large canvases and reflective metallic paints), Richard Hamilton (for his 'Guggenheim Museum' series of fibre glass reliefs sprayed with cellulose paints to give a highly polished surface), and sculptors such as Eduardo Paolozzi, Clive Barker and Lucas Samaras (for their use of chromium plate and mirror glass), Claes Oldenburg (for his exploitation of Kitsch decoration in his 'Bedroom ensemble').

'Flash Art' is also the title of an Italian periodical devoted to Avant Garde art.

See also Custom Painting, Kitsch.

L Riggall *Flash* (Hornsey College of Art, 1972). Unpublished thesis.

A Jacopetti & J Wainwright *Native Funk and Flash* (San Francisco, Scrimshaw Press, 1974).

228 FLOOR ART (also called Distributional Art, Ground Art, Litter Sculpture): Modern sculptures which eschew the traditional plinth and spread themselves across gallery floors or across patches of ground. Examples include open metalwork structures by Anthony Caro, works by Carl Andre (see Clastic Art), cut out shapes by Timothy Drever, pieces of rope by Barry Flanagan, lines of flour by Barry Le Va. Many modern sculptors use the floor in a painterly fashion, that is, as a 'ground' against which to display their forms (Flanagan's rope pieces resemble the compositions of middle period Mondrians).

According to the French critic M J M Ricou, fragmentation followed Minimal Art and what was left were 'crumbs', 'gestures', 'leavings', that is, cloth in shreds, piles of mud and sand scattered across the gallery floor. It is a short step from such works to the idea of creating sculpture directly out of the surface of the earth (see Earth Art).

Another writer claims that the use of the floor was the major sculptural innovation of the 1960s, and that the rejection of the vertical dimension in favour of the horizontal reflected the aerial viewpoint associated with jet travel.

See also Art Povera, Minimal Art.

229 FLUXUS: An international avant-garde movement born officially in 1962 and active throughout the 1960s. The word 'fluxus' is Latin for 'flowing', in English 'flux' means 'a gushing forth', 'an abnormal discharge of fluid or blood from a body', 'a fusion', 'a state of continuous change'; all these shades of meaning apply to the art movement Fluxus. According to Joseph Beuys, its purpose was to "purge the world of bourgeois sickness . . . of dead art", to "promote a revolutionary flood and tide in art, promote living art, anti-art, promote non art reality . . ." and to "fuse the cadres of cultural, social and political revolutionaries into united front and action". The movement was centered initially in Germany; later Fluxus 'festivals' were held in Paris, Copenhagen, Amsterdam, London and New York. The events, situations, performances, concerts of electronic music, anti-theatre, and street art of Fluxus are similar in many respects to the Happenings of American art, though in Europe these tend to be called 'Aktions'. One of the most striking features of Fluxus art is the variety of artforms employed simultaneously and the way they are mingled together with no regard for the purity of the medium aesthetic.

The rollcall of participants in Fluxus includes almost every major avant-garde artist of the 1960s—Joseph Beuys, Wolf Vostell, Robert Filliou, George Brecht, Dick Higgins, La Monte Young, Ben Vautier, Yoko Ono, Emmett Williams, Henry Flynt, Robert Watts and others too numerous to mention. The movement has been co-ordinated, and its many publications, edited by George Macuinas. Robert Filliou describes Fluxus as a 'non group' because it was composed of individualists with divergent ideas and work, but they did share a revolutionary, Dadaist spirit, a desire to introduce spontaneity, joy and humour into art while avoiding at all costs any limiting theory or programme.

Ken Friedman has claimed that Fluxus originated the notion of Conceptual Art and that it is still a thriving, expanding movement.

See also Actions, Concept Art, Decollage, Happenings, Inter-Media.

V TRE (Fluxus newspaper, 9 issues 1964-1970).

Happening and Fluxus (Cologne, Kolnischer Kunstverein, 1970).

K Friedman 'Notes on Concept Art' *Schmuck* March 1972 6-16.

'Free Fluxus now' *Art & artists* 7 (7) October 1972 (special issue on Fluxus).

Fluxshoe (Cullompton, Devon, Beau Geste Press, 1972).

D Mayor 'Something about Fluxshoe' *Southern arts diary and review* February 1973 10-11.

230 FOOD ART (also called Eat Art, Gourmet Art, Gourmandism, Gustatory Art): Cooking and baking have long been described as 'arts' and the decoration of food, especially the icing of cakes, is a minor folk art in its own right. However, the label 'Food Art' popular in recent years refers not to cooking but to at least three different kinds of work produced by fine artists: (1) alterations to the shape and colour of existing foodstuffs and the creation of new objects composed of edible materials; (2) paintings and sculpture depicting food; (3) artworks composed of edible materials, depicting food.

(1) The Swiss artist Daniel Spoerri ran, for a number of years in Dusseldorf, a restaurant/gallery called 'Eat Art' where invited artists exploited different foodstuffs. The American painter Richard Lindner has issued a series of ginger-bread multiples; the German artist Tim Schroder has altered the shape of food and given it bizarre colours by the addition of vegetable dyes; he called the results 'Gourmet Art'. Food thus treated often serves as the theme of festivals: two Paris based artists—Antoni Miralda and Dorothée Selz—have organized such events.

(2) Wayne Thiebaud, the American West Coast artist, delights in painting items of food, such as fancy cakes, which he renders in thick, succulent impasto to simulate the actual quality of cream and icing sugar coatings; one critic described these paintings as 'edibles'. Another American Pop artist, Claes Oldenburg, often employs food as subject matter, producing sculptural facsimiles of popular snacks—hamburgers, ice cream cones—much enlarged in scale and constructed from incongruous materials. In 1964 an exhibition entitled 'The Supermarket' was held at the Bianchini Gallery, New York in which Pop artists displayed images and three dimensional replicas of vegetables, fruit, and canned goods arranged and signposted in faithful imitation of a supermarket.

(3) Peter Kuttner (another artist who enjoys altering the colour of food) has submitted to open exhibitions in Britain 'paintings' of cakes made of edible matter, one of which was entitled 'Something for the critic to get his teeth into'!

Some readers may feel that Food Art lacks significance; however, it is possible for this form of art to make a serious point: in 1973 Carl Andre produced a sculpture consisting of huge quantities of cottage cheese and gallons of tomato ketchup (the ingredients of Richard Nixon's favourite lunch); evil smells caused by the putrefaction of the food resulted in an early closing of the exhibition. The title of Andre's work was 'American decay'. Academics have also paid serious attention to food as an artform: the British anthropologist Mary Douglas has examined the aesthetics of

137

food and discussed the formal rules governing the combination of dishes, the structure of courses, which make up the events we call meals.

'Artefacts for eating:the confectioners plastic art, Eat art' *Die kunst und das schone heim* 82 (12) December 1970 769-773.

Eats, an exhibition of food in art (Hofstra University, Emily Lowe Gallery, 1972).

'Events by Miralda and Selz' *Studio international* 181 (932) April 1972 p167.

P Kuttner 'Coloured food' *Studio international* 181 (932) April 1972 p166.

M Deserti 'Cucina: a tavola con l'arte' *Casa vogue* (14) May/June 1972 126-129.

M Douglas 'Food as an artform' *Studio international* 188 (969) September 1974 83-88, front cover.

231 FORMALISM: An art theory or practice which assigns priority to the form of an artwork at the expense of all its other characteristics; a term of abuse in certain art circles in the 1970s. On the plane of analytical thought it is possible to abstract, or single out, certain properties, qualities or relations from an object but this mental operation can only be performed by ignoring other properties, etc, of the object, hence critical analysis inevitably disrupts the totality of an artwork. It is possible, for example, for an art critic to discuss the form (shape, structure, pattern, organisation of parts to whole) and the content (substance, purport, argument, subject, reference to external reality) of an artwork as if they were autonomous rather than inter-dependent. (More fashionable terms for 'form/content' are 'Signifier/signified' derived from linguistics.) The word 'forms' is often used in a narrower sense to refer to depictions of three-dimensional objects regardless of their colours, or textures (eg a canvas painted all over with a single colour might be described as 'having no forms'; in fact it would be 'uniform').

The philosophical problems associated with the concept of form date back to the Ancient Greeks, but Formalism in the visual arts is generally considered an issue peculiar to the twentieth century, to modern art, and to theorists such as Clive Bell, Roger Fry, and Clement Greenberg. In the face of the bewildering variety of objects from many epochs and cultures which are subsumed under the heading 'visual art' Bell looked for some denominator common to them all. The only single quality he could detect was what he called 'significant form': combinations of lines and colours which stir our aesthetic emotions. Writers such as Alois Riegl

have claimed that artists have 'a will to form' and since the art closest to pure form is thought to be music, many theorists have claimed that all the arts aspire to the condition of music. The end result of this line of thought was the emergence of the concept of an abstract art of pure forms without content: Formal Abstraction (in fact there can be no such thing, even abstract art has a content: form itself); artists have since attempted to construct artworks by taking as their raw material shapes, colours, textures, and lines and they have discounted as literary any references to a reality external to the artwork. In short, an art has been forwarded which claims to be autonomous and which isolates form, in terms of part/whole relationships, as an absolute value. (Of course, there are many abstract painters who consider their work has a non-formal content, eg the Abstract Expressionists.)

While British art was dominated by American art, Formalism permeated British art practice via American aesthetics and criticism. However, as Victor Burgin has pointed out, there is another tradition of Formalism worth considering namely Russian Formalism (the work of a group of literary critics including Viktor Shklovsky, Boris Tomashevsky, Boris Eichenbaum, active in Russia in the 1920s) out of which a Socialist Formalism might be derived.

By the 1960s a considerable number of artists and critics had begun to feel that Formal Abstraction had exhausted itself, that its vocabulary, in Jack Burnham's phrase, had become weary. It was argued that by failing to engage issues and problems of contemporary reality and by refusing to use signs comprehensible to the mass of the population Formal Abstractionists were elitist and socially irresponsible. It was also argued that their art was based on unsound philosophical premises because no art can have meaning outside of history and society. The distinction between form and content has itself been questioned by artists such as John Stezaker.

See also Anti-Form, Modernist Painting, Political Art.

C Bell *Art* (Arrow Books, 1961) first published 1914.

V Erlich *Russian Formalism* (The Hague, Mouton, 1955).

R Ekman 'Paradoxies of Formalism' *British journal of aesthetics* 10 (4) October 1970 350-358.

C Greenberg 'The necessity of "Formalism" '*Art international* 16 (8) October 1972 105-106.

V Burgin 'Socialist Formalism' *Studio international* 191 (980) March/April 1976 148-154.

232 FORMALIST CRITICISM: In the United States from 1960 onwards, the formalist tradition of art criticism received new impetus under the influence of Clement Greenberg and British linguistic philosophy. Writers such as Michael Fried, Rosalind Krauss, Sidney Tillim and others, mostly associated with *Artforum* magazine, excluded lyrical description and literary generalisations from their writings. Instead they derived conclusions from close analysis of actual art works; as W C Seitz remarks, they "carried the verbalised observation and examination of art objects to questionable extremes of phenomenological and syntactical nuance and sometimes opaque rhetoric which did a disservice by ignoring content". Subject content in the form of narration or symbolism was regarded as extraneous to the essential purpose of painting, which was reduced to a single concept: formal organisation (thus Pop Art was scorned by Formalist critics because of its 'inessential' subject matter). Formalist critics also ignored the intentions, opinions, and beliefs of the artist. Leo Steinberg described this attitude as interdictory—it tells the artist what he must and must not do—and he called it 'preventive aesthetics'.

See also Modernist Painting, Objecthood, Presence.

B M Reise 'Greenberg and the group: a retrospective view' *Studio international* 175 (901) June 1968 314-316.

W Seitz 'Mondrian and the issue of relationships' *Artforum* 10 (6) February 1972 p74.

L Steinberg 'Reflections on the state of criticism' *Artforum* 10 (7) March 1972 37-49.

233 FOTEXUR: A method of producing decorative textures and patterns from photographs of cracks in mud, plant forms, and the bark of trees. A technique popular in British design in the mid 1950s.

M Farr 'Fotexur: pattern making based on photographs' *Design* (100) April 1957 44-53.

234 FRANKFURT SCHOOL AESTHETICS: The term 'Frankfurt School' refers both to a specific approach to philosophy and to a group of Marxist philosophers and social theorists who were members of, or who were associated with, the Institut für Sozialforschung (Institute of Social Research) operative in Frankfurt during the years 1923-1933 and 1950 onwards. The best known of these theorists are Theodor W Adorno, Walter Benjamin, Erich Fromm, Jurgan Habermas, Max Horkheimer, Leo Lowenthal, Herbert Marcuse, and Franz Neumann. In the 1930s Marxist/Jewish intellectuals were forced to flee Europe by the rise of

Nazism and for a period the work of the Frankfurt School was centred in the United States. During the 1960s the ideas of the Frankfurt School became fashionable amongst the New Left and the student activists in Europe and, through the writings of Marcuse, they influenced a generation of protesting American students.

The character of Frankfurt School philosophy has been summed up by the term 'Kritische Theorie' (Critical Theory): an open ended search accompanied by an aversion to closed philosophical systems; analysis allied to empirical research; a dialectical critique of other thinkers; a synoptic interdisciplinary approach; a negative, critical attitude towards bourgeois society and culture; theory for revolutionary praxis rather than for its own sake; pessimism. Art, aesthetics and mass culture were topics of particular interest to the Frankfurt School: Adorno wrote treatises on aesthetics, modern music, and radio; Benjamin wrote on poetry, theatre, film and the implications for art of mechanical reproduction; Horkheimer, Adorno, and Marcuse wrote (hostile) critiques of popular culture and its relation to art. The critical theorists regarded art, variously, as a code which when deciphered revealed the hidden processes of society; as a negative force which by its very existence opposed the domination of the mass culture industry; as a foretaste of a future society radically different from our present one.

Notwithstanding the insights of Critical Theory there is little of positive value to the practising artist in the writings of the Frankfurt School (unlike the writings of Brecht). Critics of the Frankfurt School accuse it of elitism; they note its failure to unite theory and practice, its failure to adopt a practical class standpoint and regret its dismissal of agitational and revolutionary art.

See also Marxist Aesthetics, Political Art.

M Horkheimer 'Art and mass culture' *Studies in philosophy and social science* 9 (2) 1941.

T W Adorno *Asthetische theorie* (Frankfurt, Suhrkamp, 1970).

H Marcuse 'Art as a form of reality'—in—*On the future of art;* edited by E Fry (NY, Viking Press, 1970) 123-134.

H Marcuse 'Art in the One-dimensional society'—in—*Radical perspectives in the arts;* edited by L Baxandall (Penguin Books, 1972) 53-67.

T W Adorno *Philosophy of modern music* (Sheed & Ward, 1973).

M Jay 'Aesthetic theory and the critique of mass culture'—chapter in —*The dialectical imagination: a history of the Frankfurt School . . .* Heinemann, 1973).

P Slater 'The aesthetic theory of the Frankfurt School' *Cultural studies* (working papers in) (6) Autumn 1974 172-211.

235 FREE FORMS: Organic, biomorphic forms or shapes produced by free hand drawing, as opposed to rectangular or circular shapes produced by rulers and compasses. This term was applied to the kind of forms featured in paintings by Arshile Gorky, William Baziotes and Mark Rothko, created during the 1940s; these artists had been influenced by the forms used by the Dada sculptor Hans Arp and by Joan Miro and other Surrealist painters.

In the following decade Free Forms, or 'quartics' as they are called in co-ordinate geometry, became extremely popular in the applied arts; for example, kidney shapes, boomerang shapes, egg shapes and rounded squares all appeared in the design of furniture, fabrics and tableware.

'Free Form' is also the name of a British community arts group based in Hackney, London.

L Alloway 'The biomorphic forties' *Artforum* 4 (1) September 1965 18-22.

J Manser 'Free form furniture' *Design* (240) December 1968 28-33.

J A D Wedd 'Quartics' *Design* (49) January 1953 15-17.

J A D Wedd 'Two familiar quartics' *Design* (59) November 1953 25-27.

R P Metzger *Biomorphism in American painting* (UCLA, 1973); *Dissertation abstracts international* 36 (4) December 1973 3264 A (73-28735).

236 FREUDIAN AESTHETICS: Following the development of Sigmund Freud's revolutionary theory of the unconscious and the psycho-analytic method, many writers have used his theoretical concepts to explain the phenomenon of art (Freud himself wrote essays on Leonardo and Dostoevsky) or have been influenced by his thought, for example, Ernst Kris, Ernest Jones, Anton Ehrenzweig, Adrian Stokes, Marion Milner, V Lowenfeld, and many others. The problematic of Freudian Aesthetics includes: the role of the unconscious in the production and appreciation of artworks; the relation of dream symbolism to art; the value of art as therapy; the relation between art and neurosis; the origins and motivations of creativity; the relation between creativity and day-dreams; the function of art to the psyche; the relevance of psycho-analytical findings concerning an artist's personality to his/her art. Freudian theory has also

inspired the imaginations of numerous artists, most notably, the Surrealists.

In France Freud's ideas have been re-interpreted and extended by Jacques Lacan. His complex theories, in particular the theory of the mirror-phase in child development, have become extremely fashionable in writings on the cinema in France and Britain (see *Screen* 16 (2) Summer 1975), and have also been applied to Video Art.

See also Jungian Aesthetics, Remedial Art.

'Psychoanalysis, psychiatry and art'—chapter 14 in—*Psychiatry and psychology in the visual arts and aesthetics: a bibliography;* compiled by N Kiell (Madison & Milwaukee, U of Wisconsin Press, 1965).

J J Spector *The aesthetics of Freud: a study in psychoanalysis and art* (Allen Lane, 1973).

S Marshall 'Video art, the imaginary and the parole vide' *Studio international* 191 (981) May/June 1976 243-247.

237 FRONTE NUOVO DELLE ART (New Front of the Arts): A broad post-war Italian art movement sponsored by the critic Guiseppe Marchiori in 1947. A number of artists working in a variety of styles contributed to group exhibitions to draw the attention of the public to the achievements of avant-garde Italian art. The best known of these artists were Renato Guttoso, Guiseppe Santomaso, Emilio Vedova and Ennio Morlotti.

238 FUN PALACE: A scheme devised by the theatrical director Joan Littlewood in 1961 for an entertainments and community arts centre to be established in London. The British architect Cedric Price produced designs for a highly flexible structure which Reyner Banham described as 'anti-building' because it avoided the solid, permanent forms of traditional architecture; another critic dubbed it 'Aleatory Architecture'.

Littlewood's vision has never been realised, but the name 'Fun Palace' has been applied to other structures, such as one designed by Keith Albarn and displayed at the seaside resort of Girvan, Ayrshire. His 'palace' consisted of a series of plastic domes inside which spectators were diverted by sound and light patterns, wall textures and moving floors. After one year of operation the interior was redesigned by John Ballantyne and Denis Barns, and equipped with sound and light feedback systems capable of responding to the noise and movement of spectators (see Cybernetic Art). The term 'Fun Palace' has also been applied to recreation centres such as the vast structure called 'Summerland' created by the Japanese architects Kinji Fumada, Minoru Murakami and Toshio Sato.

'Fun Palace, Camden, London' *Architectural design* 37 (11) November 1967 522-525.

'Summerland: a serviced space frame for changing fantasy and fun' *Architectural design* 38 (7) July 1968 318-321.

A Best 'Funny business at the seaside' *Design* (251) November 1969 58-61.

239 FUNDAMENTAL PAINTING: A term coined by E de Wilde to describe abstract paintings produced from about 1960 onwards by such European and American artists as Jake Berthot, Louis Cane, Alan Charlton, Robert Mangold, Brice Marden, Agnes Martin, Edda Renouf, Gerhard Richter and Robert Ryman.

'Fundamental painting' was used as the title of an exhibition of such pictures held at the Stedelijk Museum, Amsterdam in 1975. This major exhibition was not an isolated event, rather it was the culmination of a number of less ambitious shows; it marked the public recognition of a mode of painting which had been around for some years but which had not been seen as constituting a category as such. A variety of other terms have been proposed to describe Fundamental Painting: Geplante painting (Planned), Analytische malerei, Introspective painting, Silent painting, Nouvelle peinture, Post-Minimal painting, Post-Conceptual painting, Reductivist painting, Opaque painting, Pure painting, Essential painting, Absolute painting. A term such as 'Post-Conceptual' is indicative of the situation of painting in the aftermath of Conceptual art and at least one critic has suggested that the plethora of shows devoted to Fundamental Painting is an attempt on the part of dealers, for reasons of commerce, to re-instate painting as the leading form of art.

Since Fundamental Painting is, in the words of de Wilde, 'a reflection on the foundations of painting', it continues the self-critical tendency which Greenberg identified as the essence of Modernism but in its emphasis on process and the literal, physical character of its materials Fundamental Painting incorporates certain notions derived from the theory of Minimal Art developed in the first half of the 1960s in relation to three-dimensional objects.

In my view, the attempt to make painting a completely autonomous entity is socially irresponsible, and the search for an essentialist definition of painting, whether by artists or critics, is mistaken. There is no 'essence' of painting whether it is located in phenomenal experience (colours, forms) as in Formalism or whether it is located in the physical constituents of painting (pigment, canvas, etc) as in Fundamentalism. Both these 'essences'

are in fact theories concerning the nature of painting (neither of which are correct or immutable); these theories are restrictive in that they limit the potential of painting. What is unhealthy about Fundamental Painting is that means are given precedence over ends. By looking inward (paintings about painting) rather than outwards towards the world an inbred, narcissistic art is produced which neglects the fact that paintings are first and foremost devices which mediate social relations between people.

C Ratcliff 'Once more with feeling' *Art news* 71 (4) Summer 1972 34-37, 67-69.

Arte come arte (Milan, Centro Comunitario di Brera, 1973).

Nouvelle peinture en France: pratiques/theories (Saint-Etienne, Musée d'Art et d'Industrie, 1974).

R Brooks 'An international exhibition of Post-Minimal painting' *Studio international* 188 (972) December 1974 11-12 (review section).

Fundamental painting (Amsterdam, Stedelijk Museum, 1975).

C Blok 'Holland' (review of Fundamental painting show) *Studio international* 190 (976) July/August 1975 74-75.

J A Walker 'John Hoyland & Bob Law' *Studio international* 191 (979) January/February 1976 79-81.

240 FUNK ARCHITECTURE (or Alternative Architecture): Makeshift structures erected by members of the Alternative Society at such venues as Pop music festivals. The term also refers to geodesic domes constructed from waste materials by members of rural communes such as that at Drop City, Colorado.

See also Ant Farm, Underground Art, Urban Guerrilla Architecture.

B Voyd 'Funk architecture'—in—*Shelter and society;* edited by P Oliver (Barrie and Rockliff, The Cresset Press, 1969) 156-164.

241 FUNK ART (also spelt Funck, Phunck, or called Grotesque Art, Sick Art): The adjective 'funky' was first applied to visual artworks by artists living in the Bay Area of San Francisco in the late 1950s. They borrowed the word from Blues or Jazz terminology where 'funky' means a heavy beat, an earthy sensual sound. Orthodox dictionaries reveal that the word has several meanings, one of which is 'strong smell or stink' and Jeff Nuttall has defined it as a "thick pungent odour given off by sexually aroused female" (at least one artist's work has been described as 'funky as a whore's drawers'). In 1967 funky became a four letter word when

145

the first exhibition with the title 'funk' was held at the University of California.

Funk Art is usually three-dimensional, but it does not resemble traditional sculpture. Rather is it an uneasy hybrid of painting and sculpture. Materials such as leather, clay, steel, fibre-glass, nylon, vinyl are employed in bizarre combinations; the resulting objects are eccentric in appearance and this imagery is visceral, organic or biomorphic, often with ribald, sexual or scatological connotations. Funk artists draw their inspiration from outside Fine Art; they delight in the vulgar elements of their surroundings. Their attitude to materials is anti-functional, anti-Bauhaus; their aesthetic is anti-intellectual, anti-formal; Nuttall describes it as the 'aesthetic of obscenity'. Precedents for Funk have been found in the sculpture of Joan Miró, in some of Marcel Duchamp's objects, in the architecture of Antonio Gaudi and in the Pop Art of Claes Oldenburg. Many Funk artists are ceramicists (their work is often called Pop Ceramics), and this medium seems peculiarly appropriate to the needs of the style.

Major artists included Kenneth Price, Bruce Conner, Robert Hudson, James Melchert, David Gilhooly, Robert Arneson, Peter Vandenberge, Clayton Bailey, Chris Unterscher, Joseph A Pugliese, Richard Shaw and Mel Henderson. The French critic Jean Clay regards the German Joseph Beuys as a Funk artist, because of his emphasis on materials, and also Richard Long, an English exponent of Land Art (see Earth Art and Land Art), defining their work as the 'embodiment of nostalgia'.

See also Kitsch, Eccentric Abstraction, Pop Art.

P Selz *Funk* (Berkeley, University of California, 1967).

D Zack 'Funk Art' *Art & artists* 2 (1) April 1967 36-39.

D Zack 'Funk 2: the Grotesque show at Berkeley, California' *Art & artists* 2 (7) October 1967 20-21.

D Zack 'California myth making' *Art & artists* 4 (4) July 1969 26-31.

J Nuttall *Bomb Culture* (Paladin, 1970) p 173.

J Pierre 'Funk Art' *L'Oeil* (190) October 1970 18-27 and 68.

A Jacopetti & J Wainwright *Native funk and flash* (San Francisco, Scrimshaw Press, 1974).

G

242 GAME ART: The expressions 'Game Art', 'Toy Art', 'Play Art' and 'Ludic Art' refer, in most instances, to games, toys and playthings made by artists; an exhibition of such works entitled 'Play Orbit' was held in 1969 at the ICA, London. In other instances the expressions refer to a more sophisticated notion of art: since 1945 many artists have become convinced that play serves vital cultural functions for adults as well as children and that it will become more important in the future (assuming the leisure society becomes a reality). Consequently they have produced works with variable elements which heighten spectator involvement and works which encourage adults to play (see Cybernetic Art, Participatory Art). A British group promoting this form of art was formed in 1970 by Rob Con, Julian Dunn, and Harry Henderson called 'GASP' (Games of Art for Spectator Participation). In France another group called 'Group Ludic' (ludic' is the Latin for 'play') composed of two architects—David Roditi, Simon Koszel—and a sculptor—Xavier de la Salle—was formed in the late 1960s to produce play objects for children to be installed in parks and other public spaces.

In the uncertain political climate following the second world war scientists developed a keen interest in the theory of games, in particular the theory of war games; an artist who has exploited war games as subject matter is the Swedish painter Oyvind Fahlstrom.

Wittgenstein used the analogy of the game in his linguistic philosophy and on occasion art critics apply the same analogy to art; both human activities are indeed similar and it is difficult to pinpoint the precise differences between them. No writer has yet made a systematic study of the relationship between games and art; no doubt Marcel Duchamp would feature prominently in such a study, given his penchant for games of all kinds.

J Von Neumann & O Morgenstern *Theory of games and economic behaviour* (Princeton U Press, 1944; OUP, 1953).

J Huizinga *Homo ludens: a study of the play element in culture* (Routledge, 1949; Paladin, 1970).

'Games & toys'—in—*Encyclopedia of world art* vol 6 (NY, McGraw Hill, 1962) 1-18 columns.

'Fun & Games' *Art & artists* 2 (9) December 1967 (special issue on games).

L Barrow 'A too—summary' *Control* (5) 1969 8-9.

F Popper 'Le Group Ludic' *Prisme international* (6) May/June 1969 50-59.

G Ortman 'Artists' games' *Art in America* 57 (6) November/December 1969 69-77.

J Reichardt (ed) *Play orbit* (Studio International, 1969).

C Bouyeure 'Design Ludique' *Jardin des arts* (192) November 1970 76-77.

N Calas 'Games'—in—*Icons and images of the sixties,* by N & E Calas (NY, Dutton, 1971) 316-323.

A Everitt 'Four exhibitions in the midlands' *Studio international* 183 (941) February 1972 76-78.

Games that artists play (Camden Arts Centre, 1972).

T Del Renzio 'Spectator at the games' *Studio international* 185 (956) June 1973 p255.

B R Tilghman 'Wittgenstein, games and art' *Journal of aesthetics and art criticism* 31 (4) Summer 1973 517-524.

243 GARBAGE HOUSING: Dwellings made from waste products such as empty bottles and tins which have themselves been designed with this second use in mind. In this sense Garbage Housing is distinct from the one-off adaptation of waste products as building material. This concept owes much to Martin Pawley, an American architect, who developed his ideas while working on emergency housing problems in Chile in 1972 and 1973. The design for re-use concept was pioneered by the 'WoBo', a bottle which could serve as a brick when empty, designed by John Habraken for Heineken Breweries, Holland in 1962.

M Pawley 'Garbage housing' *Architectural design* 43 (12) December 1973 764-784.

M Pawley *Garbage housing* (Architectural Press, 1975).

R Van Den Berg 'About re-use' *Domus* (562) September 1976 18-26.

244 GENERATION: A word art critics have used a great deal since 1945, in expressions such as 'new generation', 'first generation', 'second generation', 'middle generation', to describe waves of artists who emerge into public view at roughly the same time and who are generally of similar age. In America 'first generation' invariably means painters associated with Abstract Expressionism. Robert Hughes points out that it is a mistaken notion to expect, as some exhibition organisers and critics appear to do, a fresh generation of talent to emerge annually; he regards this

expectation as a parody of the accelerated turnover in the avant-garde.

R Hughes 'Arts in society: stop wasting time' *New society* February 2 1967 170-171.

245 GENERATIVE ART GROUP (GAG): This 'group' was founded in 1972 and consists of the painters Husny Belmood, Edward Larsocchi, the designer Philip Honeysuckle, and the poet Anton Paidola. In fact the members of GAG are fictional beings, they are the multiple personae of Paul Neagu (b1938) a Rumanian artist living in London who generates a wide variety of artworks: paintings, drawings, tactile objects, performances, and publications. Neagu is also author of a manifesto on 'Palpable Art'.

A Mackintosh 'Paul Neagu' *Art & artists* 6 (5) September 1971 52-53.
P Neagu *Generative Art Group* (Neagu, 1972?).
Gradually going tornado . . . (Sunderland, Ceolfrith Press, 1976).

246 GEOMETRIC ABSTRACTION: A broad category of art, encompassing both sculpture and painting, which finds in geometric forms universal symbols for rational, idealist concepts. Geometric Abstraction makes use of shapes such as circles, rectangles and triangles, its colours are usually primary and its forms are sharply defined; all its elements are carefully composed and related one to another (*cf* Non-Relational Art). Because of its cool rationality, Geometric Abstraction has also been termed 'Cold Abstraction' and described as 'hygienic'. This kind of art developed largely in Europe in the years between the two world wars and was associated with the Bauhaus, Concrete Art, de Stijl, and Constructivism. In the immediate post-war years art entered an anti-geometric phase: artists in Europe and the United States rejected Geometric Abstraction in favour of looser, more intuitive styles (see Assemblage Art, Abstract Expressionism, L'Art Informel). However, in the 1960s geometric forms reappeared (see Hard-Edge Painting, Minimal Art, and Op Art).

See also Cool Art.

Geometric Abstraction in America (NY, Whitney Museum, 1962).

H L C Jaffe, 'Geometrical Abstraction: its origin, principles and evolution'—in—*Abstract art since 1945,* by W Haftmann and others (Thames & Hudson, 1971) 163-190.

Geometric Abstraction (Omaha, University of Nebraska, 1974).

247 GEOMETRY OF FEAR: A phrase used by Herbert Read to characterise the work of a number of British Sculptors—Lynn Chadwick, Reg Butler, Kenneth Armitage, F E MacWilliam and Bernard Meadows—who achieved international recognition in the early 1950s. Their sculpture was influenced by the work of Alberto Giacometti and Germaine Richier; it had an angst-ridden look which reflected the post-war mood of tension and uncertainty. Their work was figurative, often combining human and animal forms; they made use of welded metal to construct cage-like structures enclosing or piercing modelled forms with tortured surface textures.

H Read *New aspects of British sculpture* (Venice Biennale, 1952).

248 GILBERT & GEORGE: A humorous, vaudeville double-act by two London-based artists who have renounced the use of their surnames and who have blended their separate identities into a composite 'living sculpture'. G & G studied sculpture at St Martins School of Art, London in the mid 1960s but ignored the Caro-inspired colour sculpture of their predecessors. Their best known performance, 'Underneath the Arches' (1969-70), consisted of the artists standing on a table repeating a series of contrived movements like motorized statues, accompanied by a recording of the pre-war musical hall song which supplied the title of the piece.

In addition to performances G & G have produced landscape paintings, drawings, videotapes, books, magazine features, and photo-works. Perversely, most of this disparate output is labelled 'sculpture'.

Like the superstars of the cinema and pop music, G & G have made their whole public lives into art. In return for fame they offer their audiences wit, nostalgia, a parody of Englishness, and a devastating critique of the artistic life and the artworld which they simultaneously send-up and milk.

See also Body Art, Conceptual Art, Performance Art.

B Reise 'Presenting Gilbert & George, the living sculptures' *Art news* 70 (7) November 1971 62-65, 91-92.

Gilbert & George, the sculptors *Side by side* (Art for all, 1972)

Gilbert & George *Oh the grand old Duke of York* (Luzern, Kunstmuseum, 1972).

D Zec 'The odd couple' *Studio international* 184 (949) November 1972 p158.

C Ratcliff 'The art and artlessness of Gilbert & George' *Arts magazine* 50 (5) January 1976 54-57.

Gilbert & George *Dark shadow* (Nigel Greenwood, 1976).

150

249 GLASS BOX ARCHITECTURE: Box like office blocks encased by glass curtain walls. John Jacobus describes Glass Box Architecture as "a trend in commercial architecture which reached fever peak in the mid 1950s" and "belatedly spread to Europe at a point when its popularity was ebbing in America". This type of architecture was characterised by uniformity; although it was modern in style, its anonymity made it "acceptable to the cautious taste" of corporation directors and property developers.

J Jacobus *Twentieth century architecture: the middle years 1940-65* (Thames & Hudson, 1966).

250 'GOOD DESIGN': In the years since 1945 well-intentioned designers, and officials attached to institutions such as the Design Council in London and the Museum of Modern Art in New York, have espoused the cause of modern design in articles, lectures, exhibitions, and also by means of design awards and seals of approval given to selected products. Its advocates described modern design in terms of its 'honesty', 'integrity', 'truth to materials', by adjectives such as 'decent', 'modest', 'wholesome', and thus good modern design came to be regarded as good in a moral as well as an aesthetic sense. In the beginning the adjective was a compliment, but consumer goods, manufactured for a mass public, have to appeal to the average man; this fact, coupled with the selection of approved products by committee, resulted in a middle-brow aesthetic. Good Design became a cliché and the term acquired its disparaging inverted commas, or was called 'Easy Art'; it became boring and dowdy—as Christopher Cornford puts it "like cold rice pud: plain, nutritious, high-minded and off-white"— especially when contrasted with the Pop Art design of Carnaby Street, customized motor cycles and automobiles, and the zest of Italian design (see Supersensualists). Some writers have since noted a cult of the ugly and the vulgar which they call 'anti-design'.

See also Design Council, Kitsch, Post-Modern Design.

L B Archer 'What is Good Design?' (I) *Design* (137) May 1960 28-33; (II) *Design* (140) August 1960 26-31.

C Cornford 'Cold rice pudding and revisionism' *Design* (231) March 1968 46-48.

F MacCarthy *All things bright and beautiful* . . . (Allen & Unwin, 1972) 178-179, 214-215.

251 GRAFFITI: Originally, Graffiti were drawings or writings scratched into the surface of walls (the word derives from the Italian 'graffio' meaning 'scratch') but today they are almost invariably executed with cans of spray paint or with felt-tipped pens and markers.

Graffiti has existed as a kind of subversive folk art since the days of Ancient Egypt but only recently has it aspired to the condition of fine art and been taken seriously by writers on art. While professional artists associated with the Tachist and Matter Art movements, such as Cy Twombly, Antonio Tapies, and Jean Dubuffet, took over certain characteristics of Graffiti it was not until the following decade and the appearance of cheap aerosol paint sprays that Graffiti, at a popular level, achieved a new dimension. A striking outbreak of Graffiti occurred in New York in the winter of 1971-72 when subway trains were covered with polychromatic scrawls. While the authorities viewed the Graffiti as vandalism others considered them to be a manifestation of street culture. On investigation it turned out that they were the work of various groups of 'deprived' teenagers. Each group had their own techniques, rules, vocabulary, stylistic mannerisms, and even martyrs (by electrocution). The process of social assimilation was rapid: an exhibition called 'United Graffiti artists' was held at Artists' Space in 1975, commissions, awards, and books followed.

In Britain the interest in Graffiti has also been marked, though British examples are not so sensational as those in the United States. Not all Graffiti is what it seems: the slogan 'Its only rock'n roll' which appeared all over London was the work of a record company publicising the LP with the same name by the Rolling Stones. Indeed, the graphic spontaneity, vulgarity, and subversion of Graffiti have now become part of the repertoire of manipulative devices of the advertising industry.

R Freeman *Graffiti* (Hutchinson, 1966).

C Prevost 'Graffiti: spontaneous graphical expression of the people' *Prisme international* (4/5) January/April 1969 86-91.

C Ward 'Graffiti guerrillas' *Architectural design* 43 (8) 1973 487-488.

R Reisner *Graffiti: two thousand years of wall writing* (Muller, 1974).

M Kurlansky *The faith of graffiti* (NY, Praeger, 1974); English edition *Watching my name go by* (Mathews Miller Dunbar, 1974).

United graffiti artists 1975 (NY, Artists Space, 1975).

R Perry & George Melly *The writing on the wall* (H Hamilton, 1976).

252 GRAFILM: J Bryne-Daniel defines 'grafilm' as 'a graphic/poetic approach to film making rather than a photographic/prosaic one'. He encourages would-be Grafilm makers to use a wide variety of techniques working directly on the film stock, as well as using more orthodox photographic methods, and to analyse the elements in each shot so that every frame is a considered composition. Many of the techniques he describes are similar to those used by Norman McLaren in the films he made with the Canadian National Film Board in the 1940s and 1950s.

J Bryne-Daniel *Grafilm* (Studio Vista, 1970).

253 GRASS ROOTS ART: Work by untrained artists; an alternative term for 'primitive', 'folk', or 'naive' art, coined by G N Blasdel.

G N Blasdel 'The Grass Roots artist' *Art in America* 56 (5) September/October 1968 24-41.

'Grass roots art in Canada' *Arts Canada* (138/139) December 1969 (special issue).

254 GRAV (Groupe de Recherche d'Art Visuel): A group founded in Paris in 1960 to encourage research into light, illusion, movement, and perception. Its chief members were Yvaral, François Morellet, and Julio Le Parc. Members of GRAV were largely inspired by the work and theories of Victor Vasarely; the group was also closely associated with the Denise René Gallery, Paris. GRAV opposed improvised abstract painting by instituting a programme of pseudo-scientific research and by substituting group activities and anonymous works for individual creation. In addition they sought to increase the physical involvement of the spectator by the provision of environments and participatory works. By producing Multiples GRAV hoped to reach a mass market. All these gestures were intended to narrow the division between art and life. Much of the work of GRAV has been categorised as Kinetic Art. The group became defunct in 1969 because its members, having developed their ideas in different directions, could no longer agree on a common policy.

See also Kinetic Art, Multiples, Op Art, Participatory Art.

'Texts of the Groupe de Recherche d'Art Visuel 1960-1965' *Image* Winter 1966 13-30.

C Barrett 'Mystification and the Groupe de Recherche' *Studio international* 172 (880) August 1966 93-95.

Groupe de Recherche d'Art Visuel (Dortmund, Museum am Ostwall, 1968).

J Stein 'Dissolution du GRAV' *Leonardo* 2 (3) 1969 295-296.

S Bann 'Groupe de Recherche d'Art Visuel: Yvaral'—in—*Experimental painting* (Studio Vista, 1970) 41-46.

255 GREAT WEST ROAD STYLE: A somewhat facetious phrase used to describe the pre-war commercial architecture of Wallis, Gilbert and Partners who designed several factories in West London, in particular, along the Great West Road (A40). The 'style' is an amalgam of Art Deco, pseudo-Egyptian, and self-conscious 1930s moderne.

See also Art Deco.

J J Snowden and R W Platt 'Great West Road Style' *Architectural review* 156 (929) July 1974 21-27.

256 GRIDS: Those painters and sculptors who opted in the early 1960s for art that was totally abstract and non-relational (no hierarchies of forms from small to large) found they needed some kind of neutral structure or armature to work with or to work against; the grid which painters have traditionally used to square-up a canvas provided the answer. The grid, as Sol LeWitt explains in a note in the margin of one of his drawings, 'is a convenience. It stablilizes the measurements and neutralizes space by treating it all equally'. For these reasons grids became the biggest cliche of American and British abstract art of the 1960s and 70s, so much so that a whole exhibition could be devoted to grid-based art in 1972. In her catalogue introduction Lucy R Lippard notes that the grid is 'an arbitrary framework on which to build an entity, a self-restrictive device by which to facilitate choice . . . is music paper for colour, idea, state of mind. It is a standard measure. It repeats the traditional shape of the canvas itself. It implies, illogically, logic, harmony and unity'. Amongst the American artists who have used the grid device are Jasper Johns, Ad Reinhardt, Sol LeWitt, Will Insley, Eva Hesse, Ellsworth Kelly, Alan Shields, Larry Poons, and Agnes Martin.

See also Minimal Art, Modular Art, Serial Art.

Grids, grids . . . (Philadelphia, University of Pennsylvania, ICA, 1972).

J Elderfield 'Grids' *Artforum* 10 (9) May 1972 52-59.

A Goldin 'Patterns, grids, and painting' *Artforum* 14 (1) September 1975 50-54.

257 GROUP FORM: An architectural term devised by the Japanese architect Fumihiku Maki to refer to the sum of relationships between a

number of buildings. In other words, the form of individual buildings is subordinated to the form of the group as a whole.

F Maki 'The theory of group form' *Japan architect* February 1970 39-42.

258 GROUP ONE FOUR: A London based group of painters and sculptors formed in 1964 by Brian Yale and Mauro Kunst while they were teaching at Hornsey College of Art. The group had two other members: John Berry and Roy Grayson. Its name derived from the flat where discussions were held. Group One Four produced Multiples in an attempt to combine art and industrial techniques, and promoted itself by means of business methods, ie it issued its own publicity material and designed a packaged exhibition of work for international circulation.

See also Multiples.

E Wolfram 'Group One Four' *Art & artists* 3 (2) May 1968 50-53.

E Rowan 'Group One Four' *Studio international* 178 (917) December 1969 228-229.

259 GROUP ZERO (or Group 0, often referred to simply as 'Zero'): An influential German group formed in Dusseldorf in 1957 by Otto Piene and Heinz Mack; a third member, Gunther Uecker, joined in 1960. The word 'zero' does not equal 'nothing', but a 'zone of silence for a new beginning'; it derives from the countdown sequence of a rocket take-off. The German artists were strongly influenced by the work of the Nouvelle Tendance, especially artists like Yves Klein, Jean Tinguely, and Lucio Fontana, and reacted against the prevailing fashion for improvised abstract painting. They developed a form of Kinetic Art exploiting light and motion, which attempted to re-establish a harmonious relationship with the forces of nature. The group disbanded in 1966.

See also Dusseldorf School, Kinetic Art, Light Art, Nouvelle Tendance

Zero (magazine issued in Dusseldorf, three issues 1958-61) reprinted in 1973 by MIT Press, Cambridge, Mass.

J A Thwaites 'The story of Zero' *Studio international* 170 (867) July 1965 2-9.

C Barrett 'Group Zero' *Art & artists* 1 (9) December 1966 54-57.

260 GROUPE INTERNATIONAL D'ARCHITECTURE PROSPECTIVE (GIAP): A group that has met since 1965 under the leadership of Michel Ragon to discuss visionary and futuristic concepts of architecture.

155

M Ragon 'Le Groupe International d'Architecture Prospective' *Cimaise*
(79) January/March 1967 42-51.

261 GUERRILLA ART ACTION: A New York art and politics group
(or concept—anyone may use its name and ideas); members include Jean
Toche and Jon Hendricks. They criticise current art on the grounds that
it is merely a commodity of the capitalist society, and that museums and
artists in their present roles are adjuncts to fascism. In order to challenge
this state of affairs, the group performs actions or demonstrations in
public places, for example the Museum of Modern Art, New York, to
provoke a reaction from the authorities.

See also Art Workers Coalition, Actions, Cultural Art, Political Art.

G Battcock 'Guerrilla Art Action' *Art & artists* 6 (11) February 1972
22-25.

'Art Workers Coalition, New York (Guerrilla Art Action)' *Die flug/
FluxBlattzeitung* (12) nd (Stuttgart, Albrecht D).

Guerrilla Art Action Group 'Letter . . . ' *Left curve* (1) Spring 1974
4-15.

262 GUTAI GROUP: An organisation of Japanese artists devoted to
the cause of experimental art, which was founded in Osaka in 1954. The
word 'gutai' approximates to the German 'gestalt'. The original members
of the group were young artists influenced by the master Jiro Yoshihara.
The Gutai Group were particularly noted in the West for their theatre
art, or public spectacles, which pre-dated the Happenings of New York.
In 1957 contacts were established between the Gutai Group and L'Art
Informel of Europe via Michel Tapié who visited Japan in that year.

Following the death of Yoshihara in 1972 the group disbanded.

See also L'Art Informel, Happenings.

A Kaprow *Assemblage, Environments, Happenings* (NY, Abrams,
1965).

J Langster 'Gutai: an on the spot report' *Art international* 9 (3)
April 1965 18-24.

M Cohen 'Japan's Gutai Group' *Art in America* 56 (6) November/
December 1968 86-89.

J Love 'The group in contemporary Japanese art: Gutai and Jiro Yoshi-
hara' *Art international* 16 (6-7) Summer 1972 123-127, 143.

H

263 HABITAT: A vogue word among architects and designers in the 1950s and 1960s. According to the dictionary, 'habitat' refers to the natural environment or locality in which plants and animals develop, hence a place of abode. For human beings 'habitat' generally means an artificial environment designed by architects, such as Le Corbusier's 'Unite d'Habitation', Marseilles 1945-1952, a village in one vertical structure. The ninth assembly of the Congrès Internationaux d'Architecture Moderne (CIAM) held in Aix en Provence in 1954 made Habitat its theme.

In 1967, for the Expo at Montreal, the Israeli architect Moshte Safte built a cliff-like structure using mass production methods to create modular housing units which were then stacked in a variety of ways. The structure, called 'Habitat', accommodated a large population in a limited space without restricting human needs for privacy and comfort.

Habitat was also the name chosen for a large international conference on the crisis in human settlements, organised by the United Nations, held in Vancouver in 1976.

Terence Conran, the English designer, opened his first shop called 'Habitat' in Fulham Road, London in 1964. By 1976 he had established an empire of thirty Habitats (five in Europe) selling plain, tasteful furniture and household goods in an eclectic style, 'a mixture of good design basics, like Bentwood, Bauhaus and Butcher's block'.

M Bateman 'A master of interior design' *Sunday times magazine* September 12 1976 22-23.

'Habitat reconsidered' *Architectural design* 46 (10) October 1976.

264 HAPPENINGS (also called Action Theatre, Event Art, Painters' Theatre, Total Art or Total Theatre, Theatre of Mixed Means): The name 'Happenings' derives from Allan Kaprow's earliest public work, 'Eighteen Happenings in six parts', which was performed in New York in 1959.

Happenings integrate several media (hence the description 'Mixed Means' and 'Total Art'); they are a cross between an art exhibition and a theatrical performance developed by painters and sculptors, and consequently they emphasise visual, tactile, and olfactory responses, rather than literary or verbal experience. Generally they avoid such features of traditional theatre as plot, character, actors, and repetition of performance, but they do make use of scripts, themes, and rehearsals, (they are not

157

merely improvised events). Happenings are not fixed in time (their duration tends to be uncertain), or venue (they can be performed in galleries, private houses, back yards or in the countryside). Great stress is laid on materials, and participants are often made to look like objects, performances usually result in a great deal of mess and destruction, and impermanence is an essential part of the aesthetic of Happenings. Audiences at these events have to be prepared to endure physical discomfort and possible abuse.

Happenings lack rational plots or storylines; their structures are compartmentalised like a collage or Assemblage, a dreamlike conjunction of objects, environments, and actions. Precedents for the phenomena of Happenings can be found in the Dada 'Cabaret Voltaire', and the unlikely juxtapositions typical of Surrealism. It is possible to trace a line of development from the Cubist collage via Assemblage—Tableau—Environments— to Happenings, but this explanation is probably too pat. Perhaps more important was the influence of the idea that the artists' creative performance was as important as the end product (see Action Painting); and also the influence of John Cage: several artists later associated with Happenings attended his courses at Black Mountain College in the early 1950s.

The major centre of Happenings was New York, and artists working there during the 1960s included Allan Kaprow, Jim Dine, Red Grooms, Claes Oldenburg, George Segal, Robert Whitman, Al Hansen and George Brecht; but similar events have taken place in Japan (see Gutai Group) and in cities throughout Europe (see Fluxus, Direct Art, Presentological Society, Decollage, Actions).

A Hansen *Primer of Happenings and time/space art* (NY, Something Else Press, 1965).

A Kaprow *Assemblage, Environments and Happenings* (NY, Abrams, 1965).

A Kaprow 'The Happenings are dead . . . long live the Happenings' *Artforum* 4 (7) March 1966 36-39.

J-J Lebel *Le Happening* (Paris, Denoel, 1966).

M Kirby *Happenings: an illustrated anthology* (NY, Dutton, 1966).

Happenings & Fluxus (Cologne, Kolnischer Kunstverein, 1970).

R Kostelanetz *The theatre of mixed means* (Pitman, 1970).

U Kulterman *Art-Events and Happenings* (Mathews Miller Dunbar, 1971).

C Oldenburg *Raw notes* (Halifax, Nova Scotia, Press of the Nova Scotia College of Art & Design, 1973).

A Henri *Environments and Happenings* (Thames & Hudson, 1974).

A Kaprow *2 measures* (Torino, Martano Editore, 1976).

265 HARD ARCHITECTURE: Prisons, mental hospitals, and other public buildings are increasingly being designed to resist the human imprint: they are often impervious, impersonal, inorganic, windowless, with rough surfaces to prevent graffiti. Robert Sommer argues that this type of hard, sterile architecture is symptomatic of the security state of mind and that it exacerbates alienation and isolation. The antithesis of Hard Architecture is, of course, Soft Architecture (eg inflatables).

R Sommer *Tight spaces: Hard Architecture and how to humanize it* (Englewood Cliffs, New Jersey, Prentice Hall, 1974).

266 HARD-EDGE PAINTING: This expression was first used by the Californian critic Jules Langster in 1959 to characterize the abstract paintings of four West Coast artists—Karl Benjamin, Lorser Feitelson, Frederick Hammersley, John McLaughlin—positing an alternative to the gestural, improvised painting produced by Action painters and Tachists. (The four painters themselves preferred the term 'Abstract Classicism'.)

According to Lawrence Alloway, a critic who has extended the Hard-Edge concept, this type of painting treats the whole picture surface as one unit: forms extend across the canvas from edge to edge, and therefore Hard-Edge Painting has no 'figures on a field' or other depth effects. Paint is applied evenly to produce an immaculate finish, colours are restricted to two or three saturated hues and delineations between areas of colour are abrupt (hence Hard-Edge); often this creates optical shimmer. (If by 'Hard-Edge' we mean merely a technique of painting with sharp edges of colour rather than blurred edges—some writers use the term in this sense—then it is also applicable to many of the paintings of Pop artists.) The main exponents of the style are Ellsworth Kelly, Alexander Liberman, Al Held, and Jack Youngerman; their precursors were Josef Albers, Ad Reinhardt, and Barnett Newman (see Colour-Field Painting). At first sight Hard-Edge Painting appears to continue the linear, rational, geometric abstraction of artists like Malevich, Mondrian and Max Bill but in most instances the relation is to preceding American painting than to the European tradition. Many painters and sculptors outside the United States have been influenced by Hard-Edge, or have arrived at a comparable style independently, especially in Britain (see Situation).

See also Non-Relational Painting.

159

J Langster 'Four Abstract Classicists'—in—*West Coast Hard-Edge* (ICA, 1960) 3-6.

L Alloway 'On the edge' *Architectural design* 30 (4) April 1960 164-165.

L Alloway 'Classicism or Hard-Edge?' *Art international* 4 (2-3) 1960 60-62.

J Coplans 'John McLaughlin, Hard-Edge and American painting' *Artforum* 2 (7) January 1964 28-31.

M Baigell 'American Abstract Expressionism and Hard-Edge: some comparisons' *Studio international* 171 (873) January 1966 10-15.

267 HARMONOGRAM: A machine-engraved linear design. The term implies a high degree of precision in the mathematical/geometric patterns (like those found on British bank notes).

K Yukimasa 'Geometric patterns by Guilloche engraving machines' *Graphic design* (48) December 1972 67-72.

268 HAUS-RUCKER-CO (House-mover company): An experimental Austrian architectural design group formed in 1967 by two architects, Laurids Ortner, Zamp (Gunter Kelp), and Klaus Pinter, a painter/designer; they are also assisted by a staff of five with other skills. Their particular specialities are plastics—they are sometimes referred to as the 'plastics people'—pneumatic structures, air mattresses and life support systems.

'Conceptual architecture' *Design quarterly* (78/79) 1970 29-33.

'Haus-Rucker-Co-Live!' *Craft horizons* 30 (4) August 1970 30-33.

269 HERMETICISM: A term used by Werner Haftmann to describe a variety of post-war European painting exemplified by the work of artists such as Jacques Villon, Jean Bazaine, Alfred Manessier, Ernst W Nay, Theodor Werner, Fritz Winter, and Guiseppe Santomaso. The word 'hermetic' derives from alchemy and means 'airtight', 'closed in', 'absolutely sealed', and many critics use it in this sense to describe self-contained, self-referring styles of painting. However Haftmann's term refers to painting that appears abstract, but which is pregnant with representational references. See also Homeless Representation, Intrasubjectives.

W Haftmann *Painting in the twentieth century* vol I (Lund Humphries, 1960).

270 HISTORICISM: Nikolaus Pevsner uses this word to describe a post-modern, anti-rational tendency in twentieth century architecture and design which relies on historical precedents as a source of inspiration. In Pevsner's view Historicism marks an unfortunate retreat to those nine-teenth century values that the Modern Movement architects sought to re-place. As examples of recent stylistic revivals Pevsner lists Neo-Accommodating, Neo-Liberty, Neo-German Expressionism, Neo-Perret, Neo-De Stijl, Neo-Art Nouveau and Neo-School of Amsterdam.

P Collins 'Historicism' *Architectural review* 127 (762) August 1960 101-103.

N Pevsner 'The return of Historicism' *Studies in art, architecture and design vol 2: Victorian and after* (Thames & Hudson, 1968) 242-259.

271 HI-WAY CULTURE: Lawrence Alloway's term for the icons and hardware generated by automative transport and the road system in the United States. More particularly, the motifs of traffic signs, petrol stations, speed, commerce, and urban folklore found in the work of such Pop artists as Claes Oldenburg, George Segal, and Allan D'Arcangelo.

See also Pop Art.

L Alloway 'Hi-Way culture' *Arts magazine* 41 (4) February 1967 28-33.

272 HOLOGRAPHS: Three-dimensional images can be reconstructed by passing a beam of laser light through a hologram wave interference photo-graph. The British artist Margaret Benyon has made use of this technical achievement to produce what are called 'Holographs' or 'Stereo-Paintings'.

In the United States an exhibition of Holography and art entitled 'N dimensional space' was held at the Finch College Museum of Art in 1970.

Holography is also claimed to be a new tool of value to architectural designers. See also Laser Art, Conceptual Architecture.

H Wilhelmsson 'Holography: a new scientific technique of possible use to artists' *Leonardo* 1 (2) April 1969 161-169.

D Dickson 'Art: holographs by Margaret Benyon' *New scientist* May 20 1971 p 480.

L Fader & C Leonard 'Holography: a design process aid' *Progressive architecture* 52 (6) June 1971 92-94.

J Benthall 'Laser holography and interference patterning'—chapter in—*Science and technology in art today* (Thames & Hudson, 1972) 85-98.

273 HOMELESS REPRESENTATION: A trend in American and European painting of the 1950s identified by Clement Greenberg: painterlessness which tends towards abstraction but which continues to suggest representation. An example would be Willem De Kooning's series of 'Women' paintings executed between 1952 and 1955. Subsequently this approach to painting became a mannerism adopted by artists outside the Abstract Expressionist style.

See also Bay Area Figuration, Hermeticism.

274 L'HOMME TÉMOIN: A group of young French painters, including Bernard Buffet and Paul Rebeyrolle, exhibiting in Paris in 1949, whose work was described as a kind of "pictorial existentialism bearing witness to the emptiness and desolation of the world".

275 HOUSE STYLE (also called Group Identity, Company Handwriting): A design trend that emerged in the 1950s. Alec Davis defines a House Style as "a visual character—in all means whereby an organisation comes into contact with people—which is recognisable as belonging to that organisation". Designers are usually specially commissioned by large industrial concerns and public enterprises to impose a common design style on items such as publications, advertising, signs, letter headings, packaging, symbols, exhibition stands, name plates, labels, overalls or uniforms, and colour schemes. In the United States, House Style is usually referred to as 'Corporate Design'.

A Davis 'House Style: a special issue' *Design* (95) November 1956.

J Pilditch *Communication by design: a study in corporate identity* (McGraw-Hill, 1970).

276 HUMANIST ART: Barry Schwartz, the American apostle of 'Humanist Art', believes there is an irreconcilable opposition between technology and humanity. He divides all art into 'humanist' and 'non-humanist' according to whether it aligns itself with the increasing technocratization of human existence and the environment (non-humanist) or whether it opposes that tendency (humanist). He identifies four varieties of Humanist Art: metaphysical, existential, absurdist, and political. 'The metaphysical humanist creates work that is active symbolically; he engages the viewer in the interpretation of the work' (eg Leonard Baskin, Philip Evergood, George Segal). 'The existential humanist creates images that confront the viewer by provoking a response' (eg Duane Hanson, Francis Bacon, John Bratby). 'The absurdists employ a repulsion-curiosity

162

mechanism' (eg Robert Crumb, Jim Nutt, Gladys Nilsson). 'The political humanist wants to contact the viewer's feelings of oppression and struggle' (eg Ben Shahn, Duane Hanson, Edward Kienholz, May Stevens).

Although not all figurative art is Humanist, all Humanist Art is figurative as opposed to abstract. Schwartz does not justify his assumption that the experience of artworks expressing dismay or disillusion towards society will improve the viewer's social conscience; for someone who believes that 'optimism is a lie', he displays a remarkably optimistic belief in the reforming potential of art.

In the USSR, where technology is looked upon as a positive force, the apostle of humanism in art is Vladislav Zimenko: 'art at its best has always glorified Man, poeticised his wisdom, strength and beauty and has always been an active means of affirming humanistic ideas . . .'

Predictably, Zimenko equates the humanistic essence of art—depictions of man as a social being—with the official Soviet aesthetic doctrine of Socialist Realism which is presented as the heir to the great tradition of Humanist Art dating back to cave painting. Artists whom Zimenko admires include A Deyneka, A Plastov, B Ioganson, V Ivanov, D Zhilinsky and G Korzhev. Zimenko ignores American Humanist Art (and Chinese peasant painting), while condemning as anti-humanist all manifestations of the Western Avant Garde.

B Schwartz *The new humanism: art in a time of change* (David & Charles, 1974).

V Zimenko *The humanism of art* (Moscow, Progess Publishers, 1976).

277 HYBRID ENTERPRISES: A market research approach to art initiated by two English artists, Peter Phillips and Gerald Laing, while resident in New York in 1964/65. They compiled kits of materials—colour samples, optical patterns, choice of forms, statistical sheets—and issued them to a number of critics, dealers, and collectors. When the data was returned it was processed by computer and art objects constructed in accordance with the specifications provided. The objects that resulted were three dimensional but unlike traditional sculpture, for they were made of glamorous materials such as perspex and aluminium.

See also Custom Painting.

M Amaya *Pop as art: a survey of the New Super Realism* (Studio Vista, 1965) 129-130.

'Hybrid Consumer Research Project' *ICA bulletin* (151) October 1965 17-18.

G Laing 'Hybrid' *Control* (8) August 1974 p15.

278 HYPER-REALISM: An international trend in art on display at the seventh Paris Biennale in 1971. A form of extreme realism often combined with alterations of scale: wall-size photographs transferred to canvas, the image of a crumpled bed on canvas which itself is crumpled; paintings of corners of rooms sited to create trompe l'oeil effects; life-size three dimensional figures. Many European writers use the term 'Hyper-Realism' as an equivalent of 'Photo-Realism' and 'Verist Sculpture' which are the terms preferred in Britain and the United States.

See also Photo-Realism, Verist Sculpture.

U Kultermann & P Faveton 'La révolte des réalistes' *Connaissance des arts* (244) June 1972 118-123.

I

279 ICA (Institute of Contemporary Arts, London): The ICA was founded in 1947 by Herbert Read and Roland Penrose to encourage new developments in the arts. Its programmes include art exhibitions, films, theatre performances, concerts, poetry readings, lectures, and discussions. Many leading British artists have been members of the ICA and have formed fruitful associations under its auspices (see Independent Group). For many years the ICA was located in Dover Street but it moved to more spacious premises in The Mall in 1967. The ICA is an organisation which has a rapid turnover of directors, which frequently experiences financial difficulties, and which is often uncertain about the role it should play in the artistic life of London.

ICA bulletin (1953-1968).

S Braden 'Malaise in the Mall' *The guardian* June 23 1972 p10.

ICA quarterly (1) September/December 1975- .

280 ICOGRADA: Acronym for 'International Council of Graphic Design Associations', a body founded in 1963. Three years later an audio/visual archive and library service of slides, films, slide/tape lectures relating to graphic design was established; it is located at Bolton College of Art and Design, Lancashire.

S Adshead 'The ICOGRADA audio/visual archive' *Art libraries journal* 1 (3) Autumn 1976 18-20.

281 ICONICS: W H Huggins and D R Entwisle have argued that there is a need for a science of Iconics which would stand in relation to images and pictures as linguistics stands in relation to language. Iconics would be concerned with 'that body of knowledge . . . common to art and aesthetics, cognitive and perceptual psychology, education and learning, linguistics and semantics, and computer graphics'.

See also Pictorial Rhetoric, Semiotics.

W H Huggins & D R Entwisle *Iconic communication: an annotated bibliography* (Baltimore, Johns Hopkins U Press, 1974).

282 ICP (Institute of Contemporary Prints): A British national graphic archive established in 1973 with the financial aid of the Sir Robert McAlpine Foundation. Stewart Mason, the curator of ICP, persuaded most British publishers of prints to participate in a voluntary deposit scheme. He also acquired Henry Moore's complete graphic archive. Since 1974 the print department of the Tate Gallery has been taking over the work of the ICP.

'The National Archive of Graphic Arts' *Arts review* 28 (1) January 9 1976 p6.

283 ICSID (International Council of Societies of Industrial Design): A body founded in 1957. The secretariat of ICSID is located at 45 Avenue Legrand, 1050 Brussels, Belgium and it publishes a quarterly information bulletin made up of contributions from several European design organisations.

284 INDEPENDENT GROUP (IG): The name of an informal ideas group composed of members of the ICA, London, who met intermittently between 1952 and 1954. Participants included Lawrence Alloway, Reyner Banham, Magda and Frank Cordell, Theo Crosby, Toni Del Renzio, Richard Hamilton, Nigel Henderson, John McHale, Eduardo Paolozzi, Colin St John Wilson, Alison and Peter Smithson, and William Turnbull. Thus the IG represented a wide cross-section of the visual arts: architecture, painting, sculpture, photography, and art criticism. Its purpose was to examine the implications of science, technology, the mass media, and popular culture for art at mid-century. Topics discussed included the machine aesthetic, Action Painting, popular music, car styling, consumer goods, fashion, and communication theory. American mass circulation magazines, advertising, cinema, and science fiction provided much of the source material. The term 'Pop Art' was used during IG meetings to refer to popular, mass

165

culture products. Subsequently, after the IG had ceased to exist, the term was applied to fine artworks exploiting popular culture, ie using its imagery and graphic techniques.

Various members of IG were involved in the mounting of two important exhibitions of the 1950s, namely, 'Parallel of life and art' (ICA, 1953), and 'This is tomorrow' (Whitechapel Gallery, 1956).

According to Toni Del Renzio the article on the IG by Frank Whitford (listed below) is misleading.

See also Pop Art.

L Alloway 'The development of British Pop'—in—*Pop Art*, by L R Lippard & others (Thames & Hudson, 1966) 27-67.

F Whitford 'Paolozzi and the Independent Group'—in—*Eduardo Paolozzi* (Tate Gallery, 1971) 44-48.

Pop art in England: beginnings of a new figuration (Hamburg, Kunstverein, 1976).

T Del Renzio 'Style technique and iconography' *Art & artists* 11 (4) July 1976 34-39.

T Del Renzio 'Pop' *Art & artists* 11 (5) August 1976 14-19.

285 INDETERMINATE ARCHITECTURE: A new approach to architectural design propounded by the English architect John Weeks in the early 1960s. His buildings—in particular the Northwick Park Hospital of 1961—were designed to provide "inbuilt potential for growth and change which is matched to the growth and change in the organisation which the buildings house"; therefore their form is 'indeterminate' from the outset. The notion of 'indeterminacy' derives, ultimately, from the uncertainty principle of physics formulated by W Heisenberg in 1927.

Weeks' idea for a completely flexible architecture has been developed further by the Archigram group.

See also Random Art, Endless Architecture, Archigram.

J Weeks 'Indeterminate Architecture' *Transactions of the Bartlett Society* 2 1963-1964 85-106.

286 INFORMATION: Title of a major exhibition held at the Museum of Modern Art, New York in 1970. The show presented a report, international in scope, on the activities of younger artists working with photographs, films, documents, concepts, and language rather than with paint or clay. The choice of the word 'information' as a title reflected the consciousness of the artists of the age of information and mass media systems of communication, and also the fact that documentation was itself the means by which the artists presented their ideas.

166

K L McShine (ed) *Information* (NY, MOMA, 1970).

G Battcock 'Informative exhibition . . .' *Arts magazine* 44 (8) Summer 1970 24-27.

287 INSTALLATION: A word frequently used in art magazines, especially American ones, in captions to photographs of galleries showing the layout and disposition of artworks in exhibitions. Its use reflects the dependence of much recent art on particular gallery spaces or settings. An installation show is normally a once-only affair and close-up photographs of single works would not reveal their crucial relationship to the environment. The word also has industrial or mechanical associations appropriate to Minimal sculptures, which are often fabricated in factories according to specifications supplied by the artist.

See also Minimal Art, Environmental Art.

288 INTER-ACTION: A community arts association, established in 1968, located in houses due for redevelopment in Kentish Town, London. Inter-Action has forty associates and is led by an ex-Rhodes scholar, Ed Berman. Its aim is to involve ordinary people in local affairs, to give them a sense of belonging to a community and of living in a particular neighbourhood. Their methods of achieving this aim include game techniques, Street Theatre, a Fun Art Bus, 'technological folk art' forms such as Media Vans, video, photography, and films. The intention is to communicate positive social messages via entertainments and spectacles; primarily these forms are directed at children and adolescents in the hope that through them adults will become involved.

A plan exists for a more permanent structure to house Inter-Action, to be designed by Cedric Price.

See also Action Space, Actions, Community Art, Street Art.

'Invisible London' *Time out* (116) May 5 to 11 1972.

P Harrison 'Art and community' *New society* 27 (590) January 24 1974 202-203.

289 INTER-MEDIA, MIXED-MEDIA, MULTI-MEDIA:Three expressions which art critics use more or less synonymously; they all reflect a trend towards an integration of the traditional forms of art—painting, sculpture, poetry, music, dance, theatre, etc—a trend characteristic of much art activity since 1945.

'Mixed-Media' is probably the broadest term of the three because it refers to fairly conventional art works composed of different materials—

oil paint, fabric, sand, metal and wood collaged together—and also to performances combining say, dance, film, light and sound. The latter phenomena are also called 'Multi-Media', meaning many media used simultaneously.

Dick Higgins, a member of Fluxus, has popularised the term 'Inter-Media', which he defines as 'media between media'. Higgins is proprietor of 'Something Else Press', a publishing concern which promotes all forms of Inter-Media art. It is claimed that there has been an 'Inter-Media revolution', whose prophet was John Cage; parallels have also been drawn with the development of interdisciplinary sciences such as Cybernetics.

Festivals and exhibitions devoted to Inter-Media include 'Intermedia '68' held in New York, and 'Intermedia '69' held in Heidelberg.

Inter-Media appears to have become formalised into an art form in its own right, if the number of groups devoted to it are any guide: in 1965 Otto Beckmann founded a group in Vienna called 'Art Intermedia'; in 1968 Joe Kyle founded a group in Vancouver called 'Intermedia'; the American artists' collective known as USCO has recently formed a group called 'the Intermedia Systems Corporation'.

Many writers regard the Inter, Mixed, Multi-Media trend as indicating the ultimate disintegration of the traditional art forms, and they talk constantly about the 'death of painting'; but, as Susan Sontag points out, while there are artists who break down distinctions between genres, there are always other artists and critics, equally radical, who differentiate ever more precisely between genres, and who strive to isolate the essential characteristics of each art form (see, for example, Modernist Painting).

See also Assemblage Art, Fluxus, Happenings, Environmental Art.

Intermedia '69 (Heidelberg, Edition Tangente, 1969).

L Warshaw 'Intermedia workshop' *Arts in society* 6 (3) Fall/Winter 1969 448-451.

G Youngblood *Expanded cinema* (NY, Dutton, 1971) 345-398.

S Kranz 'The forms of Intermedia'—chapter 9—*Science and technology in the arts* (NY, Van Nostrand Reinhold, 1974) 209-287.

290 INTRASUBJECTIVES: Title of an exhibition of paintings by American artists held in New York in 1949, including work by Willem De Kooning, Hans Hofmann, Arshile Gorky, Mark Tobey and others. The show was organised by Harold Rosenberg and Samuel Kootz in an attempt to delineate a cohesive movement. The name 'Intrasubjectives' derives from an essay by José Ortega y Gasset and refers to a method of arriving at abstraction via subjective experience rather than by an objective study

of the external world. The label did not catch on, but later the majority of these artists were subsumed under the name Abstract Expressionism. See also Hermeticism.

The Intrasubjectives (NY, Kootz Gallery, 1949).

291 INUIT ART (also called Eskimo Art, Artic Art): 'Inuit' is the Eskimo word for the Eskimo people. The Eskimos themselves have no word for art therefore 'Inuit Art' is a concept of the white culture of North America; the term was popularised via books and exhibitions organised by the Canadian Eskimo Arts Council. Although some applique panels, basketwork, and jewellery are known Inuit Art primarily consists of carvings made from soapstone, whale bone, walrus ivory, antlers, and driftwood, and to prints made from carved stone plates. Typically the carvings depict hunters, animals, mothers and children; they are usually small in scale since they are designed to be handled: they appeal to the sense of touch as much as the sense of sight. Carving was a traditional activity of the Eskimos but it had fallen into disuse until it was revived in the late 1940s as a means of providing employment for the Eskimo people. The process of printmaking was introduced in 1958. Edmund Carpenter, the anthropologist, has suggested that James Houston, the man primarily responsible for promoting Inuit Art, has not preserved an indigenous art but rather has created a new art which relates more to the tourist industry than to the past of the Eskimo.

J Meldgaard *Eskimo sculpture* (Methuen, 1960).

G Swinton *Eskimo sculpture* (Toronto, McCelland & Stewart, 1965).

Canadian Eskimo Arts Council *Sculpture/Inuit-Eskimo* (Toronto, U of Toronto Press, 1971).

C Burland *Eskimo art* (Hamlyn, 1973).

E Roch (ed) *Arts of the Eskimo: prints* (Toronto, OUP, 1975).

E Carpenter *Oh, what a blow that phantom gave me!* (Paladin, 1976).

292 INVISIBLE PAINTING: A description applied to paintings by three American artists—Ad Reinhardt, Paul Brach and Ludwig Sander—that have colour or tonal values so closely attuned that they exist on the threshold of human perception. At first glance Invisible Paintings appear to the viewer to be uniform in tone, but if time is allowed for the eye to accommodate to the subtle differences, then the image contained in the painting, usually a cross form, becomes visible. Reproductions of such painting in art books are virtually worthless, they give no indication of their

merit. It is part of the programme of these artists that they oppose the easy assimilation of art via illustrations in art books and magazines.

293 IRASCIBLES: Eighteen American artists who sent a letter of protest to the Metropolitan Museum, New York and who refused to participate in national art competitions because they claimed award juries were so hostile to advanced modern art. The Irascibles included the leading figures in the Abstract Expressionist movement. A photograph depicting fifteen of them appeared in *Life* on January 15 1951.

I Sandler *Abstract Expressionism: the triumph of American painting* (Pall Mall Press, 1970) frontispiece, p213.

294 IRAT (Institute for Research in Art and Technology): An administrative organisation working on behalf of various autonomous groups that from time to time make up the institute. IRAT was founded in 1968 and was first located at the New Arts Lab, London. Later it moved to an old dairy in Kentish Town, London. The institute provides studio space for individual artists, and assists groups concerned with alternative theatre, alternative television, film and photography co-operatives, printing, electronics, computers, plastics, children's workshops. The television department of IRAT has published a report on the influence of video in community development. Trustees of IRAT include the writer J G Ballard, Reyner Banham and Joe Tilson; its secretary-general is Michael Julian.

See also Technological Art, Arts Lab.

295 ITALIAN CRAZE (or Expresso Style): In Britain during the years 1953-1960 a mania developed for Italian design—Olivetti typewriters, Expresso coffee-making machines, Piaggio 'Vespa' scooters, Gio Ponti furniture, Nebiolo typefaces, Italian clothes and Italian films—especially among young, newly affluent, teenagers. In 1956 Cecil Gee introduced Italian male fashions into England: narrow trousers, winkle-picker shoes, short 'bum-freezer' jackets with narrow lapels, and striped shirts.

Italian products continue to excite interest. One writer claims that there is a 'design explosion' in Italy called the 'poltrona (armchair) boom'. Leading Italian designers include Gio Ponti, Ettore Sottsass, Joe Colombo, Bruno Munari, Gae Aulenti and Achille Castiglioni. They are particularly admired for the high quality and elegance of their architecture, interior design, furniture, and ceramics, all of which are regularly featured in *Domus* magazine.

170

See also the Supersensualists.

M Laski 'Expresso' and S Gardiner 'Coffee bars' *Architectural review* 118 (705) September 1955 165-173.

Italy: the new domestic landscape (NY, MOMA, 1972).

P Fossatti *Il designo in Italia 1945-1972* (Torino, Einaud, 1973).

J

296 LA JEUNE PEINTURE: A group of young artists based in Paris, formed in 1965, who used their art as a means of political protest. A work which received a great deal of publicity concerned Marcel Duchamp —an artist La Jeune Peinture regarded as the apotheosis of art for art's sake—it depicted Duchamp's 'murder'. The group also protested about American involvement in Vietnam and about the repressive role of culture in France: in 1968 members of the group participated in the poster workshop Atelier Populaire. The best known members of La Jeune Peinture were Gillies Allaud, Eduardo Arroyo, Antonio Recalcati, and Bernard Rancillac.

See also Atelier Populaire, Political Art.

M Gibson ' "La Jeune Peinture"—protest and politics' *Art in America* 58 (6) November/December 1970 142-145.

297 JOHN MOORES: An open exhibition of British painting, sponsored by John Moores, held biennially since 1958 at the Walker Art Gallery, Liverpool. Entries are selected by a panel of experts and a number of prizes are awarded. The exhibitions are reviewed at length in the British art press.

298 JUDD'S DICTUM: A remark by the American sculptor and writer Don Judd in answer to the perennial question 'but is it art?' to the effect that 'if someone calls it art, it's art' (to which one is tempted to reply 'if someone else says it is not art, it's not art.). Judd's Dictum has been discussed at length in Conceptual Art journals.

See also Artworld.

R Pilkington & D Rushton 'Don Judd's dictum and its emptiness' *Analytical art* (1) July 1971 2-6.

299 JUNGIAN AESTHETICS: Whereas Freudian analysis concentrates on individual histories and idiosyncrasies, Jungian theory is concerned with the psychological character of humanity in general. Jungian theories of art tend, therefore, to stress artists' use—conscious or unconscious—of archetypes in their work and their semi-conscious awareness of the 'collective unconscious'. Jungian theorists generally assume that all artists are men urged into creativity (which is Feminine) by various types of involvement with the Mother archetype. However, Neumann's explanation that 'in opposition to the demands of the cultural canon, the creative man holds fast to the archetypal world and to his original bisexuality and wholeness, or, in other words, to his self' could equally well apply to women artists.

A Jungian analysis has been applied to the sculpture of Henry Moore. And while Moore himself wished to avoid conscious knowledge of such theories, American artists such as John Graham, Rothko, and Gottlieb were keen to learn all they could. For some years Jackson Pollock underwent analysis by a Jungian and produced drawings for his psychotherapist which were later published. The American examples demonstrate that not all art is a direct reflection of the unconscious; in many instances the artist reflects upon the material of the unconscious and works with the psychological theories which are current in his time.

See also Freudian Aesthetics.

E Neumann *The archetypal world of Henry Moore* (Routledge & Kegan Paul, 1959).

E Neumann *Art and the creative unconscious* (Routledge & Kegan Paul, 1959).

M Philipson *Outline of a Jungian aesthetic* (Evanston, Illinois, North Western University Press, 1963).

A Jaffe 'Symbolism in the visual arts'—in—*Man and his symbols;* edited by C G Jung (Aldus Books, 1964) 230-271.

C L Wysuph *Jackson Pollock: psychoanalytic drawings* (NY, Horizon Press, 1970).

J Wolfe 'Jungian aspects of Jackson Pollock's imagery' *Artforum* 11 (3) November 1972 65-73.

300 JUNK CULTURE: Lawrence Alloway coined this term in the 1950s to describe art that rescues the waste products of city life, art that incorporates objects that accumulate in drawers, cupboards, and attics, discarded but still retaining the history of their human use.

See also Junk Sculpture, Assemblage, Le Nouveau Réalisme.

L Alloway 'Junk culture' *Architectural design* 31 (3) March 1961 122-123.

301 JUNK SCULPTURE (also called Scrap Art): A form of collage or assemblage popular in Europe and the United States during the 1950s. Metal objects, automobile parts and other debris taken from refuse dumps were used as a basis for sculpture by artists such as John Chamberlain, César, Richard Stankiewicz, Eduardo Paolozzi and Lee Bontecou. Some artists presented objects as found, others transformed their discoveries, usually by welding metal parts together to form abstract sculptures. The method of collaging junk together can be seen as a reaction against the carving and modelling traditions of sculpture. It derives primarily from the work of Kurt Schwitters, the first great exponent of the artistic exploitation of street debris.

See also Assemblage Art, Nouveau Réalisme.

K

302 KINETIC ARCHITECTURE: In their book published in 1971 William Zuk and R H Clark argue that the static, fixed forms of traditional architecture are unable to respond to the pressures exerted on them by a society in a state of flux, and therefore they make a plea for a new type of architecture, called 'Kinetic', which would be dynamic, adaptable, and responsive to the changing demands of its users. The broad category of Kinetic Architecture includes a number of other concepts: 'Reversible Architecture', 'Incremental Architecture', 'Deformable Architecture', and 'Disposable Architecture'. Zuk and Clark quote examples of the work of R Buckminster Fuller, Pier Luigi Nervi, the Metabolists, Archigram, and others, to show that forms of Kinetic Architecture already exist.

A similar concept called 'Mobile Architecture' was proposed by a number of young architects from France, Holland, Poland and Israel who met in Paris in 1957 and formed an organisation called 'Groupe d'Études d'Architecture Mobile' (GEAM). In a manifesto published in 1960 GEAM suggested the reform of property and land rights to make possible constructions that would be variable and interchangeable, buildings with movable

floors and ceilings, buildings on rafts, etc. The demand for such extreme flexibility was made in response to the overwhelming problems of modern town planning. Mobile Architecture would not be expected to be constantly on the move, only to be capable of being moved if required.

See also Additive Architecture, Indeterminate Architecture, Plug-in Architecture.

M Ragon 'Architecture Mobile' *Cimaise* (64) March/June 1963 106-115.

H Dudar 'Mobile architecture' *Art in America* 54 (4) July/August 1966 70-87.

W Zuk & R H Clark *Kinetic architecture* (NY, Van Nostrand Reinhold, 1971).

303 KINETIC ART (also called the Movement Movement): The word 'kinetic' derives from the Greek for 'moving'. In the nineteenth century it was applied to movement phenomena in physics and chemistry; in the twentieth century it was used sporadically in the context of plastic arts, but Kinetic Art as a distinct movement did not emerge until the 1950s. Kinetic Art has been described as four-dimensional because it adds the dimension of time to sculpture. According to Frank Popper, various kinds of movement can be identified (a) actual movement—mobiles, moving lights, machines, (b) virtual movement—a response within the spectator's eye to static visual stimuli, (c) movement of the spectator in front of the art work or manipulations of parts of the art work by a spectator. Some theorists do not accept examples of virtual movement as truly Kinetic, they prefer to classify virtual movement as Optical Art (see Op Art); Popper regards virtual movement as half-way between static and Kinetic Art. Nevertheless, Kinetic Art can be viewed as a logical extension of virtual movement and the two forms of art—Op and Kinetic—are frequently discussed together.

Kinetic Art requires technical proficiency, and therefore Kinetic Artists seek a union of art and technology. They have a natural tendency to form groups and claim to pursue 'visual research' rather than art activities (see for example GRAV, Group Zero, Nouvelle Tendance). Unfortunately, merely to ape the teamwork and techniques of science does not by itself produce comparable results. Many kinetic artists seem to believe that static art in inherently inferior to art that moves, while critics who believe the opposite refer to Kinetic Art disparagingly as 'turnable art'. Kinetic Art is an international movement, but is especially favoured in Europe and South America, and the major artists associated with it are

174

Yaacov Agam, Nicolas Schoffer, Jean Tinquely, Victor Vasarely, Yvaral, J R Soto, Frank Malina and Pol Bury.

See also Electronic Art, Light Art, Technological Art.

G Kepes (ed) *The nature and art of motion* (Studio Vista, 1965).

S Bann & others *Four essays on Kinetic Art* (Motion Books, 1966).

(Special issue on Kinetics) *Studio international* 173 (886) February 1967.

M Compton *Optical and Kinetic Art* (Tate Gallery, 1967).

G Brett *Kinetic Art: the language of movement* (Studio Vista, 1968).

F Popper *Origins and development of Kinetic Art* (Studio Vista, 1968).

Kinetics (Hayward Gallery, 1970).

(Six articles on Kinetics) *Studio international* 180 (926) October 1970.

F J Malina (ed) *Kinetic Art: theory and practice, selections from the journal Leonardo* (NY, Dover, 1974).

304 KINETIC MOBILES: The name given to works by the British artist Bryan Wynter (1915-1975), consisting of cutout shapes, abstract elements, suspended in space and turning before concave mirrors to produce kaleidoscope effects of colour in space.

P Heron 'Bryan Wynter' *Studio international* 189 (975) May/June 1975 227-229.

305 KITCHEN SINK SCHOOL: A label applied by David Sylvester to the realist paintings of John Bratby, Derrick Greaves, Jack Smith and Edward Middleditch—four English artists, ex-students of the Royal College of Art—exhibiting at the Beaux Arts Gallery, London, in the middle 1950s. These painters specialised in depicting domestic squalor; their work resembled, to some extent, Social Realist art, but they disavowed any political intentions. Their banal subject matter—tables loaded with food and cereal packets—anticipated the content of Pop Art, but their vision and manner of painting were fundamentally academic. Edward Lucie Smith described Kitchen Sink as 'an eccentric detour' in the history of British painting; he also included under this heading two followers of David Bomberg (see Bomberg School): Frank Auerbach and Leon Kossoff.

The Kitchen Sink trend was not restricted to painting; it was also manifested in the films of the period and in plays by John Osborne and Harold Pinter.

'The Beaux Arts Gallery and some young British artists' *The studio* 154 (775) October 1957 110-113.

306 KITSCH: Most writers on Kitsch state that the word derives from the German 'verkitschen'—to make cheap. Hence Kitsch is artistic rubbish, or 'low art' that apes the effects of past fine art styles, and in the process cheapens them. However, Gilbert Highet has suggested that the word may derive from the Russian 'Kichit'sya' meaning to be haughty and puffed up. Harold Rosenberg describes Kitsch as the daily art of our time—all those cheap, sentimental, cute artifacts found everywhere in Western industrialised societies—an art form that follows established rules when the genuine modern artist puts into question all rules in art. Clement Greenberg remarks that if the avant garde represents the forefront of art, Kitsch represents the rearguard, or, as another writer expresses it, Kitsch is the mirror image of formalism.

Kitsch is a form of art pollution, or pseudo-art, created for mass consumption. It is a commodity among commodities, and its audience and effects are utterly predictable; it is one-dimensional and therefore unable to provide an authentic aesthetic experience. Since the vast majority of the populations of Western societies are now 'middle-class', Kitsch is an expression of their taste in striving to possess the opulence previously enjoyed only by the aristocracies. Examples of Kitsch include cheap replicas of famous artworks, factory-produced paintings sold in Woolworths, most 'art' sold in 'art' shops, the enormous output of products associated with the gadget, gift, souvenir, and tourist industries, as exemplified by the garden gnome and Disneyland. Kitsch manifests itself in every media—films, advertising, interior decoration, music, fiction, etc. Most critics regard Kitsch as an inevitable consequence of the industrial revolution—a mass produced art catering for millions who wish to embellish their environment, but who are philistine in their tastes because they lack formal education and have lost contact with traditional folk culture. Abraham Moles, who has undertaken the most complete analysis to date of the phenomenon of Kitsch, claims that it satisfies the bourgeois values of security, self-esteem, ownership, geniality, and the need for daily rituals.

Mass taste is manipulated above all by advertising, and the latter is frequently geared to the exploitation of sex, hence the expression 'Porno Kitsch' coined by Gillo Dorfles. Most critics discuss Kitsch in a tone of moral disapproval—Kitsch has been called the cultural revenge of the lower classes—but it does have its appreciators; for example, Camp taste delights in outrageously bad art. Many artists and designers are also attracted to Kitsch as a contrast to the over-refined quality of much fine art—Yves Klein expressed his intention to produce art in bad taste, Claes

176

Oldenburg has made use of Kitsch decoration in his environmental sculptures , and the Italian design groups Archizoom and Superstudio exploit similar sources. The American architect Morris Lapidus builds highly successful Kitsch hotels, the decoration of which bastardises many styles; they provide, according to one critic, a "medium for visceral and tactile fulfilment, the pornography of comfort".

Other fine artists who utilize Kitsch are Robert Warrens, Andrew Logan, Robin Page and Mathius Klarwein. Artists whose work can be classified as Kitsch include Salvador Dali (late work), Anthony Brandt, Leonor Fini and Vladimir Tretchikoff (dubbed 'King of Kitsch').

In the United States an alternative term to Kitsch is 'Schlock Art' (from the Yiddish meaning 'cheap merchandise').

See also Biba, Camp, Disneyana.

G Dorfles (ed) *Kitsch: an anthology of bad taste* (Studio Vista, 1969).
Kitsch: the grotesque around us (Wichita Art Museum, 1970).
L Giesz *Phänomenologie des kitsches* (Munich, Fink, 2nd ed 1971).
J Sternberg *Les chefs d'oeuvre du Kitsch* (Paris, Editions Planète, 1971; English edition: Academy, 1972).
A Moles *Le Kitsch: l'art du bonheur* (Paris, Mame, 1971).
R Steinberg (ed) *Nazi-Kitsch* (Darmstadt, Melzer Verlag, 1975).
C F Brown *Star-spangled Kitsch* (George Prior, 1976).
'Kitsch issue' *Artlook* (100) April/May 1976.

307 KRAZY KAT ARCHIVE: A pop culture/kitsch/media collection containing several thousand items—images, books, comics, science-fiction magazines, postcards, toys, modelling kits, etc—donated to the Fine Art department of St Andrews University, Scotland by the Scottish sculptor and Pop artist Eduardo Paolozzi (the collection had previously served as source material for Paolozzi's work). The official title for the collection is 'The Archive of Source Material for Twentieth Century Art' but the name 'Krazy Kat' is more appropriate: Krazy Kat was a cartoon character of the 1920s.

See also Pop Art, Kitsch.

R Spencer 'Krazy Kat Archive' *Studio international* 185 (952) February 1973 47-48.

308 KUNSTKOMPASS: An annual listing of the top one hundred artists of the Western world. For five years in succession number one has been Robert Rauschenberg. The Kunstkompass, devised in 1969 by the German Dr Willi Bongard, is not a best-seller list but a reputation scale which

is arrived at by awarding points according to certain criteria, for example, works purchased by museums; artists whom museum curators would ideally like to collect; representations of artists in exhibitions and in art literature. Bongard is the editor of *Art aktuell* a newsletter (available on subscription only) which provides confidential information, gossip, and business trends concerning the international art scene.

F Whitford 'You're the tops' *Studio international* 184 (950) December 1972 211-212.

'Top hundred for 1972' *Flash art* (38) January 1973 p17.

F Whitford 'Doctor Bongard's list to starboard' *Studio international* 188 (971) November 1974 p6 review section.

'W Bongard, Kunstkompass' *Domus* (564) November 1976 21-24.

L

309 LANDSCAPE SCULPTURE: A new type of sculpture identified by the magazine *Landscape architecture* in 1971, and defined as "designed landscape forms which embody more than one sculptural medium beyond earth itself; an organic system of materials used to express a unified aesthetic concept, and responsive to conditions set by its physical environment".

See also Earth Art, SITE.

'Landscape sculpture' *Landscape architecture* 61 (4) July 1971 special issue.

310 LANGUAGE ART: A large number of artists use, or have used, language (or words, or letters) in a manner which relates to the tradition of visual art rather than to literature (see, for example, Book Art, Calligrams, Concrete Poetry, Conceptual Art, Lettrism, Story Art) but their work is so diverse that it is virtually impossible to bring it together under one heading. The introduction of the term 'Language Art' is an attempt to provide such a heading but it is so lacking in specificity as to be almost useless.

J G Bowles & T Russell (eds) *This book is a movie: an exhibition of Language Art and Visual Poetry* (NY, Dell, 1971).

178

Language & structure in North America (Toronto, Five Six Seven Gallery, 1975).

311 LASER ART (laser = acronym for 'light amplification by stimulated emission of radiation'): According to Dr Leon Goldman, lasers—devices for producing coherent, high intensity beams of radiation, or light—provide artists and craftsmen with a new tool for use in the fields of design, etching and sculpture. Lasers have already been used to carve jade and plastic and a helium/neon laser has been used, in association with optical and acoustic systems, to produce a form of Kinetic Art. Laser holography enables three-dimensional sculpture to be presented when the original is unavailable (see Holographs).

Pencil-thin light beams of various colours up to a mile in length, produced by lasers, have been employed by artists such as Rockne Krebs and Keji Vsami to create Environmental artworks. An exhibition devoted to Laser Art was held at Cincinnati in 1969.

See also Conceptual Architecture, Light Art.

Laser light: a new visual art (Cincinnati Art Museum, 1969).

L Goldman 'Lasers—a coherent approach to art' *New scientist* January 21 1971 146-148.

L Goldman 'Progress of Laser Art in lapidary work' *Lapidary journal* 25 (2) May 1971 328-329.

312 LETTRISM: An international avant garde movement, based in Paris, established in 1950 by Isidore Isou (a Rumanian writer who came to France in 1945) and Maurice Le Maitre. Lettrists publicise their ideas with 'aggressive megalomania'; they believe that the word in poetry has been exhausted and concentrate instead on the letter. Similarly they believe that figuration and abstraction in painting and sculpture are dead ends, and as an alternative they propose a new formal structure based on the letter or sign. In fact Lettrism "claims to be able to revolutionise every aesthetic discipline of its time", including, besides those already mentioned, the novel, the theatre, the cinema, architecture, and even politics!

The term 'Lettrism' is also employed by art critics in a wider sense; that is, to describe the introduction of words, letters, signs and pictographic symbols into paintings by artists such as Jasper Johns, S Arakawa, Robert Watts and Robert Indiana.

See also Concrete Poetry.

I Isou 'The creations of Lettrism' *Times literary supplement* (3,262) September 1964 796-797.

C Cutler 'Paris: the Lettrist movement' *Art in America* 58 (1) January-February 1970 116-119.

N & E Calas 'Lettrism'—chapter in—*Icons and images of the sixties* (NY, Dutton, 1971) 131-148.

G-P Broutin & others *Lettrisme et Hypergraphie* (Paris, Georges Fall, 1972).

313 LIGHT ART (also called Lumia or Luminism): Willoughby Sharp believes that Light Art—the literal use of light in art—is the only totally new art form of our time. The term itself is a broad concept encompassing such diverse phenomena as colour organs, fireworks, projected light, and sculpture made of neon tubes. Light Art is usually treated as a subdivision of Kinetic Art, but some writers claim it is such a large movement that it deserves a separate status. A more pertinent reason for such a separation is the fact that not all artists who use light are concerned with movement or a changing display of lights in time; for example, Dan Flavin's austere neon sculpture relates to Minimal Art, and Chryssa's neon tube lettering relates to Pop Art, not to Kinetic Art.

Among the best known Kinetic artists who have exploited light in the years since 1945 are Lucio Fontana, Nicholas Schoffer, Julio Le Parc, Bruno Munari, Frank Malina, and those artists associated with the German Group Zero, and the French organisation GRAV.

See also Electrographic Architecture, Kinetic Art, Laser Art.

Kunst-licht-kunst (Eindhoven, Stedelijk Van Abbemuseum, 1966).

N R Piene 'Light art' *Art in America* 55 (3) May/June 1967 24-47.

A T Spear 'Sculptured light' *Art international* 11 (10) Christmas 1967 29-49.

F Popper 'Light and movement'—in—*Origins and development of Kinetic Art* (Studio Vista, 1968) 156-189.

T B Hess & J Ashbery (eds) *Light from Aten to laser* (NY, Macmillan, 1969) Art News Annual 35.

W Sharp 'Luminism and kineticism'—in—*Minimal art: a critical anthology;* edited by G Battcock (Studio Vista, 1969) 317-358.

314 LIVING ART: In its straightforward sense this expression means the art of now, art by living artists; hence it has been chosen as a title by periodicals dealing with contemporary art—for example, *Living art*

published by the ICA, London during the early 1960s, and the French journal *L'art vivant* (1968-1975).

More profoundly, the expression refers to an attempt to transcend the division (that Robert Rauschenberg believes exists) between art and life, by substituting 'the real for the aesthetic object' (see, for example, Actions, Actualism, Direct Art, Living Sculpture). In effect, Living Art seeks the end of art. However, as Ad Reinhardt noted, "art is always dead, and a 'living art' is a deception". Herbert Marcuse agrees that the notion is absurd, because art "must retain, no matter how 'minimally', the Form of Art as different from non art, and it is the Art Form itself which frustrates the intention to reduce or even annul this difference . . . Art cannot become reality, cannot realise itself without cancelling itself as Art in *all* its forms . . ."

H Marcuse 'Art as a form of reality'—in—*On the future of art* edited by E Fry (NY, Viking Press, 1970) 123-134.

A Reinhardt—quoted in—*Conceptual art* by U Meyer (NY, Dutton, 1972 p 167.

315 LIVING SCULPTURE: An example of the persistent tendency in the art of recent years for the artist to abandon the production of physical objects and to present himself, or a tableau vivant, as the artwork. In 1961, for example, the Italian artist Piero Manzoni signed nude models and also declared his friends to be works of art. The trajectory of Manzoni's oeuvre was towards a total identification of his body, its processes and products, with art. In 1962, during the Fluxus-inspired 'Festival of Misfits' held in London, Ben Vautier exhibited himself in the window of Gallery One for fifteen days and nights as an example of 'Living Sculpture'.

In Stockholm in 1969, Pi Lind, following the precedent established by Manzoni, provided a number of pedestals in a gallery so that real people could sit motionless pretending they were statues. The Greek artist Jannis Kounellis, who works in Rome, has introduced parrots and cacti into artworks; in 1969 he exhibited a number of horses in an art gallery. The English artist Stuart Brisley has in recent years presented himself in various gallery settings described as 'life situations'.

In London in 1972 Ann James mounted an exhibition called 'Sculpture in Reverse' based on the idea that visitors to the show themselves constituted the exhibition; Ann James provided a setting of cobwebs. In exhibitions of extremely realistic sculpture it has become a cliché to

include a motionless live human in order to induce uncertainty in the spectator about what is, and what is not, real.

See also Gilbert & George, Performance Art, Verist Sculpture.

316 LOGOPTICS: In 1974 Michael Peters registered Logoptics as a tradename. It is a pictorial sign system designed to replace verbal language, for example, in simple instructions on medicine bottles, first-aid boxes, freezers, etc. UNESCO and others have shown an interest in Logoptics because it may be able to overcome language barriers.

'I've rediscovered hieroglyphics' *Design* (323) November 1975 48-51.

317 LOS ANGELES FINE ARTS SQUAD: A group of four painters— Victor Henderson, Terry Schoonhover, Jim Frazin, and Leonard Korin— who live and work in Venice, Los Angeles. The squad was founded in 1969 and specialises in the creation of large-scale murals on the blank walls of buildings. One of their paintings may take as long as a year to complete; scenes depicted include views of local streets rendered in a trompe l'oeil, sign-painter's style, but while they are life-scale and realistic, they usually contain incongruous additions; for example, a street scene may be given a layer of snow (which has never fallen in Venice, California).

See also Street Art.

T H Garver 'Venice in the snow . . .' *Artforum* 9 (6) February 1971 91-92.

G Glueck 'Art notes: the art squad strikes again' *The New York times* July 9 1972 p16.

W Wilson 'The LA Fine Arts Squad: Venice in the snow and other visions' *Art news* 72 (6) Summer 1973 28-29.

318 LOST SCULPTURES (or Invisible Sculptures): 'Lost' is used as the opposite of 'found' in 'found objects'. A term applied by Max Kozloff and others to the Minimal Art of Don Judd, Carl Andre, and Robert Morris, whose sculptures are so sparse in their visual appeal that they may easily be read as real, nondescript objects of the everyday world. A work by Carl Andre exhibited at the Sonsbeek tri-annual at Arnhem in 1971 was mistaken for rubbish by a park attendant and cleared away. Claes Oldenburg created an Invisible Sculpture called 'Placid City monument' for the 'Sculpture in Environment' exhibition held in New York in 1967. It consisted of a trench 6ft x 6ft x 3ft excavated by two gravediggers and then filled in again. A similar project for a buried cube has been put

forward by Carl Andre. Spectators would have to take the existence of such works on trust.

319 LYRICAL ABSTRACTION: A phrase suggested by the French painter Georges Mathieu as a title for an exhibition held in Paris in 1947 (the show was in fact called 'The imaginary') featuring work by Wols, Hans Hartung, Jean-Paul Riopelle, Camille Bryen, Jean Atlan, and others. Pierre Restany and other critics have employed it to refer to the more decorative, non-violent, poetical painters of L'Art Informel and Abstract Expressionism (eg Sam Francis, Philip Guston, James Brooks, Helen Frankenthaler). Many American critics regard Lyrical Abstraction and its recent revivals (see The New Informalists) as an emasculated version of Abstract Expressionism.

P Restany *Lyrisme et abstraction* (Milan, Apolinaire, 1960).
Lyrical Abstraction (NY, Whitney Museum, 1971).

M

320 THE MADI MOVEMENT: A South American Kinetic Art movement founded in Buenos Aires in 1946 by Gyula Kosice and others. The word 'madi' is a contraction of 'Madrid'! Kosice and his colleagues attempted to create a totality of the arts based on the common denominator, movement. Their ideas were expressed in manifestos and in the magazine *International Madi Art*, eight numbers of which appeared between 1947 and 1954.

See also Kinetic Art.

M Ragon 'Kosice the poorly-known precursor and the Madi Movement' *Cimaise* (95/96) January/April 1970 30-45.

321 MAGAZINE ART: Since their emergence in the eighteenth century, art magazines have been growing in numbers and influence. Their ability to establish the reputation of an artist and to promote an art movement has been particularly marked in the twentieth century. Realising the power of the art magazine groups of artists have used existing ones or founded their own journals in order to publicize their work and theories. By the 1970s the power of the art magazine to define and legitimise new

developments in art had overtaken that previously exercised by the art gallery and museum. In the period 1966-1976 a significant number of artists adopted the use of language and/or photo-text combinations as their primary mode of communication and, as a result, a number of new art magazines were founded which presented themselves as art (that is, were no longer merely about art), hence the expression 'Magazine Art'.

In 1976 conferences, exhibitions, and special issues of periodicals were devoted to the subject of art magazines.

See also Book Art.

T Fawcett & C Phillpot (eds) *The art press* (Art Book Co, 1976).

'Art magazines' *Studio international* 192 (983) September/October 1976.

322 MAIL ART (also called Correspondence Art, Envois, Postal Sculpture): In recent years an increasing number of individuals—poets, designers, photographers, architects, painters, typographers—and small groups of artists, mostly residing in the United States and Canada, have made use of the postal system as a means of creating art. The postal service enables information to be recycled, it enables artists to form communication networks, it acts as an interface between artists and the world outside art.

The originator of 'Correspondence Art' was probably Ray Johnson, an American painter who in the late 1950s presided over the creation of a series of seminal collages; they were produced with the help of friends and strangers who posted them to each other for alterations and additions. Johnson describes these activities under the heading 'the New York Correspondance School'. Hundreds of people are now involved in Johnson's network, which Thomas Albright describes as "a continuous happening by mail". Currently such 'schools' are legion: 'Airpress', 'Fat City School of Finds Art', the 'North West Mounted Valise', 'Ace Space Company', 'a space', 'Image Bank', 'Mail Order Art', 'Sam's Cafe', Ant Farm and also the international art federation known as Fluxus. Individual artists exploiting the postal system include Robert Watts and John Dowd.

In Britain Robin Klassnik has distributed a number of large envelopes and constructed a sculpture (which was then displayed in a shop window) from the various items posted to him; this 'Postal Sculpture' event took place in 1972.

The emergence and popularity of Mail Art can be accounted for in several ways: (1) the availability of cheap offset printing machines and zerox machines; (2) it reflects a desire on the part of many artists to collaborate in the creation of artworks, especially to collaborate in ways

184

which make use of the element of chance; (3) it provides a means of linking like-minded artists separated by vast geographical distances and frontiers, (it exemplifies the internationalism of contemporary art); (4) it marks a response to the information explosiom and the massive output of printed ephemera and images associated with it; (5) it provides an outlet for subversive artists who hope to undermine the art establishment and other social institutions by an anti-functional use of communication systems, by means of humour, crank letters, and misinformation.

Thomas Albright claims that Mail artists form an underground whose work is intended as an alternative to the museum/gallery system; however, the movement is now documented, anthologies of Mail art are being published, and large scale exhibitions have already been mounted, for example at the Whitney Museum, New York in 1970. Therefore Mail Art seems fated to become overground, established art.

See also Media Art, Underground Art.

W Wilson 'NY Correspondence School' *Art & artists* 1 (1) April 1966 54-57.

'The New York Correspondence School' *Artforum* 6 (2) October 1967 50-55.

D Bourdon 'Notes on a letter head' *Art international* 13 (9) November 1969 78-80.

R Carline *Pictures in the post: the story of the picture postcard . . .* (Gordon Fraser Books, new ed 1971).

J G Bowles 'Out of the gallery into the mailbox' *Art in America* 60 (2) March/April 1972 p 23.

T Albright 'New Art School' Correspondence' *Rolling stone* (106) April 13 1972 p 20.

T Albright 'Correspondence Art' *Rolling stone* (107) April 27 1972 20-21.

J M Poinsot *Mail Art* (Paris, Cedic, 1972).

D Zack 'An authentik and historikal discourse on the phenomenon of Mail Art' *Art in America* 61 (1) January/February 1973 46-53.

M Kozloff 'Junk mail:an affluent art movement' *Art journal* 33 (1) Fall 1973 23-26.

323 MARXIST AESTHETICS: Although Marx's and Engels' comments on art—generally literature—provide models for marxist criticism, their treatment of art was unsystematic and their references to its role in a future communist society were brief and extremely utopian. Marxist aesthetics, therefore, have developed mostly in the last fifty years as an

attempt by subsequent marxists to explain art in ways consistent with marxist theories of economics, culture, and society. European marxists in the 1930s, such as Theodor W Adorno, Walter Benjamin, György Lukács, Herbert Marcuse, and Max Raphael, explored the possibilities of a marxist aesthetic, but their work was subject to repression both by the rising fascist regimes and by Stalinist Russia where 'Zhdanovism' (named after Zhdanov, its main Russian exponent) became the official approach to art until at least the late 1950s (leading to the identification of marxist aesthetics with prurient and anti-modernist censorship and the promotion of Socialist Realism). The work of Adorno et al (see Frankfurt School Aesthetics) became influential in the West during the 1960s and the importance of Raphael's writings is now being recognised internationally. Other writers on art inspired by marxism include E Fischer, Christopher Caudwell, Arnold Hauser, Frederick Antal, F D Klingender, Stefan Morawski, John Berger, Toni Del Renzio and Peter Fuller; also relevant are the theoretical statements of practising marxist artists such as Bertold Brecht.

Briefly, the main themes of marxist aesthetic theory are: the origins of art and the aesthetic sense; the historical development of art and its relation to the theory of dialectics, to the means of production and the relations of production; the implications for art of economic and social changes and the invention of new technologies such as photography; the relation between form and content; the use-value of art and how artworks acquire exchange-value; art's relation to class, ideology, truth, alienation, and the mass media; the question of the relative autonomy of art; the relevance of art to political struggle and the propaganda needs of communist parties; the role of art in bourgeois, socialist, and future communist societies.

The scattered remarks of Marx and Engels on art cause problems for those writers who feel obliged to insist that these comments must be (1) consistent with each other; and, (2) consistent with later theories. Problems also arise because of the various political uses to which marxist theory has been put, and the frequent reluctance on the part of marxists to subject their mentors to a marxist critique, ie to show in what respects Marx's and Engels' taste in art was shaped by the society in which they lived.

One recurring puzzle of marxist aesthetic theory stems from Marx's observation that despite the passing of Ancient Greece the charm of Greek art persists. The question this raises is posed by Raphael: 'How can art . . . an ideological superstructure in a specific type of economy continue to be effective after this type of economy has ceased to exist?

How can the ideological superstructure be timeless if the foundation has a finite history?'

Another issue concerns the question whether art merely reflects the society in which it is produced or whether artists can, by reflecting on that society, be revolutionaries through their art: 'If ideas can transform society, how can it be asserted that economic forces are in the last analysis decisive? If superstructural categories are contingent upon the material base, how can it be said that such categories are in turn decisive in the transformation of the material base?' (Maynard Solomon).

Marxist aesthetics is still relatively underdeveloped: most collections of essays on the subject rely heavily on pre-war writings, on painstaking analyses of each reference to art made by Marx and Engels, and on the largely tactical comments about the uses of art made by leaders in newly emerged communist states, such as Lenin, Trotsky and Mao. However, the potential of a marxist approach to art is great for two main reasons: (1) marxism does not treat art as autonomous but as integral to the social structure, nor does it treat art as a static, fixed phenomenon but as one which is constantly changing and which can be changed by the self-conscious actions of men and women; (2) since marxism is a philosophy which has no ambition to establish itself as an academic discipline but to realise itself in the world, since it is a philosophy in which all theoretical problems are to be solved in practice, it is one of the few philosophies which is relevant to the needs of the practising artist.

See also Peasant Painting, Political Art.

F D Klingender *Marxism and modern art: an approach to social realism* (Lawrence & Wishart, 1943, repr. 1975).

G V Plekhanov *Art and social life* (Moscow, Progress Publishers, 1957).

E Fischer *The necessity of art: a marxist approach* (Penguin, 1963).

V I Lenin *On literature and art* (Moscow, Progress Publishers, 1967).

L Baxandall *Marxism and aesthetics: a selected annotated bibliography* (NY, Humanities Press, 1968).

M Raphael *The demands of art* (Routledge & Kegan Paul, 1968).

B Lang & F Williams (eds) *Marxism and art: writings in aesthetics and criticism* (NY, David McKay, 1972).

M Lifshitz *The philosophy of art of Karl Marx* (Pluto Press, 1973).

M Solomon (ed) *Marxism and art: essays classic and contemporary* (NY, Knopf, 1973).

A S Vasquez *Art and society: essays in marxist aesthetics* (NY, Monthly Review Press, 1973).

H Avron *Marxist aesthetics* (Ithaca, NY, Cornell U Press, 1973).

K Marx & F Engels *Karl Marx and Frederick Engels on literature and art: a selection of writings;* edited by L Baxandall (NY, International General, 1974).

324 MASS ART: Harold Rosenberg used this expression to describe popular art consumed by a mass audience: Hollywood movies, pulp fiction, television shows . . . (see also Kitsch). More recently, Jasia Reichardt has applied it to psychedelic posters, or non-utilitarian objects, produced for a mass market but not necessarily created by professional artists.

A special issue of *Revue d'esthetique* (3/4) 1974 was devoted to the theme of Mass Art. Among the topics discussed were Pop music, garden Kitsch, photo-novels, graffiti, and street murals.

L'Art de masse n'existe pas (Paris, Union Generale d'Editions, 1974) special issue *Revue d'Esthetique.*

325 MATTER ART: An aspect of L'Art Informel. During the 1950s European painters such as Jean Dubuffet, Jean Fautrier, Antonio Tapies, Enrico Donati and Alberto Burri made use of 'unworthy' materials (*ie* non fine art) such as cinders, sand, old sacking, charred wood, etc, in place of, or in addition to, oil paints. The surface of their paintings resembled a hardened crust, a rind. Matter artists wanted to incorporate 'reality' in a non-illusionistic way, thus matter was not only the medium but also the subject. A similar attitude is evident in the work of those artists belonging to the Art Povera, Earth Art and Anti-Form movements. Recent paintings (1971) by Larry Poons suggest a revival of interest in Matter Art among younger artists.

326 MEC ART (or Peinture Mécanique) is short for 'Mechanical Art'. It is a term used by the French painter Alain Jacquet and the Italian artist Mimmo Rotella to describe 'paintings' produced entirely by the creative manipulation of photo-mechanical reproduction processes. Such works are issued in editions of 200 or more. Mec Art reflects the influence of techniques pioneered by the American painters Robert Rauschenberg and Andy Warhol.

See also Multiples, Silk Screen Printing.

O Hahn 'Lettre de Paris: La peinture mécanique' *Art international* 9 (6) September 20 1965 70-72.

P Restany 'Alain Jacquet:the big game of reality and fiction' *Domus* (510) May 1972 51-55.

327 MEDIA ART: All art is embodied in a physical medium (intermediate agency or substance) whether it is oil paint, bronze, photography, television image, or language, therefore the description 'Media Art' could legitimately apply to all artworks. However, the word 'media', in the twentieth century, refers specifically to those vehicles of mass communication—books, magazines, newspapers, posters, films, television, radio, tapes/records—which dominate the culture of developed societies.

The mass media, it should be noted, are material forms cum distribution systems which package and disseminate primary media (eg music on records). Marshall McLuhan regards the mass media as a global extension of man's senses and consciousness which in turn influence our view of the world (his concept of media is very broad: it includes such things as clothes, the motor car, money). The development of the mass media has had immense repercussions on the fine arts (too complex to enter into here) with the result that there is now a love-hate relationship between them. Pop artists ransack the mass media for images and techniques, while others use art to perform a critique of the mass media (see Pictorial Rhetoric). The fact that a fine artist may use the same technology as the mass media (eg video equipment) does not eradicate the difference between them. On the other hand, there are artists who are employed by the mass media, so that an editor of an annual devoted to illustrations and graphics produced for advertising, cinema, etc felt justified in describing the contents as 'Media Art'.

Gregory Battcock has categorised Les Levine as a Media artist and Thomas Albright has also used the term in relation to a group called 'Sams Cafe' based in Berkeley, California. This group consists of three artists, Marc and Terri Keyso and David Shine. Sam's Cafe makes use of existing structures or institutions such as the postal system, the Press and television in order to reach a huge, non-art audience. For example, in 1971 the group pretended to be a debt collection agency and distributed 20,000 mythical bills giving the address of the local television station as the centre for all enquiries. Naturally enough within a short time the Press, television, radio and police were embroiled in the art work, creating a great deal of documentation. Media Inversion—the feeding of alien elements into sophisticated communications systems in order to turn the networks against themselves—was a political idea fashionable in the 1960s.

In 1977 the theme of Documenta 6 is to be 'Art and the media'.

See also Documenta, Information, Book Art, Magazine Art.

M McLuhan *Understanding media: the extensions of man* (Sphere Books, 1967).

T Albright 'Visuals' *Rolling stone* (85) June 1971 36-37.

D Davis 'Media/art/media' *Arts magazine* 46 Summer 1971 43-45.

J Benthall 'The inflation of art media' *Studio international* 183 (937) October 1971 125-126.

E Booth-Clibborn (ed) *European illustration 74,75* (Constable, 1974).

G Battcock 'Les Levine: media artist' *Domus* (560) July 1976 50-51.

328 MEGASTRUCTURES (including Omnibuildings): During the 1960s a number of architects, in response to the daunting urban problems of the twentieth century, proposed vast new structures (mega=great) to replace existing cities, on the grounds that large problems require large technological solutions. In the design of Megastructures individual buildings become merely components or lose their separate identity altogether; these designs also attempt to allow for the demand for universal mobility and for rapid change, their overall purpose being to provide a total environment for work and leisure. The best known architects associated with the Megastructure concept are Kenzo Tange (Tokyo Bay project), Leonardo Ricci, Paolo Soleri (see Arcology), Yona Friedman and the British group Archigram. Commonly cited examples of Megastructures are Place Bonaventure, Montreal and Cumbernauld town centre, Scotland.

The American architect Robert Venturi has dismissed Megastructures as designs for 'fashionable hill towns with technological trappings'. The term 'mega-structure' is credited to the Japanese architect Fumihiku Maki and dates from 1964.

See also Archigram, Metabolist Group, Utopian architecture.

W Karp 'Omnibuilding' *Horizon* 12 (1) Winter 1970 48-55.

J T Burns 'Social and psychological implications of Megastructures' —in—*Arts of the environment;* edited by G Kepes (Aidan Ellis, 1972) 135-151.

R Banham *Megastructures: urban futures of the recent past* (Thames & Hudson, 1976).

329 META-AESTHETICS: Philosophical inquiry about aesthetic inquiry.

M C Rose 'Nature as aesthetic object: an essay in meta-aesthetics' *British journal of aesthetics* 16 (1) Winter 1976 3-12.

330 META-ART: The increasingly fashionable prefix 'meta' (from the Greek meaning 'together with', 'after', 'behind') has been linked to the word 'art' since about 1970. The new term was formed by analogy with 'meta-language', 'meta-mathematics', etc. A meta-language is any language

190

which is used to discuss another language. The former is called 'the observer's language' and the latter 'the object language' (because it is the object of study). As J G Kememy points out, the terms 'meta-language' and 'object-language' are relational and he stresses that 'it is nonsense to ask whether a given language is a meta-language; we can only say that it is being used as a meta-language of another language at the moment. The meta-language can in turn be studied, in which case it is used as an object language, and the previous object language can be the meta-language of a third language.' Consequently there can be an infinite hierarchy: language, meta-language, meta-meta-language, etc.

Straightforward examples of Meta-Artworks are Roy Lichtenstein's paintings, which take as their subject matter paintings by Monet, Picasso, and others. In other instances the term has been introduced to characterise artworks (usually Conceptual) which take as their subject matter the concept 'Art' in its most general sense. Ian Burn and Mel Ramsden have used the term in this way. Similarly, the critic Jack Burnham regards Meta-Art as art activity which makes propositions about art (he believes all forms of non-objective, abstract art are meta-languages). In 1973 the American Conceptual artist Adrian Piper suggested that 'Meta-Art' should be used to describe a new occupation for artists: 'the activity of making explicit the thought processes, procedures and pre-suppositions of making ... art'. She suggested that this activity 'exists as part of, alongside, or instead of the art itself'. It is difficult to see how Meta-Art in these terms differs from existing artists' statements and art criticism.

Another writer, Stanley Paluch, designates as Meta-Art 'those things, in themselves aesthetically irrelevant or insignificant, which take on an aesthetic significance in special contexts and lose that significance as soon as removed from those special contexts' (eg Duchamp's readymades which become art when displayed in art galleries).

E H Johnson 'Jim Dine & Jasper Johns: art about art' *Art & literature* (6) Autumn 1965 128-140.

J G Kemeny 'Semantics in logic'—in—*Encyclopedia Britannica* vol 20 (Chicago, Encyclopedia Britannica Inc., 1970).

S Paluch 'Meta-Art' *Journal of value inquiry* 5 (4) Winter 1971 276-281.

A Piper 'In support of Meta-Art' *Artforum* 12 (2) October 1973 78-81.

J A Walker (Letter) *Artforum* 12 (5) January 1974 p9.

331 METABOLIST GROUP: A Japanese experimental architectural group formed under the direction of Kenzo Tange in 1960. Members include Norboru Kawazoe, Noriaki Kurokawa, Kiyonori Kikutake, Fumi-hiku Maki and Masato Otaka. The Metabolists envisage an architecture whose principles are analogous to those of biology. They are concerned with the design of urban systems, services and connections between build-ings rather than with individual buildings themselves. Kukokawa has de-signed a plant type community with living space above ground and pro-duction facilities below ground level. In a project for the development of the Tokyo Bay area the Metabolists planned a linear, open system capable of responding to different rates of change.

G Nitschke 'The Metabolists of Japan' *Architectural design* 34 (10) October 1964 509-524.

K Kurokawa *Metabolism in architecture* (Studio Vista, 1976).

332 METAMATICS: Jean Tinquely constructed between 1955 and 1959 a number of humorous Kinetic Art works which were both sculptures and painting machines. Coin operated Metamatics displayed at the 1959 Paris Biennale scribbled in coloured inks on sheets or rolls of paper; stylistically the results resembled the abstractions of L'Art Informel and Tachisme.

J Reichardt 'Art at large: the painting machines' *New scientist* 53 (786) March 9 1972 p 563.

333 METRO-LAND: Suburbs, commuting, and rush hours are the inevi-table consequences of the Englishman's determination to enjoy the ben-efits of both urban and rural life, by working in the city and residing in the country. In the period between the two world wars parts of Buck-inghamshire, Hertfordshire, and Middlesex were linked to London by an extension of the Metropolitan electric railway running North West of the capital from Baker Street station. Suburbs were built at intervals along the track and the railway company advertised their creation as 'Metro-land'. In the hamlets along the railway are a number of houses of archi-tectural distinction built by such notable architects as Norman Shaw, Charles Voysey, and Amyas Connell.

Sir John Betjeman, poet and architecture enthusiast, nostalgic for the pre-way idyll of the British middle class has celebrated Metro-land in his poetry and in a film made for television first shown on BBC TV in 1973.

'All stations to Amersham—Sir John Betjeman in Metro-land' *The listener* 96 (2472) August 26 1976 240-241.

334 MINIMAL ART (also called ABC Art, Anti-Illusionism, Bare Bones Art, Cool Art, Literalist Art, Know Nothing Nihilism, Idiot Art, Object Art, Reductive Art, Rejective Art, Primary Structures): The term 'Minimal Art' is thought to have been used first by Richard Wollheim in 1965, though some writers ascribe it to Barbara Rose. It describes a major art movement of the 1960s, primarily American—its supporters claimed that it was the first American movement to owe nothing to Europe—though British artists, such as Anthony Caro, were sometimes included in discussion. The chief exponents of Minimal Art were Robert Morris, Don Judd, Sol LeWitt, Robert Smithson, Ronald Bladen, Walter De Maria, Tony Smith, Dan Flavin, Larry Bell and John McCracken. A major exhibition of Minimal Art called 'Primary Structures' was held at the Jewish Museum, New York in 1966.

Minimal Art was essentially sculptural, despite the inclusion of painters such as Kenneth Noland and Frank Stella by some critics, because the literal, physical space occupied by sculpture was regarded as intrinsically more powerful in the perception of art works than the illusionary space of painting. The most outstanding feature of Minimal Sculpture was its clarity and simplicity, characteristics which reflected the influence of older artists such as Barnett Newman, Ad Reinhardt and David Smith; it also marked a reaction against the emotional self-expression of Abstract Expressionism and Assemblage Art. Minimal artists, by their cooler, blander approach, hoped to create works which would be more resistant to assimilation and so avoid the rapid obsolescence of modes such as Op Art and Pop Art.

Art critics have disagreed as to whether the adjective 'minimal' applies to the finished sculpture—Wollheim's view and also Clement Greenberg's who says that Minimal Art aspires to the condition of non-art (*cf* Lost Sculptures)—or whether it refers to the means by which the sculpture is produced, the opinion held by John Perrault.

Yvonne Rainer has conveniently listed those sculptural qualities which Minimal artists reject or minimise—left hand column—and those they substitute or emphasise—right hand column:

figurative references	non-referential forms
illusionism	literalness
hierarchical relationship of parts	unitary forms or modules
complexity, detail	simplicity
monumentality	human scale
hand craftsmanship	factory fabrication
texture	uninterrupted surfaces

The purpose of such criteria was to establish the autonomous nature of sculpture, to isolate those qualities of scale, shape, proportion and mass considered specific to it and to avoid those qualities appropriate to architecture, monuments and ornaments. Sculpture that was dependent on internal part to part relationships—the Cubist aesthetic—was eschewed on the grounds that it was fundamentally anthropomorphic. In its place the Minimal artist presented unitary, gestalt like forms—for example a cube—which could be perceived at once. In such works aesthetic interest shifts from internal to external relationships, for example to the relationship between the mental concept 'cube' and the varying perceptual shapes of the object as one moves around it, or that between the sculpture and the negative space of its architectural setting: sculpture as place. Many Minimal sculptures were produced for particular gallery or exhibition spaces and were not transferable, thus making Installation a crucial factor.

Often Minimal artists submitted plans or instructions to industrial firms for their pieces to be fabricated. The skilled handwork traditionally associated with sculpture was totally superseded by the process of making aesthetic decisions. This method of working influenced the development of Conceptual Art.

Minimal Art has been strongly attacked for, it is claimed, lacking genuine surprise, for being merely 'Good Design' reflecting the influence of Basic Design courses in art colleges. It has also been criticised on political grounds for being an art form entirely appropriate to big business and right wing attitudes.

See also Art Povera, Earth Art.

G Battcock (ed) *Minimal art: a critical anthology* (Studio Vista, 1968).

C Blok 'Minimal art at the Hague' *Art international* 12 (5) May 15 1968 18-24.

'Aspects of art called "Minimal" *Studio international* 177 (910) April 1969 165-189.

W Van Ness 'The Minimal era' *Arts in society* 11 (3) Fall/Winter 1974 436-451.

335 MODERN ART: A complex notion scrupulously ignored by most art dictionaries. In a broad sense it is a chronological concept describing all the painting and sculpture of present and recent times; more narrowly it is an ideological concept referring to that art of our era which self consciously rejects past modes and aggressively asserts its claim to be the only art truly reflecting our age. No two critics or historians agree exactly

on a date for the birth of Modern Art but it is generally located in the middle, or second half, of the nineteenth century because the revolutionary changes in science, in industry, and in society during that period profoundly influenced the arts and resulted in the formulation of new aesthetic theories, in the development of new techniques and materials, and in changes in the social status of the artist.

Modern architecture and design are also considered to have originated in the nineteenth century but not to have become a fully fledged movement until the twentieth century (see The Modern Movement).

The intensive use of any adjective in relation to the art of a particular historical period inevitably links the word with that period; hence 'modern' is most closely associated with European art movements appearing between 1910 and 1938. Consequently there is a constant search for a term to replace 'modern'. 'Contemporary' was tried but critics claimed it was suggestive of only one generation of artists and therefore too limited in scope. In Britain during the late 1940s and early 1950s 'contemporary' was overworked and became indelibly associated with the art and design of that period (see Contemporary Style). The feeble expression 'new art' is generally employed when critics and exhibition organisers are at a total loss for a name; it has been popular at least since the 1890s (Art Nouveau), was used to greet the arrival of Pop Art (by Alan Solomon, see his essay 'The New Art' in the anthology of the same title edited by G Battcock (NY, Dutton, 1966)) in the 1960s and in 1972 it was used as the title of a major exhibition of the latest trends in British art held at the Hayward Gallery, London.

See also Post-Modernism.

'Modernism'–in–*Encyclopedia of World Art* vol 10 (NY, McGrawHill, 1965) 201-209 columns.

336 THE MODERN MOVEMENT: This expression is virtually synonymous with 'Modern Art' but tends to be used in reference to architecture and design rather than to painting and sculpture. However, R H Wilenski's book *The modern movement in art* first published in 1927 did focus on the latter arts. Wilenski situated the origins of the movement in 1884—the first exhibition of the Salon des Indépendants—and identified its salient characteristics as art in the service of an idea of art (rather than in the service of religion), and a return to classicism.

Nine years after Wilenski's book appeared, Nikolaus Pevsner's *Pioneers of the Modern Movement* was published (the 1960 revised edition is entitled *Pioneers of modern design*), and again the origins of the movement

were located in the nineteenth century. Some writers plump for Art Nouveau as the first Modern style because it avoided the eclecticism of Victorian design; still others are certain the Modern Movement was a manifestation of the inter-war years. They equate 'modern' with the plain, rational designs without ornament associated with the Bauhaus. It was thought at that time that modern architects could produce forms without style which would not date (cp 'Good Design'). Alison and Peter Smithson identify a 'heroic period' which lasted from 1915 to 1929.

Charles Jencks' recent history of Modern Movements begins in 1920. He argues that earlier histories were distorted by omissions caused by ideological bias, and instead of giving a monist account which ascribes value to only one tradition, he presents a plurality of six traditions: logical, idealist, self-conscious, intuitive, activist, and unself-conscious.

Since 1945 it has become clear that the pre-war notions of functionalism were naive. The masters of modern architecture have continued to produce elegant buildings but it is now seen that their work constituted a style like any other. By 1960 Modern Design had become an established tradition against which a younger generation of architects and designers have reacted vehemently.

See Post-Modern Design.

R H Wilenski *The modern movement in art* (Faber & Faber, 4th ed 1957).

N Pevsner *Pioneers of modern design from William Morris to Walter Gropius* (Penguin, 1960).

A & P Smithson 'The heroic period of modern architecture' *Architectural design* 35 (12) December 1965 590-639.

C Jencks *Modern movements in architecture* (Penguin, 1973).

337 MODERNISM: The ideological basis of Modern art, architecture, and design. Ihab Hassan identifies the following conditions and features as relevant to Modernism: urbanism, technologism, 'dehumanization', primitivism, eroticism, antinomianism, and experimentalism. While Clement Greenberg claims that 'Modernism distinguishes itself by its inclusiveness, its openness, and also by its indeterminateness', he also claims that 'Modernism defines itself in the long run not as a "movement", much less a programme, but rather a kind of bias or tropism: towards aesthetic value as such and as an ultimate'. In this way Modernism differentiates itself from popular culture and the mass media.

Other striking characteristics of Modernism are self-consciousness and reflexivity: art which takes itself as subject matter, emphasis on medium, process, and technique, 'honest' use of materials, foregrounding of devices.

Modernism's relation to tradition is somewhat paradoxical. Initially Modernist artists rejected the past in order to stake their claim to being the true representatives of the present age. This rejection became institutionalized in the form of the Avant Garde (see Avant Garde Art) but as time passed Modernism itself became the tradition against which Vanguard artists were expected to rebel; they now find themselves in the uncomfortable situation of being the allies of reactionary anti-modernists. Greenberg argues that Modernism's break with the past (ie Academic Art) was in fact a dialectical move designed 'to maintain or restore continuity . . . with the highest aesthetic standards of the past', to restore 'levels of quality' which in turn were to be preserved by 'constant renewal and innovation'.

For some marxist critics the term 'Modernism' has pejorative connotations of bourgeois decadence and disintegration. By the late 1960s a number of theorists had begun to suspect that Modernism had finally run its course (see Post-Modernism).

The term 'Modernistic' is often used disparagingly to refer to the dominant design style of the 1920s and 1930s (see Art Deco) which combined elements of modern design with past motifs for decorative purposes, or used functional ideas for their visual appeal, for example, streamlining static objects; hence the expression 'bogus Modernism'.

See also Modern Art, Formalism.

(Special issue on Modernism and Post-Modernism) *New literary history* 3 (1) Autumn 1971.

338 MODERNIST PAINTING: The influential American art critic Clement Greenberg, leader of the school of Formalist Criticism, has developed an aesthetic of painting based on the ideological concept of Modernism. Greenberg defines the essence of modernism in painting as "the use of the characteristic methods of a discipline to criticise the discipline itself . . . to entrench it more firmly in its area of competence". He regards Modernist Painting as the mainstream of painting since Manet, painting which openly acknowledges as virtues its physical constraints: flat surface, properties of pigments, shape of support. Movements in painting outside this narrow category Greenberg tends to dismiss as Novelty Art.

See also Formalist Criticism, Novelty Art.

C Greenberg 'Modernist painting' *Arts yearbook* (4) 1960 102-108 (reprinted in *Art & literature* (4) Spring 1965 143-201, and *The new art;* edited by G Battcock (NY, Dutton, 1966) 100-110).

R Krauss ' A view of Modernism' *Artforum* 11 (1) September 1972 48-51.

E A Carmean 'Modernist art 1960 to 1970' *Studio international* 188 (968) July/August 1974 9-13.

339 MODULAR ART: Paintings and sculpture based on a module, that is a unit of size or measurement that is repeated throughout the art work. Architects have used the modular concept for centuries, especially since the development of standardised building components. In recent years furniture designers have also produced many ranges of modular or unit furniture.

The explicit use of modules in the fine arts only developed during the 1960s. The term 'modular' has been applied by critics to sculpture by Carl Andre, Tony Smith and Sol LeWitt, and to paintings by Robert Mangold and Brice Marden. In 1970 an exhibition entitled 'Modular Painting' was held at the Albright-Knox Gallery, Buffalo, New York. Its curator, Robert M Murdock, described the modular approach as "the use of structural elements; a technique in which physically separate modules are constructed as opposed to those represented on a surface".

See also Serial Art.

G Kepes (ed) *Module, symmetry, proportion* (Studio Vista, 1966).

Modular painting (Buffalo, Albright-Knox Gallery, 1970).

340 MOMA: Initials standing for 'Museum of Modern Art' (New York), an influential institution noted for its exhibitions and publications. In 1971 the American artist Les Levine parodied MOMA by creating the 'Museum of Mott Art Inc', located at 181 Mott Street, New York.

341 MONOCHROMATIC & MONOTONAL PAINTING: Since 1945 many painters have followed Malevich's and Rodchenko's example and produced a series of paintings in a single colour or a single tone. Among these artists are Piero Manzoni, Lucio Fontana, Yves Klein, Frank Stella, Robert Rauschenberg, Robert Mangold, Philip Guston, Robert Ryman and Ad Reinhardt. Monochromatic paintings can be regarded as extreme instances of the reductivist aesthetic. Perhaps the most famous series of monochromatic canvases were those produced by Yves Klein in the 1950s

for which he created and patented, special colours: International Klein Gold, International Klein Rose, and International Klein Blue. Udo Kultermann organised an exhibition of monochromatic paintings in 1960.

See also Colour-Field Painting, All-Over Painting, Fundamental Painting.

Monochrome malerei:eine neue konzeption (Leverkusen, Schloss Morsbroich, 1960).

White on white: the white monochrome in the twentieth century (Chicago, Museum of Contemporary Art, 1971/72).

342 MULTIPLES: In the past etchings, lithographs, bronzes and china ornaments have been produced in edition form. They provided—and still provide—collectors with signed artworks cheaper than unique originals. Such editions were strictly limited in order to preserve reproduction quality but there have been signed editions of graphics up to 5,000. Multiples, an extension of the edition concept, are works created by artists that can be repeated—multiplied—in production, theoretically without limit; they are manufactured from a design or matrix.

The idea of Multiples was first suggested by Agam and Jean Tinguely. They put their idea to the Parisian gallery dealer Denise René in 1955 but none were produced until 1962. René tried, unsuccessfully, to patent the word 'multiple' for the exclusive use of her stable of artists; René's Multiples are always issued in strictly limited editions.

During the 1960s many artists produced Multiples: Claes Oldenburg, Daniel Spoerri, Julio Le Parc, Joe Tilson and others. Usually Multiples are a minor stylistic version of an artist's painting or sculpture.

New materials, such as plastics, and new industrial techniques, such as vacuum forming, make possible the mass production of artworks. This, together with the possible utilization of non-art outlets like supermarkets, have caused some critics to view Multiples as a means of democratising art. However, the idea is shallow for, as Jasia Reichardt points out, Multiples are not cheap enough to appeal to a mass market and are still sold through the established gallery system. They are in fact merely another élite category of decorative objects. Other writers have pinpointed the basic problem: Multiples occupy a no man's land between unique artworks and ordinary shop commodities; objects of such uncertain identity are unlikely to sell to a mass market.

See also Cultural Art.

'Multiples Supplement' *Art & artists* 4 (3) June 1969 27-65.

New Multiple Art (Whitechapel Gallery, 1970).

J Reichardt 'Multiples' *Architectural design* 41 (2) February 1971 p 71.

Multiples: the first decade (Philadelphia Museum of Art, 1971).

'Multiples supplement' *Studio international* 184 (947) September 1972 94-108.

J De Sanna 'I multipli: esistono veramente? *Domus* (528) November 1973 1-4.

343 MUSEUM WITHOUT WALLS: The French writer André Malraux has examined the way museums condition our experience of art—we see works divorced from their original context and thus become aware of style above all the other qualities—and believes that reproductions of works of art on cards, in books and periodicals constitute a 'musée imaginaire', an imaginary museum. The Museum Without Walls extends the process set in motion by the physical museum, making available to the private individual the art of all times and of all peoples, though at the cost of providing substitutes for the originals.

See also Slide Culture.

A Malraux *The voices of silence* (Secker & Warburg, 1954).

344 MUSICAL GRAPHICS: As a result of new techniques of composition traditional forms of musical notation have proved inadequate hence the development of unconventional notations called 'musical graphics' or 'implicit notation'. Musical Graphics are drawings or designs whose purpose is to stimulate the musician to produce sounds equivalent in some way to the quality of the image. Composers who have made use of Musical Graphics include Earle Brown, John Cage, Malcolm Carder, Cornelius Cardew, R Haubenstock-Ramati, Mauricio Kagel and Robert Moran. Some examples of Musical Graphics have been regarded as artworks in their own right and have been exhibited in art galleries.

E Karkoschka *Notation in new music: a critical guide to interpretation and realisation* (Universal Edition, 1972).

H Cole *Sounds and signs: aspects of musical notation* (OUP, 1974).

N

345 N E THING COMPANY (NETCO): An avant garde Canadian group established in Vancouver in 1966. 'Anything' is structured like a business company with a 'president'—Iain Baxter—and a number of departments—Research, Things, Accounts, ACT (Aesthetically Claimed Thing), ART (Aesthetically Rejected Thing), Photography, Films, Projects, Consultations and COP. The last department is concerned with 'Cop Art', that is, the use, exploitation or annexation of other artists' work, for example a chevron by Kenneth Noland was extended by fifteen feet, a carrying case was designed for one of Andy Warhol's pillows. NE Thing is not interested in the production of art objects, it regards itself as an alternative device for exploiting cultural knowledge.

L R Lippard 'Art within the Arctic Circle'—in—*Changing: essays in art criticism* (NY, Dutton, 1970) 277-291.

'N E Thing Co Ltd'—in—*Information* (catalogue) (NY, MOMA, 1970) 88-91.

346 NAIVE ART: A taste for exotic and primitive art was a salient characteristic of Modernist culture from its inception. This taste encompassed the work of talented peintres naifs who were contemporaneous with the masters of modern art, the most famous example being 'Le Douanier' Rousseau (an artist who considered himself the equal of Picasso). Recognition of the naive artist's work beyond a local sphere generally depends upon the appreciation of professional modern artists and critics but naive artists themselves remain ignorant of the theory and practice of Modernism while at times influencing it. For example, in St Ives the paintings of Alfred Wallis were admired by the artist Ben Nicholson and the critic Adrian Stokes and while Wallis influenced artists such as Christopher Wood, he himself remained free of influences.

There is some difficulty in arriving at a clear-cut definition of naive art: the term 'primitive' used by many writers is inappropriate because it leads to confusion with tribal art; the description 'non-professional'—without art college training—does not accurately describe naive artists because many of them make a living from their art; in any case many 'professional' artists made their names without benefit of the art education system. Nor is the term 'Laienmalerei' (layman's painting) adequate because although naive artists are often elderly men and women who turn to art as a hobby

in their retirement it is necessary to distinguish their products from those of the majority of amateur, Sunday, spare-time, or do-it-yourself artists who lack the intense and obsessional character of the true naive. The term 'naive' derives from the Latin 'nativus' meaning 'acquired through birth' hence the typical naive artist is naturally gifted and his/her work has a childlike innocence, a spontaneous, ingenuous, unaffected quality. The paradox of naive art is that it is apparently artless, yet naive artists deploy cunning and guile if not the repertoire of acquired skills available to the professional. Naive artists generally favour painting as a medium, they prefer bright colours, they revel in meticulous detail and precise draughtsmanship, they play havoc with the rules of perspective, they almost invariably treat figurative subjects and paint from their immediate experience or knowledge. Their pictures tend to be small in scale, flat, decorative, highly finished, static and crowded. Naive artists ignore the historical stage of development of their chosen medium; their outlook is uncritical, anachronistic and provincial, they address themselves to matters of private import rather than to issues of public moment; they suffer from an excessive narrowness in imagination and are limited in terms of methods and techniques; their art is frequently ingratiating in its appeal. Schools of naive art flourish in such countries as Spain and Yugoslavia where there are strong folk art traditions. Clearly the regimes of these countries are willing to encourage naive art because it is politically harmless.

Clement Greenberg argues that naive painting 'begins with the industrial age. Amid the decay of folk art, picture making—more exactly, easel painting—provided a new outlet for plebeian "artistic energy" '. He claims that its practitioners belong mostly to the petty bourgeois and that it is 'temperamental and psychic factors rather than social ones' which prevent them from acquiring artistic sophistication. In his view it is the 'bungled realism' of their work which is the hallmark of the naive artists, that 'the contradiction between their conscious striving for realism and their inability to organise their pictures except by tidying them up decoratively is precisely what keeps their art styleless'.

The best known naive artists are: André Bauchant, Camille Bombois, Ivan Generalić, Edward Hicks, Morris Hirshfield, Grandma Moses, Joseph Pickett, Henri Rousseau, Séraphine de Senlis, Louis Vivan, and Alfred Wallis. Professional painters who have deliberately adopted the gauche mannerisms of naive art include Marc Chagall, David Hockney, L S Lowry, Ben Shahn, and Christopher Wood.

See also L'Art Brut, Outsider Art, Peasant Painting.

C Greenberg ' "Primitive" painting' (1942, 1958)–in–*Art & Culture* (Thames & Hudson, 1973) 129-132.

O Bihalji–Merin *Modern primitives* (Thames & Hudson, 1971).

R Nacenta *Les naïfs* (Paris, Nouvelles Editions Françaises, 1973).

D Larkin *Innocent art* (Pan/Ballantine, 1974).

A Jakovsky *Peintres naïfs: lexicon of the world's naive painters* (Basel, Basilus Presse, 2nd ed 1976).

G Gamulin *Les peintres naifs:ecole de Hlebine* (Paris, Robert Laffont, 1976).

J A Vallejo–Nagera *Naifs Espanoles contemporaneos* (Madrid, Mas Actual, 1976).

347 NARRATIVE FIGURATION: Narration in art has been out of favour since its 'misuse' by Victorian genre and history painters, but from 1963 onwards a number of painters, mostly based in Europe, developed a new form of Narrative art. The French critic Gerald Gassiot-Talabot organised an exhibition at the Galerie Europe, Paris in 1965 to define the new tendency. Modern narrative art represents events in time–with or without a storyline–on a single canvas. Frequently its imagery is distorted and its subject content fragmented: several sequences may be compressed into one painting. Jasia Reichardt, an English critic who has employed the comparable term 'Narrative Art', claims that it can also include abstract paintings that deal with successive transformations of an image (see Systemic Painting). Narrative Figuration blends aspects of Pop Art with Illustration; it has been influenced by the Cinema and comic strip cartoons. The major artists associated with it are Oyvind Fahlstrom, Gianfranco Baruchello, David Powell, Dado, Hervé Télémaque and Bernard Rancillac.

See also Story Art.

P Couperie & others *Bande dessinee et figuration narrative* (Paris, Musée des Arts Decoratifs, 1967) 233-253.

G Gassiot-Talabot 'Everyday mythologies . . .'–in–*Figurative art since 1945* by J P Hodin & others (Thames & Hudson, 1971) 272-302.

348 NART: Mario Amaya's alternative description for Cool Art and Minimal Art. His neologism is a combination of 'Nothing' and 'Art' and means 'less equals more'. Nart is characterised by impersonality and boredom of repetition; its objects have no development or climax, it is unphotogenic and mechanical. Amaya includes in his category a number of works in different media: 'Dance', a construction by Robert Morris, visual poems by Dieter Rot, musical compositions by La Monte Young,

Andy Warhol's eight hour films 'Sleep' and 'Empire', Carl Andre's sculptures, and paintings by Mark Lancaster. According to Amaya, Nart reflects the influence of Ad Reinhardt, Frank Stella and Zen philosophy.

J Reichardt 'Simplicity and inspired boredom' *Studio international* 171 (874) February 1966 44-45.

M Amaya 'Views/Reviews: Mario Amaya on Nart' *Vogue* (British) 123 (11) September 1966 18-20.

349 NATIONAL ART WORKERS COMMUNITY (NAWC): An organisation which emerged following the dissolution of the Art Workers Coalition. In January 1971, as a result of a College Art Association meeting in Chicago, the first issue of *Art Workers newsletter* appeared announcing the NAWC. It was to be a community service for artists providing advice and information about cheap housing, exhibition space, and insurance.

See also Art Workers Coalition.

J Skiles 'The National Art Workers Community—still struggling' *Art journal* 34 (4) Summer 1975 320-322.

350 NAZI ART: In the 1970s renewed interest has been shown in the artistic products of the Third Reich. On the one hand there are collectors of Nazi regalia motivated by nostalgia, or by a sympathy for fascism, and on the other hand there are art historians who wish to situate Nazi Art in the general history of art. Also there are neo-marxists who wish to display Nazi Art in order to forestall its uncritical rehabilitation. The latter group hope to expose the ideology of fascism, as reflected in Nazi Art, as a weapon against contemporary revivals of fascism. A major exhibition designed for this purpose—'Art of the Third Reich: documents of oppression'—toured Germany in 1974-75. As a follow-up to this show Gustav Metzger organised a symposium (the AGUN symposium) on Nazi Art in London in 1976.

The major Nazi artists were Albert Speer, Ludwig Troost (architects), Ivo Saliger, Paul M Padua, Johannes Schult, Werner Peiner, Adolf Ziegler and Fritz Erler (painters), and Josef Thorak, Arno Breker (sculptors). Realising the importance of art as a cultural weapon the Nazi leaders encouraged the above named artists and suppressed radical and modernist art. Expressionist and abstract art was dismissed as 'degenerate, Jewish and Bolshevik'; it was held up to ridicule in the infamous 'Degenerate Art' exhibition of 1937 which opened at the same time as the official 'Haus der Deutschen Kunst'. Nazi Art celebrated sentimentality (soul, yearning, beauty), the heroism of the German soldier, the land and the

peasantry, the near-pornographic nakedness of Aryan men and women; and monumental architecture and portraits entrenched the power and authority of the Fuhrer. The approved style was neo-classicism for sculpture and architecture and a form of social realism for painting.

Bess Hormats points out that only a small proportion of the art produced in Germany in the 1930s and 1940s was Nazi, the majority was German art of a conservative, academic kind. Nevertheless these conservative artists did not oppose Nazism in their art and they benefited from the Nazi suppression of modern and radical art. There was also the anomalous case of Emile Nolde, an Expressionist sympathetic to Nazism who was forbidden to paint by the Nazis.

See also Political Art.

Die kunst im Dritten Reich 1937-44.

F Roh *'Entartete' kunst: kunstbarbarei im Dritten Reich* (Hanover, Fackeltrager, 1962).

J Wulf *Die bildenden kunst im Dritten Reich: eine dokumentation* (Gutersloh, Sigbert Mohn Verlag, 1963).

H Brenner *Die kunstpolitik des Nationalsozialismus* (Hamburg, Rowohlt, 1963).

G L Mosse (ed) *Nazi culture* (W H Allen, 1966).

A Speer *Inside the Third Reich* (Weidenfeld & Nicolson, 1970).

R R Taylor *The world in stone: the role of architecture in the National Socialist ideology* (U of California Press, 1974).

Art in the Third Reich . . .(Frankfurt, Kunstverein, 1974).

M Hoelterhoff 'Art of the Third Reich . . .' *Artforum* 14 (4) Decmber 1975 55-62.

G Metzger 'Art in Germany under National Socialism' *Studio international* 191 (980) March/April 1976 110-111.

B Hormats 'Whatever happened to the German war art collection?' *Art monthly* (2) November 1976 6-9.

351 NEO-DADA: A label applied in 1958 by *Art news, Newsweek,* and *Time* to the work of Jasper Johns and later extended to cover the work of Robert Rauschenberg. Johns painted banal images—flags, targets, maps, and numbers—filling the whole surface of the canvas, thus raising a question in the spectator's mind as to the identity of the object he was confronting. Rauschenberg incorporated industrial refuse into his Combine Paintings in a manner which reminded critics of Kurt Schwitters' collages. These works were thought to be Anti-Art like Dada, hence the label 'Neo-Dada'. However, the comparison was superficial because the Americans

had little in common with the pre-war European movement, and much of their work retained certain mannerisms of Abstract Expressionism, for example, splashy paint and emphasis on facture, while at the same time reacting against it by focusing on popular imagery. For this latter reason Neo-Dada heralded the arrival of Pop Art, and was called 'Proto-Pop'.

In Europe the equivalent to Neo-Dada was the movement orchestrated by Pierre Restany (see Nouveau Realisme). The work of this group of artists was also categorised as 'Neo-Dada', but in this instance there was more justification because the first Paris exhibition of the group held in 1961 was given the title '40 degrees above Dada'.

352 NEO-LIBERTY: During the 1950s there occurred a revival of interest in the Art Nouveau style, especially in Italy. Architects such as Vittorio Gregotti, M D Bardeschi, Raffaello Lelli, and Leonardo Savioli came under its influence; also the furniture designer Gae Aulenti. Their work was described as "sensuous, decorative, with flowing lines and flower like profiling". Reyner Banham attacked it as a retreat from the ideals of the Modern Movement and dismissed it as 'an infantile regression'.

The expression 'Neo-Liberty' was first used by Paolo Portoghesi in 1958 and was derived from 'Stile Liberty', the Italian name for Art Nouveau (after the British firm of 'Liberty's' which had supplied Art Nouveau style goods to Italy).

R Banham 'Neo-Liberty: the Italian retreat from Modern Architecture' *Architectural review* 125 (747) April 1959 231-235. 'Neo-liberty, the debate' *Architectural review* 126 (754) December 1959 341-344.

T Del Renzio 'Neo-Liberty' *Architectural design* 30 (9) September 1960 375-376.

353 NEO-PICTURESQUE: In Britain in the middle 1940s a revival of interest in the picturesque developed among architects and writers associated with the journal *Architectural review*. As a result of the wartime bombing, Britain's towns had many ruins and in accordance with the picturesque taste for crumbling remains architects were encouraged to retain them.

For example, Basil Spence in his plan for the new Coventry Cathedral incorporated the shell of the old building into his design instead of demolishing it.

354 NEO-ROMANTIC PAINTING: An aspect of British art that developed during the 1930s and continued in the immediate post-war period. A number of painters—John Piper, Edward Burra, Paul Nash, and Graham Sutherland—and the sculptor Henry Moore created works, usually in

watercolour, depicting landscapes in a highly theatrical and emotional manner influenced by the romantic tradition of English art.

Probably this tradition was revaluated during the 1930s as a result of the impact of Surrealism on English artists. In the 1940s younger painters such as John Minton, Robert MacBryde and Robert Colquhuon worked in the same Neo-Romantic vein.

R Ironside 'Painting since 1939'—in—*Since 1939* (Phoenix House, 1948) 147-181.

W Feaver 'Rogue males' *London magazine* 12 (2) June/July 1972 124-136.

W Feaver 'Wartime romances' *Sunday times magazine* May 20 1973 74-85.

355 THE NEW BRUTALISM: A movement in British architecture primarily associated with Alison and Peter Smithson—especially their work during the years 1953 to 1955—and the critical writings of Reyner Banham. The New Brutalism was not so much a style as "a programme or an attitude to architecture"; as the Smithsons put it, "an ethic, not an aesthetic". Above all, the New Brutalists waged a moral crusade against the diluted versions of modern architecture produced in England in the immediate post-war period, and against the compromises they felt even the masters of the Modern Movement were making; the Smithsons set out to re-establish the original integrity and strength of modern architecture. They tried, in buildings like the Hunstanton secondary school, to express structure and services honestly, to use materials truthfully in the tradition of Le Corbusier and Mies van der Rohe. They also admired the sensuous use of materials in Japanese architecture and were conscious of certain classical canons of proportion.

The phrase 'The New Brutalism' emerged in the early 1950s and was used by young architects who had adapted it from the term 'Neo-Brutalists' coined by the Swedish architect Hans Asplund. The phrase has other shades of meaning besides the one given above: it is used in a superficial sense to refer to an international architectural style, popular in the late 1950s, concerned with a Corbusier like treatment of building surfaces (the word 'Brutalism' has been associated with Le Corbusier's béton brut—rough honest brickwork, exposed concrete imprinted with the grain of wooden shuttering—an approach to building design reflecting his intention 'to construct moving relationships out of brute materials'); on other occasions the phrase was linked with L'Art Brut of Jean Dubuffet, the paintings of Magda Cordell, and the sculpture of Eduardo Paolozzi.

R Banham 'Brutalism'—in—*Encyclopedia of Modern architecture* (Thames & Hudson, 1963) 61-64.

R Banham *The New Brutalism: ethic or aesthetic?* (Architectural Press, 1966).

R Boyd 'The sad end of New Brutalism' *Architectural review* 142 (845) July 1967 9-11.

356 THE NEW EMPIRICISM: A term applied by British writers to Scandinavian architecture produced during the immediate post-war period. Also described as 'gentle and self effacing' and 'Welfare State Architecture'.

'The New Empiricism: Sweden's latest style' *Architectural review* 101 (606) June 1947 199-204.

E De Maré and others 'The New Empiricism' *Architectural review* 103 (613) January 1948 8-22.

357 NEW FIGURATION: In the early 1960s, after a decade of abstraction, art critics noted a resurgence of figurative painting in Paris, London and New York. In 1961 the French critic Michel Ragon called this tendency 'Nouvelle Figuration'. A wide spectrum of artists falls into this category, most of them of little merit, the exception being Francis Bacon.

It is claimed that the artists associated with New Figuration continue the 'figural experiments' of Jean Dubuffet, the COBRA painters, and Willem De Kooning. Some writers include the whole Pop Art movement under the heading of New Figuration.

A Pellegrini *New tendencies in art* (NY, Crown, 1966) 197-210.

M Ragon *Vingt cinq ans d'art vivant* . . . (Paris, Casterman, 1969).

358 THE NEW FORMALISM: In the late 1950s several critics noted a new classicising trend in American architecture, manifested in buildings by Mies van der Rohe, Philip Johnson, Paul Rudolph and Minoru Yamasaki. This tendency was labelled 'The New Formalism'.

W H Jordy 'The formal image USA' *Architectural review* 127 (757) March 1960 157-165.

359 THE NEW INFORMALISTS (or New Colourists, Lyrical Colourism, Beautiful Painting): In the last few years a wave of American painters—David Diao, Robert Duran, Alan Shields, Ken Showell, James Sullivan, David Cummings, Donald Lewallen and others—have challenged the view that painting is dead by producing large scale pictures using acrylic pigments sprayed or stained onto the canvas. These works are abstract and extremely decorative. The New Colourists apply paint in multiple layers, a method which 'imitates a natural way of forming matter'. Their emphasis on work procedures reflects the influence of the Process Art aesthetic.

Critics have compared these new works to the painting styles of the 1950s—Action Painting, L'Art Informel, Lyrical Abstraction, Painterly Abstraction—especially the more decorative aspects of these modes. In 1970 Carter Ratcliff called these painters 'The New Informalists' because their work sidestepped the 'formalist' concerns of American painting of the previous decade. He also noted a connection between their use of colour and texture and certain mannerisms associated with youth cult light shows, drug sensibility and tie dye fabrics. Another critic dismissed the new paintings as 'a wave of visual muzak'; nevertheless the influence of this American style has already been registered in work done by fine art students in British colleges of art.

L Aldrich 'Young lyrical painters' *Art in America* 57 (6) November/ December 1969 104-113.

D Ashton 'Young Abstract painters: right on' *Arts magazine* 44 (4) February 1970 31-35.

R Channin 'New directions in painterly abstraction' *Art international* 14 (7) September 20 1970 62-65.

C Ratcliff 'The New Informalists' *Art news* 68 (10) February 1970 46-50.

360 THE NEW MATERIALISM: An extremely broad label devised by William Feaver to describe art that is part painting, part sculpture and part stage prop, made of unworthy materials such as dirt, refuse, slag and perishables. His category includes work by artists such as Keith Milow, Stephen Buckley, David Medalla, Jeff Nuttall and Kenneth Price. Further details on the kind of art Feaver is referring to can be found under the headings Art Povera, Food Art, Funk Art.

W Feaver 'The New Materialism' *London magazine* 10 (8) November 1970 77-85.

361 NEW REALISM: In spite of the dominance of abstraction in twentieth century art many painters and sculptors continue to work in representational or figurative modes. Periodically groups of such artists are 'discovered' by art critics and hailed as embodiments of the New Realism or the New Figuration. For example, since about 1970 a number of American painters (discussed in this glossary under the heading Photo-Realism) have been labelled New Realists.

Critics also claim, from time to time, that a variety of abstract art reveals a new insight into reality, and consequently the words 'real' and 'realism' are in constant use.

See also Le Nouveau Réalisme and under Realism in the Index.

362 THE NEW SENSUALISM: A broad movement in modern architecture identified by *Progressive architecture* magazine in 1959, and essentially the post-war work of the architects Le Corbusier, Paul Rudolph, Eero Saarinen, Minoru Yamasaki, Felix Candela, Pier Luigi Nervi, Jorn Utzon and others. The buildings are sculptural in design and possess a sensuous plasticity of form in contrast to the rectilinear, modular, or flat-surfaced style usually considered typical of modern architecture.

T H Creighton 'The New Sensualism I' *Progressive architecture* 40 (9) September 1959 141-147.

T H Creighton 'The New Sensualism II' *Progressive architecture* 40 (10) October 1959 180-187.

363 THE NEW YORK SCHOOL: A phrase that dates from the 1940s. The growth of the New York School of painting and sculpture since the end of the second world war has been largely responsible for the American domination in art, paralleling the United States' political, economic and military leadership of the West. The New York School usurped the position previously held by the School of Paris.

According to Harold Rosenberg the term is a neutral geographical description referring to a cluster of styles—but primarily Abstract Expressionism—that developed in New York or were given a special inflection there. It is difficult to identify the characteristics of New York painting but Rosenberg suggests a largeness of scale, a direct or crude method of execution, a hardness of light.

R Goldwater 'Reflections on the New York School' *Quadrum* (8) 1960 17-36.

'The New York School' *Artforum* 4 (1) September 1965 (special issue).

H Geldzahler *New York painting and sculpture 1940-1970* (Pall Mall, 1969).

M Tuchman *The New York School: Abstract Expressionism in the 40s and 50s* (Thames & Hudson, 1970).

D Ashton *The New York School: a cultural reckoning* (NY, Viking Press, 1972).

H Rosenberg 'École de New York'—in—*The de-definition of art: Action Art to Pop to Earthworks* (Secker & Warburg, 1972) 188-200.

364 NICE STYLE: The name of a short-lived British performance group —billed as 'the world's first pose band'—consisting of Bruce McLean, Garry

Chitty, Robin Fletcher and Paul Richards operative in the years 1971-1975. A representative performance consisted of three members of the group dressed incongruously in dark lounge suits executing violent and acrobatic movements to the directions of the fourth who sat in the audience; periodically the performers froze so that viewers could appreciate the finer points of their postures; successful poses were described as 'nice' or 'sharp'. The aim of the group was to execute all movements 'with style'. The action took place on a specially constructed scaffold and included in the stage props was a fork-lift truck. In terms of subject the performance satirized the career development of an artist on the make, and it incorporated a humorous critique of Modernist sculpture and criticism. Nice Style's sweaty, campy, absurd proxemics evoked the theatre, fashion modelling, Hollywood musical dancing, boxing, athletics, and the attitudinising required of ambitious business executives.

See also Body Art, Camp, Gilbert & George, Performance Art.

'Nice Style' *Studio international* 186 (960) November 1973 190-191.

'Nice Style at The Hanover Grand' *Audio arts* 1 (2) 1974, sound recording.

C Tisdall 'Nice Style' *The guardian* October 30 1974 p12.

M Hartney 'Nice Style at Garage' *Studio international* 188 (971) November 1974 p1, 9-10 (review section)

'Nice Style at Garage' *Audio arts* (supplement) 1974, sound recording.

'Nice Style' *Studio international* 189 (974) March/April 1975 p i, xiv-xv (advertisement section).

365 NO ART (also called Shit Art, Doom Art): Paintings, sculpture, collages and Assemblage Art by a group of American artists—Boris Lurie, Stanley Fisher, Sam Goodman, Michelle Fisher—exhibiting in New York between 1959 and 1964. Their exhibitions, at the March Gallery and at the Gallery Gertrude Stein, were given provocative titles —'The Doom Show', 'The No Show', 'The Vulgar Show', 'The Involvement Show'—and consisted of chaotic assemblages of rubbish, bloody dismembered toys and sexual fetishes designed to shock the viewer. No Art occurred during the McCarthy era in American politics; essentially it was a form of social protest. No artists disliked uncommitted art, especially Pop Art. They said 'No' to exploitation and pollution of all kinds: advertising, armaments, hunger, poverty, pornography, religion . . . Their preoccupation with faeces —a work by Lurie consisted of mounds of excrement—has prompted the usual psychoanalytical explanation 'anal fixation'.

See also Pop Art, Assemblage Art, Political Art.

L R Lippard & others *Pop art* (Thames & Hudson, 1966) 102-103.

B Lurie 'No Art' (statements)–in–*Aktionen: Happenings und demonstrationen seit 1965,* by W Vostell (Hamburg, Rowohlt, 1970).

G Glueck 'The Non gallery of No Art' *The New York times* section 2, January 24 1971.

E K & R S Schwartz 'No Art: an American psycho-social phenomenon' *Leonardo* 4 (3) Summer 1971 245-254.

B Lurie 'Shit no! ten years after'–in–*Something else yearbook* (Barton, Something Else Press, 1974) 63-73.

B Lurie 'Violence and caprice in "No-Art" ' *Leonardo* 7 (4) Autumn 1974 343-344 bibliog.

366 NOMADIC FURNITURE: It has been calculated that the average American moves his abode every three to four years. Nomadic Furniture is therefore domestic furniture that folds, stacks, inflates, and packs flat, thereby facilitating easy transportation and re-use.

J Hennessey & W Papanek *Nomadic furniture* (NY, Pantheon Books, 1973).

367 NON-RELATIONAL ART: According to Lawrence Alloway, relational paintings, for example Cubist paintings or Hans Hofmann's colourful abstractions, contain a hierarchy of forms—large, medium, small—related one to another. Such paintings exploit the depth effects of 'figures on a field'. In contrast, Non-Relational paintings, for example Frank Stella's canvases of the 1960s, have a single uniform space and avoid depth effects by means of forms which stretch across the picture from edge to edge. Other painters avoid depth by means of an even distribution of accents—see All-Over Painting—or by means of single colours—see Monochromatic and Monotonal Painting.

Because there is a dearth of internal relationships in Non-Relational Painting more importance comes to be attached to the external shape of the support and the rectangle, or Shaped Canvas, itself becomes a 'figure' against the 'field' of the wall on which it is hung. The lack of depth in Non-Relational painting tends to emphasise the lateral reading of pictures, that is left to right or right to left across the surface of the canvas.

The term 'Non-relational' has also been applied to Minimal Art because Minimal sculptors claim that their work is non-figurative, non-symbolic, non-illusionistic, and does not relate to anything outside of itself.

See also Push and Pull, Colour-Field Painting, Hard-Edge Painting, Minimal Art, Shaped Canvas.

368 LE NOUVEAU RÉALISME: A movement in European art, centred on Paris and active during the period 1960 to 1963, sponsored by the French critic Pierre Restany. The expression 'New Realism' was first used by Restany in a manifesto published in April 1960 in anticipation of an exhibition taking place in Milan the following month. In October of the same year at the home of Yves Klein in Paris, Restany formally constituted the New Realist group in the presence of Arman, François Dufrêne, Raymond Hains, Klein, Martial Raysse, Daniel Spoerri and Jean Tinquely; several other artists—J M de la Villeglé, César, Mimmo Rotella, Niki de Saint-Phalle, Gerard Deschamps and Christo—participated in later manifestations of the group.

Many diverse personalities are included in this list. They worked in a variety of different modes (see for example Destructive Art, Metamatics, Monochromatic Painting, Performance Art, Packaging, Snare Pictures, Affiche Lacerees) and despite Restany's rhetoric it is difficult to see what they had in common. A number of these artists were practitioners of Assemblage Art and were called 'Realists' because they appropriated material from the urban environment and incorporated it, unadulterated, into their art works. New Realism has been described as 'art de constant', an art of factual affirmation, an art of precise testimony.

Other activities of the group included a number of spectacles, Actions or Happenings. The title of an exhibition—'Forty degrees above Dada'—held in Paris in 1961 indicated the major source of the New Realist aesthetic. Restany's group were contemporaneous with the American Neo-Dada artists and joint shows were organised in Paris and New York in 1962; thus one finds the terms 'Neo-Dada' and 'New Realism' used interchangeably by some critics. Both movements are seen as presaging the development of Pop Art.

P Restany *Les Nouveaux Réalistes* (Paris, Editions Planète, 1968).

P Restany 'The New Realism'—in—J P Hodin and others *Figurative Art since 1945* (Thames & Hudson, 1971) 242-271.

P Trigano 'Les Nouveaux Réalistes . . .' *Realities* (367) September 1976 56-65, 84.

M Giroud 'Le Nouveau Réalisme' *Art press international* (3) December 1976 30-31.

369 NOUVELLE TENDANCE: An international Kinetic Art movement operative during the first half of the 1960s. The name derives from the title of an exhibition organised by Matko Mestrovic in Zagreb in 1961.

Artists from France, Spain, Holland, Yugoslavia, Switzerland, Germany and South America banded together into groups to produce collective or anonymous work, to exploit new materials and techniques, to explore the use of movement, light and spectator participation in art. The loose association of these groups and their shared attitudes formed the Nouvelle Tendance. Another major exhibition was held in Leverkusen and Paris in 1964.

See also Kinetic Art, Light Art.

Nouvelle Tendance (Paris, Musée des Arts Décoratifs, 1964).

F Popper *Origins and development of Kinetic Art* (Studio Vista, 1968) p102.

370 NOVELTY ART: Clement Greenberg's derogatory term for those art movements of the 1950s and 1960s—Kinetic Art, Pop Art, Op Art, Funk Art—which, in his opinion avoid the essential problems of Modernist Painting. He claims that they are self consciously innovatory, and that they are only capable of offering a one-time aesthetic surprise.

371 NUAGISTES: A minor group of French gestural painters formed by Julien Alvardin in the early 1950s. Members of the group included Frédérick Benrath, Jean Messagier and René Duvillier. Their work employed cursive lines and circular rhythms reminiscent of cloudscapes; 'nuage' is the French word for cloud.

G Gassiot-Talabot 'Les Nuagistes' *Opus international* (28) November 1971 14-17.

L'exposition le nuagisme même (Lyons, Musée des Beaux Arts, 1973).

372 NUCLEAR ART: A short lived movement associated primarily with the Italian artists Enrico Baj (whom Italian critics claim is the father of Pop Art) and Dangelo. Their first manifesto was issued in 1952. A further statement dated 1957 declared its opposition to all forms of geometric abstract art and indeed to any fixed style of art; it proposed instead experimentation with tachist, calligraphic and automatic techniques. The language employed by the Nuclearists refers to 'atomised situations', 'states of matter' and 'heavy water' colours, but exactly what connection was intended with nuclear physics is not clear.

214

The British abstract relief artist, Mary Martin has also employed the term 'nuclear' to describe her method of working, that is building up part by part around a central core or theme.

T Sauvage *Art Nucléaire* (Paris, Editions Vilo, 1962).

'The end of style' *Leonardo* 3 (4) October 1970 465-466.

373 NUL GROEP: A Dutch group established in 1962 by Henk Peeters and Armando. 'Nul' is the Dutch equivalent of 'zero' and the group was directly inspired by the work of the German Group Zero.

O

374 OBJECT ART: This term, or 'Object Sculpture', was used before 1945 to describe paintings or constructions by Futurists, Dadaists, and Surrealists incorporating previously independent non-art objects. It has been employed occasionally in this sense since the war and is essentially an alternative to 'Assemblage'. In 1965 the French critic Alain Jouffrey labelled a group of artists, incorporating objects into their work or taking casts of objects, 'Objecteurs'; the artists concerned were Antonio Recalcati, Jean Pierre Raynaud, Tetsumi Kudo, and Paul Van Hoeydonck.

In 1970 the book of the exhibition of craft objects which had toured the United States was given the title 'Objects USA'.

Earlier in the mid and late 1960s the term 'Object Art' was employed as an alternative for 'Minimal Art'; this usage derived from the expression 'specific objects' coined by Donald Judd. In theoretical terms Minimalism sought to reduce the meta-physical category 'art' to the status of the real by claiming that its essence lay in the materials from which it was made. This forlorn enterprise was thrown into disarray by the emergence of Conceptual Art which forwarded 'mental objects' as art; immediately there was talk of 'post-object art', 'anti-object art', and 'the dematerialization of the art object'. All such quibbles derive from the longstanding philosophical antinomies: subject/object, mind/body, idealist/materialist, meta-physical/physical.

A Jouffroy 'Les objecteurs' *Quadrum* (19) 1965 5-32, 185-189.

F Mathey 'L'objet de notre temps' *Quadrum* (20) 1966 121-136, 180.

D Ashton 'Furnishing an objective world: the role of objects in modern art'—in—*A reading of modern art* (Cleveland, Press of Case Western Reserve University, 1969) 167-176.

L Nordness (ed) *Objects USA* (NY, Viking Press, 1970).

D Karshan 'Post-object art'—in—*Conceptual art & conceptual aspects* (NY, Cultural Centre, 1970).

Métamorphose de l'objet: art et anti-art 1910-1970 (Brussels, Palais des Beaux-Arts, 1971).

W Rotzler *Objekt-kunst von Duchamp bis Kienholz* (Cologne, Dumont, 1972).

L R Lippard *Six years: the dematerialization of the art object . . .* (Studio Vista, 1973).

J Weightman 'The obsessive object'—in—*The concept of the Avant Garde: explorations in modernism* (Alcove Press, 1973) 38-60.

D Brook 'Flight from the object' (1969)—in—*Concerning contemporary art;* edited by B Smith (Oxford, Clarendon Press, 1975) 16-34.

C Newman (ed) 'Anti-object art' *Triquarterly* (32) Winter 1975 (special issue).

E H Johnson *Modern art and the object: a century of changing attitudes* (Thames & Hudson, 1976).

375 OBJECTHOOD: A word that frequently occurs in Formalist Criticism, especially in the writings of Michael Fried. It is Fried's contention that there is a conflict between our readings of physical works of art as art, and as objects; he claims that when we view a painting as an object we are regarding it as a non-art entity. He believes that Modernist Painting, to be valid, must find means to defeat or suspend its own objecthood but without resorting to illusionistic pictorial devices of the past.

The problem is complicated by the fact that the whole trend of art since Gauguin has been to stress the literal, object qualities of painting.

During the 1960s Frank Stella emphasised the box-like quality of the picture support by the use of very thick stretchers. Minimal sculptors banish illusion from their work and stress its Objecthood. They are accused by Clement Greenberg of cultivating a non-art look.

M Fried 'Art and objecthood'—in—*Minimal Art: a critical anthology;* edited by G Battcock (Studio Vista, 1968) 116-147.

376 OP ART (also called Perceptual Abstraction): The term 'Op Art'— short for Optical Art—was first used by *Time* magazine in 1964 and

popularised by James Canaday, art news editor of the *New York times*.
It describes an international movement in painting that emerged during
the 1960s and specialised in the production of violent optical effects
within the visual system of the viewer.

Op paintings are abstract. They make use of parallel lines or patterns
of squares or circles, all painted with sharp precision, and employ strong
colour contrasts, or black and white contrasts, to produce optical shim-
mer. Illusions, after-images, moiré patterns, periodic structures, ambigu-
ous figures are all illustrated in the text books on the psychology of per-
ception and all feature in Op Art. Kinetic Art and Op Art are closely
related and are often discussed together; Op Art provides many examples
of virtual movement and its effects are accentuated by the movement of
the spectator in front of the canvas.

A large scale exhibition of Op Art called 'The Responsive Eye' was
held at the Museum of Modern Art, New York in 1965. The best known
practitioners of Op painting are Victor Vasarely, Bridget Riley, Richard
Anuszkiewisz, Larry Poons, Reginald Neal and Jesus Raphael Soto.

Some critics regard Josef Albers as a precursor of Op Art, but he ob-
jects strongly to the term, claiming that all pictorial art is 'optical' and
that it would be just as nonsensical to speak of 'acoustic music' or 'tactile
sculpture'. As an alternative he proposes 'perceptual painting', but this
does not seem to be an improvement since all painting is, presumably,
perceived.

For a short period of time Op Art was extremely fashionable; to the
distress of some of the painters, their designs were adopted by the textile
and clothing industries and eye dazzling patterns appeared everywhere.
However, the movement lacked staying power, according to Lucy Lippard
because of its "essential dullness, predictability and spurious contempor-
aneity".

See also Retinal Art.

W C Seitz *The responsive eye* (NY, Museum of Modern Art, 1965).

R G Carraher and J B Thurston *Optical illusions and the visual arts*
(Studio Vista, 1966).

M Compton *Optical and Kinetic Art* (Tate Gallery, 1967).

R Parola *Optical art: theory and practice* (NY, Van Nostrand Reinhold,
1969).

C Barrett *Op Art* (Studio Vista, 1970).

C Barrett *An introduction to Optical Art* (Studio Vista, 1971).

L Lippard 'Perverse perspectives'–in–*Changing: essays in art criticism*
(NY, Dutton, 1971) 167-183.

377 OUTSIDER ART (also called Art of the Alienated, Alternative, Anti-Cultural, Non-Conformist, Subversive and Autistic art): A term devised by Robert Cardinal to describe artworks that represent an alternative to the academic, official, professional and cultural art of the museums and galleries. He includes in his category many examples drawn from the L'Art Brut collection of Jean Dubuffet: paintings, drawings and sculptures by schizophrenics; also works by uneducated, innocent artists such as hermits and mediums. Cardinal maintains that such artists exist outside normal society and evade its cultural conditioning, consequently they remain free to produce highly original works of art which satisfy their own psychic needs rather than those of the public. For this reason Cardinal excludes peasant and folk art, popular arts, naive and Sunday painters, tribal and child art and the work of prisoners.

Outsider art is prized by its admirers for its rawness, savagery, strangeness, authenticity, vital realism and, in some instances, its magical powers. Among the artists identified as outsiders are Clarence Schmidt, Scottie Wilson, Madge Gill, Simon Rodia, Adolf Wölfli, Augustin Lesage, Abbé Fouéré, Ferdinand Cheval and Aloise.

See also L'Art Brut, Cultural Art, Naive Art, Remedial Art.

R Cardinal *Outsider art* (Studio Vista, 1972).

P

378 PACKAGING (or Wrapping, Bagging): The Surrealist Man Ray invented this technique with his mysteriously wrapped object called 'The enigma of Isidore Ducasse'. At least one post-war artist—Christo—has devoted his whole oeuvre to this idea; he has wrapped chairs, nude girls, whole buildings and even stretches of coastline. The significance of this technique may be indicated by market research studies which reveal that the packaging of a product is almost as important as the product itself to a potential customer. The Canadian artist, Iain Baxter also wraps or 'bags' whole rooms and all their contents using transparent polythene; the result is called a 'bagged place'.

See also Emballages.

379 PAINTERLY PAINTING (or Painterliness): A concept first intro-
duced into art theory by Heinrich Wolfflin in 1915. He applied the term
'Malerische' (painterly) to Baroque styles in order to distinguish them
from linear, classical modes. In his analysis Wolfflin equated the linear
with the tactile sense and the painterly with the optical sense, or pure
visibility. Formalist critics such as Clement Greenberg and Michael Fried
have applied these concepts to movements in painting since 1945. For
example, Greenberg suggested 'Painterly abstraction' as an alternative to
'Abstract Expressionism': 'if the term "Abstract Expressionism" means
anything verifiable, it means painterliness: loose rapid handling . . . masses
that blot and fuse instead of shapes that stay distinct; large conspicuous
rhythms; broken colour; uneven saturations or densities of paint; exhibited
brush, knife, finger or rag marks . . . ' Artists considered painterly include
Velasquez, Titian, Renoir, Rubens, Manet, Monet, Constable, Hofmann,
De Kooning, Guston, and Olitski.

To some critics the whole notion of Painterly painting seems absurd:
it would appear to be a redundant use of language to describe a painting
as 'painterly', unless one accepts the arguments of the Formalists that
there are certain essential characteristics of the art of painting which are
to be found to their fullest degree in only a proportion of the class of
objects we call 'paintings'.

See also Formalist Criticism, Post-Painterly Abstraction, New Infor-
malists.

H Wolfflin *Principles of art history: the problem of the development
of style in later art* (NY, Dover, 1950).

C Greenberg 'After Abstract Expressionism'—in—*New York painting
and sculpture: 1940-1970* by H Geldzahler & others (Pall Mall Press, 1969)
360-371.

T B Hess & J Ashbery (eds) *Painterly painting* (NY, Newsweek, 1971)
Art News Annual 37.

G Muller 'Materiality and painterliness' *Arts magazine* 46 (1) September/
October 1971 34-37.

J Elderfield 'Painterliness redefined: Jules Olitski and recent abstract
art' Part I *Art international* 16 (10) December 1972 22-26; Part II *Art
international* 17 (4) April 1973 36-41, 101.

380 PAINTERS ELEVEN: A Canadian group founded in Montreal in
1953. Jack Bush and Harold Town are two internationally recognised
painters who were members of this group.

381 PARAMETRIC DESIGN: A term used in writings on architecture in the past decade. Charles Jencks remarks 'The Parametric School of Design . . . grew up in the middle 1960s to become a major movement around the world . . . This school placed emphasis on the analysis, measurement and reconciliation of all the elements which could be called parameters in a building . . . even such things as marital relations and kinship systems.' As examples he quotes the systematic and rational design taught at Ulm and the work of Christopher Alexander, Ezra Ehrenkrantz, and Yona Friedman.

C Jencks *Modern movements in architecture* (Penguin, 1973).

382 PARTICIPATORY ART: All art works require the involvement of a spectator before they are complete—a point emphasised by Marcel Duchamp at a discussion session on the creative act held at Houston, Texas in 1957—and to this extent all art is participatory. However, the traditional artist did not make spectator participation his prime aim. In contrast, since 1945 many avant garde artists have created objects, or structured situations, explicitly to encourage adult play, to invite spectators to join in games and in physical activities.

The participation tendency can be detected in Op Art (which involves vision more actively than traditional oil painting); in some forms of Kinetic Art (those which make use of spectator movement); in Cybernetic Art sculptures (those which respond to sounds made by spectators); in Environmental Art (inflatables which require athletic ability to be appreciated); in Happenings and Street Art (where the audience is often an integral part of the art work).

In 1968 an exhibition entitled 'Options', held in Milwaukee and Chicago, was designed specifically to encourage visitor involvement. Lawrence Alloway devised the term 'Option Art' to describe works which allowed the artist and the visitor a number of choices in the arrangement of the elements from which they were composed. Alloway's term is applicable to 'Variable Paintinges' by the Swedish artist, Oyvind Fahlstrom. These paintings are composed of detachable figures and images, hinges and magnets permitting of endless permutation; characters can even be dressed and undressed. The term is also applicable to 'Change Paintings' by the English artist, Roy Ascott; to 'Transformables' by the Israeli artist Agam; and to the contour shapes that Timothy Drever, an English sculptor, spreads out on floors or lawns for spectators to rearrange.

From this general tendency has emerged the concept of 'Part Art'. An exhibition called 'Pioneers of Part Art'—featuring the artists John

220

Dugger, David Medalla, Lygia Clark, Helio Oiticica and Li Yuan Chia—
was held at the Museum of Modern Art, Oxford in 1971. Medalla uses
the word 'art' as in 'articulation', not as in 'art object'. The American
sculptor Robert Morris designed a series of objects—described by one
critic as an assault course—for his show at the Tate Gallery, London in
1971 to be physically used instead of contemplated. In this instance the
works were too successful: the audience participated over vigorously and
to prevent further destruction and injury this section of the exhibition
was closed.

In the United States Part Art is called 'Fun Art'. According to Thomas
Meehan it is a new art form that has excited large crowds of visitors to
American galleries and museums in 1970. Fun Art is often expensive be-
cause of its technical complications—it may employ plastics, currents of
air, strobe lights, electronic devices, feedback systems—hence it tends to
be created by artists versed in engineering skills. Mostly these artists are
young and unknown, but three—Howard Jones, Stanley Landsman and
Jean Tinguely—are established names. Clearly the name 'Fun Art' stresses
spectator enjoyment. However, the pleasure provided by this type of art
does not seem to be primarily aesthetic.

Experimental groups such as the Haus-Rucker-Company, the Situation-
ists, the Event Structure Research Group and GRAV are also dedicated to
the idea of spectator participation, as are community art associations such
as Action Space and Inter-Action. In 1972 Inter-Action transformed a
London Transport double decker bus into a mobile theatre, equipped it
with video, and called it the 'Fun Art Bus'.

The concept of participation in art has aroused much adverse criticism,
for example, Michael Billington claims that "the notion of physical par-
ticipation" is "one of the great myths of contemporary art" and is not
to be "equated with spiritual involvement" because "more often than not
. . . it's a substitute for it".

See also Technological Art.

M Duchamp 'The Creative Act'—in—*Marcel Duchamp* by Robert Lebel
(Paris, Trianon Press 1959) 77-78.

Directions 1: Options (Milwaukee Art Centre, 1968).

L Alloway 'Interfaces and Options: participatory art in Milwaukee and
Chicago' *Arts magazine* 43 (1) September/October 1968 25-29.

L Alloway 'Options' *Art & artists* 4 (7) October 1969 16-21.

T Meehan 'Fun Art' *Daily telegraph magazine* (276) January 30 1970
18-23 + cover.

A Forest 'Popa at Moma' *Art & artists* June 1971 46-47.

E Lucie-Smith 'Art and playpower: a new philistinism' *Encounter* (8) August 1971 58-60.

M Billington 'Life Copying Art' *The guardian* June 2 1972 p 8.

J Wintle *The fun art bus* (Methuen, 1973).

S Kranz 'Toward environmental art . . .'–chapter 7 in–*Science and technology in the arts* (NY, Van Nostrand Reinhold, 1974) 155-162.

F Popper *Art-action–participation* (Studio Vista, 1975).

383 PAVILIONS IN THE PARKS (PIP): In 1968 six British artists founded an organisation called 'The Pavilions in the Parks Advisory Service' to make painting, sculpture, films, poetry, music and mixed-media events available to the general public in informal settings such as parks. Lightweight, demountable structures are used to display art works and to house events. The pavilions move from site to site during the summer but remain in one place for up to three months. This scheme enables local artists–selected by a random method–to show their work to local communities and provides an alternative to the commercial gallery system.

Finance is provided by local authorities and arts associations. Not everyone is impressed by the PIP project; one writer dismissed it as 'Random art for a random audience'.

S W Taylor 'Pavilions in the Parks' *Art & artists* 3 (5) August 1968 58-59.

'Pavilions in the Parks Project' *Leonardo* 2 (2) April 1969 209-210.

S Braden 'Pavilions in the Parks' *Studio international* 178 (914) September 1969 p94.

'Pavilion Design Competition' *Architectural design* 41 (3) March 1971 183-184.

384 PEASANT PAINTING: In communist China art is not merely the province of an educated elite of specialists, but an activity in which all members of society are encouraged to take part. Following the cultural revolution in 1966, many peasants began painting in their spare time and thousands of works have since been produced which depict the social and technological progress of China, and illustrate scenes of agricultural labour, construction work, political meetings, village recreations and the materiality of everyday life. What is striking about these paintings is their high level of technical proficiency (surprising in view of the fact that they are claimed to be by untrained peasants painting after work), and also their stylistic uniformity: bright, flat, emblematic colours, muscular drawing

with precise outlines, an all-over decorative effect, decentralized compositions (very rarely does a painter focus on a single individual, it is the group and collective activity which is emphasised). The paintings seem to be a successful mixture of Western comic-book art and traditional Chinese painting (the 'tipped-up' perspective is retained). Socialist Realist stereotypes are, in general, avoided.

In China art is considered an ideological weapon in the class struggle; therefore peasant paintings are wholly public in their appeal; they do not present the personal vision or private concerns of gifted individuals. Unlike Avant Garde art of the West, much of which is decadent, narcissistic, nihilistic, sex-obsessed, (what Rosetta Brooks calls 'ego art'), Chinese art radiates pride, confidence and optimism. 'They are pictures of a utopia made by people who believe they inhabit one' (Brooks). Just as in the West it is advertising which celebrates the joys of capitalism so in China it is art which celebrates the joys of communism.

Several touring exhibitions of Chinese graphic art have been seen in the West in recent years and a display of Chinese paintings was shown at the 9th Paris Biennale in 1975. As Brooks explains, in a review of the Biennale, Mao's demand for a unity of art and politics, of content and form, is achieved in the realist style of peasant paintings but this realism is not 'a Western version of realism in the sense of paring away rhetoric and connotation to achieve a pure denotative reference of reality, but one which accepts its rhetorical orientation and denotes social relations as its reality'. Colour, for example, simultaneously serves realistic, symbolic and decorative functions but it is never isolated for its own sake, it is always subservient to ideological ends.

See also Naive Art, Political Art.

Mao Tse-Tung *Talks at the Yenan forum on literature and art* (Peking, Foreign Languages Press, 4th ed 1967).

Chinese graphic art (Fribourg University, 1973).

Peasant paintings from Huhsien county (Peking, Foreign Languages Press, 1974).

G Brett 'China's spare-time artists' *Studio international* 189 (973) January/February 1975 12-15.

P Pacey 'The art of Red China: a note on the literature' *ARLIS newsletter* (22) March 1975 19-21.

R Brooks 'France: 9th Paris Biennale' *Studio international* 190 (978) November/December 1975 230-233.

R Skoggard 'Report from China: Chinese art, from Tao to Mao' *Art in America* 64 (6) November/December 1976 52-55.

385 PENTAGRAM (A star shape with five points): The name of Britain's largest design group, formed in London in 1972 by five mature designers—Theo Crosby, Colin Forbes, Alan Fletcher, Mervyn Kurlansky and Kenneth Grange—each of whom have international reputations in their own special fields. Pentagram blends graphic, product and architectural design skills in order to provide a comprehensive service for large companies.

H Spencer 'Pentagram: a London Design Group' *Graphis* 27 (158) 1971/72 550-567.

R Carr 'Main Line Merger' *The guardian* June 16 1972 p 12.

Pentagram Design Partnership—editors—*Pentagram: the work of five designers* (Lund Humphries, 1972).

386 PEOPLE'S DETAILING: According to Charles Jencks People's Detailing was a style of house building popular in Britain during the 1950s characterised by "pitched roofs, bricky materials, ticky-tacky, cute lattice work, little nooks and crannies, picturesque profiles all snuggled within cardboard-like rectitude".

C Jencks 'Pop-non Pop' (1) *AAQ* 1 (1) Winter 1968/1969 48-64.

387 PERCEPTUAL REALISM: A term used by the Canadian artist John (or Jack) Chambers (b1931) to characterize a particular group of realistic paintings based on coloured photographs which he has produced since 1969. The paintings are straightforward enough but they are accompanied by verbose, obscure statements. The theory of Perceptual Realism appears to be based on the idea that there are moments of disinterested vision which precede our normal recognition of the world of objects. In other words a kind of pure visual experience which occurs before culture intervenes. It is this experience which Chambers attempts to capture in his paintings and films.

See also Photo-Realism.

J Chambers 'Perceptual Realism' *Arts Canada* (136/137) October 1969 7-13.

Jack Chambers (Vancouver Art Gallery, 1970).

R Woodman 'The realism of John Chambers' *Art international* 14 (9) November 1970 37-41.

M Amaya 'Jack Chambers' *Art in America* 58 (5) September/October 1970 118-121.

D Shadbolt 'On the evolution of John Chambers' Perceptual Realism' *Arts Canada* (148/149) October/November 1970 57-62.

J Chambers 'Perceptualism' *Art & artists* 7 (9) December 1972 28-33.

388 PERFORMANCE ART: An extremely broad category encompassing a variety of activities, styles, and intentions ranging from the formalist to the political having as a common denominator the execution of prescribed courses of action before a live audience. Performance Art occurs internationally but tends to be called by different names in different countries and there are local variations caused by the different historical evolutions and degrees of integration with national cultural traditions. It is a form of art which intersects and overlaps with Actions, Body Art, Community Art, Happenings, Process Art, Street Art, and has affinities with folk art, busking, stunts, children's play (eg dressing-up), Shamanism, and tribal ritual. Because of its diversity, transience, and geographic dispersal no single critic is in a position to give a complete account of Performance Art; for the same reasons definitions of it vary markedly and are usually negative rather than positive, ie Performance is defined by itemising in what ways it is not like theatre or dance. Artists in particular resent having to categorise their behaviour—Stuart Brisley's reaction was to label his work 'Anti-Performance Art'—but in Britain this is necessary if Arts Council grants are to be obtained. In spite of its elusiveness Performance Art has become established as a genre and its parameters are becoming clearer (what is needed is an anthropological/structuralist analysis using knowledge already gained from the study of ritual in many different cultures).

Apart from isolated examples in Japanese art—the painting of huge scrolls in the presence of the Emperor and his court—traditional painting and sculpture had nothing in common with the performing arts, but in the years since 1945 the situation has altered drastically. An element of performance has appeared in much recent art, especially since so much stress was placed on the artist's creative act in Action Painting. In 1956, for example, the French painter, George Mathieu created a large work entitled 'Homage to Louis XIV' before a theatre audience. The painting was executed on the anniversary of a battle and the time spent on the canvas equalled the time taken by the conflict.

A popular art film made in 1953 showed Pablo Picasso displaying his graphic skill by drawing in paint on glass, and in darkness with a light source. In 1960 Yves Klein directed the production of a series of paintings called 'Anthropometrics'. They were made by three naked models rubbing their paint covered bodies against canvas; these activities were accompanied by music and performed before an invited audience.

According to Lucy R Lippard, the performing arts have become a neutral territory in which visual artists with different styles can meet and

agree. In New York three American artists—John Perreault, Marjorie Strider, and Scott Burton—have formed the 'Association for Performances' to promote, present and preserve new forms of artists' theatre. Other American Performance artists of note include Vito Acconci, Richard Foreman (founder of the Ontological-Hysteric Theatre), Joan Jonas, Yvonne Rainer, and Chris Burden (an artist who organises situations in which his life is put at risk); a festival of Performance was held at the Whitney Museum, New York in February 1976.

In Britain the popularity of Performance is evident from the proliferation of groups: John Bull Puncture Repair Kit, Fine Artistes, Nice Style, Phantom Captain, COUM, Words Actions & Situations, Situations & Real Lifescapes, etc (quaint or fey names appear to be a feature of British groups). A Performance Show was held in Southampton in July 1975 and a special issue of *Studio international* was devoted to Performance in the following year.

See also Living Sculpture, Nice Style, Gilbert & George.

E S Robbins 'Performing art' *Art in America* 54 (4) July/August 1966 107-110.

V Acconci 'Some notes on activity and performance' *Interfunctionen* (5) November 1970 138-142.

'Performance at the limits of performance' *The drama review* 16 (1) March 1972 70-86.

A Henri 'The artist as performer'—chapter 4 in—*Environments and happenings* (Thames & Hudson, 1974) 133-185.

R Goldberg 'Space as praxis' *Studio international* 190 (977) September/October 1975 130-135.

M Chaimowicz 'Performance' (irregular column) *Studio international* 191 (979) January/February 1976- .

C Tisdall 'Performance Art in Italy' *Studio international* 191 (979) January/February 1976 42-45.

'Performance' *Studio international* 192 (982) July/August 1976 (special issue).

A Kaprow 'Non-theatrical performance' *Artforum* 14 (9) May 1976 45-51.

'Actions/Performance issue' *Musics* (9) September 1976.

389 THE PHASES MOVEMENT: Since 1952 the French poet, Eduouard Jaguer has presided over an international movement centred on Paris devoted to the art of the imaginary, that is, continuing the principles of Surrealism. It is known as 'the Phases Movement' after a review published
226

in 1954 (*Phases*). Jaguer has organised a number of exhibitions which included artists as various as Enrico Baj, Pierre Aelchinsky, Antonio Tàpies, and Oyvind Fahlstrom.

A Pelligrini *New tendencies in Art* (NY, Crown, 1966) 283-292.

G Ollinger-Zinque 'Phases'—paragraph in—'The Belgian contribution to Surrealism' *Studio international* 183 (937) October 1971 p 155.

390 PHENOMENAL ART: A term used by the American sculptor James Seawright to describe those of his works that undergo changes with the passage of time, for example changes of illumination, spatial relationships or sound production. He specifically disclaims any connection with the philosophical notion of phenomenology discussed in the following entry.

J Seawright 'Phenomenal Art: form, idea and technique'—in—*On the future of art;* edited by E Fry (NY, Viking Press, 1970) 77-93.

391 PHENOMENOLOGY & ART: Phenomenology is a school of philosophy associated principally with the writings of Edmund Husserl and Maurice Merleau-Ponty. It is concerned with the description and analysis of subjective processes and it stresses the primacy of perception. Hence it is a philosophy which is particularly suited to the appreciation and critical evaluation of artworks which are, in the main, objects addressed to the mind and senses of the viewer. In his paper 'Eye and mind' Merleau-Ponty explored the relationship between vision and consciousness with especial reference to the painter's mode of seeing; in addition he produced a profound study of Cézanne's work. Attempts have been made, by writers such as Dufrenne and Kaelin, to construct a phenomenological aesthetics and various concepts from phenomenology have been applied in a piecemeal fashion to examples of recent art by certain American critics. For example, Minimal sculpture was interpreted in terms of phenomenology because it eschewed internal formal relations and thus emphasised the spectator's perceptual experience as he moved round the work and the sculpture's relationship to its environment, the space in which the visitor moved.

Bruce Nauman was described as a 'phenomenologist' (hence Marcia Tucker's pun 'PhenNaumanology') because he isolated sensory phenomena —sound, light, or colour—for our contemplation. Another crucial feature of phenomenology is its emphasis on intentionality hence by giving priority to the artist's intention it usurped 'the ultimacy traditionally reserved

for the artistic object . . .' (Kuspit) and thereby opposed the formalist approach to art.

M Merleau-Ponty 'Eye and mind'—in—*The primacy of perception;* edited by J M Edie (North Western U Press, 1964) 159-190.

M Merleau-Ponty 'Cézanne's doubt' *Art & literature* (4) Spring 1965 106-124.

E F Kaelin *Art and existence: a phenomenological aesthetics* (Lewisbury, Buckness U Press, 1970).

P Smith 'Phenomenology as a hermeneutic of art' *Analytical art* (1) July 1971 50-56.

N Calas 'The phenomenological approach'—in—*Icons and images of the sixties,* by N & E Calas (NY, Dutton, 1971) 249-257.

J G Place 'Merleau-Ponty and the spirit of painting' *Philosophy today* 17 (414) Winter 1973 280-291.

D Kuspit 'A phenomenological approach to artistic intention' *Artforum* 12 (5) January 1974 46-53.

L Borden 'The new dialectic' *Artforum* 12 (7) March 1974 44-51.

M Dufrenne *The phenomenology of aesthetic experience* 2 vols (North Western U Press, 1974).

392 PHOTOMONTAGE: The German word 'montage' means 'fitting' or 'assembly line', and the word 'monteur' means 'mechanic' or 'engineer', therefore Photomontage is the art and technique of cutting up photographs and re-assembling the parts to produce a composite image with a new meaning. In fact the scope of Photomontage is not restricted to the use of parts of photographs but also includes the addition of texts, colour or drawing to photographs. Photomontage has been called 'static film' because it is a still equivalent to the montage technique used by filmmakers when editing film sequences. Although many examples of Photomontage are to be found in nineteenth century scrapbooks, screens, and postcards it was not until 1916-17 that it was taken up by fine artists in a serious way, that is, by the Dadaists of Berlin: Georg Grosz, John Heartfield, Hannah Höch, Johannes Baader, and Raoul Hausmann. Major artists who have exploited the possibilities of Photomontage include: El Lissitzky, Laslo Moholy-Nagy, Alexander Rodchenko, Herbert Bayer, Gustav Klutsis, Max Ernst, Man Ray, Marcel Duchamp, Kurt Schwitters, R B Kitaj, Richard Hamilton and Ray Johnson. This list of names reveals that the technique has lent itself to a variety of different art movements—Dada, Surrealism, Constructivism, Pop Art— however,

228

Photomontage found its greatest fulfilment as a political propaganda instrument in the hands of John Heartfield.

In the 1970s Photomontage has again become fashionable amongst artists in Europe and the United States (see Photo-Works, Story Art) but in this instance montage involves the juxtaposing and ordering of sequences of photographs and texts rather than the cutting up of photographs.

See also Assemblage Art, Factography.

A Scharf *Art and photography* (Allen Lane, The Penguin Press, 1968).

John Heartfield (Arts Council of Great Britain, 1969).

J Berger 'The political uses of photo-montage'—in—*Selected essays and articles: the look of things* (Penguin Books, 1972) 183-189.

L Kuleshov 'The origins of montage'—in—*Cinema in revolution: the heroic era of the Soviet film;* edited by L & J Schnitzer and M Martin (Secker & Warburg, 1973) 67-76.

D Ades *Photomontage* (Thames & Hudson, 1976).

393 PHOTO-REALISM (also called Artificial Realism, New Realism, New New York Naturalism, Radical Realism, New Academicians, Post-Pop Realism, Super-Realism, Sharp-Focus Realism): Periodically a fresh generation of painters finds it necessary to confront that great nineteenth century rival of painting, photography. A recent example of such a confrontation is Photo-Realism (or, as it is known in Europe, 'Hyper-Realism') a genre which developed quietly throughout the 1960s and only emerged as a fully fledged movement when it was shown in force at the vast Documenta 5 exhibition held in 1972.

Well-known Photo-Realists include Robert Bechtle, Claudio Bravo, John Clem Clarke, Chuck Close, Robert Cottingham, Don Eddy, Richard Estes, Bruce Everett, Franz Gertsch, Ralph Goings, Michael Gorman, John Kacere, Alfred Leslie, Richard McLean, Malcolm Morley, and John Salt. This inventory reveals the international character of the style, though the majority of the names are, as one might expect, American.

Most Photo-Realists use photographs as an impersonal source of visual imagery. Because their attitude to subject matter is neutral, they prefer reportage photographs of banal motifs: urban landscapes, automobiles, shop fronts, horses, and faces. Clarke and Morley also revamp coloured reproductions of old masterpieces. The photographs are meticulously copied in acrylic paint; the prefixes 'Super-', 'Radical-', 'Hyper-', 'Sharp-Focus' have been applied to this realism because of its extreme verisimilitude and thoroughness of technique. Often the scale of Photo-Realist

229

canvases is monumental; their inflated size and cold, mechanical finish endows them with a disturbing quality which recalls Surrealist painting.

Photo-Realists are not interested in photographic realism in the sense that they seek to emulate the detailed accuracy of camera vision. To them photographs are simply flat images for use on flat planes. What intrigues them are the technical problems of rendering tones across a surface and capturing reflections and highlights. They treat all parts of the image impartially: Morley turns his photographs sideways to negate their subject matter and also cuts them into small squares for transposing to canvas. Therefore Photo-Realism is, in some respects, more akin to formalist abstraction than to the tradition of realist painting. Photo-Realist paintings fulfil their destiny by being reproduced in art magazines for when they are seen in this context it is often impossible to tell whether one is seeing a photograph of reality or a photograph of a painting based on a photograph of reality. Many critics have reacted negatively to Photo-Realism condemning it as "a late bourgeois edition of salon painting".

See also Verist Sculpture,

U Kulterman *New Realism* (Mathews Miller Dunbar, 1972).

Photo-Realism . . . (Serpentine Gallery, 1973).

Hyperréalisme: maîtres Americans & Europeens (Brussels, Isy Brachot Editeur, 1973).

L Chase *Les Hyperréalistes American* (Paris, Filipacchi, 1973).

G Battcock (ed) *Super-Realism: a critical anthology* (NY, Dutton, 1975).

394 PHOTO-WORKS: Since the invention of photography fine artists have made use of it in multifarious ways (fully documented in the histories of art and photography). For over a century there has been a mutual interaction and rivalry between the established fine arts—painting, sculpture—and the upstart photography. However, the fierce debate as to whether photography is an art or not has finally fizzled out with photography emerging victorious. Evidence for photography's new status includes the number of galleries and centres devoted to it that have been established in the major cities of Europe and North America, the interest fine art magazines have shown in it, and the high prices paid by collectors for old photographs in salerooms.

By 1970 the intensity of the competition between photography and the fine arts had diminished and photography had become fully accepted as part of the stock of media any fine artist might use if he/she wished. This situation was to some extent a result of Conceptual Art which

230

opposed the specialization and medium priority associated with being a painter or sculptor. Fine artists who use photographs include, John Hilliard, Klaus Rinke, Richard Long, Hamish Fulton, Gilbert & George, Victor Burgin, Arnulf Rainer, John Stezaker, Jonathan Miles, John Baldessari, James Collins, and Jan Dibbets, but the way in which they are used varies widely according to the intentions of the artist and the function the works are designed to serve (see discussions under particular headings such as Body Art, Earth Art, Conceptual Art, Pictorial Rhetoric, etc). Hence while the term 'Photo-Works' is a neutral description of value to critics and cataloguers there is a danger of stressing the medium as a common denominator and in this way obscuring the many differences between the work of the artists cited above. One characteristic which is common to recent Photo-Work is the use of a series of separate images to record a process or event, or to generate new meanings. In other words the montage does not take place within a single frame (as in the photo-montages of John Heartfield) but, as in film, by abutting a number of separate elements. The meaning of an image can also be modified according to the words which accompany it, consequently besides image/image relations, image/text relations are explored in Photo-Work (more accurately 'Photo-Text Work'). Many artists use readymade material—'found' photographs and quotations—and deploy their skill in the areas of intertextuality. This kind of art often aspires to the condition of photo-journalism.

See also Anonymous Sculpture, Concerned Photography, Photomontage, Story Art.

L Alloway 'Artists and photographs' *Studio international* 179 (921) April 1970 162-164.

'Special on photoworks' *Flash Art* (52-53) February-March 1975.

V Kahmen *Photography as art* (Studio Vista, 1975).

'Art and photography' *Studio international* 190 (976) July/August 1975.

R Brooks 'Please, no slogans' *Studio international* 191 (980) March/April 1976 155-161.

Time, words, and the camera: photoworks by British artists; edited by J Reichardt (Graz, Kunstlerhaus, 1976).

'Kunst—fotografie . . .' *Magazine kunst* 16 (4) 1976 60-124.

395 PICTOLOGY: A term used by the Dutch writer Maurits M Van Dantzig (1903-1960) to describe an analytical method for attribution and evaluation of paintings: 'Pictology has two functions: first, to identify the maker of a depiction, and second, to determine its relative quality'.

The method involves the examination of a number of artworks in relation to such pictorial features as spontaneity of line, organisation of surface, light/dark contrasts, warm/cold colour contrasts, negative shapes, materials and technique, etc.

M M Van Dantzig *Pictology: an analytical method for attribution and evaluation of pictures* (Leiden, E J Brill, 1973).

396 PICTORIAL RHETORIC: In Ancient Greece a rhetor was an orator whose task was to persuade, exhort, instruct and influence an audience. Rhetoric is therefore the art of using speech or writing to persuade, exhort, etc. It was considered to be the second of the seven liberal arts. The practice of rhetoric quickly became codified and the Greeks compiled manuals and treatises which served as models for the textbooks subsequently used throughout Europe in the Middle ages and Renaissance. The basic skills of rhetoric were thought to be invention, arrangement, style, memory, and delivery. Over the centuries literary theorists have identified and named over two hundred verbal ornaments—schemes, tropes, figures of speech—which authors and poets commonly use, for example, metaphor, metonymy, synecdoche, paranomasia. In the course of time rhetoric became morally suspect because it lends itself to artificiality and ostentation and because its devices can be deployed for dishonest and unjust ends (rhetoric has been called 'the mother of lies'); As a result the study of rhetoric declined but rhetoric itself did not: modern copywriting, publicity handouts and political speeches are clear examples of rhetoric in action.

Most advertisements employ combinations of pictures and texts to influence the behaviour of a defined audience hence the applicability of the term 'pictorial rhetoric'. Furthermore, if advertising photographs and graphic layouts are examined visual devices equivalent to the familiar literary figures can be identified. Advertising is a 'language' which is understood by millions because it relies on conventions, stereotypes, and clichés known to those millions. Avant Garde art, on the other hand, is only appreciated by a minority because it despises such conventions and always attempts to transcend meaning or to devise a new 'language' or code from scratch. In an effort to reach a wider audience a number of British artists have begun to use the pictorial rhetoric of the mass media in their artworks. This rhetoric is placed in the service of different ideological ends from that of the mass media. Victor Burgin has used the term 'guerrilla rhetoric' to characterise his recent photo-works.

See also Semiotics.

G Bonsiepe 'Persuasive communication: toward a visual rhetoric' *Uppercase* (5) 1961 19-34.

J Durand 'Rhetorique et image publicitaire' *Communications* (Paris) (15) 1970 70-95.

R Barthes 'Rhetoric of the image' *Cultural studies* (working papers in) Spring 1971 36-50.

V Burgin 'Photographic practice and art theory' *Studio international* 190 (976) July/August 1975 39-51.

V Burgin 'Socialist formalism' *Studio international* 191 (980) March/April 1976 146-154.

R Brooks 'Please, no slogans' *Studio international* 191 (980) March/April 1976 155-161.

397 PIN-UPS (including Calendar Girls, Cheesecake): Mark Gabor defines a Pin-Up as 'a sexually evocative image, reproduced in multiple copies, in which either the expression or attitude of the subject invites the viewer to participate vicariously in, or fantasize about, a personal involvement with the subject'. Pin-Ups almost invariably depict women and they are almost exclusively collected by men. They enable men to dominate women—in their imaginations—in a manner impossible in reality. Pin-Ups are not generally considered to be pornographic because their sexuality is restricted; nevertheless those in favour of female emancipation regard them as a degradation of womanhood; in 1976 an exhibition of calendar girls held at the ICA, London was defaced by women's liberationists.

Although the term itself dates from the second world war—it derives from the American GI's habit of pinning up on lockers and walls pictures of nubile females—the Pin-Up itself is much older; some authorities cite examples from the fifteenth century. A great boost was given to the Pin-Up by the advent of photography, and they appeared on post cards in vast numbers during the first world war. In the 1930s Hollywood film-stars added glamour to the genre and during the same period cartoonists began to incorporate Pin-Up girls in their strips, for example, Al Capp's 'Daisy Mae' and Norman Pett's and Mike Hubbard's 'Jane'. The 1950s and 1960s were marked by an ever-growing permissiveness and a greater sophistication of colour photography, so much so that the Pin-Up achieved the status of fine art: the famous Pirelli Calendars became collectors items and were sold for high prices in fine art auctions.

In the 1970s the Pin-Up attracted the attention of art historians and several studies were published analysing its development and social

function. Pin-Ups have also invaded every bookshop and newsagent in Europe and the United States via such lavishly produced and highly profitable magazines as *Playboy, Mayfair, Club international,* etc.

See also Erotic Art.

M Gabor *The pin-up: a modest history* (Deutsch, 1972).

'Pin-up and icon'—in—*Woman as a sex object;* edited by T B Hess (Allen Lane, 1973) Art News Annual 38.

J Sternberg & P Chapelot *Pin-Up* (Academy Editions, 1974).

The complete Pirelli calendar book (Pan Books, 1975).

M Casalis 'The discourse of Penthouse: rhetoric and ideology' *Semiotica* 15 (4) 1975 355-391.

M Colmer *Calendar girls* (Sphere Books, 1976).

398 PLACE: An example of Environmental Art consisting of large-scale abstract paintings by Robyn Denny, Ralph Rumney, and Richard Smith arranged in such a way as to divide up the space of a gallery. This exhibition was held at the ICA in 1959.

See also Environmental Art.

R Coleman *Place* (ICA, 1959).

A Bowness 'Smith, Denny and Rumney in "Place" ' *Arts* 34 (20) September 1959.

R Coleman 'The content of environment' *Architectural design* 29 (12) December 1959 517-518.

Robyn Denny (Tate Gallery, 1973).

399 LES PLASTICIENS: A movement in Canadian painting established in Montreal in 1954 by the painter/critic Rodolpe de Repentigny. Les Plasticiens reacted against gestural painting and produced a style of Geometric Abstraction continuing the tradition of Mondrian and Malevich and related to the international genre known as 'Hard-Edge'. The best known artist of the group was Guido Molinari.

F Saint-Martin 'Le dynamisme des Plasticiens de Montreal' *Vie des arts* (44) Autumn 1966 44-47, 98.

P Theberge 'Les Plasticiens'—in—*Canadian art today;* edited by W Townsend (Studio International, 1970) 25-26, 86.

400 PLASTICS: The adjective 'plastic' derives from the Greek 'plastikos' meaning 'mouldable'. Traditionally the plastic arts were those which employed substances capable of being moulded, modelled, or shaped. Applied to paintings the term 'plastic' refers to depicted forms giving an

impression of relief or three-dimensionality. Today 'plastics' is a common noun describing a group of natural and synthetic materials which can be shaped when soft and which then become hard. When they were first introduced plastics tended to be used as substitutes for existing materials with the result that the term 'plastic' acquired a pejorative connotation (ie 'not the real thing') which is no longer appropriate.

Although the first man-made plastic (celluloid) was patented in the USA in 1869, and the first synthetic plastic ('Bakelite') was produced in 1907, the modern plastics industry was not established until the 1930s; every succeeding decade has since been heralded as 'the plastic age'.

A number of architects, designers and artists have used plastics—some examples of artistic use are cited below—but because of their lack of access to industry and their relative ignorance of modern plastics technology artists have yet to realise the full potential of plastics. In his book *Beyond modern sculpture* Jack Burnham suggests another reason: 'Plastics have an aggressive neutrality which runs counter to the emotionalism of most figurative and semi-abstract work. In general plastics are equated with total alienation of the senses.' (Burnham believes that this was the reason why plastics appealed to Minimal sculptors.)

Antoine Pevsner and Naum Gabo were the first artists to use plastics (celluloid sheets) as a material for sculpture in the 1920s. Other artists to have made use of plastics since are: Dr A Fleischmann (noted for his figures in the 1950s carved from blocks of acrylic in order to exploit the translucency of this material); Claes Oldenburg (soft sculptures in the 1960s made from shiny PVC (vinyl) stuffed with kapok); Alexander Calder (in 1939 Calder won first prize in a competition organised by MOMA, involving the use of acrylic); Piero Gilardi ('nature carpets' painted with lacquer made from expanded polyurethane); César (chemical mixtures poured on to gallery floors before an invited audience; the mixtures formed shapes and set rigid in minutes); Michael Sandle and Philip King (these artists have used GRP—glass fibre reinforced plastic—because it can be built up in layers to yield an infinite variety of shapes); Arman (this artist has exploited the transparency of GRP resin by embedding objects in it); L Moholy-Nagy, Soto, Yvaral, Le Parc, Schöffer, Agam (kinetic artists favour acrylic sheets because they can be engraved and lend themselves to coloured light and optical illusion effects).

Manufacturers find plastics ideal for producing editions of those Kitsch objects half way between art and furniture; for example, a wall seat in the shape of Mae West's lips designed by Salvador Dali in 1936 was manufactured in polyurethane foam by the Italian firm Gufram thirty years later.

235

Although the introduction of acrylic pigments has not revolutionized the practice of painting it has influenced it considerably: greater output is possible because of the speed with which resin pigments dry, new techniques have been introduced (see Stain Painting) which rely on the fact that acrylics can be thinned to the consistency of a water colour wash. David Hockney is a painter whose work gains a great deal of its character from his use of acrylics.

A comprehensive text on the use of plastics by fine artists has yet to be written; however, one source of reference for this topic are the articles which appear regularly in the Milan journal *Materie plastiche ed elastomeri*.

See also Air Art, Blow-up Furniture, Pneumatic Architecture.

J F Mills *Acrylic painting* (Pitman, 1965).

Plastic as plastic (NY, Museum of Contemporary Crafts, 1968-69).

T Newman *Plastics as design form* (Philadelphia, Chilton, 1972).

N Roukes *Sculpture in plastics* (Pitman, 1972).

T Newman *Plastics as an artform* (Pitman, 1973).

A Quarmby *The plastics architect* (Pall Mall Press, 1974).

Plastics antiques 1850-1950s (Wolverhampton Polytechnic, 1976).

S Katz *Plastics . . .* (Studio Vista, 1977).

401 PLUG-IN ARCHITECTURE: A design for a new type of architecture evolved by Peter Cook of the Archigram group. Plug-in architecture consists of a basic structure—to contain transportation and communication services—and a series of separate units—domestic environments, shops, leisure centres—that can be plugged into it. These plug-in units can be added to or replaced as required. The design claims to take account of the need for expansion and also the fact that various systems are semi-autonomous and change at different rates.

See also Archigram.

'Plug-in city' *Sunday times supplement* September 20 1964.

402 PNEUMATIC ARCHITECTURE (including Airdomes, Airhouses, Blow-ups, Inflatable Structures): The example of balloons and airships indicates that pneumatic technology has existed for some time. However, it was not until 1917 that the first patent for Pneumatic Architecture (a field hospital) was filed by the British engineer F W Lanchester, and despite the appearance of Stomeyer inflatable tents in the 1930s, it was not until the Radomes of the second half of the 1940s that large-scale Pneumatic structures were erected. By 1957 there were fifty firms in

America producing Pneumatics. A decade later the first international colloquium on Pneumatics was held at Stuttgart. In recent years a number of well known architects have designed pneumatic structures for example, Jean Paul Jungmann, Yutaka Murata, and Cedric Price.

In traditional architecture it was the structure of buildings which determined their internal environments whereas in Pneumatic Architecture structural stability is the product of the release of internal environmental energy (air or gas pressure) within a membrane or bag (generally made of PVC coated nylon). Pneumatic Architecture is therefore a sub-category of pressurized construction (water or other liquids can also be used to pressurize). Three main types of Pneumatic structures are identified: air-inflated, air-supported, and air-controlled. Because of their mode of construction Pneumatics generally consist of curved forms such as domes or half cylinders. Their rounded forms, organic, and responsive characteristics have prompted some writers to make comparisons with the human body.

Pneumatic structures have been used as tents, warehouses, offices, arts centres, exhibition pavilions, greenhouses, swimming pool and stadium covers, and for various military purposes. The advantages of Pneumatic structures are: speed of erection and dismantling, lightness, portability, flexibility, cheapness in terms of materials. They can be used on a short-term basis to provide shelters against the weather while more conventional buildings are put up inside them. Pneumatics can also be used in construction itself: concrete domes have been constructed using inflated domes as formworks.

See also Air Art, Blow-up Furniture, Utopie Group.

F Otto *Tensile structures Vol 1* (MIT Press, 1967).

Proceedings of the 1st International Colloquium on Pneumatic Structures (Stuttgart, University of Stuttgart, 1967).

C Price & others *Air structures: a survey commissioned by the Ministry of Public Buildings and Works* (HMSO, 1971).

R Dent *Principles of Pneumatic architecture* (Architectural Press, 1971).

403 POLITICAL ART (including Activist Art, Agit-Prop, Angry Art, Art Dirigé, Art Engagé, Democratic Art, Dialectical Art, Didactic Art, Dissident Art, Leftist Art, Marx Art, Progressive Art, Propaganda Art, Protest Art, Radical Art, Revolutionary Art, Socialist Formalism, Subversive Art, Utilitarian Art): To the politically conscious observer all art is political in the sense that it either affirms (tacitly or openly) or it challenges the ethos of the society in which it is produced. In most societies

237

art has been a conservative force because artists have been dependent upon the ruling classes for patronage and their ideas have been subject to the dominant ideology of those societies. However, in art criticism the term 'political art' is generally restricted to those artworks whose subject matter explicitly concerns political issues and artworks which were deliberately intended by their creators to have a political impact; for example, Agit-Prop (Agitation, Propaganda) Art in Russia following the revolution, Picasso's 'Guernica', John Heartfield's anti-Nazi photomontages, Brecht's epic theatre, Social Realist painting in Russia and in the United States in the 1930s, mural paintings in Mexico and Chile, the posters of the Atelier Populaire, Chinese peasant paintings, wall newspapers and didactic comic books, the recent films of Jean-Luc Godard, certain works by Richard Hamilton, the paintings of Leon Golub, etc, etc.

In the immediate post-war years totalitarian regimes condemned formalist abstract art and demanded that artists in Western Europe produce works that were socially and politically committed, Soviet Socialist Realism being the only acceptable style. In France the Communist party literary spokesman Louis Aragon echoed these demands, and painters such as André Fougeron and Boris Taslitzky fulfilled them. The Italian artist Renato Guttuso, a member of the Communist party since 1935, emerged as the leading Socialist Realist painter of Europe.

Although the examples cited so far refer to art which is sympathetic to left-wing views, there is nothing to prevent explicitly Political Art serving the right or fascism; indeed, in pre-war Italy and Germany many artists produced work celebrating the fascist ideologies of those countries (see Nazi Art).

Discussion of Political Art is complicated by the fact that once outside the control of the artist artworks can be used in ways never intended by their producers. For example, whatever the internal political content of Abstract Expressionist paintings, exhibitions of these works were used by the American State as cultural weapons in the cold war of the 1950s. Furthermore, artworks have different political implications depending upon the context in which they appear: an open-air exhibition of abstract art in the West generally signifies tolerance and freedom, while in Russia the same exhibition would be seen as an act of provocation. Another problem is the difficulty of estimating the precise influence which Political Art has on society; often the only evidence of its impact is of the negative kind (suppression by the police or censorship).

Victor Burgin has argued that it is not possible to politicize art for the simple reason that it is already politicized. What the artist can do is

238

to change its politics (in Burgin's case the change is in the direction of Socialism). For various reasons there has been, in recent years, a pronounced drift towards the left amongst art intellectuals in Europe, South America and North America; witness the emergence of artists' unions and action groups of all kinds and the founding of such magazines as *Artery, Black graphics international, Cultural studies, The fox, Left curve, May Day magazine, Ostrich, Praxis, Screen,* the contents of which are heavily influenced by marxism. In Germany there is a particularly strong tradition of Political Art, and artists such as Joseph Beuys and Klaus Staeck have succeeded in producing works which have had a political impact.

Contemporary artists who promote an art which is consciously political and politically conscious distrust the label 'Political Art' because they fear it heralds the recuperation of their work as a new movement, a stylistic innovation, by dealers and by museum officials. The prospects for a genuinely Political Art are therefore highly problematical, and a wide-ranging debate is currently being undertaken in an effort to establish a firm theoretical base for future practice.

See also entries under 'Politics' in the index.

H Rosenberg 'The politics of art'—in—*The anxious object: art today and its audience* (Thames & Hudson, 1965) 214-223.

'Art and politics: the artist and the social order' Section 8—in—*Theories of modern art: a source book by artists and critics;* edited by H B Chipp (Berkeley, U of California Press, 1968) 456-500.

D D Egbert *Social radicalism and the arts: Western Europe* (Duckworth, 1970).

Kunst und politik (Karlsruhe, Badischen Kunstvereins, 1970).

L Baxandall (ed) *Radical perspectives in the arts* (Penguin, 1972).

D Dickson 'Art politic' *Art & artists* 7 (6) September 1972 18-21.

Kunst im politischen kampf (Hanover, Kunstverein, 1973).

Art into Society: society into art (ICA, 1974).

Art: politics: theory: practice (conference papers) (Royal College of Art, 1974).

'Art and social purpose' (special issue) *Studio international* 191 (980) March/April 1976.

Art and politics Group 'Art and politics: Socialist art, Brecht, semiology' *Cultural studies* (working papers in) (9) Spring 1976 119-131.

404 THE POMPADOUR STYLE: A description applied by Brian O' Doherty to the environment of Miami Beach—the design of hotels, night

clubs, shop products—and to the life style of its inhabitants, especially their clothes. The Pompadour Style is, he claims, a woman's style based on excessive decoration and opulence exploiting glitter and transparent materials. It is vernacular style that originated in the 1930s and reached a peak in the 1960s.

B O'Doherty 'Miami and the iconography of the Pompadour Style' *Art international* 13 (7) September 1969 23-25.

405 POP ARCHITECTURE: This expression is used by architectural writers to refer to at least four distinct types of architecture:

(1) Buildings that are popular with large sections of the general public and/or property developers and spec builders, for example SPAN Housing; Centre Point office block, London; Coventry Cathedral . . . this type of architecture has also been called 'commercialised modern'.

(2) Buildings or structures that are symbolically styled, for example a hamburger stall in the shape of a hamburger; the Brown Derby restaurant, Los Angeles; Granada and Odeon cinemas; large scale illuminated signs (see Electrographic Architecture); advertising hoardings . . . according to Reyner Banham this type of architecture is a branch of commerce packaging "imagery of dreams that money can buy". Robert Venturi, discussing Las Vegas, describes it as 'autoscape architecture' and claims it is based on communication, not form.

(3) Buildings by professional architects who have been influenced by the example of the Pop Architecture of commerce described in (2) above; examples include the 'House of the Future' project designed by Alison and Peter Smithson in 1956, which incorporated ideas of styling, expendability and annual model changes; the Windsock Schooner Inn, Dunstable; and certain projects by Robert Venturi and by Charles Moore.

(4) Fantastic designs and projects by artists (mainly Pop artists such as Claes Oldenburg) for vast sculptures on an architectural scale, or images of destructive transformations of existing architecture and landscapes.

Architectural theorists, like fine artists, have been interested in popular culture as a source of ideas since the 1950s. Many architects reacted against the purist tradition of modern architecture and envied the vitality of Las Vegas; its chaos and vulgarity appealed particularly to Robert Venturi, who made a plea for greater complexity and contradiction in architectural design. In the view of architectural theorists, associative and symbolically styled architecture meets genuine psychological needs and they believe modern functionalist theory needs to be revised in the light of this.

R Banham 'On trial 5: the spec builders, towards a pop architecture' *Architectural review* 132 (785) July 1962 43-46.

G Broadbent 'Towards a Pop Architecture' *RIBA journal* 72 (3) March 1965 142-143.

R Venturi *Complexity and contradiction in architecture* (NY, MOMA, 1966).

P Reilley 'The challenge of Pop' *Architectural review* 142 (848) October 1967 255-259.

G M Lehmann 'Pop Architecture' *Architecture Canada* 45 (6) issue No 513, June 1968 69-71.

'Pop Architecture' *Architecture Canada* 45 (10) issue No 517, October 1968 (Special issue) 35-56.

C Jencks 'Pop-non Pop (1)' *AAQ* 1 (1) Winter 1968/1969 48-64.

C Jencks 'Pop-non Pop (2)' *AAQ* 1 (2) April 1969 56-74.

F Vostell & D Higgins *Fantastic Architecture* (NY, Something Else Press, 1969) German edition published as 'Pop Architektur'.

F Schulze 'Chaos in architecture' *Art in America* 58 (4) July/August 1970 88-96.

R Venturi & others *Learning from Las Vegas* (MIT Press, 1972).

F Schulze 'Toward an "impure" architecture' *Dialogue* 7 (3) 1974 54-63.

406 POP ART (also called Commonism, O K Art, Industrial Art, Consumer Style, Factualist Art, New Super Realism, New Sign Painting, Commodity Art, Gag-Art): The term 'Pop Art' is credited to the English critic Lawrence Alloway. It was first used during meetings of the Independent Group in the middle 1950s, to refer to the popular arts of mass culture and later to a fine art movement drawing inspiration from mass culture sources.

Pop Art celebrated the affluent consumer society, its stars and its culture heroes. Motifs were derived from commercial photography, advertising, packaging, supermarkets, comic strips, films, automobile styling . . . but as several critics have pointed out, such subject matter is not particularly new in painting. What was distinctive about the Pop Art of the late 1950s and early 1960s was that its techniques and visual vocabulary were also derived from the same sources. Fine artists are professionally interested in the ways reality can be coded for representational purposes and were impressed by the highly sophisticated and abbreviated codes used by commercial artists (Warhol and Rosenquist were commercial artists before they became fine artists). Pop artists treated their subject

matter in an impersonal way, avoiding moral judgements, and frequently echoed the mass production techniques used in industry to manufacture consumer goods (see Silkscreen Printing).

Variations of Pop Art occurred in most Western capitalist societies but the major centres were Great Britain and the United States. American Pop Art developed out of Neo-Dada and was usually stronger and more direct than the English variety, which tended to be over complicated, whimsical and nostalgic. The major Pop Artists: Roy Lichtenstein, Andy Warhol, Claes Oldenburg, Robert Indiana, Jim Dine, James Rosenquist, Tom Wesselman, Richard Hamilton, David Hockney, Eduardo Paolozzi, R B Kitaj, Derek Boshier, Allen Jones, Patrick Caufield, Peter Blake, and Peter Phillips.

See also Capitalist Realism, Independent Group, Neo-Dada, Nouveau Réalisme.

M Amaya *Pop as art: a survey of the new super-realism* (Studio Vista, 1965).

J Rublowsky *Pop Art: images of the American dream* (NY, Nelson, 1965).

L R Lippard & others *Pop Art* (Thames & Hudson, 1966).

C Finch *Pop Art: object and image* (Studio Vista, 1968).

C Finch *Image as language: aspects of British art 1950-1968* (Penguin, 1969).

J Russell & others *Pop Art redefined* (Thames & Hudson, 1969).

M Compton *Pop Art* (Hamlyn, 1070).

G Melly *Revolt into style: the Pop Arts in Britain* (Allen Lane, The Penguin Press, 1970).

J Weber *Pop Art, Happenings & Neue Realisten* (Munich, Heinz Moos, 1970).

L Alloway *American Pop Art* (NY, Collier-Macmillan, 1974).

Pop Art in England (Hamburg, Kunstverein, 1976).

407 POPULAR ART: A term used by Geoffrey S Fletcher and others to encompass those minor artforms produced anonymously which are enjoyed by the majority of the British public, for example, Christmas cards, Valentines, decorated vehicles, pictorial tiles, souvenirs, tattoos, ship models in bottles, glassware, cast ironwork, public house and theatre interior decor, children's peepshows, etc. Fletcher characterises these arts as 'escapist' and regretfully admits that they are now largely anachronisms.

See also Fairground Art, Kitsch, Mass Art.

G S Fletcher *Popular art in England* (Harrap, 1962)

B Jones & B Howell *Popular arts of the first world war* (Studio Vista, 1972).

408 POST-ART ARTIST: A highly critical phrase used by Harold Rosenberg in 1971; it refers to ' "the artist" in a pure state, without the benefit of art. Having put aside the art of the past to the point of putting aside art itself, he has passed beyond art to its essence . . . this Post-Art Artist has no need of art since, by definition, he is a man of genius, sensitive, open to experience, a communicator and a perceiver of social realities.'

H Rosenberg 'The artist as perceiver of social realities: the Post-Art Artist' *Arts in society* 8 (2) Summer/Fall 1971 501-507.

409 POST-FORMALIST ART: A term used by Jack Burnham from 1968 onwards. Formalism was characterized by emphasis on formal properties of the art object, craft fetishism, and a drive towards total hermeticism; in contrast, Post-Formalist Art emphasizes systems rather than objects, procedures rather than end-results, and aims towards an interactive relationship with the world. Many writers on art consider that the work, example, and influence of Marcel Duchamp contributed most to the reaction against Formalist Art, consequently the term 'Post-Duchampian Art' has also been used to cover Systems Art and Conceptual Art (for example, Burnham and John Stezaker have employed it).

See also Formalism.

J Burnham *Great western salt works: essays on the meaning of Post-Formalist Art* (NY, Braziller, 1974).

410 POST-MINIMALISM (and Anti-Minimalism): This term was coined by the American art critic Robert Pincus-Witten to encompass those developments in American art of the late 1960s—"from process orientated experience to an art of purely intellectual activity such as we find in the conceptualist movement"—which succeeded Minimalism and reacted against its aesthetic. 'Anti-Minimalism' refers to those modes of art—fetishistic, obsessional sculptures by James Rosenquist, Lucas Samaras, Eva Hesse and others—that appeared at the same time as Minimal Art but opposed its aesthetic.

See also Eccentric Abstraction, Funk Art.

R Pincus-Witten 'Eva Hesse: Post-Minimalism into sublime' *Artforum* 10 (3) November 1971 32-44.

R Pincus-Witten 'Rosenquist and Samaras: the obsessional image and Post-Minimalism' *Artforum* 11 (1) September 1972 63-69.

411 POST-MODERN ARCHITECTURE: A concept employed by Charles Jencks in a critique of modern architecture. The term characterizes the present situation in which modern architecture persists but is under attack; it also denotes those forces 'countering the trend toward an abstract and supposedly universal architecture', for example ARAU (Atelier de Recherche et d'Action Urbaine)Belgium, and ARC (Architects Revolutionary Council) London. After reviewing the current options Jencks concludes: 'If a lasting change is to be made, it will probably have to be the whole system of architectural production and this implies a revolution in society'.

See also Community Architecture.

C Jencks 'The rise of Post-Modern Architecture' *AAQ* 7 (4) October/December 1975 3-14.

412 POST-MODERN DESIGN (or Pop Design): Since 1945 many young architects and designers have reacted against the values established by the masters of the Modern Movement. Modern architecture and design is seen by them to constitute a tradition. They believe that the functional theories of modern design—fitness for purpose, truth to materials, functional efficiency—have proved inadequate because they fail to allow for the emotional, psychological and irrational needs of human beings, needs that are clearly revealed by the existence of popular culture, by the continuing appeal of Kitsch, and by the demand for consumer products.

In recent years the history of the development of modern architecture has been rewritten to correct an imbalance; too much weight had been given to rational forms of architecture at the expense of expressionistic and fantastic traditions.

During the 1960s the emergence of Pop Art and 'Pop Design'—exemplified by Carnaby Street, London—indicated the extent of the reaction to the modern tradition and initiated the Post-Modern Design era.

See also Modern Movement, Kitsch.

K & K Baynes 'Behind the scene' *Design* (212) August 1966 18-29.

P Reilly 'The challenge of Pop' *Architectural review* 142 (848) October 1967 255-257.

C Hughes Stanton 'What comes after Carnaby Street?' *Design* (230) February 1968 42-43.

C Cornford 'Cold rice pudding and revisionism' *Design* (231) March 1968 46-48.

413 POST-MODERNISM: The ideology of Modernism has existed for approximately 125 years, and still dominates artistic practice, art teaching, and writing on art in the West, but since the late 1960s a number of dissenting voices have been heard—Daniel Bell's, Ihab Hassan's Brian O'Doherty's and Harold Rosenberg's—claiming that Modernism is exhausted, that we are now entering a Post-Modernist era. For example, Bell writes: 'Today modernism is exhausted. There is no tension, the creative impulses have gone slack. It has become an empty vessel. The impulse to rebellion has become been institutionalised . . . and its experimental forms have become the syntax and semiotics of advertising and haute couture'; and Rosenberg declares: 'modern art is art of the past, a period style . . .'.

Doubts concerning the continued viability of Modernism were generated by the unforeseen and unwelcome side effects of modernisation in all spheres of life, by the disastrous failures of modern architecture and planning, by the absurdities which resulted when Minimal and Conceptual artists took certain premises of Modernist theory to their logical conclusions, by the frenetic turnover of artistic 'revolutions' which had little real effect, by the self-destructive tendencies within Modernism itself (see Anti-Art), by the changes in attitudes brought about by the cultural revolution of the 1960s, and by the ever-growing influence of Marxism and the increasing number of communist states whose art and culture is not based on Modernism.

Another sign of the growing disenchantment with Modernism is the decision by several American museums to run down their contemporary art programmes or even to de-modernize their collections. Clearly, the development of Post-Modernism presents opportunities for reactionary as well as progressive forces.

Post-Modernism is not, as yet, a positive, coherent system of ideas (Hassan claims that Post-Modernism has tended towards anarchy) but rather a sceptical, critical consciousness motivated by the desire for fundamental change (O'Doherty believes that 'angry dumbness' is the primary emotional content of Post-Modernism). Post-Modernists necessarily scavenge amongst the ruins of Modernism whilst they attempt to construct a viable alternative: the negation of Modernism. In all likelihood Post-Modernists will be compelled to appropriate many Modernist concepts but they will use them in the service of different ends.

See also Avant Garde Art, Modernism.

B O'Doherty 'What is Post-Modernism?' *Art in America* 59 May-June 1971 p 19.

I Hassan 'Post-Modernism: a paracritical bibliography' *New literary history* 3 (1) Autumn 1971 5-30.

P L Berger & others *The homeless mind: modernization and consciousness* (Penguin Books, 1974).

D Bell 'The double bind of modernity'—in—*The cultural contradictions of capitalism* (Heinemann, 1976) 33-171.

H Rosenberg 'The old age of Modernism'—in—*Art on the edge: creators and situations* (Secker & Warburg, 1976) 281-287.

414 POST-PAINTERLY ABSTRACTION (or New Abstraction): Title of a major exhibition of American painting, organised by Clement Greenberg, held in Los Angeles in 1964. Greenberg's term 'painterly abstraction' was an alternative to 'Abstract Expressionism' (he derived 'painterly' from Heinrich Wolfflin—see Painterly Painting), hence 'Post-Painterly Abstraction' refers to work produced after Abstract Expressionism by a younger generation of artists, for example, Paul Feeley, Frank Stella, Ellsworth Kelly, Al Held, Alexander Liberman, Sam Francis, Helen Frankenthaler.

Most of these artists reacted against the gestural romanticism of Abstract Expressionism and preferred greater clarity and openness of design. (For a fuller discussion, see Hard-Edge Painting, Systemic Painting, Stain Painting).

An alternative term, but less informative, is 'New Abstraction' which derived from an exhibition held in New York in 1963. this show featured many of the same artists cited above; in his catalogue introduction Ben Heller claimed that these painters shared 'a conceptual approach to painting'. Subsequently the term 'New Abstraction' was taken up by other critics, for example, John Coplans applied it to the work of a number of West Coast artists.

New Abstraction (NY, Jewish Museum, 1963).

Post-Painterly Abstraction (Los Angeles, County Museum of Art, 1964).

J Coplans 'The New Abstraction on the West Coast, USA' *Studio international* 169 (865) May 1965 192-199.

415 PRESENCE: According to American critics, Presence is an attribute of Minimal Art sculpture. William S Rubin defines it as "the ability of a configuration to command its own space"; Michael Fried believes it is basically theatrical: a stage presence; Clement Greenberg, the first writer

to analyse Presence, claims that it is not an artistic quality, and that the Presence of Minimal sculpture is a result of its size and non-art look.

M Fried 'Art and Objecthood'—in—*Minimal art: a critical anthology;* edited by G Battcock (Studio Vista, 1969) p 127.

W S Rubin *Frank Stella* (NY, MOMA, 1970) p 37.

416 PRESENTOLOGICAL SOCIETY: An avant garde group concerned with Happenings and Street Art founded in Prague in 1968 by Rodolf Nemec and Eugen Brikcius.

See also Happenings, Actions, Street Art.

E Brickcius 'Happenings in Prague' *Studio international* 179 (919) February 1970 78-79.

417 PRIMATE AESTHETICS: Some monkeys and chimpanzees enjoy painting and are capable of a degree of pictorial control, for example, balancing a composition. The pictures they produce are abstract and calligraphic; in style they resemble Action painting or Tachisme. The scientific study of ape art and the investigation of the visual preferences of apes and monkeys has been called 'primate aesthetics'. The purpose of this discipline is to discover if there are any biological principles common to both ape and human art.

D Morris 'Primate aesthetics' *Natural history* 70 1961 22-29.

M Levy 'Chimpanzee painting: the roots of art' *The studio* 161 (818) June 1961 203-207.

D Morris *The biology of art...* (Methuen, 1962).

T Osman 'The aesthetic ape' *Sunday times magazine* January 14 1973 30-32.

A Whiten 'Primate perception and aesthetics'—in—*Beyond aesthetics: investigations into the nature of visual art;* edited by D Brothwell (Thames & Hudson, 1976) 18-40.

418 PROCESS ART (or Procedural Art): Recently an English art critic noted that the word 'process' had topped the art terminology charts. However, the notion it refers to dates back to 1950 and the emphasis placed on the artist's creative behaviour in Action Painting. As Robert Motherwell said at the time—during a discussion on the question of when a painting could be regarded as finished—"We are involved in 'process' and what is a 'finished' object is not so certain". In other words, to Action painters the final object was primarily a record of their creative performance and they thought of the painting as 'unfinished' because their

performance could be continued, or repeated, on other occasions. Furthermore, as in the Drip Painting of Jackson Pollock and the later Stain Painting of Morris Louis, the end results were predicated by the nature of the materials and procedures used to create the work. Robert Morris has emphasised the fact that many American artists have, in order to make art, adopted systematic methods of behaving as an alternative to the tasteful arrangement of forms (though taste remains in the choice of materials and procedures). The essence of Process Art is that the process of making the work becomes the subject of the work; fairly simple techniques are employed so that the viewer can mentally reconstruct, from the final object, the procedure by which it was made.

Several critics maintain that Process Art tends towards the production of series, hence Systemic Painting has been included in this category. Two English painters whose works have been interpreted as an enquiry into the process of painting are Bernard Cohen and Mark Lancaster. However, the process aesthetic is not restricted to the realm of painting. During the 1960s it was adopted by a number of sculptors—Richard Serra, Keith Sonnier, Robert Morris—and in the 1970s by artists working in several international modes.

A number of exhibitions held in 1969 marked the ascendancy of Process Art: the Anti-Form show; the travelling exhibition 'When attitudes become form'; the 'Anti-Illusion: procedures/materials' show held at the Whitney Museum, New York; the 'Place & Process' exhibition held at the Edmonton Art Gallery. A typical example of a Process piece, by Robert Morris, consisted of firing a shotgun at a wall, photographing the result, then firing a shotgun at the enlarged photograph, photographing the result, etc.

Morris believes that once an artist has adopted systematic procedures including some that rely on the element of chance, he has, to a certain extent, automated art making; this he regards as an advantage because it provides 'coherence'. The Process artist has a special regard for materials and the natural laws that affect them. Rafael Ferrer has created works with blocks of ice which, over a period of time, alter their shape and finally disappear; Carl Andre welcomes the fact that his open air pieces are in a constant state of change, for example steel units that rust; thus the "work becomes a record of everything that happened to it".

According to Thomas Albright, Process Art is "the act of change, the process of creation itself". He distinguishes two kinds—Performance Art, which he regards as an extension of theatre, and 'Force Art', which makes use of natural forces or elements (see Ecological Art).

The popularity of the Process concept in recent art is based on the fact that it allows the visual artist to deal with time and also to dematerialise the now despised art object. The artist himself, as the embodiment of the creative process, becomes the art work, as in Body Art.

W Sharp 'Place and Process' *Artforum* 8 (3) November 1969 46-49.

R Motherwell—in—*The New York School: Abstract Expressionism in the 40s and 50s;* edited by M Tuchmann (Thames & Hudson, 1970) p 26.

T Albright 'Visuals' *Rolling stone* (85) June 14 1971 36-37.

J Burnham *The structure of art* (NY, George Braziller, 1971).

Robert Morris (Tate Gallery, 1971).

419 PROGRAMMED ART: A description applied by the Italian artist/designer Bruno Munari to certain of his own works produced since 1945. His art objects generally take the form of small viewing screens displaying changing combinations of colour and shape. These transformations are produced by electric motors turning movable parts. Programming, a word derived from computer terminology, consists in deciding operating speeds and the length of time required to complete a cycle of transformations. According to the artist, Programmed Art 'aims to show forms in the process of becoming'; it seems to be a variety of Kinetic Art but Munari denies this hypothesis. Nevertheless the label 'Arte Programmata' has been used to describe the Kinetic works produced by the Italian Group N of Padua.

Certain movements of the 1960s—Op Art, Systemic Painting, Serial Art—have also been described as 'programmed' meaning that their forms and relationships are often pre-determined by the use of mathematical series. The term 'Programmed Art' refers most aptly to Computer Art since this type of art is literally programmed.

B Munari 'Programmed art' *Times literary supplement* (3262) September 3 1964 p 793.

B Munari *Design as art* (Penguin, 1971) p 174.

P Selz 'Arte programmata' *Arts magazine* 9 (6) March 1965 16-21.

J Hlavacek 'About the interpretation of programmed art' *BIT international* (7) 1972 67-74.

420 PROJECT 84: A centre established in London in 1971 to promote co-operation and understanding between artists and scientists. The centre organises discussions, lectures and working groups; in the future it hopes to set up a reference library and workshop facilities. Project 84 is co-ordinated by the mathematics graduate and science journalist David

Dickson; its organising committee includes Conrad Atkinson, Guy Brett, Peter Byrne and Alan Campbell.

D Dickson 'Project 84' *Studio international* 181 (931) March 1971 90-91.

'Exhibitions: Project 84' *Time out* (115) April 28-May 4 1972 p 61.

421 PROJECTED ART: Title of an exhibition held at Finch College Museum in the winter of 1966/67. 'Projected Art' simply refers to those works which require projection equipment to be seen, for example, films, slides, and video enlargements.

Increasing use is being made of slide projection as a means of displaying visually a greater range of work than could normally be accommodated in a gallery; it is also being used as a medium in its own right. For example, the British artist Tim Head has produced several exhibits in which photographs of objects in a gallery space were projected on to those very same objects and spaces. A device popular with Performance artists at the moment is to perform actions in front of projected slide images.

See also Slide Culture;

E H Varian *Projected art* (NY, Finch College Museum of Art, 1966/67).

L Carney 'The revival of the slide' *Art magazine* (Canada) 19 (6) Fall 1974 22-23.

J Tagg 'In camera . . ' *Studio international* 190 (976) July/August 1975 55-59.

422 PROP ART: Short for 'Propaganda Art', the kind exemplified by political posters. Also termed 'Persuasive art'.

See also Atelier Populaire, Political Art.

G Yanker *Prop Art: international political posters* (Studio Vista, 1972).

A Rhodes *Propaganda: the art of persuasion world war II* (Angus & Robertson, 1976).

423 PSYCHEDELIC ART: A trend in the painting and Light Art of the late 1960s coincident with the Hippy and Flower Children drug culture, international in scope but primarily an American West Coast phenomenon. Drugs such as LSD and techniques of sensory deprivation produce states of consciousness very different from normal waking experience. Drugs, it is claimed, enhance perception, increase aesthetic sensitivity, improve creativity, unlock the subconscious mind. The Psychedelic artist is one whose works are influenced by his altered consciousness. Often he

250

attempts to communicate, via a visual analogue, the drug experience itself. Admirers of this kind of art postulate a psychedelic sensibility to account for stylistic precedents in the work of Hieronymus Bosch and William Blake, and in Art Nouveau and Surrealism. Drug influenced art was not exclusive to the 1960s: the Decadent and Symbolist painters of the late nineteenth century sought inspiration from similar substances.

Characteristics of modern Psychedelic Art: all over decorative patterning, a melange of abstract and figurative motifs, snaky, dissolving forms, ambiguous spacial effects, iridescent or acid colours. Timothy Leary summarised their impact as 'retinal orgasm'. Other writers found the style 'tedious', its forms 'niggling' and its colours 'emetic'. The Psychedelic style was quickly assimilated by advertising, the cinema, by clothing and textile manufacturers. No major artist emerged from the movement; perhaps the best known is Isaac Abrams.

The kaleidoscope effects sought by Psychedelic painters were more successfully reproduced by light shows; these are now obligatory at any Pop music concert or dance. Multi-media performances attempt to induce synaethesia, making use of sound, coloured smoke and strobe lights to assault several senses at once. The extreme loudness of the music and the intensity and frequency of the light oscillations are designed to produce sensory overload, a disorientation of normal consciousness—in fact, a synthetic trip.

'Are we suffering from psychedelic fatigue?' *Design* (229) January 1968 p 21.

R E L Masters & others *Psychedelic Art* (Weidenfeld & Nicolson, 1968).

N Gosling 'Snakes in the grass' *Art & artists* 4 (9) December 1969 26-31.

424 PUBLIC ART: A term used to describe artworks—usually sculptures —which are designed specifically for public open spaces (parks, squares, courtyards, waste ground). Most Public Art is sited at ground level and is accessible to pedestrians whereas traditional monuments and statues were set on plinths and were often placed in the middle of roads. Because Public artworks occupy unregulated sites—they are not guarded as are artworks in museums—and are often regarded as unwarranted intrusions into the territory of those who live near the sites they are sometimes subject to vandalism.

Perhaps the most extensive Public artwork to date was Christo's twenty-four mile long, eighteen foot high, white nylon 'Running fence' erected in California in 1976.

In a paper entitled 'Togetherness' (1961) the British painter Robyn
Denny developed the notion of Public Art (as against Studio Art) in more
theoretical terms and claimed that Public Art could be fitted into four
categories, namely, information, decoration, integration, and collabor-
ation.

See also Street Art, Screevers.

J Rees & others 'Public sculpture' *Studio international* 184 (946)
July/August 1972 9-47.

L Alloway 'The public sculpture problem' *Studio international* 184
(948) October 1972 122-125.

J Rees & T Stokes 'Public sculpture' *Studio international* 185 (952)
Fbeurary 1973 46-47.

Robyn Denny (Tate Gallery, 1973).

'Public art' *Art in America* 62 (3) May/June 1974 (special issue).

H M Davis & S E Yard 'Some observations on public scale sculpture'
Arts magazine 50 (5) January 1976 67-69.

425 PULSA: An American art, research, and technology group formed
in 1967 by ten artists but by 1970 consisting of seven: Michael Cain,
Patrick Clancy, William Crosby, William Duesing, Peter Kindlmann, David
Rumsey and Paul Fuge. Pulsa makes use of electronic technology to pro-
duce sensory phenomena in programmed environments. For example,
in a sculpture court at the 'Spaces' Exhibition, Museum of Modern Art,
New York, in the winter of 1969-1970, they created an environment of
computer linked light, sound and heat systems responsive to spectator
behaviour and to the noise of the urban setting.

See also Technological Art, Environmental Art.

J Burns *Arthropods: new design futures* (NY, Praeger, 1972) 138-142.

'The city as an artwork'—in—*Arts of the environment;* edited by G
Kepes (Aidan Ellis, 1972) 208-221.

426 PUSH AND PULL: A dynamic theory of pictorial tensions devised
by Hans Hofmann, a German/American painter who has been called "the
dean of Abstract Expressionism". 'Push and Pull' refers to those 'in and
out' forces that occur in abstract paintings composed of many patches
of colour. This kind of pictorial depth is achieved not by means of per-
spective or tonal gradation, but by the control of colour relationships.
The forces of Push and Pull operating three dimensionally must also be

balanced against other forces functioning across the canvas in the two dimensional plane.

H Hofmann *Hans Hofmann* (NY, Abrams, 1964).

427 PUSH PIN STUDIO: An influential American graphic design organisation of twenty artists founded in 1954 by Milton Glaser and Seymour Chwast. Admirers of the Push Pin style claim that it combines wit, superb draughtsmanship and diverse imagery. The Studio issues a magazine: *Push Pin graphic.*

A Ferebee & M Genehell 'Revivalism revisited' *Design* (242) February 1969 32-37.

E Stephano 'The Push Pin Studio' *Art & artists* 5 (6) September 1970 26-27.

The Push Pin style (Palo Alto, California, Communication Arts Magazine, 1970).

Push Pin Studios: Idea extra issue 1972 (Tokyo, Orion Books, 1972).

R

428 RADICAL DESIGN: In writing on the arts it has become fashionable to link the adjective 'radical' to 'art', 'architecture' and 'design'. In some instances 'radical' denotes art that is extreme in its form or technique (eg Photo-Realist painting has been called 'Radical Realism'), while in other instances it denotes art based on extreme political principles, especially left-wing principles. Those artists whose ambition is to produce effective political art are concerned to synchronize these two facets of radicality.

The concept of Radical Architecture/Design is heavily promoted in Italy: the magazine *Casabella* (Milan, 1928-) describes itself as 'the magazine of radical design'. In practice Radical Architecture generally consists of the presentation in graphic layouts of fantastic, utopian projects and conceits by small groups of architects and designers (Archizoom, Superstudio, UFO, etc), the aim of which is to challenge established notions of what architecture is; theoretical writings are also produced which attack the socio-economic, ideological structures of 'normal' architecture

253

and industrial design. The terms 'negative', 'critical', 'oppositional' are often applied to these activities but Radical Design is to be distinguished from Alternative or Counter Design by its greater awareness of politics and ideology. For radical designers and architects the built environment is primarily a system of meanings, architecture is seen as a language which serves the dominant class, hence the view that changes of consciousness in regard to architecture are as important as the production of actual buildings.

See also Alternative Design, Community Architecture, Conceptual Architecture, Political Art.

A Mendini 'Radical design' *Casabella* (367) July 1972 p 5.

A Branzi 'A long term strategy' *Casabella* (370) October 1972 p 13.

G Celant 'Radical architecture'–in–*Italy: the new domestic landscape* (NY, MOMA, 1972) 380-387.

'Architecture and design' *Contemporanea* (Florence, Centro Di, 1973) 289-334.

P Navone & B Orlandoni *Architettura 'radicale'* (Milan, Documenti di Casabella, 1974).

429 RANDOM ART: A concept announced by the Dutch artist Hans Koetsier in 1969, referring to art based on the laws of probability or chance. Artists have always been willing to take advantage of happy accidents or to incorporate random elements into their creative procedures, for example Marcel Duchamp's 'Standard Stoppages', Hans Arp's collages (created by dropping scraps of paper on to a paper ground), or the technique called Drip Painting, but in recent years chance procedures have become much more formalised. Science orientated artists have employed statistical techniques derived from probability theory and information theory, giving rise to expressions such as 'Aleatory Art' or 'Stochastic Painting'.

See also Computer Art, Indeterminate Architecture.

A M Bork 'Randomness and the twentieth century' *ICA bulletin* (175) November/December 1967 7-16.

F L Whipple 'Stochastic painting' *Leonardo* 1 (1) January 1968 81-83.

M Challinor 'Change, chance and structure: randomness and formalism in art' *Leonardo* 4 (1) Winter 1971 1-11.

430 REMEDIAL ART (including Insane Art, Mad Art, Pathologic Art, Psychotic Art, Psychoneurotic Art, Psychotherapeutic Art, Psychiatric Art): Doctors, psychoanalysts, and psychiatrists working in mental

254

institutions encourage patients to produce 'art'—usually paintings, drawings, or sculptures—as a form of therapy and as aids to diagnosis. Increasingly tutors in art (ie not trained in medicine) are being employed in such institutions to give technical advice and to supervise patients' creative work. A course in Remedial Art to prepare tutors has been established at St Albans School of Art (it is also concerned with the application of art to health in a more general way, eg the design needs of the physically handicapped). Several journals are concerned with Remedial Art, namely, *American journal of art therapy* (1961-), *Art psychotherapy* (1973-), *Japanese bulletin of art therapy* (1969-), *Inscape* (1962-).

Psychoanalysts are primarily dependent upon the established body of Freudian and Jungian theory for their analysis of the art of mentally disturbed; it is assumed that art expresses the unconscious aggression and sexuality inherent in human beings and that therefore artworks provide information about their producer's mental condition which they would be unable or unwilling to supply more directly. Classic texts on the art of the insane were written some decades ago by authors such as Ernst Kris and Hans Prinzhorn. This is an extremely problematical area of knowledge: the variables normal/disturbed, untrained person/trained artist, immediately yields four different kinds of work. Although writers on the art of the mentally ill are certain there is a distinction between it and 'real art' the precise differences remain vague, and analysts are unable to resist the temptation to search for neurotic symptoms in accepted works of art; Leonardo, Bosch, Goya, Van Gogh, are favourite subjects for this kind of enquiry.

See also L'Art Brut, Freudian Aesthetics, Jungian Aesthetics.

H Prinzhorn *Artistry of the mentally ill . . .*(Berlin, Springer Verlag, 1972) first published 1922.

E Kris *Psychoanalytic explorations in art* (Allen & Unwin, 1953).

F Reitman *Psychotic art* (Routledge & Kegan Paul, 1950).

N Kiell (ed) *Psychiatry and psychology in the visual arts and aesthetics; a bibliography* (Madison & Milwaukee, U of Wisconsin Press, 1965).

R W Pickford *Studies in psychiatric art* (Springfield, Illinois, Charles S Thomas, 1967).

Art and mental health (Commonwealth Institute, 1968).

E Adamson 'Art for mental health'—in—*The social context of art;* edited by J Creedy (Tavistock, 1970).

P Pacey 'Remedial Art' *ARLIS newsletter* (9) October 1971 10-14.

431 RETINAL ART: Paintings that appeal primarily to the eye and emphasise sensuous painterliness. Marcel Duchamp, an artist who tried consistently to reintroduce intellectual content into art, used the word 'retinal' disparagingly. He believed that Impressionist painting–indeed all painting since Courbet, apart from Surrealist–was retinal. As Op Art is the retinal style par excellence, Retinal Art is sometimes used as an alternative description of it.

P Cabanne *Dialogues with Marcel Duchamp* (Thames & Hudson, 1971) p 43.

432 RILA (Repertoire International de la Littérature de l'Art): A quarterly abstract journal of current art historical literature made possible by the cooperation of authors of books and articles and an international network of institutions and libraries in Europe, Russia, and the United States. It specializes in the scholarship of post-classical European and post-conquest American art. The abstracts are arranged in broad subject groups and include full bibliographical details. An author and subject index is also provided. The service became fully operational in 1975.

See also ADP.

433 ROBOT ART: A form of Kinetic Art developed by the Israeli artist P K Hoenich which makes use of the forces of the sun, the wind and the movement of the earth to activate mobiles and to structure light and shadow. The operating period for such works can be as long as six months.

The American artist and art historian Jack Burnham, in his book on the impact of science and technology on modern sculpture, uses the expression 'Robot Art' to describe sculpture produced by artists such as Eduardo Paolozzi and Ernest Trova which combine robotic and human forms. Burnham discusses mock-robot sculpture as a preliminary to a full examination of working robots operating according to cybernetic principles.

See also Cybernetic Art, Kinetic Art.

M Myers and P K Hoenich 'Robot Art' *Ark* (35) Spring 1964 30-33.

J Burnham *Beyond modern sculpture* . . . (Allen Lane, The Penguin Press, 1968).

P K Hoenich 'Kinetic Art with sunlight . . .' *Leonardo* 1 (2) April 1968 113-120.

P K Hoenich ' "Robot Art": using the rays of the sun' *Studio international* 175 (901) June 1968 306-309.

P K Hoenich *Sonnen-malerei* (Cologne, Dumont, 1974).

S

434 ST IVES SCHOOL (or Cornish School, or West Country School):
St Ives is a fishing village situated in a part of England noted for the quality
of its light. In the twentieth century it has been the only significant visual
art centre in Britain outside of London. During the pre-war years a mix-
ture of abstract and naive art prevailed: artists who lived there included
Ben Nicolson, Barbara Hepworth, Naum Gabo, Alfred Wallis, and the pot-
ter Bernard Leach. During the late 1940s and early 1950s a number of
younger artists, working in a wide variety of styles, took up permanent
residence in St Ives or visited the village for the summer months: John
Wells, Peter Lanyon, Bryan Wynter, Terry Frost, Victor Pasmore, William
Scott, Roger Hilton, Patrick Heron, Robert Adams and Merylyn Evans.
 D V Baker *Britain's art colony by the sea* (Geroge Rowland, 1959).

435 SAINT MARTIN'S SCHOOL OF ART SCULPTORS: This descrip-
tion refers to a number of talented British sculptors—David Annesley,
Michael Bolus, Philip King, Tim Scott, William Tucker and Isaac Witkin—
all of whom, except Tucker, studied under Anthony Caro in the late
1950s and early 1960s at St Martin's School of Art, London. Like Caro
they rejected the modelling and carving traditions of sculpture represented
in England by Henry Moore. They rejected also the Geometry of Fear
style, submitting instead to the influence of American artists such as the
sculptor David Smith and the abstract painter Kenneth Noland.
 The British sculptors first attracted public attention at the 'New Gen-
eration' exhibition held at the Whitechapel Art Gallery, London in 1965.
Their work is generally open in format and stands directly on the floor
rather than on plinths (see Floor Art). It is made up of basic elements
in the Constructivist tradition but also stresses physical qualities such as
colour, surface texture, volume and topology. Most of the sculpture is
abstract but a vein of Surrealist imagery is discernable in some works.
Industrial materials such as sheet steel, metal pipes or netting, fibre glass
and acrylic plastic are employed in preference to marble or wood. The
sculpture is brightly coloured with commercial gloss paints (it has been
called 'Colour Sculpture') and presents a cheerful appearance (it has also
been called 'Fun Sculpture').
 The New British Sculpture in some respects resembles American Mini-
mal Art but generally it avoids the extreme severity of Minimal Sculpture.

Anthony Caro is highly regarded by many American critics but the St Martin's School as a whole has been dismissed by them as 'British lightweights'.

The new generation: 1965 (Whitechapel Gallery, 1965).

'Some aspects of contemporary British sculpture' *Studio international* 177 (907) January 1969 10-37.

The Alistair McAlpine gift (Tate Gallery, 1971).

436 SCANDINAVIAN STYLE (also called Nordic Design): During the 1950s a vogue for Swedish, Finnish, Danish, and Norwegian products—glassware, silverware, textiles, jewellery, enamels, and furniture—swept Britain; their style was quickly copied by British manufacturers. Scandinavian designers who have become internationally famous include Alvar Aalto, Tapio Wirkkala, Bruno Mathsson, Arne Jacobson, Eward Hald and Jans J Wegner.

Scandinavian Design had been developing on the lines laid down by the Arts and Crafts Movement and also pioneering new research techniques, such as anthropometrics, throughout the inter-war years; 'Swedish Modern' had achieved international recognition in the 1930s. Unlike their British counterparts, Scandinavian artist/designers were highly regarded by employers and the general public; their higher professional status permitted greater artistic freedom. The relatively small scale of Scandinavian industries made it possible for designers to be closely involved with the production processes. As a result of these factors, Scandinavia achieved a union of mass production and handicraft traditions.

The design products of Scandinavia were attractive in appearance and functional. Furniture designers made sensitive use of natural woods and woven fabrics. Generally designers sought purity and simplicity of form. Italy is currently the source of the best design in Europe (see Italian Craze and the Supersensualists) and Scandinavian products nowadays tend to be dismissed as dull and unexciting.

437 SCIART: A blend of 'Science' and 'Art' proposed by the American physicist, poet, and art gallery dealer Bern Porter. In a manifesto appended to his book *I've left* (NY, Something Else Press, 1971), Porter lists a series of scientific discoveries—such as polarised light and nuclear particle beams—which he believes should be exploited by artists.

J Reichardt 'Art at large: the union of science and art' *New scientist* January 6 1972 p 46.

438 SCI-FI ART: The term 'science fiction' was coined in 1929 by Hugo Gernsback editor of the first science fiction magazine *Amazing stories*. 'Sci-Fi Art' refers to the lurid, fantastic illustrations which appear on the covers of science fiction pulp magazines and paperback books, and the drawings in comic books. Best known of the Sci-Fi artists are Virgil Finlay, Edd Cartier, Roger Dean, Earle Bergey, Alex Raymond, and Frank Hampton of Dan Dare fame. In the 1970s Sci-Fi Art became something of a cult, judging from the number of histories published, and the appearance of the large format magazine *Science fiction monthly* (1974-) which featured Sci-Fi Art in full colour.

B Aldiss *Science fiction art* (New English Library, 1975).

L Del Rey (ed) *Fantastic science fiction art 1926-1954* (NY, Ballentine Books, 1975).

F Rottensteiner *The science fiction book, an illustrated history* (Thames & Hudson, 1975).

J Sadoul *2000 A D: illustrations from the golden age of science fiction pulps* (Souvenir Press, 1975).

D Kyle *A pictorial history of science fiction* (Hamlyn, 1976).

J Sacks (ed) *Visions of the future* (New English Library, 1976).

439 SCREEVERS: Beggars who use art (pictures in chalk drawn on the pavement) as a means of soliciting money from passers-by. The term 'screever' seems originally to have been applied to someone making a living by writing begging letters. Henry Mayhew first recorded its use for a pavement artist in his book *London labour and the London poor*; Screevers are also mentioned in George Orwell's *Down and out in London*. They are usually without professional training and generally learn by example from established Screevers. The main sites for pavement art in London are along the Embankment, Bayswater Road, at Marble Arch and outside the National Portrait Gallery.

See also Street Art.

D Winsor 'The street is their easel' *Daily telegraph magazine* (597) May 21 1976 20-27.

440 SEE-THROUGH FURNITURE: Transparent furniture dates back to the 1920s when objects such as pianos were constructed of glass (with a steel framework) although at that time such items were curiosities.

Since 1945 the development of new clear materials has made transparent furniture commonplace. Inflatable or Blow-up chairs have been made in

clear PVC, rigid chairs have been constructed out of perspex sheets and tables made of glass. A designer particularly noted for his See-Through Furniture is Quasar Khanh, a Vietnamese working in Paris.

441 SEMIOLOGICAL SCHOOL (or Semiotic School): Charles Jencks and others have argued that the urban environment is 'a communicating system, a tissue of signs and symbols' and that therefore semiology, or semiotics, (see following entry) is of fundamental importance to modern architecture. Jencks forecasts the emergence of a Semiological School of architecture which will attempt to 'make a complex environment significant', and he analyses the work of Robert Venturi and Jose Luis Sert in terms of this theory.

A number of essays on the application of semiotics to architecture are collected in the anthology *Meaning in architecture.*

See also Pop Architecture.

C Jencks & G Baird (eds) *Meaning in architecture* (Barrie & Rockliff, 1969).

C Jencks *Architecture 2000: predictions and methods* (Studio Vista, 1971).

442 SEMIOTICS: The general science of signs; the science that studies the life of signs in society; an important academic discipline which has become extremely fashionable in intellectual circles in the past few years especially in France and Italy. An international association of semiotics was founded in 1969 and several scholarly journals are devoted to the subject including *Semiotica* and *Versus*; articles applying semiotic analysis appear in journals such as *Communications, Tel quel, Cinéthique* (Paris), *Cultural studies* (Birmingham), *Screen, Studio international* (London).

The word 'semiotic' derives from the Greek 'semeion' meaning 'sign'. On the continent of Europe 'semiology' was preferred to 'semiotic', but international agreement has now been reached favouring the latter term. Various thinkers have made use of the term— John Locke in the seventeenth century, C S Peirce and Ferdinand De Saussure in the late nineteenth century. However, semiotics is essentially a twentieth century discipline.

Laymen think of signs as commercial and informational displays (shop signs, road signs), but the concept of sign in semiotics is much broader than this: according to Peirce, 'a sign is something which stands to somebody for something in some respect or capacity'. Hence a sign can stand for something which is absent or does not exist (a unicorn); a key

feature of signs is that they can be used to lie. Any process involving the communication or experience of meaning makes use of signs, consequently semiotic research encompasses human language, images, diagrams, architectural spaces, clothing and fashion, gestures, facial expressions, rites and ceremonies, animal communication, films, typologies of texts and cultures, logic, money as a system of exchange relations, all codes and symbol systems, indeed the whole of human culture can be considered to be a system of signs. Semiotics is a crucial discipline because all other forms of human knowledge are dependent upon signs in order to be understood; semiotics interpenetrates them all.

Human language is perhaps the sign system which has been most fully studied in the twentieth century therefore linguistics has tended to function as a model for all other branches of semiotics and literature is the artform which has been subjected to the most intensive semiotic analysis. As a result the application of semiotics to the visual arts, in particular painting and sculpture, is relatively underdeveloped though writers such as Eco have applied it to architecture and television; Metz has applied it to the cinema, Bertin to diagrams, P Fresnault-Deruelle to the comic strip, and Barthes to photography.

To art historians and art critics the value of semiotics is that it provides a more sophisticated analytical methodology than was hitherto available. To artists such as Victor Burgin the value of semiotics is that it exposes the mechanisms of communication systems such as advertising, and thereby enables them to control and manipulate those systems in order to serve different ends. However, in spite of the heuristic power of structuralism and semiotics some commentators argue that their philosophical basis has fundamental defects, see for example John Stezaker's critique listed below.

See also Diagrams, Pictorial Rhetoric, Structuralism.

R Barthes *Elements of semiology* (Jonathan Cape, 1967).

N Goodman *Languages of art: an approach to a theory of symbols* (OUP, 1969).

R Barthes 'Rhetoric of the image' *Cultural studies* (working papers in) Spring 1971 36-50.

P Fesnault-Deruelle *La bande dessinée . . .* (Paris, Hachette, 1972).

'The tell tale sign: a survey of semiotics' *Times literary supplement* (3735) October 5 1973; (3736) October 12 1973.

D Greenlee *Peirce's concept of sign* (The Hague/Paris, Mouton, 1973).

F De Saussure *Course in general linguistics* (Fontana/Collins, 1974).

C Metz *Film language: a semiotics of the cinema* (NY, OUP, 1974)

C Metz *Cinema and language* (The Hague, Mouton, 1974).

V Burgin 'Photographic practice and art theory' *Studio international* 190 (976) July/August 1975 39-51.

J Culler *Structuralist poetics: structuralism, linguistics and the study of literature* (Routledge & Kegan Paul, 1975).

P Guiraud *Semiology* (Routledge & Kegan Paul, 1975).

J Stezaker 'Metaphor in art and architecture' *Net* (1) 1975.

U Eco *A theory of semiotics* (Indiana U Press, 1976).

L Matejya & I R Titunik (eds) *Semiotics of art: Prague School contributions* (MIT Press, 1976).

443 SERIAL ART: A term associated with two important exhibitions held in the United States: 'Art in Series', Finch College Museum, 1967 and 'Serial Imagery', Pasadena Art Museum, 1968. The dictionary defines a series as "a number of things, events, etc ranged or occurring in spatial or temporal, or other succession". The traditional notion of art was to perfect a single unique work—what John Coplans calls 'the masterpiece concept'—but since the 1880s, when Claude Monet painted the 'Haystack' series and Eadweard Muybridge published his series of photographs depicting animal and human locomotion, many modernist artists have worked in series. Generally these artists have no stylistic or other qualities in common apart from their use of the series procedure. However, it was an idiom especially favoured in the 1960s by certain artists associated with the Minimal Art movement: Mel Bochner, Sol LeWitt, Don Judd, Carl Andre.

The main intention of artists employing serial imagery is to play variations on a theme; this can be achieved in a number of ways. Andy Warhol has created many works in which an image is repeated again and again within the confines of one canvas. The images are applied mechanically by the Silk Screen Printing process and individual variations (equivalent to the 'handwriting' of traditional art) are provided by the 'errors' of the printing, and also in some cases by the addition of colour by brush. Josef Albers is famous for a series of paintings called 'Homage to the Square', in which one variable of painting (image) is held constant while another (colour) is manipulated. Jasper Johns' 'American Flag' series is another example of the Albers approach: the flag image remains constant while Johns varies colour, brushwork and placement of image.

In order to appreciate art in which an idea is exhausted through a series of paintings, it is necessary to see the complete set so that they can be read in sequence. Individual elements of the set are relatively unimportant compared with their relation to the whole concept (the latter is

generally called the system; see Systemic Painting). Consequently the work of many modern painters appears shallow when judged from single examples in mixed exhibitions but gains in stature in the context of one man shows.

Gerald Gooch, a San Francisco artist, has parodied serial imagery in a work consisting of twenty panels showing a professor of aesthetics getting on and off a bicycle!

No element of levity is found in discussions of Minimal Art sculpture. Mel Bochner characterizes Serial Art as 'highly abstract', an "ordered manipulation of thought . . . self contained and non-referential . . . Serialism is premised on the idea that the succession terms (divisions) within a single work are based on a numerical or otherwise predetermined derivation (progression, permutation, rotation, reversal) from one or more of the preceding terms in that piece. Furthermore the idea is carried out to its logical conclusion, which, without adjustments based on taste or chance, is the work . . . The only artistic parallel to this procedure would be in music . . ." Bochner cites Sol LeWitt's 'Series A' 1967 sculpture as a prime example of these ideas.

Some examples of Minimal sculpture consist of a series of identical units (cf Clastic Art) spaced at regular intervals, like the teeth of a comb. Such a series is a segment of the infinite, a continuum with no particular beginning or end; variety is provided not by the artist but by the interaction of the work and its environment, and by the spectator's perceptual experience of the work as he moves about the gallery. A good example is Don Judd's wall piece 'Untitled' 1965.

L March 'Serial Art' *Architectural design* 36 (2) February 1966 62-63, cover design.

M Bochner 'The serial attitude' *Artforum* 6 (4) December 1967 28-33.

D Lee 'Serial rights' *Art news* 66 (8) December 1967 42-45, 68-69.

L Alloway 'Serial forms'–in–*American sculpture of the sixties* (Los Angeles, County Museum of Art, 1967) 13-14.

J Coplans *Serial imagery* (NY, Graphic Society, 1968).

M Bochner 'Serial art, systems, solipsism'–in–*Minimal Art: a critical anthology;* edited by G Battcock (Studio Vista, 1969) 92-102.

N Calas 'Art and strategy'–in–*Icons and images of the sixties,* by N & E Calas (NY, Dutton, 1971) 218-221.

444 SHAPED CANVAS (also called Topological or Sculptural canvas): The traditional shape of portable oil paintings has generally been rectangular in order to match the walls from which they derive and upon which

they are displayed. Nevertheless other shapes, such as diamond, cross and tondo, have been employed by painters from time to time. In the twentieth century, Georgio De Chirico used triangular and trapezoid shapes, Jackson Pollock worked on exceptionally long horizontal rectangles and Barnett Newman produced very narrow, vertical paintings, but despite these examples there was little experimentation with shape of support before the 1960s.

Various artists are given credit for the 'invention' of the modern shaped canvas; H H Arnason cites Lucio Fontana, William S Rubin cites Barnett Newman. Painters as different as Richard Smith, Bernard Cousinier, Anthony Green, Derek Boshier, Joe Tilson, Trevor Bell, Neil Williams, Harvey Quaytman, Charles Hinman, David Hockney and James Rosenquist have created shaped canvases, but the chief practitioner is Frank Stella.

In non-relational painting the 'figure on the field' effect is banished from the interior of the picture. This tends to emphasise the external shape of the canvas, which itself becomes a figure against the background wall, and the environmental setting of the work consequently assumes greater importance. (Patrick Heron criticises Shaped Canvases on the grounds that the artist's control does not generally extend to the settings in which his works are displayed.)

In 1960 Frank Stella began his famous series of notched canvases, the shapes of which were determined solely by the pattern of stripes of colour crossing the picture surface. Since then he has methodically explored the reciprocal relationship between internal pattern and external profile. Lawrence Alloway points out that Shaped Canvases stress the object quality of art and that despite their environmental space Stella's works have great internal solidity, emphasised by the use of thick stretchers. Alloway maintains that the contoured edges are ambiguous, keeping in suspense the balance between interior and external space. He also claims that Shaped Canvases are a mixture of painting, sculpture and craft. Despite the critical attention paid to this development, many art commentators remain unimpressed by the Shaped Canvas, regarding it as the terminal agonies of an exhausted art form.

See also Deductive Structure, Dimensional Painting, Objecthood.

L Alloway *The shaped canvas* (NY, Guggenheim Museum, 1964).

D Judd 'The shaped canvas' *Arts magazine* 39 February 1965 p56.

M Fried 'Shape as form: Frank Stella's new paintings' *Artforum* 5 (3) November 1966 18-27.

K Moffett 'Kenneth Noland's new paintings and the issue of shaped canvas' *Art international* 20 (4-5) April/May 1976 8-15, 28-30, 74.

445 SIGNALS: A London gallery and centre devoted to the promotion of Kinetic Art operative in the mid 1960s. Its name derived from the title given by the Greek artist Takis to a series of vibrating metal sculptures he began in 1955. The gallery featured the work of such artists as Sergio de Carmargo, Lygia Clark, Liliane Lijn, David Medalla, Helio Oiticica, Takis, and J R Soto. It also issued a newspaper-type magazine, edited by Medalla, *Signals bulletin* from August 1964 to March 1966.

See also Kinetic Art.

446 SILK SCREEN PRINTING: A technique used in the textile and graphic arts, appropriated by a number of easel painters in recent years, notably Robert Rauschenberg, Andy Warhol and Richard Hamilton.

Photographic images transposed on to canvas by means of the silk screen process eliminate the necessity of drawing as a preliminary to painting. In many instances painting becomes a form of tinting. The silk screen technique multiplies the image-making capacity of the artist: the same image can be repeated many times within one work or over a series of works. Such possibilities have been exploited to the full by Andy Warhol.

See also Mec Art.

447 SITE: Acronym for 'Sculpture In The Environment', a New York organisation established in 1969 consisting of five sculptors—Dana Draper, James Wines, Cynthia Eardley, Nancy Goldring and Marc Mannheimer—who operate like an architectural team, working collectively and individually on different projects. SITE artists have no pre-conceived aesthetic or style, and produce sculpture best suited to the characteristics of each individual site, hence the name of the group.

SITE issues an irregular publication documenting their activities: *On Site.*

See also Environmental Art, Public Art, Street Art, De-architecturization.

'People' *Landscape architecture* 61 (4) July 1971 282-283.

J Wines 'The case for site orientated art' *Landscape architecture* 61 (4) July 1971 317-319.

448 SITUATION: The title of two important exhibitions of painting held in London in 1960 and 1961 representing the British version of Post-Painterly Abstraction. The work was large in scale, abstract and made use of flat fields of colour (though some paintings were still gestural). It refelected the influence of Barnett Newman and American

Hard-Edge Painting. Situation, a loose association of twenty artists, included Gillian Ayres, Bernard and Harold Cohen, Robyn Denny, John Hoyland, Henry Mundy, Richard Smith, Anthony Caro and Peter Stroud. The exclusion of those British painters associated with the St Ives School indicated the emergence of a new generation of artists.

A new London gallery, or bureau, called 'Situation' was established in 1971 by Robert Self and Anthony de Kerdrel to encourage 'Openness, new directions', to act as an outlet for films, Video Art and Performance Art.

Situation: an exhibition of British abstract painting (RBA Galleries, 1960).

L Alloway 'Situation in retrospect' *Architectural design* 31 (2) February 1961 82-83.

New London Situation: an exhibition of British abstract art (New London Gallery, 1961).

' "Situation": the British abstract scene in 1960' *Isis* (1468) June 6 1964 6-9.

'Exhibitions: Situation' *Time out* (103) February 4-10 1972 p36.

449 SITUATIONISTS: An alliance of European avant garde artists, architects and poets called the 'Internationale Situationiste' (IS) was formed at a conference in Italy in 1957 by amalgamating two existing organisations: 'Lettriste Internationale' (see Lettrism) and the 'International Union for a Pictorial Bauhaus'. Members of IS included the architects Debord and Constant and the ex-Cobra painter Asger Jorn. The aim of IS was to cut across existing political and nationalistic divisions. They refused to proclaim any sort of doctrine (which makes them rather hard to define) but they did believe in a totality of the arts, an art of interaction, of participation, a spatial art or 'Unitary town planning' which would take account of the needs of different localities and specific situations. The ideal Situationist was envisioned as an amateur expert, an anti-specialist. The volatile Situationists soon split into competing groups however. One such breakaway faction, called the 'Bauhaus Situationiste Drakabygzet', was established in Sweden in 1961, and based itself on Soren Kierkegaard's philosophy of situations.

Guy Debord, editor of the main journal of the Situationists—*Internationale Situationiste*—introduced the key concepts of 'situation' and 'society of the spectacle' in 1958. In Germany Heimrad Prem, Helmuth Sturm, Hans Peter Zimmer, and Dieter Kunzelemann established a Situationist group called 'Gruppe Spur' and produced seven issues of a

266

magazine with violent graphics. In Italy Giuseppe Pinot-Gallizio exhibited and sold 'industrial paintings', that is, works produced mechanically by the roll.

Situationist theory, a kind of intellectual terrorism, was basically a total critique of everyday life in Western Bourgeois society. It achieved its greatest triumph during the revolutionary events in Paris in May 1968 when Situationist philosophy was momentarily put into practice by the masses. Although the Situationists no longer exist as a coherent force their ideas continue to influence thinkers and activists throughout the world and their political use of graphic material such as advertising, comics, and graffiti continues to inspire the practice of European political artists.

Internationale situationiste 1958-1969 (Amsterdam, Van Gennap, 1972 reprint).

Spur (Munich, seven issues 1960-1961).

M Bernstein 'The Situationist International' *Times literary supplement* (3,262) September 3 1964 p781.

J Nash 'Who are the Situationists?' *Times literary supplement* (3,262) September 3 1964 782-783.

G Debord *Society of the spectacle* (Detroit, Black & Red, 1970).

M Bandini 'Pinot-Gallizio' *Data* (9) Autumn 1973 16-26, 82-85, 94-95.

C Gray (ed) *Leaving the 20th century: the incomplete work of the Situationist International* (Free Fall Publications, 1974).

R Vaneigem *The revolution of everyday life* (Practical Paradise Publications, 1975).

450 SLIDE CULTURE: This term reflects the influence of colour photography on contemporary taste, particularly the use of colour slides in art and design education. Disturbing events, such as nuclear explosions and unsightly environments, become tolerable, even ravishing, as coloured images. Similarly, slides glamourise art works and many viewers express disappointment when they see the originals.

See also Museum without Walls, Projected Art.

451 SNARE PICTURES (or Trap Pictures): A name given by the Italian artist Daniel Spoerri to his own work. Accumulations of objects, such as those remaining on a table at the end of a meal, are 'snared' by Spoerri, that is affixed to boards, hung vertically from walls and presented as art objects.

452 SOCIOLOGICAL ART GROUP (Collectif Art Sociologique): A group of French artists—Hervé Fischer, Fred Forest, and Jean-Paul Thénot —founded in Paris in 1974. Influenced by the critical theory of the Frankfurt School of philosophy and the example of the Situationists the members of CAS are developing an artistic practice whose purpose is to question and to criticize the ideology of bourgeois society, including the role of art itself (hence art is expected to perform a self-reflexive critique). The possibility of an alternative form of society is forwarded but no blueprint for the future is presented (the aim is to get people to think for themselves), consequently CAS refuses to associate with the existing political parties of the left; indeed CAS believes that dogmatic, bureaucratic communist regimes are in need of criticism. Sociological art is so-called because it utilizes certain concepts and techniques of sociology (eg questionnaires) and it aims to transform society but is distinguished from the sociology of art by being an active practice rather than an academic, scientific discourse.

See also Frankfurt School Aesthetics, Political Art, Situationists.

Collectif art sociologique: theorie–practique–critique (Paris, Musée Galliera, 1975).

P Restany 'Sociological art' *Domus* (548) July 1975 52-53.

H Fischer 'Manifesto No 2 for sociological art' *Control* (9) December 1975 p8.

H Fischer 'Sociological art as utopian strategy' *The fox* 1 (3) 1976 166-169.

453 SOFT ARCHITECTURE: A proposal by the studio of Arata Isozaki, a Japanese architect, for a living space with as few fixed elements and permanent divisions as possible, to be achieved by inflated domes, light and sound machines and plug-in units.

454 SOFT ART or **SOFT SCULPTURE**: In the past, finished works of sculpture have generally been made of hard materials—wood, marble, bronze . . .—to ensure permanence. However, modern artists are not so concerned with perpetuity (see Expendable Art) and during the 1960s an increasing number of them have explored the possibilities of soft materials such as vinyl, rubber, fibre glass, latex, feathers, felt, plastic, hair, string and sand.

This departure was triggered by Claes Oldenburg's 'Soft typewriter' of 1963; since that date he has created many works in vinyl, canvas and kapok held together by sewing or lacing. His fellow American sculptor

John Chamberlain works with plastic foams such as polyurethane. Oldenburg's innovation was prefigured by the soft objects depicted in Surrealist paintings by Salvador Dali. However, Oldenburg claims that his objects were primarily a new way of pushing space around.

The limpness and pliability of Soft Sculpture are analogous to human flesh and organs: several critics have suggested it has visceral connotations.

The Pop artist Jann Haworth makes life-size human figures out of different pieces of fabric sewn and filled out with stuffing. The British sculptor Barry Flanagan has employed felt, rope and sand in his works, materials which accept the force of gravity as a determinant of form (see also Anti-Form, Matter Art, Art Povera).

Several exhibitions of Soft Art have been mounted in recent years: New Jersey State Museum (1969), New York Cultural Center (1973), and Camden Arts Centre, London (1974). Some critics have seen the emergence of Soft Art as a mocking attack on the pretensions to permanence of orthodox sculpture and on the sleek monumentality and durability of consumer goods.

Soft Art (Trenton, New Jersey State Museum, 1969).

R Pomeroy 'New York: Soft Art' *Art & artists* 4 (1) April 1969 26-27.

R Pomeroy 'Soft objects at the New Jersey State Museum' *Arts magazine* 43 (5) March 1969 46-48.

M Kozloff 'The poetics of softness'–in–*Renderings: critical essays on a century of modern art* (Studio Vista, 1970) 223-235.

Soft as art (NY, Cultural Center, 1973).

Soft Art (Camden Arts Centre, 1974).

D Z Meilach *Soft sculpture and other soft artforms with stuffed fabrics, fibers and plastics* (Allen & Unwin, 1974).

455 SOFTWARE: Title of a major exhibition held at the Jewish Museum, New York in 1970. The exhibition was organised by Jack Burnham and the title suggested to him by Les Levine. Software featured artists concerned with "machine aided communication or documentation".

The word 'software' derives from computer nomenclature, where it generally refers to programmes and artificial languages used to operate hardware, that is, the physical equipment. However, Burnham appears to have used it in a broader sense. In his essay 'Real Time systems', for example, he claims that "the entire art information processing cycle, the art books, catalogues, interviews, reviews, advertisements of art and contracts are all software extensions of art". The meaning of software and the appropriateness of its application to art was disputed by Robert

Mallary, and the matter was debated by Burnham and Mallary at some length in the columns of *Leonardo* magazine in 1970.

See also Systems Art, Conceptual Art.

J Burnham 'Real time systems' *Artforum* 8 (1) September 1969 49-55. *Software* (NY, Jewish Museum, 1970).

456 SoHo: This word does not refer to Soho, London. It is a contraction of 'South Houston' a business district of New York which has become a centre for art galleries and artists' lofts.

P Gardner 'SoHo, brave new bohemia' *Art news* 73 (4) April 1974 56-57.

457 SOUND ARCHITECTURE: The use of moving sound as a means of defining architectural space. A concept developed by Bernhard Leitner in 1971.

B Leitner 'Sound Architecture' *Artforum* 9 (7) March 1971 44-49.

458 SOUND SCULPTURE (or Sonic Sculpture): The use of sound in the context of the visual arts as distinct from the use of sound in the context of music can be dated from 1913 and the Futurist manifesto of Luigi Russolo entitled 'The art of noises'. The more recent career of John Cage can be cited as an example of the tendency typical of contemporary art to blur distinctions between music, the visual arts, and the performing arts. Some visual artists have used sound to add an extra dimension to their normally silent artworks, for example, Robert Rauschenberg introduced a radio into his Combine Painting 'Broadcast' (1959). While others have used sound to record the process of producing an artwork, for example, Robert Morris created in 1961 'Box with the sound of its own making', a wooden box containing a three hour tape recording of its construction. John Anderton, a British artist, has used sound recordings linked to a series of loudspeakers to produce 'sculpture'. He explains that these recordings are not intended 'as pieces of music or performances but as pieces of sculpture using sound to form patterns and occupy positions in space. Unlike traditional solid sculptures . . . sound can be experienced both from within as well as from outside the pattern formed by the speakers.'

Kinetic art works usually produce some noise, whether planned or not. The phrase 'Audio-Kinetic Sculpture' has been coined to describe those works in which sound and movement are deliberately linked. Some artists, especially in North America, have presented sound as a primary

270

sculptural experience: for the 'Magic Theatre' exhibition held at the Nelson Art Gallery, Kansas City in 1968 Howard Jones devised a 'Sonic games chamber' in which alterations of sound patterns were caused by spectator movement; in 1969 Dennis Oppenheim produced a 'sculpture' consisting of a tape recording of the sound of his footsteps as he traversed a specific area of a city; at the Museum of Conceptual Art, San Francisco in 1970 a show entitled 'Sound Sculpture As' featured the sounds of guns being fired, telephones ringing, and an artist urinating into a bucket. Artists such as Tom Marioni, who combines elements of Performance and Conceptual Art, often employ amplifiers to pick up the sound of their actions, and by a process of feedback make the sound persist in the room-space for as long as there is movement.

In 1970 the Museum of Contemporary Crafts, New York organised the first major exhibition to focus entirely on sound. Three years later an exhibition entitled 'Sound/sculpture' was held at the Vancouver Art Gallery, Canada. This show featured work by Harry Bertoia, Reinhold Marxhausen, David Jacobs, Stephen Von Huene, Charles Mattox, Walter Wright, and Francois and Bernard Baschet. Its catalogue consisted of a thirty minute recording. This reminds us that in the twentieth century many artists working in the visual arts have produced artworks using records, Kurt Schwitters' Merz poetry on disc, for example. The printed catalogue to the exhibition 'Record as artwork 1959-73' lists over fifty examples of records produced by artists. Another catalogue in the form of a disc was that for the 1969 'Art by telephone' exhibition mounted in Chicago. Clearly, sound recording can be used to produce primary material (artworks) or secondary material (documentation). A magazine presenting both types of material is *Audio arts*, a British venture dating from 1973, which presents the discourse of Conceptual artists, artists' statements, theoretical discussions, recordings of performance pieces, and interviews, in the form of a tape cassette.

L Russolo *The art of noises* (NY, Something Else Press, 1967).

Sound, light and silence (Kansas, William Rockhill Art Gallery, 1967).

Art by telephone (Chicago, Museum of Contemporary Art, 1969).

A McMillan 'The listening eye' *Craft horizons* 30 (1) January/February 1970 14-19.

Audio arts, London 1 (1) 1973- .

Record as artwork 1959-73 (Royal College of Art, 1973).

G Celant 'The record as artwork' *Domus* (520) March 1973 51-53.

M Eastley *Sonic sculpture* (Dartington Hall Press, 1973).

J Lowndes 'Sound/sculpture' *Arts Canada* (180/181) August 1973 66-69.

S Melikan 'The Baschet brothers: the sounds of sculpture' *Art news* 72 (8) October 1973 70-71.

M Neuhaus 'Sound in public spaces' *Domus* (562) September 1976 50-52.

J Grayson (ed) *Sound sculpture* . . . (Vancouver, ARD Publications, 1976).

459 SPACE (Space Provision (Artistic Cultural & Educational) Ltd): A London organisation founded in 1968 by Bridget Riley, Peter Sedgley, Professor West, Irene Worth, Peter Townsend and Maurice De Sausmaurez. Its purpose is to provide studio space for artists. The organisation developed out of an awareness of two facts: (1) the lack of large working areas for artists, (2) the availability of facilities in disused schools or factory buildings due for demolition. Within a year SPACE managed to accommodate ninety artists in Saint Katherine's Dock, a disused London warehouse; exhibitions of their work have also been mounted.

See also AIR, ACME Housing Association.

'A proposal to provide studio workshops for artists' *Studio international* 177 (908) February 1969 65-67.

S Braden 'AIR RA RIP? SPACED' *Time out* (84) September 24-30 1971 20-21.

'Notes on SPACE' *Catalyst* January 1971 p 56.

460 SPACE ART & SPACE AGE ART: The Dutch artist Paul Van Hoeydonck has been described as the 'Giotto of the age of space exploration' because the subject matter and forms of his paintings and sculpture are inspired by the Russian and American space programs; his work is for this reason called 'Space Art'.

The scientist and Kinetic artist Frank Malina prefers the expression 'Space Age Art' and defines three types: (1) "art made on Earth with new techniques or materials developed by astronautical technology, incorporating visual experiences provided by space flight and exploration", (2) "art made on Earth to express either the resulting new psychological experiences or the possible new philosophical experiences of man and of the universe", (3) "art made and used on the moon and on other planets".

The visualizing ability of the artist still has a role to play in space research, for example, artists are often employed to produce pictures or models of conditions on planets as yet unvisited by camera-equipped space craft. A specialist in this kind of art was the architect and

272

astronomer Chesley Bonestall whose first book illustrations on space themes date from the early 1950s.

A collection of Space Art is held by the National Air & Space Museum, Smithsonian Institute, Washington.

See also Sci-Fi Art

'Personal profile: Chesley Bonestall, Space artist' *Spaceflight* 11 (82) 1969.

D A Hardy 'The role of the artist in Astronautics' *Spaceflight* 12 (14) 1970.

J Van Der Marck 'Paul Van Hoeydonck's ten year Space Art program' *Art international* 14 (2) February 1970 41-43.

F J Malina 'On the visual fine arts in the space age' *Leonardo* 3 (3) July 1970 323-325.

L Pesek 'An artist in Modern times: on extraterrestrial landscapes' *Leonardo* 5 (4) Autumn 1972 297-300.

A C Clarke 'Beyond Jupiter' *Sunday times magazine* April 21 1974 30-39, cover.

461 SPACE STRUCTURE WORKSHOP: A British group founded in 1968 and operating from London, concerned with events, collaboration with industry, and Environmental Art; members include Maurice Agis, Peter Jones and Terry Scales. The workshop organises events in parks and open spaces in order to reach the general public and provides environmental structures that integrate the elements of space, colour and sound. The group's objective is to liberate the senses of the public and present an alternative aesthetic experience that will by contrast, reveal the deficiencies of the ugly, dehumanised urban environment in which most people live. By these means Space Structure Workshop hopes to stimulate social and political action.

See also Community Art, Environmental Art.

'Spaceplace: selections from the notes of Agis, Jones, Marigold and Pitt' *Studio international* 183 (940) January 1972 34-37.

462 SPATIAL ABSTRACTION: A term invented by the French abstract painter Auguste Herbin and used by Nicolas and Elena Calas to describe paintings produced in the 1960s by the American artist Leon Polk Smith.

N & E Calas 'Spatial Abstraction'—in—*Icons and images of the sixties* (NY, Dutton, 1971) 163-168.

463 SPATIALISM (or Spazialismo, or Movimento Spaziale): A grandiose doctrine developed by Lucio Fontana (an artist born in Argentina who was educated and worked most of his life in Italy) first expounded in his 'Manifesto blanco', 1946. Fontana advocated a radical break with past aesthetic concerns and proposed to end the separate forms of painting and sculpture by synthesising all physical elements—colour, sound, space, motion and time—into a new kind of art.

Fontana had been trained as a sculptor and wanted to introduce literal space, as opposed to depicted space, into his paintings; this he achieved by means of holes or slits cut in the surface of the canvas. He also added relief elements to create cast shadows. In the 1950s he became interested in Matter Art and attached pebbles, glass and other foreign materials to the paint surface. During the same period he evolved a form of Environmental Art making use of neon light in black painted rooms.

The Spatialist movement is generally limited to the years 1951 and 1952; other artists who participated were Roberto Crippa, Enrico Donati and Ettore Sottsass.

See also Concrete Poetry.

A Pica *Fontana e lo Spazialismo* (Venice, Edizioni Cavallino, 1953).

G Giana *Spazialismo . . .* (Milan, Edizioni Conchiglia, 1956).

G Balla *Lucio Fontana* (Pall Mall Press, 1971).

Lucio Fontana (Milan, Palazzo Reale, 1972).

464 SPATIO DYNAMISM: A form of Kinetic Art practised by the Hungarian/School of Paris artist Nicholas Schöffer, whose work continues the space/motion/light tradition established by Laszlo Moholy-Nagy. Schoffer's metal constructions are electronically guided mobiles or robots. Light is refelected from their highly polished surfaces and the spectacle of their movement is accompanied by tape recordings of urban sounds. Like most Kinetic artists, Schöffer believes in the fruitful co-operation of art and science; he frequently uses the vocabulary of science, calling his works by such titles as 'Cybernetic Tower'. He also employs the term 'Luminodynamism' to signify the union of light and motion. One critic has described his innovations as "hiding an incongruous poverty of sculptural ideas".

J Ernest 'Nicolas Schöffer' *Architectural design* 30 (12) December 1960 517-520.

N Schöffer *La ville cybernétique* (Paris, Tchou, 1969).

N Schöffer *Le nouvel esprit artistique* (Paris, Gonthier, 1970).

465 SPONTANEOUS ARCHITECTURE: Buildings, or additions to existing buildings, erected 'spontaneously' by ordinary members of the public without regard to architects or planning regulations.

See also Architecture without Architects.

T Sieverts 'Spontaneous architecture' *AAQ* 1 (3) July 1969 36-43.

466 STAIN PAINTING: In 1952 the American artist Helen Frankenthaler, inspired by the example of Jackson Pollock's Drip Painting, developed a similar method of painting that exploited soft stains or blots of paint on unsized canvas. Two years later Morris Louis visited Frankenthaler's studio and was so impressed that he changed his style and adopted the stain technique. Later the paintings that he, and others such as Kenneth Noland, Jules Olitski and Paul Jenkins, produced during the late 1950s and early 1960s made the stain method world famous.

Stain painters apply very diluted acrylic paints, such as Magna, to unsized, unstretched cotton duck canvas. The liquid paint is poured, spilt or flooded on to the surface (in the case of Louis these facts are deduced from his paintings: he was secretive about his working methods). Olitski also applied paint with a spray gun and rollers. The unstretched canvas is sometimes folded or pleated to create design variations. On completion canvases are stretched, a process which presents the Stain painter with the problem of placement, that is, the relating of the image to the shape of support. Diluted paint soaks into cloth and therefore stain paintings resemble dyed fabric more than they do traditional oil paintings. Stained pigment is not a skin on the surface of the canvas; it is part of the object, like the coloured skin of a peach. Thus stain paintings have no sense of paint texture or natural sheen, giving their colour a disembodied look. The absence of surface reflections enables the pictures to be viewed from wide angles of vision. In some of his works Louis applied successive waves of paint to produce translucent veils of colour which achieve a merger of figure and ground: foreground and background no longer exist as separate entities.

To a large extent the stain method is 'automatic' in operation. According to American critics certain advantages follow: (1) since no hand or arm movements are involved the painter is freed from the linear quality of drawing and the whole tradition of painting with a brush; (2) since the stained areas of paint exist as pure colour the problem of tonal modulation is transcended; (3) stain paintings are a record of the process by which they have been made, hence they unite pictorial structure with process of production.

Although stained canvases are extremely seductive to the eye (they have been called 'The New Aestheticism'), not all art critics are entranced by them. Some find their beauty 'cosmetic', and Harold Rosenberg dislikes their soaked-in quality, claiming that it affirms middle class values of tidiness and security.

See also Washington Colour School, Colour-Field Painting, Process Art.

467 STANDARD ART: The brainchild of Nicholas Wegner, artist-director of 'The Gallery' (65a Lisson St, London). Wegner argues that since artworks marketed via the gallery system tend to become standardised this process should be made explicit, therefore he developed in 1976 a modus operandi for presenting photo-text panels (either by himself or other artists) in a standard format. The notion of Standard Art has affinities with Andy Warhol's practice, that is, the industrialization of art (mass production of paintings by means of silk-screen printing in a studio entitled 'The Factory').

468 STOCKWELL DEPOT SCULPTORS: Roland Brener, David Evison, Roger Fagin, Gerard Hemsworth, Peter Hide, Roelof Louw, Alan Barkley and John Fowler: eight young British sculptors who have worked and exhibited since 1967 in a Victorian industrial building called 'Stockwell Depot' situated in South London. These sculptors are not a group in the sense of sharing a common aesthetic but their work does have two points of similarity: it is generally abstract and it is usually too large in scale to be accommodated in private art galleries.

469 STORY ART (also called Diaristic Art, Journalistic Art, Post-Conceptual Theatre, Narrative Art): A minor genre of Avant Garde art which emerged in the United States and Europe in the first half of the 1970s. The term 'Story Art' derived from the title of an exhibition held at the John Gibson Gallery, New York in 1973 and referred to certain works by the artists David Askevold, John Baldessari, Didier Bay, Bill Beckley, Robert Cumming, Peter Hutchinson, Jean Le Gac, Italo Scanga, William Wegman, and Roger Welch. These artists received critical support from the artist/critic James Collins.

Story artists employed combinations of photographs, drawings, and texts (handwritten, typed, or printed), tape recordings, and wooden models, to tell anecdotes, to create fantasies, to document their environments, and to record auto-biographical and biographical histories.

According to Collins Story Art was 'a breakaway tendency from the catholic wing of Conceptural Art', but he advised the public not to be put off by the amount of reading Story Art required because it was not 'another dated philosophic mumbo-jumbo session from the 1960s', 'suffer and learn' was not the Story artist's motto; on the contrary, his aim was to please and to entertain. Story Art gave the impression of being light-weight, amateurish, and escapist but the low-key, dead-pan approach was deliberate. Story Art had an ironic, quirky character which in part re-sulted from the presentation of banal and trivial incidents in a high art context.

In the 1970s many fine artists began to re-appraise the techniques of communication used by the mass media and as a result began to employ such devices as narrative and plot; nevertheless, as Robert Pincus-Witten pointed out Story Art's close relation to the abstract pictorial and sculp-tural mainstream prevented it from becoming a sub-category of literature.

Although the term 'Narrative Art' was used as a synonym for 'Story Art' in art literature, the latter term has been preferred here in order to retain a distinction between it and earlier forms (see Narrative Figuration).

J Collins 'Story . . . John Gibson Gallery' *Artforum* 12 (1) September 1973 83-87.

R Pincus-Witten 'Theater of the Conceptual: autobiography and myth' *Artforum* 12 (2) October 1973 40-46.

J Collins 'Narrative 2' *Artforum* 13 (1) September 1974 75-76.

Narrative Art (Bruxelles, Palais des Beaux Arts, 1974).

B Radice 'Story Art' *Data* (16/17) July/August 1975 81-109.

'Narrative Art: photo & parole' *Domus* (555) February 1976 48-51.

470 STREET ART (including Billboard Art, Contact Art, Facade Art, Gable-end Art, Mural Art, Skyline Painting, Strassen Kunst, Town Paint-ing): A broad category which includes a range of activities, such as, out-door sculpture exhibitions (see Public Art, SITE), graffiti, murals pro-duced by groups of fine artists (see City Walls, Los Angeles Fine Art Squad), and forms of street theatre (see Actions, Community Art, Event-structure, Happenings). All these have in common the fact that they are presented in public thoroughfares or in public open spaces.

Advertising hoardings present the city dwellers of the Western World with a constantly changing spectacle of graphic art. These hoardings are sought after as display sites by fine artists because of their public character. Artists who have managed to place work on billboards include Joseph Kosuth, Daniel Buren, Ian Colverson and Denis Masi. In the United States

advertising images are painted on billboards 48ft x 12 ft in size by teams of commercial artists who use techniques similar to those perfected in Renaissance Italy. (The Pop artist James Rosenquist undertook such work early in his career.) These products have been designated 'Billboard Art' and 'Skyline Painting'.

The essential significance of the term 'Street Art' is political: the street belongs to the people and therefore it can be used by artists as a forum to draw attention to urban problems—drugs, rats, police brutality. A New York artist exploiting these themes is Tosun Bayrak. The concept of Street Art in a political sense can be traced to the propaganda art and mass spectacles of the years following the Russian Revolution, when artists were encouraged by Vladimir Mayakovsky "to make the streets our brushes, the squares our palette".

See also Presentological Society, Cultural Art, Screevers.

J Perrault 'Street works' *Arts magazine* 44 (3) December/January 1969/70 18, 20.

J A Thwaites 'Street art one: Hanover . . .' *Art & artists* 5 (10) January 1971 10-15.

Art in revolution: Soviet art and design since 1917 (Hayward Gallery, 1971).

P Killer 'Fur eine farbige stadt' *Du* May 1971 342-351.

G Wise Ciobotaru 'Art on the street' *Studio international* 184 (948) October 1972 122-125.

D Kunzle 'Art in Chile's revolutionary process: guerrilla muralist brigades' *New world review* 41 (3) 1973 42-53.

T Street-Porter 'Skyline painting' *Design* (300) December 1973 56-59.

A Seide 'Strassen kunst—fur wen?' *Magazin kunst* 14 (1) 1974 p33.

R Sommer *Street art* (NY, Links, 1975).

G Oosterhof ' "Town painting", een bericht uit Rotterdam' *Museumjournaal* 21 (2) April 1976 64-67.

471 STRUCTURAL/MATERIALIST FILM: A term devised by the filmmaker and film theorist Peter Gidal in 1974 to describe his own work and that of other Avant Garde film-makers such as Hollis Frampton, Kurt Kren, Peter Kubelka, Malcolm LeGrice, and Michael Snow. Earlier, in 1969, the adjective 'structural' had been applied to film in Britain by Gidal and in the United States by P A Sitney. According to Sitney 'The structural film insists on its shape, and what content it has is minimal and subsidiary to the outline . . . Four characteristics of the structural film are: a fixed camera position . . . the flicker effect, loop printing and

rephotography off of a screen.' Sitney also sees 'elongation' as a feature of the Structural film (ie the Russian Formalist notion of estrangement, the use of technique in art to make things unfamiliar by increasing the difficulty and length of perception). Gidal regards Sitney's use of the term 'structural' as misleading hence his efforts to substitute 'Structural/ Materialist'.

Avant Garde art derives its polemical zeal from its distaste for mass culture and the mass media; consequently the S/M film project—which is aggressively Avant Garde—utterly repudiates the values and characteristics of the commercial cinema: it rejects illusionism, transparency, narrative, plot, viewer identification with characters, traditional content, mystification (using art to disguise art), manipulation (using cinematic devices to prompt an emotional response), it rejects the idea of 'great' directors or artist film-makers as 'creators', it despises entertainment (what Gidal calls 'mind-rape'). Instead S/M film focuses on the structural elements (whole/part relationships, ordering of units) and the material character of film (duration—a material piece of time—becomes the basic unit); the subject matter of S/M film—the 'content'— is form, shape, structure, the process of production ('the process of making the film is the film'—Gidal). Representation occurs in that the camera is pointed at something but this is a matter of minor importance (it appears that the camera's ability to record an image of the world is a grave disadvantage as far as S/M film-makers are concerned). Meaning is not thought of as a pre-existent which is then expressed through the film, rather meaning is generated by the internal dialectic of the film and is constructed by the viewer in his attempt to decipher the film. A critical, detached, distanced attitude is expected of the viewer. S/M film claims to be reflexive: a cinema in which one watches oneself watching (does this not produce an infinite regress?). S/M film-makers see their activity as a demystification of film and harp on the necessity to deconstruct film devices by means of film. To avoid the trap of illusionistically documenting film processes the demand is made that deconstruction should be simultaneous with construction (which is equivalent to asking that a person who is knitting should unpick their stitches as fast as they knit them!).

The word 'structural' clearly derives from the critical terminology surrounding Minimal sculpture or Primary Structures. While the word 'material' refers simultaneously to film as material and to the Marxist doctrine of dialectical materialism. Two art movements have been influential on S/M film: Abstract Expressionism (the process concept that the method of production should remain visible in the end product) and Minimal art

279

(emphasis on repetition of identical units, structures, literalism, anti-illusion, etc).

Although Gidal denies that S/M film-makers are primarily concerned with the ontology of film (its essential nature) the use of the words 'Structural' and 'Materialist' would seem to indicate a commitment to a 'truth to materials' aesthetic, to a belief that the nature of film resides in its formal properties and its physical materials rather than being a historically determined social institution.

See also Fundamental Painting, Minimal Art, Process Art.

P A Sitney 'Structural film' *Film culture:an anthology;* edited by P A Sitney (Secker & Warburg, 1971) 326-349.

P Gidal 'Definition and theory of the current avant garde: materialist/structural film' *Studio international* 187 (963) February 1974 53-56.

P Gidal 'Theory & definition of structural/materialist film' *Studio international* 190 (978) November/December 1975 189-196.

P Gidal (ed) *Structural film anthology* (BFI, 1976).

P Wollen ' "Materialism" and "ontology" in film' *Screen* 17 (1) Spring 1976 7-23.

A Cotringer 'Critique of Peter Gidal's theory and definition of structural/materialist film' *After/Image* (6) Summer 1976 86-95.

472 STRUCTURALISM & ART: Structural anthropology—a discipline derived from structural linguistics—is a method of discovering general principles, order, or structure in human culture by an empirical study of social behaviour, myths, sign systems and art. The doyen of Structuralism is the French writer Claude Lévi-Strauss. The American art historian Jack Burnham has recently used Lévi-Strauss's methodology to analyse a large number of art works—predominantly modern—in an ambitious attempt to reveal the logical structure common to all examples of successful art. Other writings on Structuralism and Art are listed below.

See also Semiotics.

A Moles 'Vasarely and the triumph of Structuralism' *Form* UK (7) March 1968 24-25.

M Pleynet 'Peinture et "structuralisme" ' *Art international* 12 (9) November 20 1968 29-34.

G Dorfles 'Structuralism and Semiology in Architecture'—in—*Meaning in architecture;* edited by C Jencks and G Baird (Barrie & Rockliff, 1969) 38-49.

G Charbonnier *Conversations with Claude Lévi-Strauss* (Jonathan Cape, 1969).

A Michelson 'Art and the structuralist perspective'—in—*On the future of art;* edited by E Fry (NY, Viking Press, 1970) 37-59.

S Nodelman 'Structural analysis in art and anthropology'—in—*Structuralism;* edited by J Ehrmann (NY, Doubleday, 1970) 79-93.

J Burnham *The structure of art* (NY, George Braziller, 1971).

P Heyer 'Art and the structuralism of Claude Lévi-Strauss' *The structurist* (12) 1972/73, 32-37.

W Vazan & P Heyer 'Conceptual art . . .' *Leonardo* 7 (3) Summer 1974 201-205.

473 STRUCTURISM: A theory and method of creation developed by the American artist Charles Biederman. He coined the term in 1952 to describe his own work from the late 1930s onwards and in order to distinguish it from his earlier concept 'Constructionism'. Biederman produces brightly coloured abstract reliefs which attempt to synthesise qualities of painting, sculpture and architecture. He claims that they are created in accordance with the structural processes of nature.

The pre-war traditions of abstract art are continued by a number of other artists resident in Europe and North America, all of whom are admirers of Biederman. They include the English artist Anthony Hill, who has used the expression 'Structural Art' to describe his own work; the Dutch artist Joost Baljeu, founder of the magazine *Structure* which began publication in 1958; and the Canadian artist Eli Bornstein, who describes his reliefs as 'structurist' and who is editor of an art annual *The Structurist,* published by the University of Saskatchewan since 1960.

The confusion that can arise in art terminology is illustrated by the fact that American art critics have also employed 'Structural Art' and 'Structuralist Art' to refer to paintings and sculpture more generally known as Minimal Art. The word 'structure' derives, in this instance, from 'Primary Structures', the title of a large scale exhibition of Minimal sculpture held in New York in 1966.

See also Constructionism, Minimal Art.

G Kepes (ed) *Structure in art and science* (Studio Vista, 1965).

E Bornstein 'Structurist art and creative integration' *Art international* 11 (4) April 20 1967 31-36.

A Hill (ed) *Data: directions in art, theory and aesthetics* (Faber, 1968).

474 STYLING: The notion of style—a distinctive visual mode, an idiom shared by a number of works for a limited period of time—is entrenched in the history of art and design. Different styles can co-exist together at

one time but it is inherent in the notion of style that they must change and be replaced by others. A stylist is a designer who seizes upon the fact of historically inevitable stylistic change and exploits it fully by conscious operation; he accelerates or induces changes of style.

The industrial and economic structures of Western capitalist countries require an ever increasing output of manufactured goods. These products could be designed to last for many years, but if they did so this would threaten the ever expanding production economy, and therefore customers are supplied with poor quality goods and encouraged to replace them, even before they wear out. This is achieved by 'psychological obsolescence', a technique pioneered in the women's clothing industry, where new style models make previous products out of date, not in terms of utility but by making them appear unfashionable. As a result, Styling has a bad name; it has been called 'superficial design' and dismissed by Raymond Chandler as "a commercial swindle intended to produce artificial obsolescence".

Because they are concerned with fashion, stylists concentrate on the look of products, altering exteriors (a procedure called 'shroud design') according to current mannerisms and clichés. They seek to satisfy psychological and symbolic needs of consumers which they have identified by motivation research studies.

Gifford Jackson has identified five different style changes in American product design since the late 1920s: Stepform, Streamform, Taperform, Sheerform and Sculptureform. A striking example of the absurdity of Styling is the application of aerodynamic streamlining to static products such as ashtrays. Styling affected designers in all fields in America in the late 1950s and reached a peak in the annual model changes of automobiles manufactured in the last years of the decade. In Germany the term 'Detroit Machiavellismus' was coined to express distaste for this aspect of American design.

'Car Styling' was one of the topics discussed by the Independent Group during the 1950s. One of its members, the English artist Richard Hamilton, has expressed great interest in Styling in his writings and in his paintings, the latter being full of imagery derived from American Styling.

G Jackson 'Analysis—design styles and clichés' *Industrial design* 9 (9) September 1962 59-67.

R Hamilton 'Urbane image' *Living arts* (2) 1963 44-59.

V Packard *The waste makers* (Penguin, 1963).

J De Syllas 'Streamform . . .' *AAQ* 1 (2) April 1969 32-41.

G Muller-Krauspe 'Design Ideologien (2) Styling—das Prinzip der Diskontinuität' *Form* (47) September 1969 31-35.

D J Bush 'Streamlining and American industrial design' *Leonardo* 7 (4) Autumn 1974 309-317.

D J Bush *The streamlined decade* (NY, George Braziller, 1975).

475 SUBJECTS OF THE ARTIST: An art school established in 1948 by a number of American artists—Barnett Newman, William Baziotes, David Hare, Robert Motherwell, Mark Rothko and Clyfford Still—at 35 East Eight St, New York. These artists were convinced that the problem of subject matter in painting had reached a crisis point, hence the rather strange name of their group, suggested by Barnett Newman. The school lasted only one year, but most of the artists continued to meet at another venue (see The Club).

476 SUBTOPIA: This word is a combination of 'Suburb' and 'Utopia', and means "making an ideal of suburbia. Visually speaking the universalisation and idealisation of our town fringes. Philosophically, the idealisation of the Little Man who lives there." It was coined in the middle 1950s by the architectural writer Ian Nairn. He used it to describe the blurring of the separate identities of town and countryside caused by urban sprawl; "a witless chaos—a dumping down of every kind of man-made object, urban, suburban and subrural with no relationship to each other or to the site", "a desert of wire, concrete roads, cosy plots and bungalows". The attack on Subtopia mounted by Nairn and the *Architectural review* had the character of a moral crusade.

In the United States two similar terms have been coined: Slurb, a combination of 'slum' and 'suburb'; and SLOAP, the initial letters of 'space left over after planning', coined by Leslie Ginsburg.

I Nairn *Outrage* (Architectural Press, 1955).

I Nairn *Counter attack against Subtopia* (Architectural Press, 1959).

I Nairn *Your England revisited* (Hutchinson, 1964).

'Public opinion versus "Slurb" ' *Design* (232) April 1968 p 24.

477 SUPERGRAPHICS: A new form of Environmental Design which appeared in Western countries from 1966 onwards. Supergraphics are akin to fine art in that they dispense with the communication of direct information: they are generally abstract designs which cover the walls, ceilings, and exteriors of shops, offices, restaurants, and homes. They are huge in scale and make use of vivid, rainbow colours. Supergraphics are a form

of decoration which provide a cheap means of enlivening dull architecture.

See also Environmental Design, Street Art.

C Bouyeure 'Le supergraphisme' *Jardin des arts* (198) May 1971 70-71.

T Albright 'Visuals' *Rolling stone* (93) October 14 1971 39-40.

'Supergraphics' *Art directions* 25 (12) March 1974 56-58.

478 SUPERMANNERISM: A trend in American interior design and decoration of the late 1960s identified by *Progressive architecture* magazine. Supermannerism, or 'Mega-decoration', opposes tasteful design and is characterised by perverse trickery, both optical and intellectual. It operates on an explosive scale and uses transparent, reflective, synthetic materials. As the term indicates, the resulting style is mannerist; it also reveals Pop Art as a major source of inspiration: Superman-nerism.

'Revolution in interior design: the bold new poly expanded mega-decoration' *Progressive architecture* (10) October 1968 148-208.

479 THE SUPERSENSUALISTS: Architectural and design journalists have described a number of European designers and design groups—Gae Aulenti, Ettore Sottsass, Hans Hollein, Archizoom, Haus-Rucker-Co, Superstudio—as Supersensualists because their work since 1960 manifests a common approach to design. According to Charles Jencks, it is a blend of extravagant sensuality, metaphysical angst, beauty, advanced technology, and, piquantly enough, Marxism. Many of these designers create fantasy worlds in which ideas are taken to extreme conclusions. Their actual commissions are usually for furniture, and for the design of boutique, apartment and restaurant interiors for the urban middle class.

The Supersensualist characteristics are specially marked in the case of the Italian designers, who have been dubbed the 'Dolce Vita School' because their permissive approach to aesthetics and good taste echoes the permissive morality of the characters in Fellini's film.

See also Archizoom, Haus-Rucker-Co, Superstudio.

480 SUPERSTUDIO: An Italian experimental architectural and design group formed in 1966 and based in Florence. Members include Adolfo Natalini, Cristiano Toraldo Di Francia, Piero Frassinelli, Allessando and Roberto Magris. The Superstudio group carry ideas to extreme conclusions; they develop anti-functional, visionary projects such as the 'Continuous Monument', designed to extend across the world; spaceship cities;

284

continuous production/conveyor belt cities; etc. Members of Superstudio and the similar group Archizoom are called 'Supersensualists'. Their work is variously described as 'Conceptual' or 'Radical' architecture, and is regularly featured in such magazines as *Domus, Casabella,* and *Architectural design.*

9999 & Superstudio *S-Space: life, death and miracles of architecture* (Florence, Separate School for Expanded Conceptual Architecture, 1971).

481 SUPPORTS/SURFACES: In the period of cultural upheaval which followed the events in France in May 1968 a number of French painters began to rethink their artistic practice and founded a group entitled 'Supports/Surfaces' which held its first exhibition in Paris in 1970.

Originally the group included Vincent Bioules, Louis Cane, Marc Devade, Daniel Dezeuze, Claude Viallat, and others but by 1973 only Devade and Cane of the founder members remained, the others having resigned for various reasons. Supports/Surfaces wished to make a break with the syndrome of Avant Garde movements by making a return to history; ie revaluating the history of modern painting since Cézanne with particular reference to the example of Matisse. The artists were strongly influenced by the writings of the poet and critic Marcelin Pleynet on painting. They also took into account the Marxist doctrine of dialectical materialism and those developments in linguistics, structuralism, and psychoanalysis which dominate French intellectual life. To provide an outlet for the theoretical writings of the group the painters founded, in 1971, a journal *Peinture, cahiers théoriques.*

Supports/Surfaces' restitution of the art object (paintings) marked a reaction against Conceptual Art and the tendency for politically committed artists to substitute demonstrations for the production of art objects. What is surprising about the paintings of the group is that they contain no explicit political subject matter. In sharp contrast to the intricacy and sophistication of their theoretical writings the paintings are extremely simple, bland, decorative abstractions, concerned with colour and the processes of painting in the manner of Americans such as Morris Louis (see Stain painting). However, as far as the group are concerned the paintings are just one element of a threefold programme: (1) signifying practice (painting); (2) ideological struggle; and (3) theoretical practice.

The painters of Supports/Surfaces have been attacked by J-L Perrier on the grounds that their understanding of Marxist-Leninist theory is superficial and that they produce paintings based on the bourgeois notion

of a classless art instead of producing artworks which would be of direct
value to the class struggle.

See also Fundamental Painting, Political Art.

Supports/ Surfaces (Paris, Musée d'Art Moderne de la ville de Paris
(ARC), 1970).

M Pleynet 'Support/ Surface' *Art international* 14 (10) December 1970
63, 70.

M Pleynet *L'enseignement de la peinture* (Paris, Editions du Seuil,
1971).

Peintures, cahiers théoriques (1) June 1971.

'Supports/Surfaces' *VH 101* (5) Spring 1971.

J-L Perrier 'Un château dans les nuages' *VH 101* (6) Summer 1972
38-44.

'Extracts from *Peinture, cahiers théoriques' Studio international* 185
(953) March 1973 110-111.

M Devade & L Cane 'The avant garde today' *Studio international* 186
(959) October 1973 145-146.

L Cane 'Marc Devade plongée dans la couleur' *Art press* (9) February
1974 12-13.

M Devade 'Painting and its double' *Tracks* 2 (2) Spring 1976 50-65.

482 SUSPENDED PAINTINGS: Canvases without stretchers hung from
walls or ceilings at various points and then draped, pleated or twisted to
create sculptural forms. An artist particularly noted for such works is
the American Sam Gilliam. His paintings are extremely colourful and
decorative because he stains his canvas with acrylic pigments. The notion
of suspended painting appears to combine elements of Anti-Form, Stain
Painting and Process Art. Other artists who have produced Suspended
Paintings are Robert Ryman, Phillip Lewis, David Stephens and Derek
Southall.

J Applegate 'Paris letter' *Art international* 15 (1) January 20 1971
p33.

G Jones 'Paintings on unstretched canvas' *Leonardo* 5 (4) Autumn
1972 337-338.

483 SYMBIOTIC ART: A new art form, or research discipline, proposed
by Jonathan Benthall in 1969, concerned with "an interaction between
the (human) organism and the environment . . . analogous to symbiosis
in nature". Benthall suggests that research might usefully be undertaken
first in the area of human perceptual response to sound and light.

286

See also Cybernetic Art, Ecological Art, Participatory Art.

J Benthall 'Technology and art 4; Symbiotic Art' *Studio international* 177 (912) June 1969 p 260.

484 SYNCRETISM: According to the American scholar Daniel Bell modern culture is defined by an 'extraordinary freedom to ransack the world storehouse and to engorge any and every style it comes upon'; therefore 'Syncretism is the jumbling of styles in modern art, which absorbs African masks or Japanese prints into its modes of depicting spatial perceptions'.

D Bell *The cultural contradictions of capitalism* (Heinemann, 1976) p13.

485 SYNERGETICS: The culminating concept of R Buckminster Fuller's design philosophy. Synergy is defined as 'the behaviour of whole systems unpredicted by the behaviour of their parts taken separately'. Fuller's concept is similar to that forwarded by the psychologists of the gestalt school: it emphasizes the whole rather than the parts, synthesis rather than analysis.

R Buckminster Fuller *Synergetics: explorations in the geometry of thinking* (Collier-MacMillan, 1975).

A L MacKay 'Spaceships to Xanadu' *Architectural design* 46 (4) April 1976 197-198.

K Critchlow 'R Buckminster Fuller' *Architectural design* 46 (5) May 1976 296-297.

486 SYNERGIC SCULPTURE: A proposal for a new form of Participatory Art put forward by J J Jehring, to consist of 'a totally designed environment made up of changing forms, moving lights and sound controlled by group participation' made feasible by Cybernetic feedback systems. The word 'synergy', derived from the behavioural sciences, means an increase in effect achieved as a result of combined or coordinated action. In other words, group participation in art will replace individual participation and lead, according to Jehring, to greater benefits.

See also Participatory Art.

J J Jehring 'Synergic Sculpture' *Arts in society* 8 (1) Spring/Summer 1971 415-418.

487 SYSTEMIC PAINTING: An aspect of Post-Painterly Abstraction defined by Lawrence Alloway in an exhibition entitled 'Systemic Painting'

held at the Guggenheim Museum, New York in 1966. On show were paintings by twenty-eight American artists including Kenneth Noland, Ellsworth Kelly, Larry Poons, Al Held, Frank Stella and Paul Feeley.

A number of Systemic painters employ a given pictorial device—chevron, cross, quatrefoil—again and again in a series of canvases (see also Serial Art). Alloway suggests they might be called 'One Image Art'. These images are subject to continuous transformations of colour, or variations of form, and require to be read in time as well as in space; the viewer must seek "variety within conspicuous unity". According to Alloway the sequence of any particular image constitutes a system—defined by the dictionary as "a whole composed of parts in orderly arrangement according to some scheme or plan"—hence the label 'Systemic'. The category is extended beyond one image painting to include works consisting of a single field of colour, or to groups of such works, and also to paintings based on modules.

The repetitive use of imagery is also common in Pop Art, for example, Andy Warhol's paintings show close affinities with the Systemic concept. Artists who employ systems make a number of aesthetic decisions before commencing to paint, and for this reason Systemic Painting has been accused of impersonality. Alloway insists, however, that choices made before beginning to paint are no less human or artistic than those made in the course of painting.

See also Modular Art.

Systemic painting (NY, Guggenheim Museum, 1966).

L Alloway 'Background to Systemic' *Art news* 65 (6) October 1966.

R Pincus-Witten ' "Systemic" painting' *Artforum* 5 (3) November 1966 42-45.

L Alloway 'Systemic painting'–in–*Minimal art: a critical anthology;* edited by G Battcock (Studio Vista, 1969) 37-60.

488 SYSTEMS ARCHITECTURE: In relation to architectural design the systems approach to problem solving has three possible meanings (listed here in increasing order of complexity): (1) system building (designing a range of components to be pre-fabricated in factories and combined in various ways to yield different types of structure): (2) systems analysis (the application of rigorous analysis and logical procedures to the supply of material and the assembly processes in building); and (3) a conceptual overview of architectural design in which each building is regarded as a part of a greater whole and each project is seen in relation to its social, cultural, economic context.

In the 1960s the systems approach to architecture achieved great popularity despite its technocratic and scientistic character but it is now somewhat discredited because it did not yield the benefits that were predicted.

'SBI: system building for industry, for the Milton Keynes Development Corporation' *Architectural design* 42 (9) September 1972 546-552.

'Whatever happened to the systems approach?' *Architectural design* 46 (5) May 1976.

489 SYSTEMS ART: The word 'system(s)' has, in recent years, become extremely fashionable among artists and art critics. Usually it is employed in the straightforward dictionary sense—'a whole composed of parts in orderly arrangement according to some scheme or plan'—for example see Systemic Painting and Systems Group.

In 1972 William Feaver, in a review of the John Moores exhibition, Liverpool, described 'system' sarcastically as 'son of process' and claimed that it served to 'reconcile figurative and abstract of all kinds; method and chance, reason and instinct, invoke "system" and a life study, a painterly grid, a scrubbed colour field, all interrelate like magic. Fix yourself up with a systematic circle of rules and you can huddle inside reciting jargon non stop to keep the spell binding.'

In other instances the word 'system' has a more complex connotation: one reflecting the influence of Ludwig Von Bertalanffy—the scientist most closely associated with General Systems Theory—and the phenomenal growth of the science of systems analysis in the years since 1945. Scientists define a system generally as an 'on going process' and specifically as 'a set of objects, or subsystems, together with relationships between them and their attributes. Since no system occurs without an environment, a characterisation on this basis is incomplete without reference to the total system, *ie*, the system plus its environment.' Systems Art in this latter sense has been discussed by Jack Burnham, an acute observer of the influence of science and technology on modern art. He believes that 'we are moving from an art centred upon objects to one based on systems, thus implying that sculptured objects are in eclipse' and that 'many artists have chosen to work with the real world including the art system, so that a monitored or documented situation becomes their art'.

The term 'Art systems' has been employed by Jorge Glusberg to describe artworks by Latin American artists with social and political implications, ie works regarded as systems of signs representing, in a critical manner, the larger social, economic, political system within which they are generated.

289

See also Conceptual Art, Ecological Art, Media Art, Process Art.

J Burnham 'Systems aesthetics' *Artforum* 7 (1) September 1968 30-35.

J Burnham 'Real time systems' *Artforum* 8 (1) September 1969 49-55.

J Burnham 'Systems and art' *Art in society* Summer/Fall 1969.

W Feaver 'Art: System' *The listener* 87 (2250) May 11 1972 p633.

Art systems in Latin America (ICA, 1974).

490 SYSTEMS GROUP: An informal association of British artists—Richard Allen, John Ernest, Malcolm Hughes, Colin Jones, Michael Kidner, Peter Lowe, James Moyes, David Saunders, Geoffrey Smedley, Jean Spencer, Jeffrey Steele and Gillian Wise Ciobotaru—whose work continues the Constructivist tradition and reflects an interest in Structuralism and Semiology. These artists exhibit together as a group with the intention of making clear to the public their idea of a modern classical art based on 'order with endless variety'. The members of the Systems Group use systematic procedures, often based on mathematics. They believe that this approach to art is equally applicable to different modes of expression such as sculpture, painting, music and film. The resultant visual art works are totally abstract and geometric in appearance. Since this kind of work is concerned with syntax—'orderly or systematic arrangement of parts or elements'—it has also been called 'Syntactic Art'.

M Hughes 'Notes on the context of "Systems" '*Studio international* 183 (944) May 1972 200-203.

Whitechapel Art Gallery *Systems* (Arts Council of Great Britain, 1972).

T

491 TABLEAU: The dictionary defines a Tableau as "a group of persons and accessories producing a picturesque effect". The theatrical tradition of 'tableau vivant' dates back to the middle ages.

Representations of such scenes are familiar to us from the displays mounted by shops, museums and waxworks. They usually consist of a shallow stage containing life size figures and real furniture.

In the early 1960s the American sculptor Edward Kienholz began to extend his relief or assemblage constructions from the wall on to the floor. His new works incorporated whole objects, and full size figures. He called them 'tableaux' after the costumed, stop action presentations he had witnessed in rural churches in his youth. Tableau sculpture can be seen as a halfway house between the single, isolated works of tradition and the total enclosures of Environmental Art. In general the spectator remains outside a Tableau, preserving the feeling of looking into a picture or through a window into a room. Exceptionally, some of Kleinholz's Tableaux are complete rooms that can be entered.

Other sculptors who have made use of the Tableau device: George Segal, Claes Oldenburg, Colin Self, Paul Thek and Duane Hanson.

See also Environmental Art, Verist Sculpture.

492 TAC (The Architects Collaborative): A partnership of architects established in 1945 by Walter Gropius and seven others of a younger generation. The establishment of TAC reflected Gropius's belief in the value of team work in architectural design.

W Gropius & others (eds) *The architects collaborative 1945-1965* (A Niggli, 1966).

493 TACHISME: An aspect of L'Art Informel that emerged around 1950 and remained fashionable for a decade. Tachist paintings are abstract but non-geometric. Some were produced by throwing or dripping paint on to the canvas (the French noun 'tache' means stain, blot, spot or speckle), others were created by gestural brush strokes. Tachist painters sought fortuitous effects, valuing above all intuition and spontaneity.

The term itself is ascribed by one writer to Pierre Guéguen (1951), while others credit it to Michel Tapié or to Charles Estienne. It was also used about the Nabis painters by Gustave Geffroy in the nineteenth century. Tachisme was the European equivalent of Action Painting, but its practitioners were less talented and less adventurous than their American counterparts; consequently Tachist paintings seem too suave and decorative for modern taste. The major artists associated with Tachisme were Pierre Soulages, Wols, Hans Hartung, Jean-Paul Riopelle, George Mathieu, H H Sonderborg, Marcelle Loubchansky and Arnulf Rainer.

See also L'Art Informel, Art Autre, Action Painting, Drip Painting.

P Guéguen 'Tachisme et désintégration' *Aujourd'hui* 5 (26) April 1960 4-5.

G Mathieu *Au-delà du Tachisme* (Paris, Julliard, 1963).

494 TACTILE SCULPTURE: Sculpture is an art in which the tactile sense plays an important role: many sculptures are made by hand and their forms and textures are designed to be touched; however, visitors to exhibitions are normally not permitted to handle sculptures (curators are fearful of damage and wear). Visitors have, therefore, to experience the tactile dimension of sculpture via the sense of sight and their knowledge of what the shapes and surfaces they can see feel like. The blind are doubly penalised in that they can neither see nor touch sculpture in public galleries. However, in recent years a number of sculptures have been produced specifically for the blind and sculpture shows have been mounted where the ban on touching has been temporarily suspended, for example, the show held at the Museum of Contemporary Crafts, New York in 1969, the 'Sculpture for the blind' exhibition held at the Moderna Museet, Stockholm in the same year and the comparable show at the Tate Gallery, London in 1976. The latter exhibition featured works by established modern sculptors—Degas, Moore, etc—and specially commissioned new works by Malcolm Hughes, Tim Mapston and Lawrence Burt.

That the blind can be trained in the 'visual' arts is demonstrated by the example of Kirsten Hearn, a blind girl studying sculpture at Goldsmiths College of Art, London.

I Horovitz 'Feel it . . . ' *Craft horizons* 29 March 1969 14-15.

L Adamson 'Blind eye' *The guardian* June 11 1976 p 9.

Sculpture for the blind (Tate Gallery, 1976).

495 TAMARIND LITHOGRAPHY WORKSHOP: This workshop was founded by June Wayne in July 1960; its name derives from the name of the avenue in Hollywood where the workshop was first located. The aim of Tamarind is to promote the art and craft of lithography by bringing together artists and master printers. It is a non-profit making organisation which has been funded largely by the Ford Foundation. In 1970 it became part of the University of New Mexico.

V Allen *Tamarind: homage to lithography* (NY, MOMA, 1969).

M N Tabak 'Tamarind lithography workshop' part 1 *Craft horizons* 30 (5) October 1970 28-33; part 2 *Craft horizons* 30 (6) December 1970 50-53.

G Antreasian & C Adams *The Tamarind book of lithography: art and techniques* (NY, Abrams, 1971).

496 TANTRA ART: A category of Indian art identified by Ajit Mookerjee, a collector of Tantra Art and author of two lavish books on the

subject. The word 'tantra' is derived from the Sanskrit 'tan' (to expand in continuing, unfolding process) and 'tra' (tool). It refers to a means of extending knowledge. The Tantra religion is a blend of Buddhist, Hindu and Yoga ideas and spans the period fourth century AD to the present day. Therefore, as Robert Fraser points out, Tantra Art provides an insight into an ancient culture whose symbols and myths are alive today. The objects of Tantra Art are various (they include ceremonial vessels, sculptures, icons, paintings, woven fabrics, diagrams, illuminated manuscripts), and have only become known to the general public in the West during the last decade. Philip Rawson stresses, in his introduction to the Hayward Gallery exhibition catalogue, the ecstatic and erotic elements of Tantra Art. As a result of the appeal of these aspects to the drug/ Eastern Mysticism/sexual revolution youth cultures of the West, something of a cult has developed. Other groups are attracted by the diagrammatic paintings of Tantra Art, which resemble modern abstract paintings.

See also Diagrams, Erotic Art, Yoga Art.

F N Souza 'Tantra Art' *Studio international* 172 (884) December 1966 306-311.

A Mookerjee *Tantra Art* (Paris, Ravi Kumar, 1967).

P Rawson 'Tantra Art' *Studio international* 176 (906) December 1968 256-259.

M Gordon 'Tantra and modern meditative art' *Art & artists* 3 (10) January 1969 32-34.

Tantra (Hayward Gallery, 1971).

A Mookerjee *Tantra Asana* (Paris, Ravi Kumar, 1971).

V Whiles 'Tantric imagery: affinities with twentieth century abstract art' *Studio international* 181 (931) March 1971 100-107.

R Fraser 'Tantra revealed' *Studio international* 182 (939) December 1971 252-253.

O Garrison *Tantra: Yoga of sex* (Academy Editions, 1972).

P Rawson *Art of Tantra* (Thames & Hudson, 1973).

497 TEAM 10: An international alliance of young, radical architects who admired each others work and shared certain ideas about the future of architecture. They were called 'Team 10' because they were given the task of preparing a programme for the tenth gathering of the 'Congrès Internationaux d'Architecture Moderne' (CIAM) at Dubrovnik in 1956. During the congress it became evident that a wide divergence of opinion existed between Team 10 and the older founder members of CIAM concerning the purpose of the congress. Team 10 believed the congress had

become too large, too diffuse and only produced vague generalisations. The disagreements led to the dissolution of CIAM but the Team 10 continued to meet. The original members of the group were G Candilis, R Gutmann, William G Howell, Alison and Peter Smithson, Aldo Van Eijck and John Voelcker.

A Smithson (ed) 'Team Ten Primer 1953-63' *Architectural design* 32 (12) December 1962 559-602.

R Banham *The New Brutalism: ethic or aesthetic?* (Architectural Press, 1966) 70-72.

498 TECHNOLOGICAL ART (also called Tech, or Tek Art, Corporate Art): As most art requires some kind of technology to bring it into being, it could be called 'technological'. But today the word 'technology' signifies a much broader concept than merely the skills of a particular craft: it denotes the techniques, processes and methods of applied science combined with the massive resources of materials, capital and labour deployed by modern industry; 'advanced technology' refers to such fields as lasers, aerospace, plastics, drugs, electronics and computers.

As Jack Burnham describes in his book *Beyond Modern Sculpture*, twentieth century artists have adopted many different attitudes to the growth of technology, ranging from ironic detachment (Marcel Duchamp) to enthusiasm (the Futurists). The Bauhaus encouraged contact with industry so that their designs could be mass produced, but this contact did not extend to fine art. Despite the dependence of Kinetic Art on mechanical and electrical engineering, most Kineticists have made only minor use of the huge potential of technology. Only in the middle 1960s was there a significant impetus among artists, especially in the United States, towards collaboration with modern industry; it is the results of such collaboration that are called 'Technological Art'.

The new dialogue between artists and industry was manifested in the development of Computer Art and in the founding of a number of new organisations—EAT, Pulsa, IRAT, APG—dedicated to the task of fostering co-operation between artists and engineers, artists and industrial companies. Fine art magazines also became interested in the topic, for example *Studio international* began publishing a regular feature on 'Technology and Art' written by Jonathan Benthall. In 1966 Billy Kluver organised in New York a festival of Art and Technology called 'Nine evenings: theatre and engineering'. However, the most elaborate scheme was that organised by Maurice Tuchman, curator of the Los Angeles County Museum. His programme of collaboration between artists and Californian

industries was initiated in 1966 and culminated five years later when an exhibition called 'Art and Technology' was held at the L A County Museum in 1971.

Artists such as Claes Oldenburg, Robert Rauschenberg, R B Kitaj, Roy Lichtenstein, Andy Warhol, Tony Smith, Robert Whitman, Newton Harrison and many others selected industrial corporations with whom they worked for periods of many months. The artists did not merely use the facilities of these companies to fabricate preconceived designs, the art works were the result of a genuine participation of both artist and corporation (hence 'Corporate Art') in exploiting the particular technological facilities of the company in question. Tuchman's project was apparently a great success but the exhibition coincided with a change in attitude on the part of artists towards technology, from envy and respect to disillusion and suspicion. Some artists feared that they would become subservient to science and technology as once artists were subservient to the church, while others regarded the industrial modes of production as dehumanised and likely to produce only 'interior design art'. There was also in the 1960s a growing political consciousness among artists. The financial complicity of American industry in the Vietnam war and the pollution of the environment by industry offended their consciences and made the prospects of collaboration with industry, in the near future, unlikely. Many artists, in particular those associated with Conceptual Art, are convinced that art essentially does not require elaborate technology in order to yield viable aesthetic results.

See also Computer Art, APG, IRAT, Pulsa, EAT, Kinetic Art.

J Burnham *Beyond modern sculpture . . .*(Allen Lane, The Penguin Press, 1968).

G Youngblood *Expanded cinema* (NY, Dutton, 1970).

A report on the art and technology program of the Los Angeles County museum of Art 1967-1971 (LA, LA County Museum of Art, 1971).

J Benthall *Science and technology in art today* (Thames & Hudson, 1972).

A Goldin 'Art and technology in a social vacuum' *Art in America* 60 (2) March/April 1972 46-51.

D Davis *Art and the future: a history/prophecy of the collaboration between science, technology and art* (Thames & Hudson, 1973).

S Kranz *Science and technology in the arts: a tour through the realm of science/art* (NY, Van Nostrand Reinhold, 1974).

J Benthall *The body electric: patterns of Western industrial culture* (Thames & Hudson, 1975).

499 TENSILE ARCHITECTURE: Structures held rigid by cables or rods under tension. Examples of tensile structures have been known for centuries but only since the 1950s have architects begun to exploit them on a large scale. The chief exponent of Tensile Architecture is the German Frei Otto. He has created vast tents composed of steel netting held under tension, which Peter Cook calls 'membranes' or 'skin architecture'. Otto's work has become known to a world audience because of the structures he designed for the Olympic games held in Munich in 1972.

Otto is the director of the Stuttgart Institute for Lightweight Structures (founded 1964), a body which organizes conferences and publishes research papers on such themes as 'Adaptable' and 'Pneumatic' architecture.

See also Penumatic Architecture.

R Body 'Under Tension' *Architectural review* 134 (801) November 1963 324-334.

G Minke 'Tensile Structures' *Architectural design* 38 (4) April 1968 179-182.

L Glaeser *The work of Frei Otto* (NY, MOMA, 1972).

P Drew *Frei Otto: form and structure* (Crosby Lockwood, 1976).

J Park 'Lightweight heavies' *Architectural design* 46 (9) September 1976 518-521.

500 TEXTUAL ART: The British writer Brandon Taylor has forwarded an ingenious interpretation of Conceptual Art: he argues that the visual display of texts and page layout in Conceptual Art journals is closely akin to the abstract, minimal paintings of such artists as Brice Marden and that therefore in becoming theoretical, art did not cease to be visual.

In France a number of artists who construct works from texts—Gérard Duchene, G B Jassaud, Jean Mazeaufroid, and Michel Vachez—founded in 1971 a group entitled 'Textruction'.

See also Book Art, Conceptual Art.

J Lepage 'Lettres: Textruction' *L'Art vivant (Chroniques de)* (41) July 1973 p23.

B Taylor 'Textual Art' *Artscribe* (1) January/February 1976 6-7, 11 (reprinted in *Artists' books* (Arts Council of Great Britain, 1976) 47-60).

501 THEORETICAL ART: According to Rosetta Brooks the work called 'Theoretical Art' consisted largely of the output of John Stezaker from about 1968 to 1971, but also the work of Jon Bird, Peter Berry, Paul Wood, Kevin Wright, and David Holmscroft. Their writings appeared

in the short-lived periodical *Frameworks journal*. The idea of Theoretical Art was also incorporated in the name Ian Burn, Mel Ramsden, and Roger Cutforth chose for their New York group: 'Society for Theoretical Art and Analyses'.

Two kinds of art theory can be distinguished: (1) theory of, or about, art (this is meta-linguistic in character and is generated by critics, art historians, philosophers, and aestheticians); (2) theory for art (ie theory informing the practice of artists). The differences between the two types are often blurred in art literature and, of course, it is perfectly possible for artists to change roles with critics. Following the rise to power and influence of American art criticism during the 1950s and 1960s, which produced a situation where critical theory dominated artistic practice, artists found it necessary to rethink their relationship to theory. Theoretical Art was therefore an attempt by artists to clarify and to make explicit the theoretical basis for their work. There was also a tendency to forward 'theoretical constructs' as art in their own right. The danger attending this whole enterprise was the possibility that the practice of theory, or theoretical practice, would become an end in itself, as it is for so many philosophers.

See also Conceptual Art.

D Holmscroft 'Some observations at the outset of a purely theoretical art'—in—*A survey of the Avant Garde in Britain vol 2* (Gallery House, 1972) 44-46.

R Brooks 'A survey of the Avant Garde in Britain' *Flash Art* (39) February 1973 p6.

J Stezaker 'Priorities 2' *Frameworks journal* 1 (2) June 1973 1-19.

502 THIS IS TOMORROW (TIT): An influential exhibition, designed by twelve teams consisting of architects, sculptors, painters and photographers, held at the Whitechapel Gallery, London in 1956. Each team created an environmental unit in an attempt to synthesise the different arts. English Constructivist artists such as Anthony Hill and Victor Pasmore participated and also ex-members of the Independent Group: Eduardo Paolozzi, Richard Hamilton, John McHale and others. Some displays were composed of images drawn from popular culture and the exhibition included Hamilton's seminal collage 'Just what is it that makes today's homes so different, so appealing?'. This is Tomorrow is chiefly remembered as a landmark in the development of English Pop Art.

This is tomorrow (Whitechapel Art Gallery, 1956).

L Alloway 'The development of British Pop'—in—*Pop art,* by L R Lippard & others (Thames & Hudson, 1966) 26-67.

503 TOWNSCAPE: A campaign mounted by the *Architectural review* in the immediate post-war years for improved planning of the urban environment, especially concerned with the need to reduce the quantity of street furniture and to improve its disposition. Recent writers on architecture dismiss the Townscape philosophy as picturesque and claim that in concerning itself with the surface appearance of towns it dealt only with the symptoms of urban blight not the root causes.

G Cullen *The concise townscape* (Architectural Press, 1973).

R Maxwell 'An eye for an I, the failure of the Townscape tradition' *Architectural design* 46 (9) September 1976 534-536.

G Burke *Townscapes* (Penguin Books, 1976).

504 TROMPE L'OEIL: The term 'trompe l'oeil'—that which deceives the eye'—made its appearance in the early nineteenth century and was coined to describe precisely rendered still lives of the seventeenth century. Since the days of ancient Greece painters have striven to develop techniques enabling them to produce a convincing illusion of reality hence the term 'trompe l'oeil' is frequently applied retrospectively to the art of Greece, Rome, Renaissance Italy and Baroque Europe.

Writers on this topic are often in disagreement as to the exact relation between trompe l'oeil in particular and pictorial illusion in general. In studying a representational picture there are two possibilities: (1) looking into it (as if it were a window); (2) looking at it (as if it were a flat object). Normally we look into pictures while remaining subsidiarily aware of their flatness, of their status as paintings, that is, we know that what is depicted is unreal but we are prepared to suspend our disbelief. If a picture deceives our visual perception completely then we cannot acknowledge the presence of art because we would take whatever was depicted to be part of the natural environment. It is clear that some artists have aimed to trick the spectator so that he only discovers his error when he tries to touch or grasp the depicted object but Martin Battersby believes that in general trompe l'oeil painters eschew total deception, in his view they aim to produce a sense of puzzlement and disquiet which induces the viewer to check his vision by means of touch.

The whole genre of trompe l'oeil is anathema to Modernism; therefore in the twentieth century this tradition of art has been kept alive by
298

unfashionable painters exhibiting at such venues as the Royal Academy, London. However, in the 1930s trompe l'oeil gained a new currency in Surrealism, and in the 1970s it has been manifested in the work of the Photo-Realist painters and Verist sculptors. A spate of books on the subject testifies to the renewal of interest in the whole question of pictorial illusion following the decline in influence of the theory of Modernist painting.

A Frankenstein *The reality of appearance: trompe l'oeil tradition in American painting* (NY, New York Graphic Society, 1970).

R L Gregory & E H Gombrich (eds) *Illusion in nature and art* (Duckworth, 1973).

M Battersby *Trompe l'oeil: the eye deceived* (Academy editions, 1974).

M L d'Otrange Mastai *Illusion in art: Trompe l'oeil, a history of pictorial illusionism* (Secker & Warburg, 1976).

505 TYPEWRITER ART: A surprisingly wide range of pictures, abstract and representational, can be produced on a typewriter. This form of art originated in 1874 and has been practised by many serious artists in the twentieth century. It achieved its greatest popularity amongst the Concrete poets in the 1950s and 1960s.

A Riddell (ed) *Typewriter art* (London Magazine Editions, 1975).

U

506 ULM: Because of its cumbersome title, 'Die Hochschule für Gestaltung', this influential German college of design was referred to throughout the design world as 'Ulm', after the town where it was located. The idea for a design school to continue the principles of the Bauhaus was first suggested in 1948 and the school opened in 1955. Its first director was the Swiss Concrete artist Max Bill, who also designed its buildings. In 1956, after policy disputes, Bill was replaced by the Argentine painter Tomas Maldonado. Ulm was noted for its rational approach to design education and its emphasis on scientific and mathematical techniques: Reyner Banham described it as a "cool training ground for a technocratic elite". Ulm was closed by the German government in 1968.

Ulm Nos 1-21, 1958-68.

R Hamilton 'Ulm' *Design* (126) June 1959 53-57.

'Homage to Ulm' *BIT international* (4) 1969 (special issue).

507 ULTIMATE PAINTING: The American artist Ad Reinhardt claimed that the paintings he produced between 1960 and his death in 1967 were the "ultimate abstract paintings". They consisted of a series of almost identical canvases, square in format (60in x 60in), divided into nine squares and painted in slightly varying shades of grey or black. Reinhardt believed that the possibilities of abstract painting were finite and that his late works represented the culminating point of the easel painting tradition, beyond which it was impossible to proceed.

See also Invisible Painting.

B Rose 'The Black Paintings'—in—*Ad Reinhardt: Black Paintings 1951-1967* (NY, Marlborough Gallery, 1970) 16-22.

A Reinhardt *Art-as-art: the selected writings of Ad Reinhardt;* edited by B Rose (NY, Viking Press, 1975).

508 UNDERGROUND ART: This expression refers to art created during the late 1960s by relatively unknown or amateur artists associated with the development of anti-establishment culture, variously described as 'the Underground', 'Counter Culture', 'the Alternative Society', 'the Youth Culture', and 'Freak Culture'.

Underground Art was primarily graphic in character. Favourite media were posters, comic books, magazines, cartoons, record covers, animated films, and tabloid newspapers. Certain modes of dress, body language, speech, and craft activities were also part of Underground Culture. Poster artists exploited Op Art effects and simulated drug delirium (one book was published with the title 'Pot Art'; see also Psychedelic Art); the illustrators were influenced by French Symbolist painting, Art Nouveau, and Surrealism. Their highly unusual page layouts appeared in such magazines as *Oz, It, Friendz,* and *Ink.* Underground graphics were called 'Freaky' because they delighted in grotesque and pornographic subject matter (obscenity and violence were two weapons used for political purposes). New printing processes—offset lithography and the IBM typesetting machine—enabled layout designers to create complex effects by means of overprinting and by the super-imposition of several colours.

Underground artists who have subsequently become known to the overground world include Michael English, Martin Sharp, Mike McInnerrey, Mal Dean, Rick Griffin, and John Hurford. American comic producers

who have become internationally known for their weird humour and graphic skill: Robert Crumb, Ron Cobb, Victor Moscoso, and S Clay Wilson.

Underground Art can be criticised on the grounds of technical crudity and eclecticism but its uninhibited, raw, and direct character was a welcome contrast to the austerity and cerebral nature of Minimal and Conceptual Art which flourished during the same period.

See also Funk Architecture, Visionary Art, Comix.

P Selz 'The Hippie poster' *Graphis* 24 (135) 1968 70-77.

G Keen & M La Rue (eds) *Underground graphics* (Academy, 1970).

T Albright 'Cartoon visions on Muni walls' *Rolling stone* (95) November 11 1971 p 10.

D Blain 'The fringe press' *Design* (285) September 1972 66-71.

D Fenton (ed) *Shots: photographs from the Underground Press* (Academy, 1972).

R Lewis *Outlaws of America: the Underground Press and its context* (Penguin, 1972).

H Jones 'Don't overlook the Underground Press' *Penrose Annual* 66 1973 49-62.

M J Estren *A history of Underground comics* (San Francisco, Straight Arrow Books, 1974).

509 URBAN GUERRILLA ARCHITECTURE: A demand by HIM—Herbert Ilya Meyer—for direct political action in architecture to solve housing problems in cities by the use of all available land and waste and surplus materials.

H I Meyer 'Viewpoint: thoughts on Urban Guerrilla Architecture . . .' *AAQ* 4 (1) January/March 1972 58-59.

510 URBAN MODELLING: The technique of using static and dynamic mathematical models of urban phenomena in the planning of cities and regions.

M Batty *Urban modelling: algorithms, calibrations, predictions* (Cambridge U Press, 1976).

511 USCO (Us Company): An American artists collective, founded in 1963 by Steve Durkee, Gerd Stern and Michael Callahan, located in an abandoned church at Garnerville, New York. Members of USCO include poets, film makers, engineers and artists; the composition of the group continually changes. USCO is committed to the multi-media approach

to art, and has produced Kinetic Art environments, Happenings (called 'Be Ins') and a multi-media discotheque. Recently they established, in conjunction with a number of behavioural scientists from Harvard University, an organisation called the 'Intermedia Systems Corporation'.

See also Inter-Media.

R E L Masters and others *Psychedelic Art* (Weidenfeld and Nicolson, 1968).

R Kostelanetz *The Theatre of Mixed Means* (Pitman, 1970) 243-271.

512 UTILITY: From 1941 to 1951 the British government instituted state control over the manufacture and design of furniture, fabrics, clothes and certain household goods in order to ensure the maximum use of scarce raw materials and labour. Utility furniture and fashion was plain, economical, simple in design, made from sound materials, and practical. Established furniture designers such as Gordon Russell (head of the Utility furniture design team) took the opportunity provided by the wartime emergency to fulfil a design philosophy: to raise the whole standard of design for the mass of the people by producing modern, functional commodities.

From 1948 onwards controls on the furniture industry were lifted hence the introduction of the term 'Freedom furniture'.

See also Austerity/Binge.

CC41: Utility furniture and fashion (Inner London Education Authority, 1974) catalogue of an exhibition held at the Geffrye Museum, London.

513 UTOPIAN ARCHITECTURE (also called Fantastic Architecture, Visionary Architecture): The constraints of everyday architecture are legion—the needs of clients, budgets, materials, building and planning regulations, etc. Therefore it is not surprising that many architects produce designs, in the form of drawings or models, for Utopian projects that transcend mundane limitations; see for example Conceptual Architecture, Absolute Architecture, Chemical Architecture, Megastructures. Projects such as these are unlikely ever to be constructed, at least in the foreseeable future, although occasionally some Utopian projects are realised on a small scale, temporary basis at international expositions.

The book *Fantastic Architecture*, first published in Germany in 1960, provides a corrective to the partial view of modern architecture as a logical and rational development by illustrating the strange forms of Antonio Gaudi, the primitive structures of Ferdinand Cheval and Simone

302

Rodilla, and the expressionistic elements in modern architecture. It identifies Bruno Taut, Hermann Finsterlin and Paul Scheerbart as the main fantasy architects and the 1920s as the chief era of such dreaming. Frank Lloyd Wright also produced extreme designs, such as his mile high office tower, and Buckminster Fuller devised a plan to enclose the whole earth in a spherical, geodesic structure.

To dream of Utopian solutions enables architects to develop technology, materials and methods far beyond their current limits, and their conclusions may possibly help to precipitate change. However, as Peter Cook points out, the Utopian label can be a disadvantage: "timid pragmatists can dismiss any experiment or any new concept as 'utopian', and thereby remove it from the discussion of practical issues". It can also be argued that vast Utopian schemes are a sign of megalomania in the architectural profession: having always seen themselves as 'universal men', architects tend to believe they know best regardless of the real needs of the people.

'Opinion: Visionary architecture at the Museum of Modern Art, New York' *Architectural design* 31 (5) May 1961 181-182.

M Nicoletti 'Flash Gordon and the twentieth century utopia' *Architectural review* 140 (834) August 1966 87-91.

U Conrads & H G Sperlich *Fantastic Architecture* (Architectural Press, 1968).

W Vostell & D Higgins *Fantastic Architecture* (NY, Something Else Press, 1969).

P Cook *Experimental architecture* (Studio Vista, 1970) p 28.

514 UTOPIE GROUP: A French experimental architectural group formed in 1967, concerned with the social utility of architecture, the notion of expendability and the use of pneumatic structures. The members of Utopie are J Aubert, J P Jungmann, A Stinco and H Tonka.

See also Pneumatic Architecture.

J Aubert and others 'Utopie' *Architectural design* 38 (6) June 1968 p 255.

'La Pneumatique' *Architectural design* 38 (6) June 1968 273-277.

V

515 VERIST SCULPTURE: The three-dimensional equivalent of Photo-Realist painting. It depends upon the technique of making casts from the human body in fibreglass and polyester resin. American practitioners, such as John De Andrea and Duane Hanson, frequently devise narrative tableaux, with social or political themes, composed of groups of life-size figures dressed in genuine clothes and other props. The literal character of sculpture militates against complete illusionism and when they are seen 'in the flesh' these petrified tableaux often fail to carry conviction: like waxworks they occupy a twilight zone between artifice and reality. Verist Sculptures are, like Photo-Realist paintings, more effective in photographs.

See also Photo-Realism.

U Kultermann *New Realism* (Mathews Miller Dunbar, 1972).

J Masheck 'Verist sculpture: Hanson and De Andrea' *Art in America* 60 (6) November/December 1972 90-97.

516 VIDEO ART (also called TV art): The Latin word 'video', meaning 'I see', was used in the United States during the 1950s to refer to television. Technological developments in the field of television hardware in the second half of the 1960s have made it possible for private individuals, in this context fine artists, to afford portable video equipment: a camera linked to a video tape recording machine (images are stored on magnetic tape) plus a television monitor screen. This system enables tape cassettes to be produced and sold for showing on television sets in the home. These tapes can be marketed in the same way as gramophone records and sound tape recordings. The significance of video tape is that it breaks the monopoly of television previously held by large broadcasting companies. Enthusiasts in the United States have founded a magazine—*Radical software*—to publicise the revolutionary potential of video.

Since the advent of video a large number of artists have availed themselves of the medium, for example, Nam June Paik, Keith Sonnier, William Wegman, Klaus Rinke, Joseph Beuys, Stana Vasulka, Bruce Nauman, Andy Warhol, Les Levine, Stan Vanderbeek, Gilbert & George, Dan Graham, Mike Leggett, Stuart Marshall and David Hall. Video appeals especially to those artists who work in the area of dance, performance, or Happenings, because it enables these transitory activities to be recorded for posterity. Precise artistic control is made possible by the instant

replay, erase, and re-record facilities of video. The video system has been described as 'the mirror machine' because by training the camera on oneself it is possible to watch oneself on a TV screen. This capacity of video is of immense value to Performance artists and to narcissistic Body artists. The medium also appeals to those artists interested in animated graphics and those interested in the physical and psychological aspects of human behaviour, ie, those artists who establish installations in galleries in which members of the public are directly involved through seeing themselves on monitors in same-time, or by means of delay mechanisms, in past-time.

Artworks on video can be presented in galleries or on broadcast television and tapes can be purchased by public museums or by private collectors. In Germany the late Gerry Schum opened a 'Videogalerie' to market artists' tapes. In spite of the daunting quantity of hardware required to mount a mixed exhibition of Video Art a number of such shows have taken place, for example, 'TV as a creative medium' (NY, Howard Wise Gallery, 1969), 'Projection' (Dusseldorf, 1971), 'Circuit' (USA, Everson Museum, 1973), 'Identifications' (London, Hayward Gallery, 1973), 'Video show' (London, Serpentine Gallery, 1975), 'Video Art' (USA, University of Pennsylvania, 1975), and 'Video show' (London, Tate Gallery, 1976). Several art magazines have also published special issues on video in recent years, namely, *Arts Canada* (Oct, 1973), *Arts magazine* (Dec 1974), *La Mamelle* (Winter, 1976) and *Studio international* (May/June, 1976).

See also Community Art.

J S Margolies 'TV—the next medium' *Art in America* 57 (5) September/October 1969 48-55.

G Youngblood *Expanded cinema* (NY, Dutton, 1970) 257-344.

D Davis 'Video Obscura' *Artforum* 10 (8) April 1972 64-71.

Video show (Serpentine Gallery, 1975).

'Video Art' *Studio international* 191 (981) May/June 1976.

J Perrone 'The ins and outs of video' *Artforum* 14 (10) June 1976 53-57.

I Schneider & B Korot (eds) *Video art: an anthology* (NY, Harcourt Brace Jovanovich, 1976).

D Davis & A Simmons (eds) *The new television: a public/private art* (MIT Press, 1977).

517 VISIONARY ART: According to Thomas Albright the mystical, symbolic, and religious undercurrents of early Psychedelic Art in San

Francisco have developed into a new movement which he calls 'Visionary Art'. The paintings and drawings of the new movement are characterised by the use of vivid colours, by a graphic sensibility, and emphasis on subject content. Its sources are Surrealism, oriental religions (Zen, Yoga, Sufism), the occult, and the drug experience. Albright identifies at least a dozen artists as belonging to the Visionary Art movement but none has yet achieved international recognition.

T Albright 'Visuals' Part I *Rolling stone* (88) August 5 1971 34-35.

T Albright 'Visuals' Part II *Rolling stone* (89) August 19 1971 34-37.

T Albright 'Visuals' Part III *Rolling stone* (91) September 16 1971 40-42.

518 VISUAL COMMUNICATION: In recent years many colleges of art and design in Great Britain and Europe have introduced courses concerned with Visual Communication, covering such topics as advertising, television, photography, films, comics, illustrated magazines, and typography, in addition to the traditional disciplines of drawing, painting and lettering. As the editors of *Art without boundaries* point out, the term 'Visual Communication' is sometimes used as a substitute for 'Graphic Design' (which in turn was coined to replace 'Commercial Art').

In Germany the term 'Visuelle Kommunikation' coined by Hans M Enzensberger and used since 1970 in such periodicals as *Aesthetik und Kommunikation* (a journal centred on the Institute for Experimental Art and Aesthetics, Frankfurt) designates a field of study concerned with raising the level of political awareness. Contemporary mass media are seen as preserving the status quo and in order to transform society it is thought necessary to expose the repressive ideology embedded in the imagery of the mass media. Traditional aesthetics are considered ideologically suspect and are rejected along with the elitist distinction between 'high' and 'low' culture.

See also Pictorial Rhetoric.

J Muller-Brockmann *A history of visual communication* (Alec Tiranti, 1971).

H E Ehmer (ed) *Visualle kommunikation* (Cologne, Dumont, 1972).

W

519 WASHINGTON COLOUR SCHOOL: Two Washington painters noted for their emphatic use of colour—Morris Louis and Kenneth Noland —achieved international recognition in the late 1950s and as a result drew attention to Washington DC as an art centre. The colour school tradition established by Noland and Louis was continued by several other Washington artists: Gene Davis, Tom Downing, Howard Mehring and Paul Reed. Their canvases are usually extremely large, totally abstract and immaculately painted. However, not all critics have succumbed to their charm, some finding them 'gutless' and describing them as 'cosmetic abstractions'.

See also Stain Painting, Colour-Field Painting, Hard-Edge Painting.

L J Ahlander 'The emerging art of Washington' *Art international* 6 (9) November 25 1962 30-33.

E Stevens 'The Washington Color Painters' *Arts magazine* November 1965 30-33.

Washington Colour Painters (Washington DC, Washington Gallery of Modern Art, 1965).

520 WEST COAST SCHOOL (Also called the Pacific School): The major art centres of the United States are located on the Eastern and Western seaboards of the continent. Since 1945 many artists have settled in the West Coast or have become internationally known because of movements originating there. Art has flourished in San Francisco, in Los Angeles, and to a lesser extent in Seattle. Periodically art critics publish articles posing the question 'is there a West Coast School?' (the answer is usually 'no but...').

The most important West Coast artists and movements are as follows: Mark Tobey and Morris Graves (two artists who lived in Seattle and were influenced by Oriental Art—the East has close contacts with the Western states of the USA); Bay Area Figuration; Hard-Edge Painting; Pop Art (represented by the artists Mel Ramos, Wayne Thiebaud and Ed Ruscha); Edward Keinholz (an artist who moved to Los Angeles in 1953 and made many of his best assemblages there); Simon Rodia (creator of the famous Watts towers).

In recent years Los Angeles has overtaken San Francisco as the leading art centre and is the home of the Finish Fetish cult. Los Angeles art epitomises the virtues of the West Coast 'School': variety, vitality, openness to new ideas, craftsmanship.

See also Los Angeles Fine Art Squad, Custom Painting, Bay Area Figuration, Hard-Edge Painting, Funk Art, Psychedelic Art, Visionary Art, Finish Fetish.

Eleven Los Angeles artists (Hayward Gallery, 1971).

P Plagens *Sunshine muse: contemporary art on the West Coast* (NY, Praeger, 1974).

Y

521 YOGA ART: A form of Indian art principally consisting of 'nuclear' or 'power' diagrams used as visual aids in yoga meditation. These yantras are generally abstract in design but they signify meaning to the initiated via such coding devices as colour symbolism.

See also Tantra art.

A Mookerjee *Yoga art* (Thames & Hudson, 1975).

BIBLIOGRAPHICAL NOTE

Books, catalogues, and periodical articles consulted during the preparation
of this glossary have been listed at the foot of each entry. These refer-
ences are selective therefore readers seeking additional references are
advised to search the following indexes:
Artbibliographies modern
Art, design, photo
Art index
British humanities index
Répétoire d'art et d'archéologie
RIBA annual index of periodical articles
RILA.
The reader will find that subject headings vary from index to index
but those in *Art, design, photo* are, in many instances, the same as in this
glossary.

Whenever possible I have listed the major artists, designers, and archi-
tects associated with each movement or group consequently readers should
find it a comparatively simple task to trace further information about
named individuals via the many monographs on artists, and via the entries
in biographical dictionaries of artists.

The following bibliography is limited to books and selected articles
that provide general or international surveys of the post-war period.

ART
P Heron *Changing forms of art* (Routledge, 1955).

M Brion & others *Art since 1945* (Thames & Hudson, 1958).

N Ponente *Modern painting: contemporary trends* (Geneva, Skira,
1960).

H Rosenberg *The tradition of the new* (Thames & Hudson, 1962).

H Rosenberg *The anxious object . . .* (Thames & Hudson, 1965).

G Battcock (ed) *The new art: a critical anthology* (NY, Dutton, 1966).

W Grohmann (ed) *Art of our time: painting and sculpture throughout
the world* (Thames & Hudson, 1966).

A Pelligrini *New tendencies in art* (NY, Crown, 1966).

N Calas *Art in the age of risk and other essays* (NY, Dutton, 1968).

U Kultermann *The new sculpture* (Pall Mall Press, 1969).

H H Arnason *A history of modern art* (Thames & Hudson, 1969).

U Kultermann *The new painting* (Pall Mall Press, 1969).

E Lucie-Smith *Movements in art since 1945* (Thames & Hudson, 1969).

M Ragon *Vingt cinq ans d'art vivant . . .*(Paris, Casterman, 1969).

M Kozloff *Renderings . . .* (Studio Vista, 1970).

D Ashton *A reading of modern art* (NY, Harper & Row, rev ed 1971).

N & E Calas *Icons and images of the sixties* (NY, Dutton, 1971).

W Haftmann & others *Abstract art since 1945* (Thames & Hudson, 1971).

J P Hodin & others *Figurative art since 1945* (Thames & Hudson, 1971).

U Kultermann *Art-events and happenings* (Mathews Miller Dunbar, 1971).

L R Lippard *Changing . . .* (NY, Dutton, 1971).

H Ohff *Galerie der neuen kunste* (Gutersloh, Bertelsmann, 1971).

J Roh *Deutsche kunst der 60er jahre . . .*(Munich, Bruckmann, 1971).

H Rosenberg *Artworks and packages* (NY, Dell, 1971).

K Groh (ed) *Aktuelle kunst in Osteropa* (Cologne, Dumont, 1972).

G Muller *The new avantgarde . . .* (Pall Mall Press, 1972).

H Ohff *Kunst ist utopie* (Gutersloh, Bertelsmann, 1972).

H Rosenberg *The de-definition of art . . .* (Secker & Warburg, 1972).

G Woods & others (eds) *Art without boundaries 1950-70* (Thames & Hudson, 1972).

G Battcock (ed) *Idea art: a critical anthology* (NY, Dutton, 1973).

C Greenberg *Art & culture* (Thames & Hudson, 1973).

H Kramer *The age of the avant garde . . .*(NY, Farrar, Strauss & Giroux, 1973).

L R Lippard *Six years . . .* (Studio Vista, 1973).

A B Oliva *Il territorio magico . . .* (Florence, Centro Di, 2nd ed 1973).

S Hunter *American art of the 20th century* (Thames & Hudson, 1973).

J Burnham *Great western salt works . . .* (NY, Braziller, 1974).

G De Vries (ed) *Uber kunst—on art* (Cologne, Dumont, 1974).

H Rosenberg *Discovering the present . . .* (Chicago, University of Chicago Press, 1974).

L Alloway *Topics in American art since 1945* (NY, Norton, 1975).

B Smith (ed) *Concerning contemporary art . . .* (Oxford, Clarendon Press, 1975).

310

J A Walker *Art since Pop* (Thames & Hudson, 1975).

T Wolfe 'The painted word' *Harpers magazine* 250 (1499) April 1975 57-92.

G Celant *Senza titolo/1974* (Roma, Bulzoni, 1976).

C Gottlieb *Beyond modern art* (NY, Dutton, 1976).

H Rosenberg *Art on the edge*... (Secker & Warburg, 1976).

E H Johnson *Modern art and the object: a century of changing attitudes* (Thames & Hudson, 1976).

ARCHITECTURE AND DESIGN

R Banham 'Design by choice, 1951-1961: an alphabetical chronicle of landmarks and influences' *Architectural review* 130 (773) July 1961 43-48.

W Pehnt (ed) *Encyclopedia of modern architecture* (Thames & Hudson, 1963).

J Jacobus *Twentieth century architecture: the middle years 1940-65* (Thames & Hudson, 1966).

R Banham 'Revenge of the picturesque: English architectural polemics 1945-1965'—in—*Concerning architecture;* edited by John Summerson (Allen Lane, The Penguin Press, 1968).

J Joedicke *Architecture since 1945* (Pall Mall, 1969).

'Anniversary issue: a visual record of 21 years, 1949-1970' *Design* (253) January 1970.

P Cook *Experimental architecture* (Studio Vista, 1970).

A Ferebee *A history of design from the Victorian era*... (NY, Van Nostrand Reinhold, 1970).

A Jackson *The politics of architecture*... (Architectural Press, 1970).

L Benevolo *History of modern architecture* 2 vols (Routledge, 1971).

C Jencks *Architecture 2000: predictions and methods* (Studio Vista, 1971).

J Burns *Arthropods: new design futures* (NY, Praeger, 1972).

J Dahinden *Urban structures for the future* (Pall Mall, 1972).

F MacCarthy *All things bright and beautiful*... (Allen & Unwin, 1972).

C Jencks *Modern movements in architecture* (Penguin, 1973).

A Whittick *European architecture in the 20th century* (NY, Abelard-Schuman, 1974).

GLOSSARIES

J N Barron *Language of painting: an informal dictionary* (NY, World Publishing Co, 1967).

'Dizionario dei nuovi termi d'arte' *Casa vogue* (14) May/June 1972 122-123.

M de Molina *Terminos de arte contemporanea* (Colombia, Bienal de Arte Coltejer III, 1972).

R Charmet *Concise encyclopedia of modern art* (Glasgow, Collins, 1972).

Phaidon dictionary of twentieth century art (Phaidon, 1973).

K Thomas *Dumont's kleines sachworterbuch zur kunst des 20. Jahrhunderts von anti-kunst biz Zero* (Cologne, Dumont-Schauberg, 1973).

T Richardson & N Stangos (eds) *Concepts of modern art* (Penguin Books, 1974).

INDEX

This index contains names of artists, critics, titles of exhibitions, and subjects. Numbers refer to the alphabetical entries not to pages. Alphabetical filing is word by word.

Commonism 406
Communication 121, 123, 176, 405, 442
Communication theory 284
Communications (Paris) 442
Communist society 323, 384, 413, 452
Community Architecture 141
Community Arts 15, 16, 142, 288, 388
Community gardening 141
Community Photography 147
Commuting 333
Company handwriting 275
Composite Art 78
Computer Art 143, 166, 419, 498
Computer Arts Society 143
Computer films 190, 212
Computer graphics 281
Computers 47, 143, 166, 176, 180, 294, 419, 455, 498
Con, Rob 242
Con Art 146
Concept Art 144
Conceptual Architecture 145
Conceptual Art 30, 54, 62, 100, 102, 146, 176, 188, 229, 239, 298, 330, 334, 374, 394, 409, 410, 458, 469, 500, 508
Concerned Photography 147
Concrete Art 148, 246
Concrete Expressionism 149
Concrete Poetry 143, 148, 150, 176, 505
Congrès Internationaux d'Architecture Moderne 263, 497
Connell, Amyas 333
Conner, Bruce 78, 241
Connoiseurship 72
Conran, Terence 263
Consensus Painting 151
Consortium of Local Authorities Special Programme 130
Constable, John 215, 379
Constant 216, 449
Constellations 150
Constructionism 152, 392

Constructivism 150, 153, 202, 246, 490
Consumer goods 106, 213, 250, 284, 454
Consumer society 225, 406
Consumer style 406
Contact Art 470
Container Corporation 77
Contemporary Art 88, 154, 215, 335
Contemporary Style 154
Contextual Art 155
Contextualism 156
Contextualistic Aesthetics 157
Continuum 158
Contract Furniture 159
Control magazine 93, 166
Cook, Peter 44, 105, 154, 401, 499, 513
Cookery 230
Cool Art 160, 348
Coop Himmelbau 65
Cooper, Austin 170
Cooper, Douglas 213
Coopérative des Malassis 161
Cop Art 345
Coplans, John 3, 414, 443
Cordier, Pierre 125
Co-Realism 162
Cordell, Frank 284
Cordell, Magda 284, 355
Cork, Richard 28
Corneille 135, 216
Cornell, Joseph 78
Cornford, Christopher 69, 250
Cornish School 434
Corporal Art 100
Corporate Art 498
Corporate Design 174, 275
Correspondence Art 322
Corretti, Gilberto 50
Corris, Michael 54
Coss, R G 208
Cottingham, Robert 393
COUM 388
Council of Industrial Design 106, 173
Counter culture 508

325

342

344

346

347

350